The Art of Music

The Art of Music

edited by

Patrick Coleman

with essays by

Simon Shaw-Miller

Richard Leppert

Sandra Benito

Michael A. Brown

Patrick Coleman

Anita Feldman

James Grebl

Ariel Plotek

Gemma Rodrigues

Marika Sardar

Christina Yu Yu

The San Diego Museum of Art San Diego

in association with

Yale University Press New Haven and London

Contents

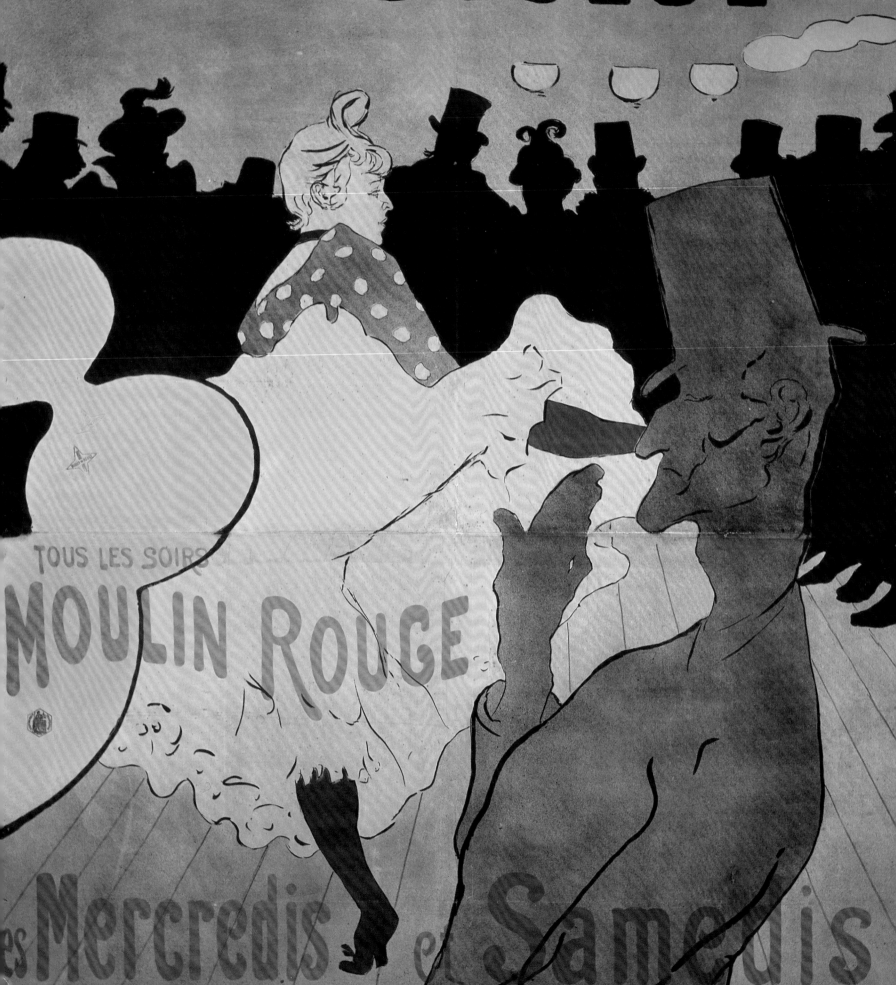

Director's Foreword

Music and the visual arts have long looked to one another for inspiration and innovative new modes. One view at the wondrous array of works discussed in *The Art of Music* suggests that they have, in all likelihood, always done so: Ancient Aztec drums, intricately carved, are resonant with meaning, even when silent. In abstract paintings by artists such as Kandinsky and Hartley, paint functions as music. Musical compositions by Wagner and Debussy seem to paint a picture clear as day in the mind's eye. Lavishly ornamented instruments augment the visual effect of musicians in performance. Prints of musical plays in Edo Japan represent and evoke the music that accompanied the original scenes. The stage design, costumes, music and choreography of the Ballets Russes reflect the collaboration and mutual influence of avant-garde artists and composers. African vocal music and drawings both synesthetically call to the spirits of the Ituri Forest. Sound art draws upon the ear more than the eye. These are the kind of multi-sensory delights explored in *The Art of Music*, one of the most extensive, global surveys of the interrelation of the sister arts to date.

While monographic and thematic exhibitions are the standard practice of art museums for good reason, an exhibition like this traces a different kind of history. Here we ask a question focused less on particular artists or movements and instead follow the various flowerings of a single idea: that the arts, especially visual art and music, share a single history—that throughout, the push-and-pull of each upon the other has been a significant and under-studied force on the development of both disciplines and in understanding human creativity. Not only is this an important part of our mission to study and interpret the world's best art for a broader audience—and *The Art of Music* has entry points for people of different levels of knowledge or experience with art, music, or both—but it allows for a provocative reshuffling of the usual art historical hierarchies. Indian *Ragamala* painting is presented on equal standing with the synesthesia of the early twentieth-century

1. Henri de Toulouse-Lautrec (1864–1901). *Moulin Rouge—La Goulue* (detail), 1891. Lithograph, 75½ × 46 in. (191.8 × 116.8 cm). The San Diego Museum of Art; Gift of the Baldwin M. Baldwin Foundation.

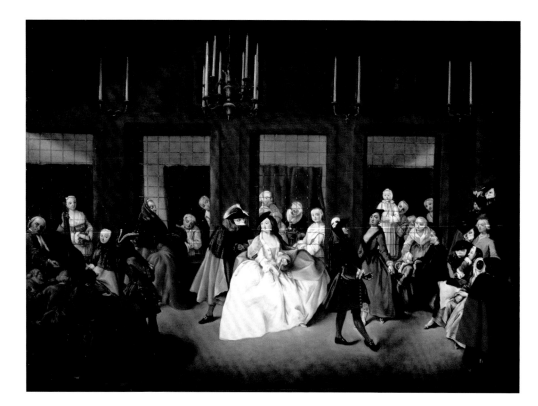

2. Giuseppe de Gobbis (1730–after 1787). *The Convent Parlor*, ca. 1755–60. Oil on canvas, 33 × 45 in. (83.8 × 114.5 cm). The San Diego Museum of Art; Gift of Anne R. and Amy Putnam.

avant-garde. Commonalities between seventeenth-century Dutch and Italian painting, Chinese literati painting and contemporary art's evocations of music can be appreciated. The persistence and permutation of antique motifs and musical associations across the centuries is made readily apparent. The influence of Kuba textile traditions on Matisse's jazz-infused cut-outs can be perceived first-hand. Though music and visual art is the subject, at every turn dance, theater, opera, drama, literature and film contribute their influence, suggesting (as various theories have over the centuries) a unity of all the arts, at the very least in how they draw on a common well of creativity and inspiration.

This exhibition is the final of a series planned in honor of the 2015 centennial of the Panama-California Exposition, which has special importance to our institution. This event, which celebrated the opening of the Panama Canal and San Diego as the first US port of call, bequeathed to us the distinctive Spanish Colonial architecture of Balboa Park, home to over twenty museums and cultural organizations including The San Diego Museum of Art. It not only featured a display of modern American painting co-curated by Robert Henri but occasioned an extensive musical program, bringing the world's best to San Diego to perform. Many of these concerts centered on the Spreckels Organ, one of the largest outdoor organs in the world, and included appearances by the New York Symphony Orchestra and Metropolitan Opera coloratura soprano Madame Bernice de Pasquali, whose rendition of "Thou Brilliant Bird" from *The Pearl of Brazil* reportedly left members of the 10,000 person audience "gasping for breath."

The exhibition and this accompanying publication, along with the companion programming of *The Art of Music* Concert Series, pay homage to that legacy, bringing together exemplary works of art from diverse eras and cultures to explore the twinned histories of music and art. San Diego is a city rich in music, from the classical to the popular, as well as in visual art. Though global in scope, the exhibition touches upon some of these intriguing local connections as well, whether it is in the musical iconography of sculpture by early San Diego artist Donal Hord (fig. 267) or the later, more audible one by John Baldessari (fig. 47), who, like Tom Waits, is from the vibrant San Diego enclave of National City, or the note on a program for a concert of Arnold Schoenberg's music at the Balboa Park–based Starlight Bowl in which the composer, having fled Nazi Germany for Los Angeles, was the surprise guest conductor of the San Diego Symphony (fig. 3).

Organizing such a world-spanning survey is no small endeavor. I want to express my admiration and gratitude for the international team of scholars and curators who helped conceive, shape and develop *The Art of Music*: Sandra Benito, Deputy Director of Education and Public Engagement, who initiated the project, and Anita Feldman, Deputy Director of Curatorial Affairs, acted as chief curators, steering a team of the Museum's specialists—Michael Brown, James Grebl, Ariel Plotek and Marika Sardar. Gemma Rodrigues, African arts scholar and Research Fellow at the University of Madeira, and Christina Yu Yu, Director of the USC Pacific Asia Museum, shared their deep knowledge in selections of objects from their areas of expertise and in their essays included here.

Special mention goes to Patrick Coleman and Cory Woodall for their tireless efforts and critical input throughout the project. Eric de Visscher, Director of the Musée de la musique at the Cité de la musique in Paris, and the indefatigable Julien Ségol brought the musicologist's perspective to bear on everything from the concept to the installation. Vincent Poussou offered his invaluable expertise in organizing such an interdisciplinary, multimedia exhibition. Add to these the contributions of the Education and Public Engagement Department in developing a robust suite of gallery multimedia and interactive experiences, in addition to their collaboration with the passionate Jann Pasler of the University of California, San Diego Department of Music to organize a yearlong series of concerts to accompany the exhibition, and you have a sense of the truly collaborative nature of this undertaking.

To mount an exhibition of this size and scale takes numerous partners. I want to thank all of the lenders for sharing their collections, time and valuable knowledge with us in the development of the project. Special gratitude goes to Juan Antonio and Josefina Pérez Simón, Frank and Demi Rogozienski and to fellow museum directors, including Thomas P. Campbell of The Metropolitan Museum of Art; Douglas Druick of The Art Institute of Chicago; Michael Govan of the Los Angeles County Museum of Art; Sylvia Navarrete Bouzard of the Museo de Arte Moderno, Mexico City; Timothy Rub of the Philadelphia Museum of Art; Julián Zugazagoitia of The Nelson-Atkins Museum of Art; and many others acknowledged elsewhere in this book.

An exhibition like this is also a costly undertaking, and I would be remiss if I did not thank those whose generous support has made it possible. My deep appreciation and thanks are extended to Conrad Prebys and Debbie Turner for their support of this project from the very beginning. And to Susanna and Michael Flaster, Roy and Joanie Polatchek, Taffin and Gene Ray, the David C. Copley Foundation, the Dextra Baldwin McGonagle Foundation, Gallagher Levine, RBC Wealth Management, and Wells Fargo, among others, for their donations in support of *The Art of Music*. Dieter Fenkart-Froeschl, Katy McDonald, and Elizabeth Kaplan all deserve praise for finding ways for the museum to achieve its ambitions—perhaps nowhere more so than in a penetrating look at the intersections of the arts throughout culture and time.

Roxana Velásquez
Maruja Baldwin Executive Director
The San Diego Museum of Art

Midsummer Night Symphony

Ford Bowl, Balboa Park

July 26, 1938, 8:00 P. M.

MODEST ALTSCHULER, Guest Conductor

A S

* * *

Program and Notes

* * *

1. Piano Quartet in A-Major Arranged for
 Full Orchestra - - - - - - *Brahms-Schoenberg*

 Intermission

2. Verklarte Nacht, Opus 4 - - - - - - - *Schoenberg*

3. Prelude and Fugue in E-Flat - - - - - *Bach-Schoenberg*

* * *

One of the most individual and important modern composers, Arnold Schoenberg has had an enormous influence on younger composers. This is largely due to his accomplishments and prestige; also, to no less extent, his development of a musical philosophy of his own. Unaided by so-called teachers, Schoenberg was self-taught and his musical works can be divided into three distinct periods. The goal of the first period was the mastery (and the emancipation thereby) of accepted forms. He carried chromatics to the limits of tonality, still retaining the old view of consonance and dissonance. Thus it is that the sounds of the accustomed neo-modernity in music come to us as pleasing. Schoenberg finds great inspiration in the music of the past. He worships Bach.

In this first period belongs the Verklarte Nacht. It was originally a sextet but later he scored the work for string orchestra, the form in which it is best known. Inspired by a poem of Richard Dehmel, the music of this translucent episode describes the transfiguration of the world thru the eyes of a benevolent lover having forgiven his sweetheart for her sin. The work, although influenced by Wagnerian styling, is fluently contrapuntal in which the suspense and drama of a sensuous night are hung over the scene with tone-colors of utmost delicacy.

The second period of Schoenberg's newly-found independence affects the dimensions of his works and the means employed. All principles of tonality were discarded and every note carried a full significance.

In the third period Schoenberg firmly establishes new formal principles to govern the new material and new experience he acquired in the second period. Its basis is the twelve-note scale. His first book, "Treatise on Harmony," has been followed by a simplified explanation of these principles entitled, "Composition with Twelve Tones."

3. Program for the July 26, 1938, concert with Arnold Schoenberg conducting the San Diego Symphony at the Ford Bowl (now the Starlight Bowl), Balboa Park, San Diego, California. Arnold Schoenberg Center, Vienna.

Acknowledgments

The San Diego Museum of Art would like to express appreciation to the following individuals:

Víctor Acuña, Armando Ángeles, Anthony Allen, Leesha M. Alston, Colin B. Bailey, John Baldessari, Dana Baldwin, James K. Ballinger, Tim Barringer, Bruce BecVar, Marla C. Berns, Melissa Beyer, Zdravko Blažeković, Bernard Blistène, Elizabeth Broun, Gudrun Buehl, Cynthia Burlingham, W. James Burns, Thomas P. Campbell, Guy Cogeval, Don Cole, Armando Colina, Thom Collins, Paula Cooper, Juan Coronel Rivera, Leslie Cozzi, Vanessa Davidson, Terry Dintenfass, Douglas Druick, Marian Eines, Peter Ellis, Cora Falero, Miguel Fernández Félix, Brian J. Ferriso, Genevieve Fisher, Kerry Gaertner, Nicole Galbraith, Amy Galpin, María Cristina García Zepeda, Amanda Gaspari, Natalia Gastelut, Timothy Goodhue, Jane Gottlieb, Michael Govan, Mike Hearn, Michael Howell, Peter Huestis, Laura Hunt, Cynthia Iavarone, Jasper Johns, Lynn Kearcher, Cindy Keefer, Claire Kennedy, Christian Kleinbub, Thomas Kren, Nancy Leeman, Óscar de León, Yu-Ping Luk, Adolfo Mantilla, Julia Marciari-Alexander, Ashley B. Marin, Sean Andrew Maynard, Alex McClave, Portland McCormick, Miranda McLaughlan, Amy Meyers, Christine Miers, Travis Miles, Blake Milteer, J. Kenneth Moore, Marjorie Ann Mopper, Therese Muxeneder, Sylvia Navarrete Bouzard, Andrés Navia, Sofía Neri, Alex Nyerges, Amy Ontiveros, Adriana Ospina, Jann Pasler, Naomi Patterson, Marnie Perez, Josefina Pérez Simón, Juan Antonio Pérez Simón, Tristan Perich, Nancy Perloff, Ann Philbin, Donna Pierce, Susana Pliego, Joanie Polatchek, Roy Polatchek, Timothy Potts, Vincent Poussou, Earl A. Powell III, Conrad Prebys, Paul Prince, Maureen Pskowski, Jeffrey Quilter, Sonya Rhie Quintanilla, Julie Robert, Demi Rogozienski, Frank Rogozienski, Andrea Rosen, Nicholas Roth, Timothy Rub, Jack Rutberg, Antonio Saborit, Julien Ségol, Piper Severance, Stacey Sherman, Guillermo Solana, Sharon Steckline, Graciela Téllez Trevilla, Gary Tinterow, Fernanda Torrente, Rafael Tovar y de Teresa, Debbie Turner, Alfredo Velásquez Martínez del Campo, Charles L. Venable, Eric de Visscher, Jerry Wagner, Simone J. Wicha, Lynn Wichern, Julie Wilson, Jay Xu, Jan Ziolkowski, Marta Zlotnick, Julián Zugazagoitia.

Lenders to the Exhibition

The exhibition would not have been possible without the generosity of the following lenders:

Andrea Rosen Gallery, New York
The Art Institute of Chicago
Art Museum of the Americas, Washington, DC
Asian Art Museum of San Francisco
John Baldessari
Beyer Projects, Los Angeles
Bitforms Gallery, New York
Blanton Museum of Art, The University of Texas at Austin
Capital Group, Los Angeles, California
Center for Visual Music, Los Angeles
Colorado Springs Fine Arts Center
Dumbarton Oaks Research Library and Collection, Washington, DC
Fine Arts Museums of San Francisco
Fowler Museum at UCLA
Grunwald Center for the Graphic Arts, UCLA
Hammer Museum, UCLA
Indianapolis Museum of Art
The J. Paul Getty Museum, Los Angeles
Jack Rutberg Fine Arts, Los Angeles
Jasper Johns
The Juilliard Manuscript Collection, New York
Kleinbub Collection
Los Angeles County Museum of Art

Merce Cunningham Trust, New York
The Metropolitan Museum of Art, New York
Museo de Arte Moderno, Mexico City
Museum of Fine Arts, Houston
National Gallery of Art, Washington, DC
National Museum of Anthropology, Mexico City
The Nelson-Atkins Museum of Art, Kansas City, MO
Paula Cooper Gallery, New York
Pérez Art Museum, Miami
Juan Antonio Pérez Simón
Peabody Museum of Archaeology and Ethnology, Harvard University, Cambridge, MA
Tristan Perich
Philadelphia Museum of Art
Phoenix Art Museum
Susana Pliego
Portland Art Museum, Portland, OR
Paul Prince
Frank and Demi Rogozienski
Smithsonian American Art Museum, Washington, DC
University of Arizona Museum of Art, Tucson
Virginia Museum of Fine Arts, Richmond
Yale Center for British Art, New Haven, CT

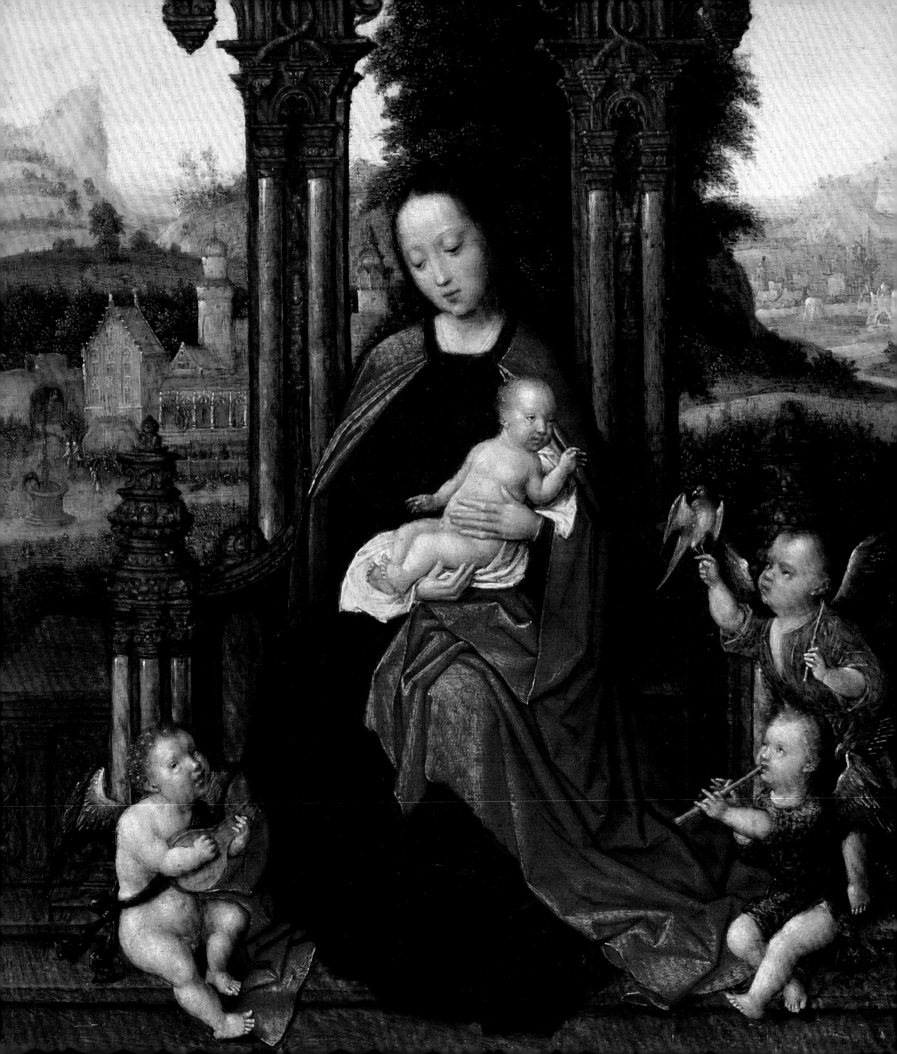

Sandra Benito and Anita Feldman

Introduction

At various times, the word "art" has meant music, poetry, dance, oratory and architecture as much as it did visual arts. For the ancient Greeks, the word "music" carried the same range of meanings, derived from the Muses who preside over all such pursuits and provide artistic inspiration (fig. 5). In art museums, "art" traditionally represents a curious and culturally circumscribed selection, meant to include the "fine arts" of painting, drawing and sculpture, then slowly broadening over the years to include architecture, film, multimedia installation and performance as well as folk art. As video, performance-based work and sound art have made apparent, the boundaries of these disciplines within art itself are porous, and the categories deployed often irreconcilable with the individual work of art before us. In the art historian's desire to classify and categorize, have we separated each individual art from the larger whole from which it springs?

The Art of Music takes the relationship between two of the more prominent and oft-intersecting branches of artistic creation as its subject. The liaison between music and the visual arts has inspired countless generations of artists. The two have had manifold complex interactions across all periods of history, in Western and non-Western contexts alike, yet their intersection has only become a rich vein for research by art historians and musicologists in the last thirty years. By tracing these relationships, both in this publication and through the exhibition, new insights into the affinities of the arts become clear. At every turn when the intimate connection between the visual arts and music is explored, the other arts —dance, theater, opera, literature, film—shadow the conversation. These relations, when elucidated, enrich the work itself in surprising ways.

4. Adriaen Isenbrandt (ca. 1500–1551). *Madonna and Child with Angels*, ca. 1510–20. Tempera and oil on panel, 9½ × 7½ in. (24.1 × 19.1 cm). The San Diego Museum of Art; Gift of Anne R. and Amy Putnam.

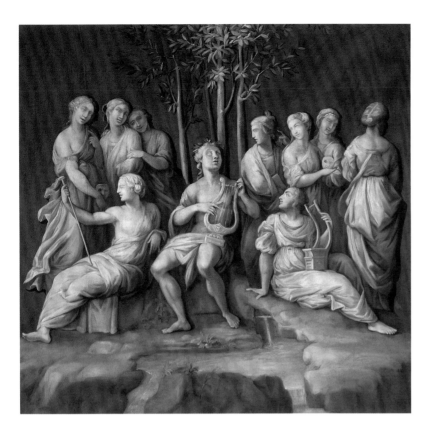

5. Anonymous. *Apollo and the Muses*, n.d. Oil on canvas and grisaille, 49¼ × 50¾ in. (125 × 129 cm). Pérez Simón Collection, Mexico.

Such an unwieldy subject, spanning media, time and culture, is focused around three central points of reference. The first examines the motifs themselves—quite literally how music itself is conveyed—from an eighth-century Chinese mirror depicting a musician in the Tang dynasty (fig. 129), to Arnold Böcklin's seductive *Nymph and Satyr* (fig. 105). Original sheet music including Beethoven's iconic Symphony No. 9 provides a rare glimpse of the hand of the composer (fig. 8). Tamara de Lempicka's *Woman with a Mandolin* expresses the dynamism of the Modernist era (fig. 151).

The central role of the arts within civilization—the social aspect of art and music—provides another rich avenue of exploration. This is evident in scenes painted on ancient Greek amphora (fig. 6) and perhaps the more familiar role of music in weddings and the church depicted in Jan Steen's *Village Wedding* (fig. 17) and Adriaen Isenbrandt's *Madonna and Child with Angels* (fig. 4), or the most secular of subjects—Richard Hamilton's famed depiction of Mick Jagger shielding himself from the press (fig. 19). A mixture of acrylic paint, screen printing and collage by the pioneer of Pop, the work portrays Mick Jagger of the Rolling Stones handcuffed to

Hamilton's art dealer, Robert Fraser. It's a literal shackling of visual art and music.

The stage provides another social arena for artists seeking to blur the boundaries between the arts, from Japanese woodblock prints depicting actors in flamboyant attire (figs. 133–41) to costumes designed by Pablo Picasso and Natalia Goncharova for the European stage (figs. 233 and 234), to Alfred Eisenstaedt's penetrating 1942 image of the Metropolitan Opera House during rehearsal, capturing its dizzying heights as the site of intense dramatic activity (fig. 11). Finally, the instruments themselves take center stage as works of art in their own right, with objects ranging from Yoruba tappers (fig. 206) to an eighteenth-century harpsichord (fig. 13), each with their functions within social ritual and entertainment.

Synesthesia, in which the stimulation of one sense triggers a reaction in another, provides one of the most compelling explorations of artistic fusion: the ability of music to evoke color and imagery as well as the visual depiction of sound itself. Vasily Kandinsky, in his 1912 treatise *On the Spiritual in Art*, charts the inward and outward movement of color and shape with their parallels in sound. Titled "Improvisations" or "Compositions," his experiments form the genesis of abstraction in painting through its aural associations—music having the ability to push the limits of art without adhering to traditional representation (fig. 195). Artists such as Robert Delaunay (fig. 203) and Sonia Delaunay-Terk in Europe and Marsden Hartley and Arthur Dove (figs. 31 and 81) in the United States soon followed in the exploration of "musical forms," as well as Latin American artists such as Carlos Mérida and Rufino Tamayo (figs. 163 and 164). Finding an inner vitality or spiritual association in the arts through abstraction was increasingly sought by artists rejecting the political climate of Europe as it entered the Great War. Metaphysical groups who espoused a unity of all the arts, such as the Theosophists, attracted numerous artists, including Piet Mondrian and František Kupka (fig. 236).

Marcel Duchamp's arrival in the United States in June 1942 to escape the German occupation of France proved to be pivotal for a younger generation of American artists, in particular Jasper Johns and Robert Rauschenberg, composer John Cage and choreographer Merce Cunningham (figs. 14–6, 257, 266). Through cross-media dialogues, they created non-conformist works that evoke Duchamp's assault on the hierarchy of fine art while retaining an essentially humanist core. Their artistic collaborations furthermore provided an alternative to the pervasive dominance of Abstract Expressionism with its emphasis on the gesture of the individual.

It is difficult to consider a single sense without appeal to the others. The language used to talk about music is rife with visual metaphors ("high" and "low" notes, for example), and the inverse

is true of visual art ("harmonious" and "rhythmic" compositions). Current scientific and philosophical thought has suggested that, in some ways, all perception is synesthetic and that the boundaries between our individual senses are not so well-defined. However, many philosophers and critics over the last several hundred years—Hegel, Lessing and Greenberg among them—have sought to restrict each art to a single corresponding sense: sight to painting, touch to sculpture, hearing to music, etc. The desire to avoid a "confusion of the arts," which motivated Greenberg, elides that there is always a blurring between the arts, even and perhaps especially when one endeavors to stress their distinctness.

What this exhibition and the essays that follow ask is to consider art in its fundamental unity by way of a series of moments in which the visual and musical arts were most intimately intertwined, along a number of different lines: conceptual, technical, formal, historical, cultural and physical. Much like Chuck Close's tapestry of Philip Glass, *Phil, State I* (fig. 21), a deceptively simple comradery between a visual artist and a composer can, when scrutinized, be composed of a startling array of individual, differently colored threads. Glass, whose minimal compositions involving series of repetitions echo the repeating strokes in Close's photo-realistic portraits, would write *A Musical Portrait of Chuck Close* for solo piano the same year Close created this tapestry. Both artists attest to the importance of their friendship in finding ways to create new forms of art, just as each work is a double portrait— of the relationship between artist and subject, self and other, as much as a portrait of the interconnectedness of art and music. Nathaniel Dance-Holland's painting of Italian composer and virtuoso Cristiano Giuseppe Lidarti sitting for his portrait at the hand of Giovanni Battista Tempesti, painted in the mid-eighteenth century, does much the same (fig. 18). Increasingly, contemporary artists such as Matthew Ritchie (fig. 20) fuse art and sound to create an experience that defies categorization.

By focusing on the dialogue between visual art and music across time and culture, we can see more clearly this aspect of creativity through some of its most powerful and lasting manifestations. That this relationship takes an inexhaustable number of forms is no surprise. In that, it is like art itself.

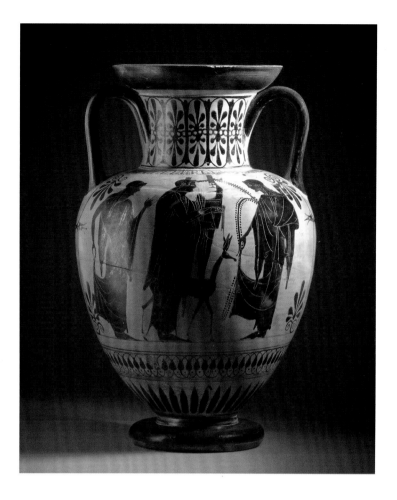

6. Neck-Amphora with Apollo Playing the Cithara, and Hermes, Athena, and Dionysos. Greece, Attica, ca. 510 BC. Black-figure terracotta with added red and traces of white, H: 17½ in. (44.5 cm); D: 11⅜ in. (29.1 cm). Los Angeles County Museum of Art; William Randolph Hearst Collection.

7. Ludwig van Beethoven (1770–1827). *Fidelio*, "Er stebe!" Act 2, No. 14, 1814. Copyist manuscript with autograph corrections by the composer. The Juilliard Manuscript Collection.

8. Ludwig van Beethoven (1770–1827). Symphony No. 9 in A, Op. 125, solo vocal part, 1824–26. Copyist manuscript. The Juilliard Manuscript Collection.

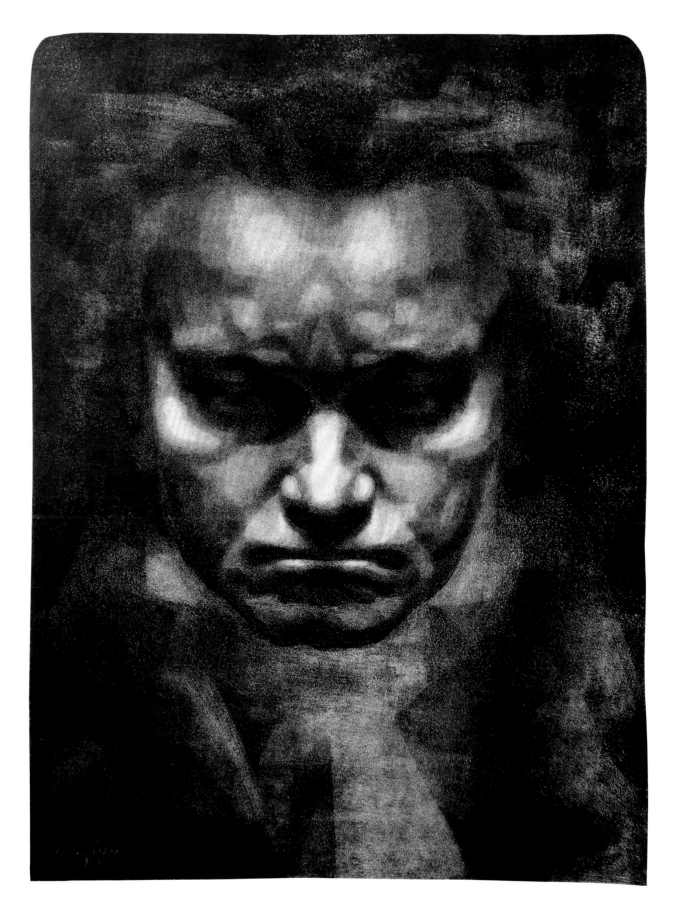

9. Johannes Hendricus Fekkes (1885–1933). *Head of Beethoven,*
1918. Lithograph, 13⅞ × 10½ in. (35.1 × 26.7 cm). The San Diego
Museum of Art; Bequest of Mrs. Henry A. Everett.

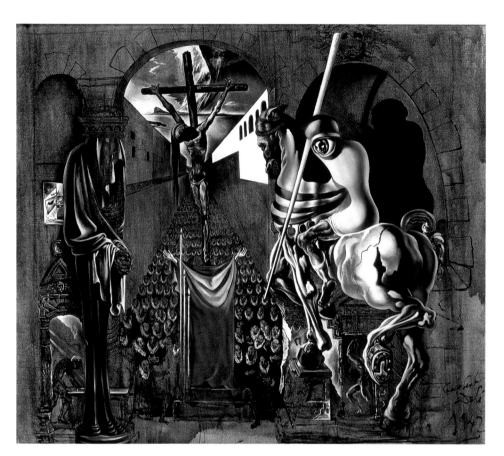

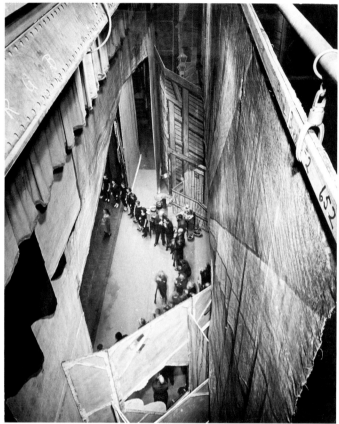

10. Salvador Dalí (1904–1989). Project for *Romeo and Juliet,* 1942. Oil on canvas, 27¼ × 31¼ in. (69.4 × 79.4 cm). Pérez Simón Collection, Mexico.

11. Alfred Eisenstaedt (1898–1995). *Stage Rehearsal, The Metropolitan Opera House, New York,* 1942. Gelatin silver print, 9⅝ × 7⅞ in. (24.6 × 20 cm). The San Diego Museum of Art; Gift of Wanda and Cam Garner.

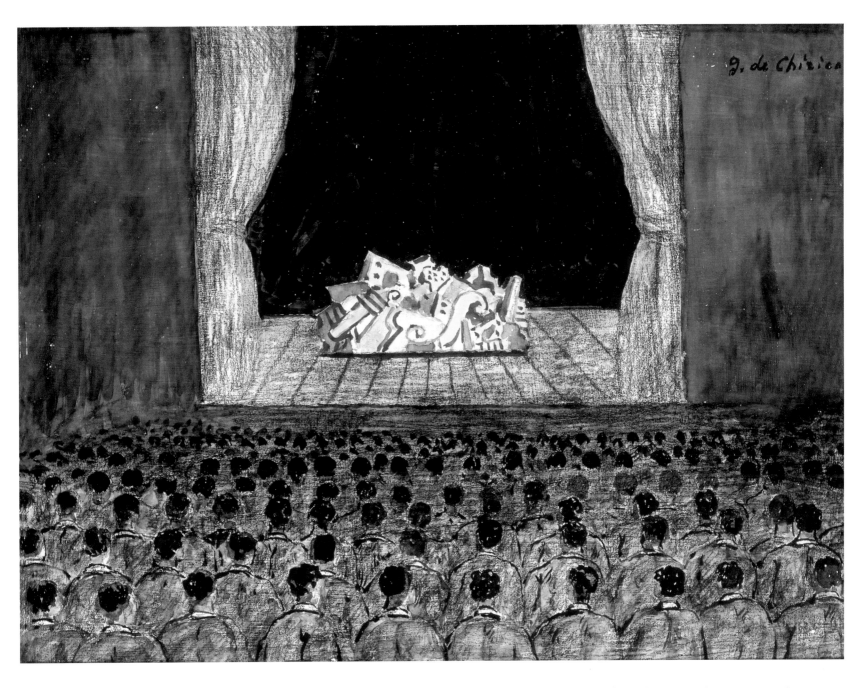

12. Giorgio de Chirico (1888–1978). *The Show,* 1966. Gouache, watercolor and crayon on paper, 11⅝ × 15½ in. (29.4 × 39.3 cm). Pérez Simón Collection, Mexico.

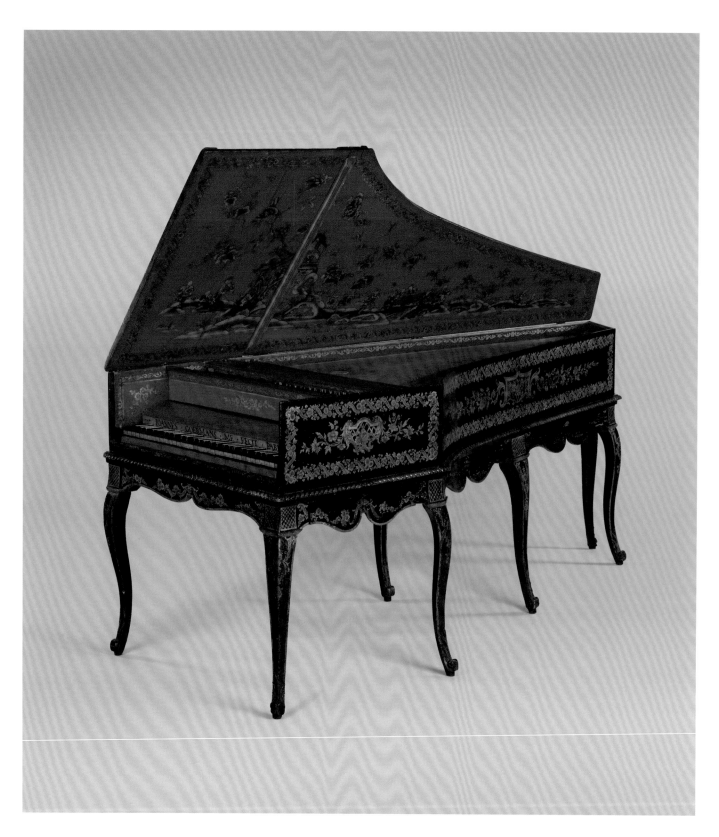

13. Jean Goermans (1703–1777). Harpsichord converted to
a piano, 1754. Wood, various materials; L: 95⅝ in. (241.7 cm).
The Metropolitan Museum of Art; Gift of Susan Dwight Bliss, 1944.

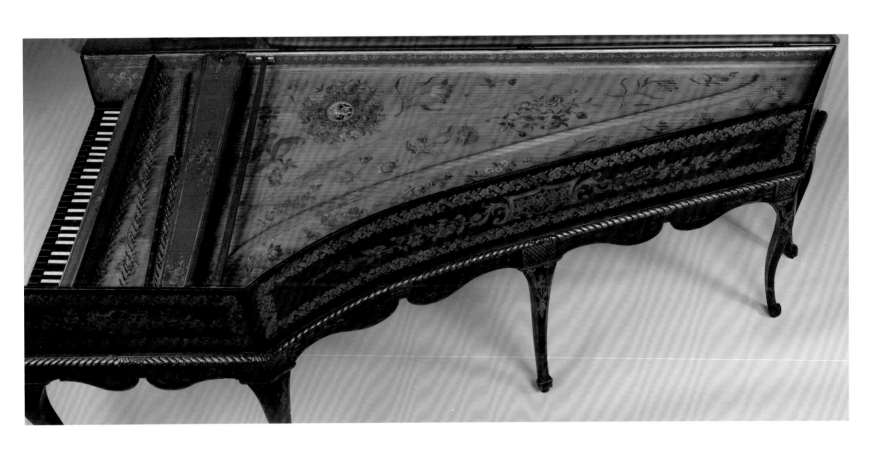

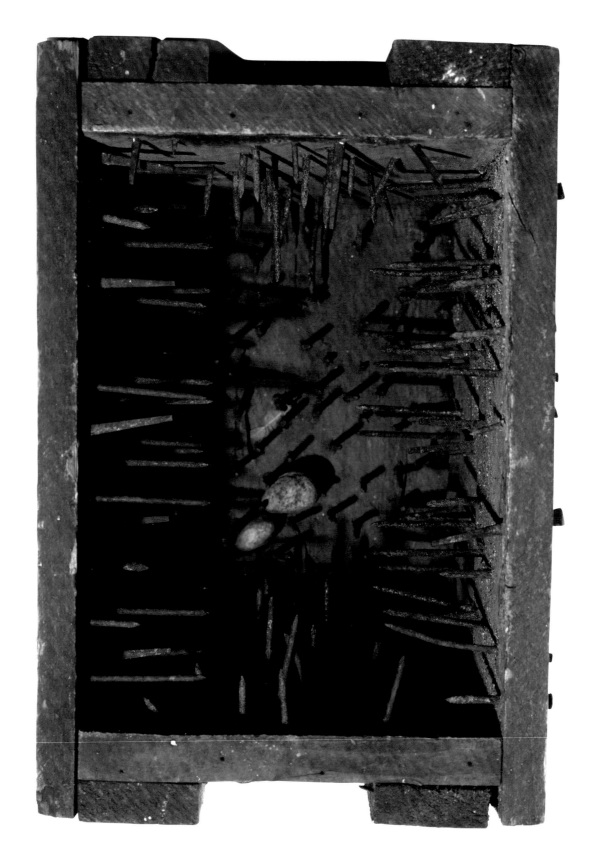

14. Robert Rauschenberg (1925–2008). *Music Box (Elemental Sculpture),* ca. 1953. Wood crate with traces of metallic paint, nails, three unattached stones and feathers, 11 × 7½ × 9¼ in. (27.9 × 19.1 × 23.5 cm). Collection of Jasper Johns.

15. Merce Cunningham (1919–2009). *Suite for Five,* 1956. Photograph by Hans Malberg. Courtesy Merce Cunningham Trust.

16. Choreographic notes of Merce Cunningham, *Suite for Five,* 1956. Courtesy Merce Cunningham Trust.

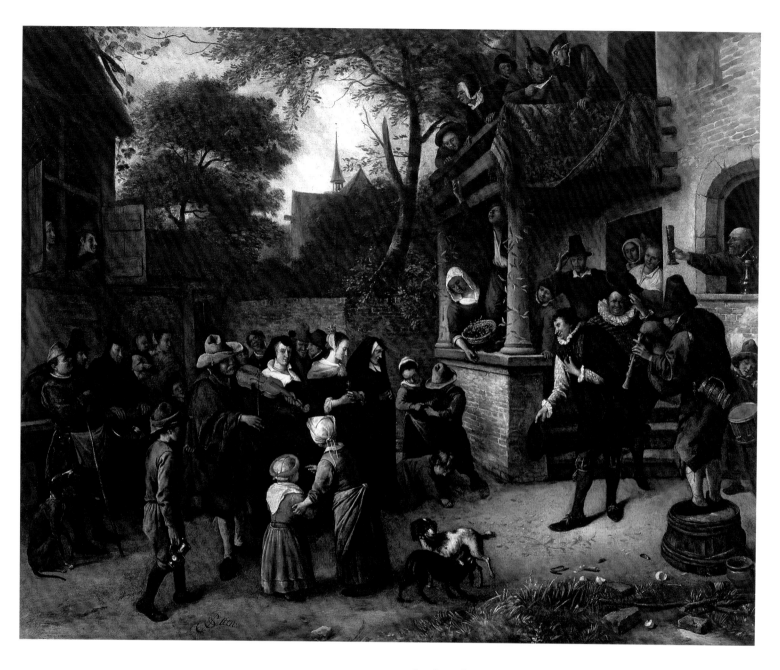

17. Jan Steen (1626–1679). *A Village Wedding,* **n.d.** Oil on canvas, 27¼ × 33¾ in. (69 × 86 cm). Pérez Simón Collection, Mexico.

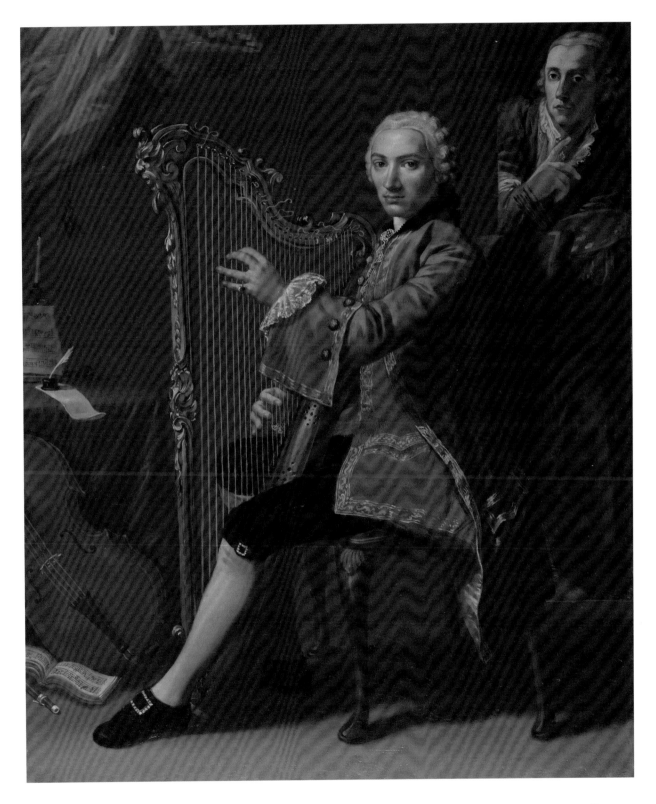

18. Nathaniel Dance-Holland (1735–1811). *Cristiano Giuseppe Lidarti and Giovanni Battista Tempesti,* 1759–60. Oil on canvas, 28½ × 24½ in. (72.4 × 62.2 cm). Yale Center for British Art; Paul Mellon Collection.

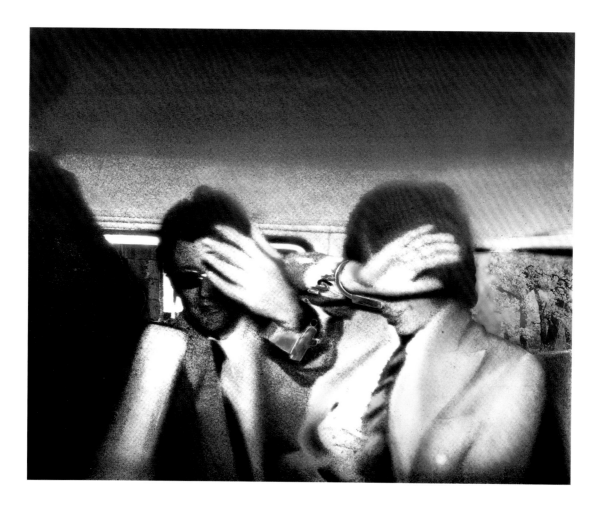

19. Richard Hamilton (1922–2011). *Swingeing London 67 (f)*, 1968–69. Acrylic paint, screenprint, paper, aluminum and metalized acetate on canvas, 26½ × 33½ in. (67.3 × 85.1 cm). Tate, London.

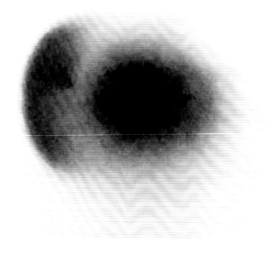

20. Matthew Ritchie (b. 1964). *Monstrance*, 2011. Video, 22 minutes, 19 seconds. Courtesy Andrea Rosen Gallery.

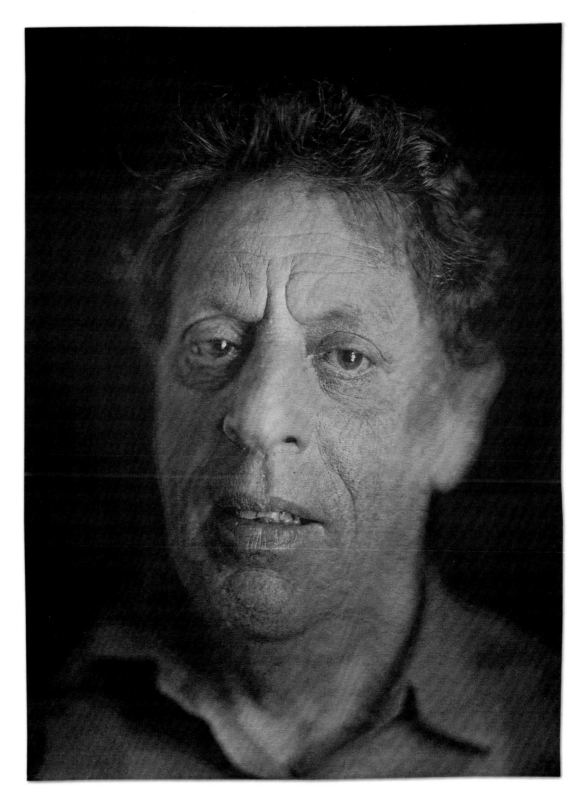

21. Chuck Close (b. 1940). *Phil, State I*, **2005.** Jacquard tapestry, edition of 6; 160 × 118 in. (406.4 × 299.7 cm). Collection Phoenix Art Museum; Gift of Mr. and Mrs. Barry Berkus and Family in honor of the Museum's 50th Anniversary.

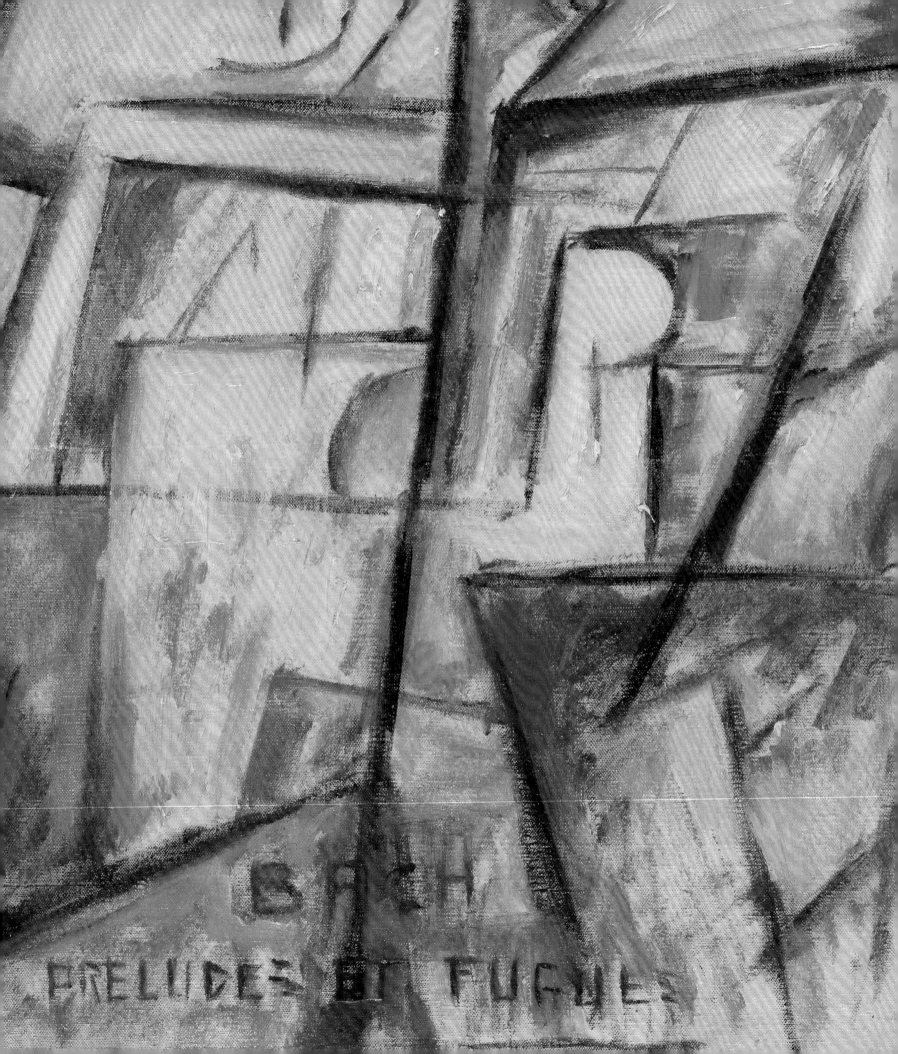

Simon Shaw-Miller

The Art of Music:
A Complex Art

*Where does music start? With a sound . . . a note . . .
an instrument . . . a record . . . or even an idea,
perhaps an image?*

While music may be an art of sound, it has never been just that. It is above all a cultural activity, one that is best considered not as singular but as *complex*—a complex that is a compound, a system, a nexus and a multiplex. Consider the oldest complete record of a piece of music, the so-called Seikilos epitaph (fig. 22), which dates from around the first or second century AD (although exact dating is difficult). While older notation exists, this is the first full (if short) composition that has survived.[1] Inscribed around the stele is the following elegiac distich, a verse with letters and signs above it that indicate a melody (e, f#, g, a, b, c#[1], d[1], e[1]):

῞Ο σον ζῆς φαίνου
μηδὲν ὅλως σὺ λυποῦ
πρὸς ὀλίγον ἐστὶ τὸ ζῆν
τὸ τέλος ὁ χρόνος ἀπαιτεῖ.

Which can be translated as:

While you live, shine
have no grief at all
life exists only for a while
and time demands its toll

In addition to this song, the stele has the following text inscribed around it:

Εἰκὼν ἡ λίθος
εἰμί. Τίθησί με
Σείκιλος ἔνθα
μνήμης ἀθανάτου
σῆμα πολυχρόνιον

I am a tombstone, an image.
Seikilos placed me here as an everlasting sign of deathless remembrance.

The implication of this text is, rather unusually, that the song is the *eikon* (or image), rather than the more common visualization of a statue or relief. In other words, music is image.

That such an early object should twin image and music is significant. To explore the tension between these concepts of "music" and "image" is to see how much of a complex this relationship is, and how, in the end (as in the beginning), image and music are not so very far apart.

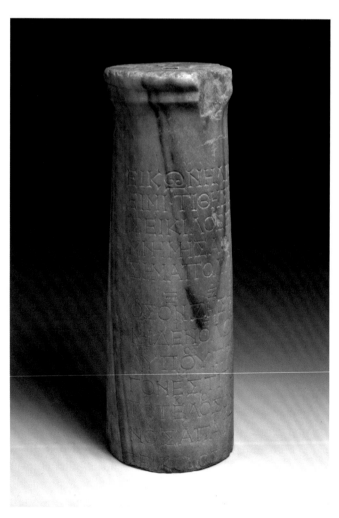

22. Seikilos epitaph. Greece, 100–200 AD. Marble,
H: 24 in. (61 cm). National Museum of Denmark.

Harmony

The idea of harmony is so entwined with the concept of music as to be often synonymous with it. But music is, of course, more than just a harmonious combination of sounds; dissonant sounds are not only functionally important in giving harmony meaning, but they are also significant in being relative to it. What constitutes harmony and its opposite throughout the history of music is never entirely clear or fixed, either across historical timeframes or across cultures. Indeed, these oppositions between music as bringer of harmony or as harbinger of discord are fundamental to many depictions of music and music making.

We can see this in Molenaer's painting *Allegory of Marital Fidelity*, where the music making and its harmonious concord is related to notions of both class and gender (fig. 66). It has been argued (including in the essay by Richard Leppert that follows this one) that here the art of music symbolizes harmonious marital union, while the fighting peasants represent an oppositional sonic order of dissonance and noise. Music also functions as a symbol of harmony in Jean-Marc Nattier's *The Artist and His Family* (fig. 23). Nattier depicts himself together with his four children and his wife, who sits at a harpsichord and turns the pages of a music score. The image alludes not only to marital and familial harmony, but also the harmony that exists between the sister arts of music and painting.

Harmony between two souls is definitive of love, and music, as its most potent symbol, offers a model of balance and concord. At the same time, music offers the promise of *voluptas*, the power to enflame the passions, to stir the emotions, and with that comes the potential for loss of control and *mesure* disrupted.

In Greek mythology this tension is played out between the characters of Apollo, the god of music and player of the lyre or kithara, and Marsyas, the Phrygian satyr who found Minerva's aulos, an ancient wind instrument. In taking up this instrument of the gods, Marsyas developed a skill as piper whose musical stirrings and frenzied dancing came to rival the thoughtful, calm and transcendental plucking of Apollo himself. The contest that ensued, presided over by the Muses, was inevitably won by the god, but Apollo then enacted a most brutal, bloody and disproportionate revenge on his playful, witless, half-human rival. He, in the words of Ovid, tore Marsyas from himself:

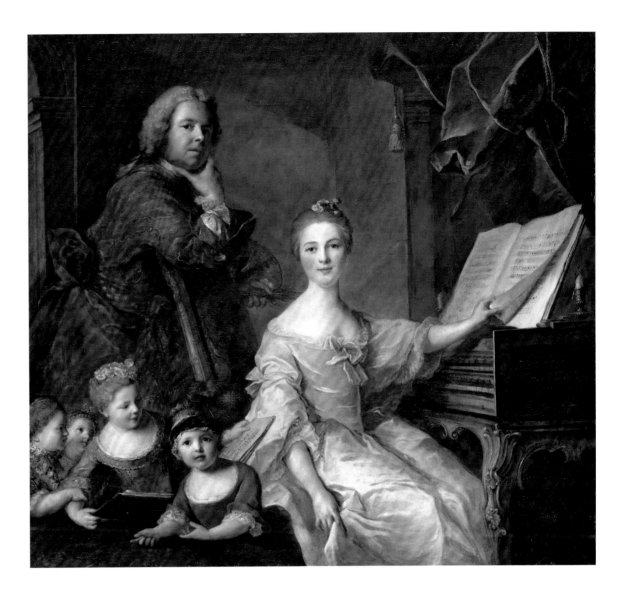

23. Jean-Marc Nattier (1685–1766). *The Artist and His Family*, 1730–62. Oil on canvas, 58⅝ × 63¾ in. (149 × 162 cm). Château de Versailles, France.

"No! no!" he screamed,
"Why tear me from myself? Oh, I repent!
A pipe's not worth the price!" and as he screamed
Apollo stripped his skin; the whole of him
Was one huge wound, blood streaming everywhere,
Sinews laid bare, veins naked, quivering
And pulsing . . .[2]

This barbarous act, which made all nature weep, ended with the animal guise of Marsyas nailed to a tree. His stretched skin quivered, an analogue of the ear/drum, the surface on which sound and music registers. His flowing blood and the tears of all who cried slowly metaphorphosed into the pure crystal waters of the river that still bears his name: a mingled, messy and synesthetic event resolving into purity and crystal clarity. This violent myth of duality and synthesis holds in it the tension, not only between *mesure* and emotional excess (*voluptas*), but also embodiment or disembodiment, of the corporeal and the spiritual. This triumph

of Apollonian *mesure* is also a triumph of objectifying sight over subjectifying sound, which makes it an attractive subject for artists (we might mention, among many others, Bartolomeo Manfredi's 1616 painting; or Jusepe de Ribera's 1637 version; or the outstanding earlier example by Titian of 1570–76 (fig. 24); or two related versions of about 1660 and 1698 by Luca Giordano). This myth constitutes an ideological dualism to which I shall return in my discussion of music as a model for abstract art.

The god's contest with that other piper of Greek mythology, Pan, resulted in a less bloody but nonetheless powerful metamorphosis. With expert touch, Apollo produced such sweet sounds from his lyre that he was "proclaimed the artist" by the mountain god Timolus, over Pan and his rustic airs. All agreed on this judgment except "crass-witted Midas," who called the outcome unjust. And then, as Ovid has it, "Apollo could not suffer ears so dull to keep their human shape. He stretched them long. . . . In that one part his punishment; he wears henceforth a little ambling ass's ears."[3] Midas becomes the living embodiment of the Greek

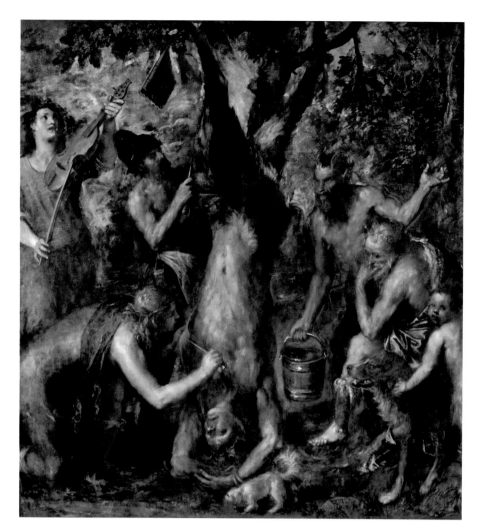

24. Titian (ca. 1485/90?–1576). *The Flaying of Marsyas*, 1570–75. Oil on canvas, 83½ × 81½ in. (212 × 207 cm). Archbishop's Palace, Kromeriz, Czech Republic.

proverb describing the unmusical as *onos lyras*, "a donkey (listening to) the lyre."

The final resolution of this tale has a curious outcome: King Midas hides his shame beneath a "clinging purple turban," but his barber sees his ass's ears and, while not wishing to betray this knowledge, cannot contain himself. And so he goes and digs a hole and whispers what kind of ears his master has, replacing the earth to thus bury his words. But in time the reeds above the hole begin to grow, and "in the soft south wind they sway and speak the buried words and tell the tale of Midas and his ass's ears."[4] The soft sounds of nature that expose the truth here recall the origins of Pan's pipes: He first heard the plaintive sound of the wind as it blew through the reeds in pursuit of the nymph Syrinx, who had been transformed into those very reeds in order to escape his lusty embrace, before he cut and bound a handful of them to make his pipe and thus to play upon her transformed body.

In both cases, the aeolian nature of the aulos of Marsyas or the pipes or flute of Pan betray a lowlier, wilder, sexual, physical, more "natural" origin and role for music than that of the lofty heights of Parnassus or Olympia, where Apollo Citharoedus sits presiding over poetic inspiration and intellectual endeavor. Apollo's ultimate victory over all comers ensures the restoration of harmony and a return to order. These two cultures of "high" and "low," or "art" and "vernacular," divide along sonic and visual lines and persist in current cultural debate; Eleanor Antin's photographic reconstruction of Poussin's *The Triumph of Pan* (1636), for instance, plays on these two cultural registrations (fig. 25). But while the liberal arts of music, painting and sculpture aimed to be seen as intellectual arts within the *Paragone* most famously articulated by Leonardo da Vinci (exercises of mind, not simply of the body or hand alone), this aspiration should not be allowed to blind us to the fact that other ideologies inevitably arise, seep out and emerge from the shadows to resist such separation and purity.

Music of the Spheres

The pervasive conception of harmony as a link between art and music is ultimately related most clearly in Western thinking to the notion of a preordained harmony of the heavenly spheres. Pythagoras first formulated the idea that the order of the celestial spheres was such as to bring about not only mathematical order,

25. Eleanor Antin (b. 1935). *The Triumph of Pan (after Poussin)* from *Roman Allegories*, 2004. Chromogenic print, edition 3/4; 60½ × 72½ in. (153.7 × 184.2 cm). The San Diego Museum of Art; Museum purchase with funds provided by the Artists Guild. Courtesy of Ronald Feldman Fine Arts, New York.

but also musical harmony; as the planets passed through the ether they produced sounds. The same notion of ancient cosmic harmony, inherited from Pythagoras and Plato, modulated into medieval European pedagogy and came to rest as music theory in the *quadrivium*, along with arithmetic, geometry and astronomy, which, combined with the *trivium* (grammar, dialectics and rhetoric), formed the seven liberal arts. The actual practice of music was separated off and associated with the emotional sphere, another Apollonian/Marsyan dichotomy. The sound of music and its theory were divided, an idea with a long life so clearly illustrated in the eighteenth-century portrait of Karl Friedrich Abel, the renowned player of the viola da gamba (fig. 26). He is shown in Gainsborough's portrait with the instrument resting against his left leg, while his hands are occupied in the writing down of a musical thought rather than with its performance.

The most sophisticated expression of *harmonia mundi* (harmony of the spheres) is to be found in Johannes Kepler's work of that name published in 1619. In it Kepler explores the congruence of geometry, harmony and physical phenomena, but with an expanded notion of harmony and a Copernican understanding of

elliptical orbits, quite different from Pythagorean numerology. He too was intrigued by the idea of a music of the heavenly bodies —not as metaphorical but as resting on physical harmonies of planetary motion. Book V of the *Harmonia Mundi*, "On the Most Perfect Harmony of the Heavenly Motions," is a breathtaking study of the concordance between the motion of the then-known planets (the earth and the moon, Saturn, Jupiter, Mars, Venus and Mercury) and musical modes or tones. He shows how the ratios of the orbits approximate closely to musical harmonies. Harmony, he states, is only comprehended through two natural occurrences, either light (image) or sound (music). That there is a relationship between them, therefore, is less surprising.[5] His empirical approach is in contrast to the Englishman Robert Fludd's proposals

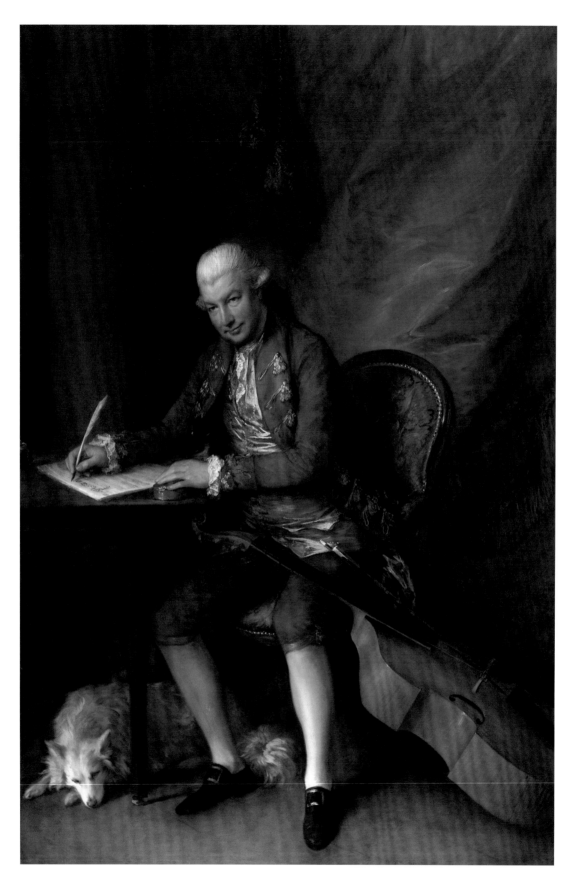

26. Thomas Gainsborough (1727–1788). *Karl Friedrich Abel,*
ca. 1777. Oil on canvas, 88¾ × 59½ in. (225.4 × 151.1 cm).
The Huntington Library, Art Collections and Botanical Gardens.

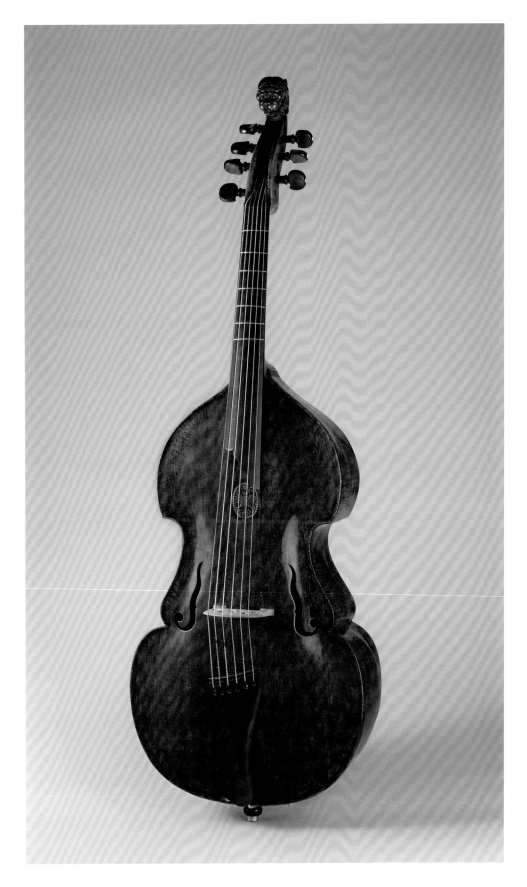

27. Bass Viola da Gamba. Absam, Austria, ca. 1669. Wood,
Body L: 27¼ in. (68.7 cm). The Metropolitan Museum of Art; Gift of
Janos Scholz, in memory of his son, Walter Rosen Scholz, 1988.

about macrocosmic and microcosmic harmony, published around the same time, which Kepler described in an appendix as a theory of cosmic harmony based on symbolism, producing a poetical or rhetorical understanding, rather than a philosophical or mathematical conclusion.[6] This difference is significant, but for Kepler:

> . . . it is no longer surprising that Man, aping his Creator, has at last found a method of singing in harmony which was unknown to the ancients, so that he might play, that is to say, the perpetuity of the whole of cosmic time in some brief fraction of an hour, by artificial concert of several voices, and taste up to a point the satisfaction of God his Maker in His works by a most delightful sense of pleasure in this imitator of God, Music.[7]

While speculation about celestial harmony and the music of the spheres—that there should be a concordance between the "two natural occurrences, [of] light or sound" in the cosmos—may seem both quaint and far-fetched to us, we should perhaps recall that the arresting visual phenomenon of the aurora borealis does indeed produce sound. The charged, moving particles from the solar wind that produce the light effects also produce intense radio emissions, albeit at very low frequencies. While these sounds are naturally outside our ability to hear without technological supplementation, there is at some level a sound of the heavens, if not a music of the spheres.

Harmony of Forms

To this conception of harmony as allegory should be added an awareness of its importance as a vital aspect of pictorial composition. However, what constitutes pictorial composition is not a simple matter. Johann Wolfgang von Goethe recognized this in an oft-quoted exchange with his assistant Friedrich Wilhelm Riemer on the 19th of May, 1807: "Painting has long since lacked knowledge of any *Generalbass*; it lacks any accepted theory as exists in music."[8] *Basso continuo*, as it is more commonly known, is a means of realizing harmony based on bass notes alone (sometimes with numbers to signify intervals, hence "figured bass"). The relevant point is that the rules of *continuo* are widely enough understood to allow a skilled player to build the harmony from an unfigured bass part. Goethe's remark was about the lack of a similar intuitively felt but objectively understood theoretical harmonic foundation in painting.

This point was later picked up by Kandinsky and understood by him as a plea for a comprehensive theory of abstraction in art, and one based on the model of music theory, the most abstract of the fine arts. However, the point should be made that what is meant by composition in art, and by harmony within that, is too complex an issue to unravel here, and we should avoid Kandinsky's assumption (key to his theory of abstraction) that pre-modernist art thought of composition in his terms. For him composition was first and foremost "the juxtaposition of coloristic and linear forms that have an independent existence as such, derived from inner necessity."[9] This preoccupation with the formal concerns of surface, support and medium was not automatically equivalent to composition for artists in the figurative tradition. For earlier artists, "to establish narrative and causal coherence in a history painting is precisely what . . . artists since Alberti, would have understood by composition."[10] In place of a conception of composition as planimetric relations, the issue is one of "the way (or ways) in which figures and objects, settings and whole pictorial worlds relate, embody, modify, even subvert and deny the basic formal intention of the bounded image."[11] In figurative art, harmonious composition was centered on relationships and dispositions of figures in terms of their meaning and role (especially in religious, mythological and historical imagery), not on the idea of structure alone. But this emerging question of "disposition" and "composition" became an increasingly self-conscious idea. The model of music as a compositional, highly sophisticated but abstract formal art had obvious appeal to artists who moved away from the figurative classical tradition. This is clearly the case where figurative elements are deployed in order to emphasize form over narrative content, as in Stieglitz's photographs of clouds in *Songs of the Sky* and *Music: A Sequence of Ten Cloud Photographs* (figs. 28 and 29). In both cases, naturally occurring but formally amorphous objects (clouds) are analogous (his word was "equivalents") to emotional states reflective of both the dynamism of a modern world in constant flux and the temporal dynamism of music. Amorphous form was also a central compositional concept in painting's drift into abstraction.

František Kupka's great series of paintings *Amorpha, Fugue in Two Colors* encapsulates this shift between issues of form, composition and music well (fig. 30). In a letter written in March 1913 to André Warnod, art critic of *Le Comoedia*, he wrote:

> Painting should be, above all, morphic ("morphique"). And, moreover, it cannot be otherwise, since the most elementary aspect of painting has always been form. I have been obliged to admit to a certain illogicality in giving the title *Amorpha* to my two paintings at the last Salon d'Automne. It was out of place, even despite my intention to go beyond the need to represent a subject. In doing that I was more obliged to remain morphic than if I had been interpreting forms taken from nature.[12]

Whatever the logic of this aim, there is a clear desire to "go beyond the need to represent a subject," by which we can take him to

28. Alfred Stieglitz (1864–1946). *Songs of the Sky, No. 2,*
1923. Gelatin silver print, 3⅞ × 4⅞ in. (10 × 12.6 cm).
The J. Paul Getty Museum.

29. Alfred Stieglitz (1864–1946). *Music: A Sequence of*
Ten Cloud Photographs, no. 1, 1922. Gelatin silver print,
7⅜ × 9½ in. (18.7 × 24 cm). The J. Paul Getty Museum.

30. František Kupka (1871–1957). *Amorpha, Fugue in Two Colors* (*Amorpha, fugue en deux coleurs*), 1912. Oil on canvas, 83⅛ × 86⅝ in. (211 × 220 cm). National Gallery, Prague.

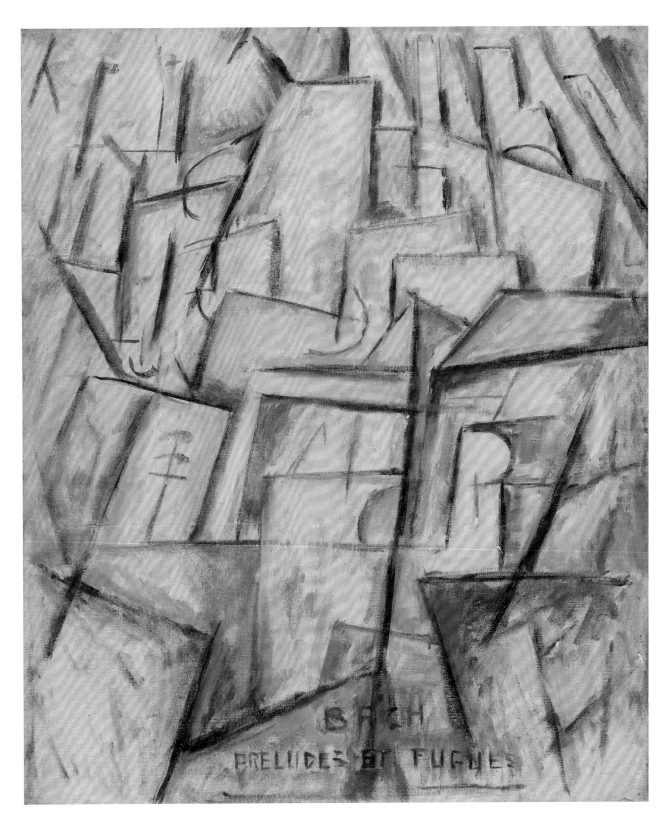

31. Marsden Hartley (1877–1943). *Musical Theme No. 2 (Bach Preludes and Fugues)*, 1912. Oil on canvas mounted on Masonite, 24 × 20 in. (61 × 50.8 cm). Museo Thyssen-Bornemisza, Madrid.

32. Stanton Macdonald-Wright (1890–1973). *"Oriental"; Synchromy in Blue-Green*, 1918. Oil on linen, 36⅛ × 50 in. (91.8 × 127 cm). Whitney Museum of American Art, New York; Purchase.

mean "subject matter" in the figurative sense; the idea of music as formally complex but without an objective representation served this purpose. In hoping to find "something between sight and hearing . . . produc[ing] a fugue in colors as Bach has done in music," Kupka pulled into alliance one of the strictest musical "forms" (fugue) with the idea of abstraction (amorphism).

This relationship was no less present in the work of other pioneers of early abstract art from America: Marsden Hartley (an artist exhibited and promoted by Stieglitz), who also "composed" paintings on themes of Bach (fig. 31), and the Synchromist artists Morgan Russell and Stanton Macdonald-Wright (fig. 32). The latter wrote:

I strive to divest my art of all anecdote and illustration and to purify it to the point where the emotions of the spectator will be wholly aesthetic, as when listening to good music. . . . I cast aside as nugatory all natural representation in my art. However, I still adhered to the fundamental laws of composition (placements and displacements of mass, as in the human body in movement) and created my pictures by means of color-form, which, by its organization in three dimensions, resulted in rhythm.[13]

This brings us to that other important element, rhythm. In relation to both music and art, rhythm is subject to even greater misunderstanding than its companion, harmony.

Rhythm and Drawing

While harmony may be said to be the vertical coordination of sounds, music's unfolding in time is called rhythm. If harmony can be said to reside in the visual arts, both on a technical level—for example, the use of the *section aurea*, golden mean, or other structural divisions—and at an analogical level, in the use of particular subject matter (not least representations of music making), then rhythm too functions in more than one way. It exists at both the macro level of composition and structure, and the micro level of gesture and mark making, but as with harmony, rhythm as both an idea and a technique in the visual arts is not a simple case of one art borrowing from the other.

The English word "rhythm" derives from the Latin *rhythmus*, "movement in time," and more fundamentally the Greek *rhythmos* (ῥυθμός), often taken to derive from the root *reo* or *rhein* (as in the German river), "to flow." However, a strong case has been made in more recent scholarship, since Eugen Petersen's important essay of 1917, that the root derives from *ern* and is therefore related to the verb "draw," rather than *reo* and "flow." Further, Petersen argues that words with the suffix *-thmos* (as *rhythmos*) originally signified an active doing rather than a passive happening, which suggests *rhythmos* was closer to "drawing" than "flowing." The Greek scholar Jerome Pollitt at Yale, in his study of the critical terminology of ancient Greek criticism, *The Ancient View of Greek Art*, points out that there are close connections in many languages between "to draw," meaning a physical action, and the

word "drawing" in a pictorial sense. Pollitt claims this understanding is key to a correct comprehension of ancient Greek usage of the concept. This makes rhythm intimate and fundamental to the plastic arts, and not a term imported from music as some commentators have suggested.

The philosopher Arthur Danto has also argued that drawing, in a pictorial sense, is intimate with this conception of rhythm as drawing and attraction (what he calls "drawing power"). This in turn might be related to Nietzsche's conception of plastic power as he expressed it in *The Birth of Tragedy* (1872): "that continual urge and surge of a creative, form-giving, changeable force," and, more fundamentally: "Man is a creature that fashions form and rhythm." Forming and rhythm are intimately connected concepts.

Eugen Petersen proposed that the move in meaning from this "drawing" to "repetition" or "pattern" emerged in discussion of dance, as the body marked distinct intervals in the music. Just as ancient dance forms are used to describe poetic meter as different kinds of metrical "feet," poetry and "music" (in its restricted meaning of sound alone) were joined in the classical concept of *mousike*.[14] Patterns in Greek sculpture were understood, Pollitt elaborates, as "rests" (*hremiai*), which Aristoxenus of Tarentum (the pre-eminent fourth-century BC theorist and historian of music, a pupil of Aristotle and later known simply as "the musician") describes as present in all movement and sound, but particularly in dancing and music. These "rests" were points at which motion came to a pause, enabling the viewer to "fasten his vision on a particular position that characterized the movement as a whole." In other words, these rests allow comprehension of movement's phrases.

The philosopher Suzanne Langer, in her book *Problems of Art* (1957), argues something similar: a rhythmic pattern arises whenever the completion of one distinct event appears as the beginning of another.[15] She gives the example of a pendulum, where rhythm is created as a "functional involvement of successive events." Pollitt evokes the same example: "When a pendulum is depicted [in a painting, for example] in a completely vertical position, we do not ascribe movement to it in our minds, but when it is depicted at the far left or far right point of the swing, at the point where it momentarily stops before changing direction [the "rest"], we naturally think of it being in motion."

I said above that forming and rhythm are intimately connected concepts. We can see this clearly in the art of the Swiss painter Paul Klee. He saw drawing as a process of forming, not a giving of form. He wrote, "All becoming is based on movement . . . space is itself a temporal concept . . . when a point turns into movement and line—it takes time." His laconic, dynamic concept of "a line on a walk" inevitably leads to rhythmic configurations as lines conjoin, complement and circumscribe.[16]

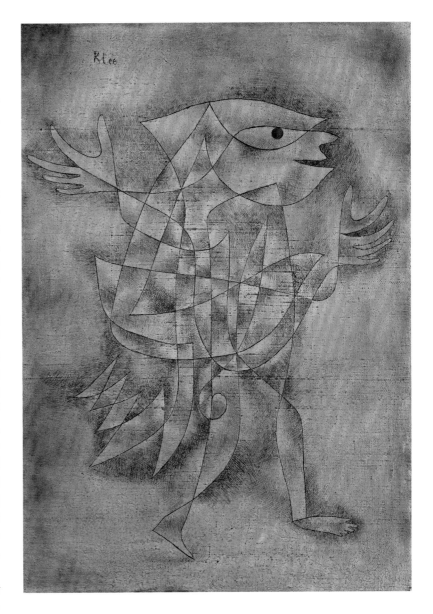

33. Paul Klee (1879–1940). *Little Jester in a Trance*, 1929. Oil and watercolor, 19¼ × 14 in. (48.9 × 35.6 cm). Museum Ludwig, Cologne, Germany.

His wonderfully witty oil and watercolor work *Little Jester in a Trance* of 1929 shows a line on a walk that, at the top of the figure's right leg, forms a partial treble clef (fig. 33). The single flowing line draws the viewer in and echoes the mesmeric trance of the little jester himself, conjoining technique and subject. The eye of the jester makes reference to the musical sign for a pause: ⌒ This arrests motion in the eye and recalls the suspension of movement, the rests that Aristoxenus regarded as important to allow us to "fasten [our] vision on a particular position that characterized the movement as a whole."[17] As a musician (a skilled violinist, husband of a pianist and son of a trained singer and a music teacher), Klee took great delight in the visual culture of

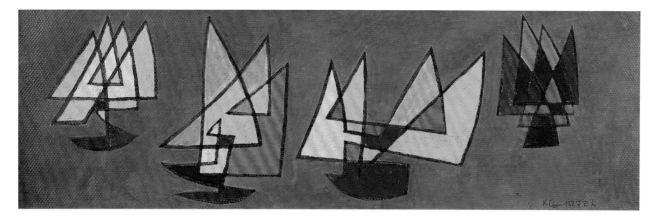

34. Paul Klee (1879–1940). *Four Sailships*, 1927. Oil on Masonite,
7¼ × 22⅞ in. (18.4 × 58.1 cm). Courtesy of Sotheby's Picture Library.

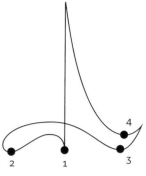

35. Diagram of conducting gestures for 4/4 time.

36. Klee's "Canon of Color Totality."

music, its signs and gestures. In his series of Sail Boat works, pro-duced around 1927, he develops patterns based on the gestures orchestral conductors make when marking four beats in a bar (figs. 34 and 35).

As Klee said, "We can perceive rhythm with three senses at once. First we can hear it, secondly see it, and thirdly feel it in our mus-cles. This is what gives it such power over our organism."[18] In other words, in grasping rhythm we attune ourselves to it, and this in turn allows for variation. This is what individualizes a rhythm, makes it non-mechanical (not simply reducible to beat or pulse). It makes rhythm iterable.

His interest in the structural possibilities of drawing the arts of music and painting closer together led Klee to consider color, not just design. His "canon of color totality" expressed color relation-ships in terms of "voices" (fig. 36). The three primary colors of red, yellow and blue, as they move round the color circle, grow louder or softer. For example, as red moves towards its neighboring pri-mary yellow, so the voice of red gets quieter and that of yellow louder. As this decrescendo and crescendo meet at equal volume, so the secondary color of orange emerges. All other gradations are accounted for through this series of dynamic shifts between the primaries. The circle also moves between two poles, of black and white. The distance of the circle from one or other of these poles likewise produces shifts in tonal saturation.

This dynamic conception of color allowed Klee to relate it to rhythmical structures in his continuing investigation of non-mimetic form. This permitted him to develop complex pictorial structures with internally logical relationships, as opposed to the narrative conventions of figurative depiction. His systematizing of the formal elements of his art was pursued for pedagogical ends, but also to extend beyond pure subjectivity. Consider the issue of rhythm and color in his painting *New Harmony* of 1936.

Grids

New Harmony is one of a series of what have been called Klee's "magic square" pictures (fig. 37). They develop a familiar trope of modernist art, the grid, but they do so in novel ways. The use of grids by different artists is various; consider Karl Benjamin's *Unti-tled* (fig. 244) and Stuart Davis's various syncopated grids, or the fractured rhythms of Cubist grids such as Braque's *Homage to J. S. Bach* (1911), or even the marvelous Kuba textiles that had such an impact on the art of Matisse, inspiring him with the spirit of jazz rhythms (figs. 218–21). In Klee's "magic square" pictures, this same emphasis on the *rubato,* agogic accent of the grid (a grid that resists the strict matrix reticulation) sets them apart from the more regular grids and networks of De Stijl and Piet Mondrian. Klee's magic squares impel the eye to bounce across the surface, his grids wobble and, while implying beat, do not reduce visual rhythm to it. This *rubato* is often equated with "rhythmic freedom," but in music theory there are two way of considering the concept: as

37. Paul Klee (1879–1940). *New Harmony* (*Neue Harmonie*), **1936.** Oil on canvas, 36⅞ × 26⅛ in. (93.6 × 66.3 cm). Solomon R. Guggenheim Museum, New York.

literally "robbed time," where duration is taken from one measure or beat and given to another, and as any "irregularity of rhythm or tempo," such as might also be signaled by the phrases *ad libitum*, and *a capriccio*, which also indicate a modification of the tempo at the will of the performer (or in the eye of the spectator). This is the application with which I am most concerned.

The grid allowed Klee to relate his interest in structural rhythm to the temporal specifics of his color theory. *New Harmony* of 1936 is concerned with dissonance, which derives from a focus on red-green tonalities—non-complementary, opposing colors. The grid, in turn, is organized in four quadrants, so that it demonstrates what can be seen as a series of transpositions, inversions and retrogressions. As Andrew Kagan has pointed out, there is bilateral inverted symmetry, so that the right half is an inverted mirror image of the left half. But it can also be divided medially, so that it forms four sections, bottom right being a retrograde inversion of top left, and bottom left a retrograde inversion of top right. This brings to mind the Second Viennese School of Schoenberg, Berg and Webern.[19] Although such techniques (as Schoenberg himself pointed out) are highly developed in the works of J. S. Bach, these techniques of serial manipulation through the variation of inversion, retrogression and retrograde inversion are central to Schoenberg's serialism. Indeed, Webern points out in his book *The Path to the New Music* (1933) that the difference between music and color is "one of degree, not of kind,"[20] and in the course of his discussion of his own Symphony, Op. 21 (1928), he states:

> In the accompaniment to the theme the cancrizan[21] appears at the beginning. The first variation is in the melody a transposition of the row starting on C. The accompaniment is a double canon. Greater unity is impossible. . . . In the fourth variation there are constant mirrorings. This variation is itself the midpoint of the whole movement, after which everything goes backwards. So the entire movement is itself a double canon by retrograde motion![22]

While this description beautifully fits Klee's painting, Webern brings in language at this point, rather than visual art, by quoting an old Latin palindrome:

```
S A T O R
A R E P O
T E N E T
O P E R A
R O T A S
```

Although Webern is, of course, correct to *see* this as a linguistic example of the same process, it should be emphasized that he *saw*

it. Palindromes have their effect visually, as do many procedures in serial music, for they remain hard (if not impossible) to detect by ear, while being evident to the eye.

Outside the Western tradition there is another tradition to which the concept of rhythm is perhaps even more important, that of China. I shall consider this in some detail, as I want to emphasize that rhythm, although less often discussed in art history, is in fact as significant a concept for art as harmony. Both these terms show important ways in which music and image are closer than some might assume.

Chinese Painting and the Rhythm of Theory

One of the most influential texts on Chinese painting was composed in the sixth century by Xie He and takes the form of the preface to his *Record of the Classification of Old Painters* (ca. 550). This brief paragraph serves as an introductory note to a list of twenty-seven artists divided into six categories with brief comments by the author. The preface describes six points or techniques to consider when judging a painting. It is the first, the most important and fundamental of these, that directly involves the concept of rhythm. As the meaning of Xie He's statement depends on a subtle understanding of sixth-century Chinese, I am dependent here on the help of a colleague, while taking responsibility for any errors in interpretation.[23]

The first of Xie He's six principles, consisting of four characters (*Ch'i-yun Sheg-tung*), has been translated in a number of different ways, as can be seen in this short list by some of the most distinguished scholars:[24]

· Spiritual rhythm; movement of life (Osvald Sirén)
· A vital tone and atmosphere (Lin Yutang)
· Rhythmic vitality (Herbert A. Giles)
· Rhythmic vitality or spiritual rhythm expressed in the movement of life (Laurence Binyon)
· Engender a sense of movement through spirit consonance (James Cahill)

While we can suppose that what is being reached for in these translations is not simple verisimilitude, what is most intriguing is the regular evocation of rhythm as cognate. The problems of translation spring mainly from the fact that there is no traditional word in China that exactly equates to our use of rhythm. In musical contexts the more common term is closer to "measure" (see discussion of harmony above): the key character involved referred originally to the regularly, but not identically, spaced segments of a bamboo stem. In poetic contexts the modern term for rhythm draws on another character, *yun* (韵), that actually signifies

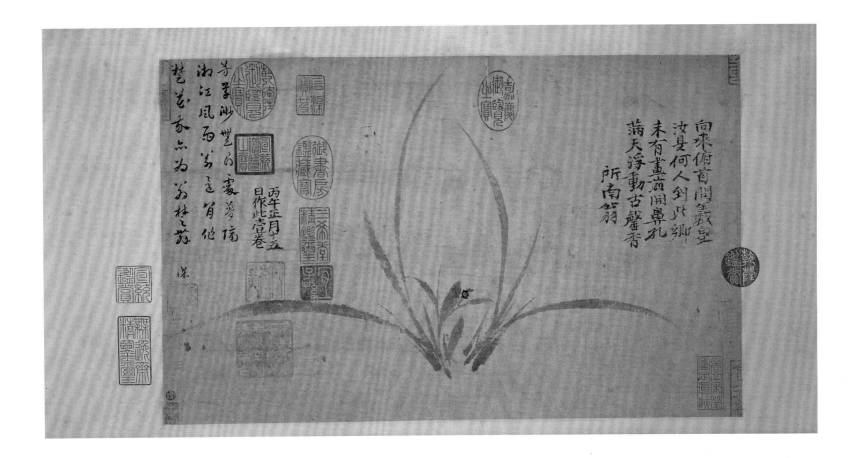

38. Zheng Sixiao (1241–1318). *Orchid*, 1306. Handscroll, ink on paper, 10⅛ × 16⅝ in. (25.7 × 42.4 cm). Osaka Municipal Museum of Fine Arts.

"rhyme." This is what Xie He uses, saying "*qiyun* produces [a sense of] movement." Here *qi* considered as an equivalent to "spirit" is misleading, though many translations use it as the closest equivalent. Etymologically the word refers to "vapor" or "steam," and so it is not "spirit" in the sense of being opposed to matter. This aqueous reference does allow us its extended use as meaning something that can *flow*, even if that something is as abstract as energy—a conception close to ancient Greek use.

The character *yun* etymologically appears to derive from another word meaning "equality," which therefore produces "consonance" in Cahill's translation (and some others). It was not apparently used in ancient China, but seems to date from a time when contact through Buddhism with Indian languages had raised awareness of the phonological structure of Chinese, in which syllables consist of an "initial" that is usually a consonant, and a "final" that is usually a vowel, sometimes with a nasal or other vestigial consonant sound after the vowel. So in translating "rhyme" as "consonance," Cahill is trying to bring out the etymology in a way that might suit an aesthetic vocabulary by softening the focus on rhyme. The character may have lost its specific association with rhyme over time—there are citations that point in this direction —but the sixth-century association seems to point strongly to the concept of rhythm, since it is used in contemporary contexts that talk of verbal rhythm. *Yun* is more closely associated with vocal articulation, but within the world of sound or image

it always signifies something potentially rhythmic, and in combination with *qi* it would be accurate to talk of "pulses of energy," even though "pulse" in its literal, medical sense is expressed by another word. That word is employed in calligraphic theory in relation to *xing* (running) script. In a *Treatise on Calligraphy* by Jiang Kuí (ca. 1155–1221) running script is described in the following way: "What matters is that heavy and light strokes alternate, like the rhythm of blood flowing through the veins within a firm, strong structure of sinews and bones." Here the word underlying "rhythm" is not that used by Xie, but the medical term for pulse. This emphasis on the brush stroke is very important. Indeed Xie's second principle of painting is concerned with the brush stroke, the "bone method" (*ku fa*), the manner of using the brush. The importance of these two principles combined is that they point to an emphasis on process rather than on simple result (fig. 38).

But tying these principles down to a specific definition is less important than the fact that rhythm, whether in all cases employed accurately or not, has so often been invoked. It suggests a conception of rhythm that relates to the Greek usage. It is not a question

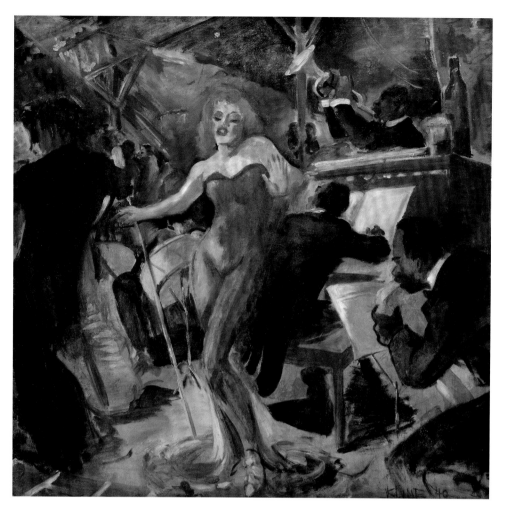

39. Franz Kline (1910–1962). *Hot Jazz (Bleecker Street Tavern Mural)*, 1940. Oil on canvas, 45½ × 46½ in. (115.6 × 118.1 cm). Chrysler Museum of Art; Gift of Walter P. Chrysler, Jr.

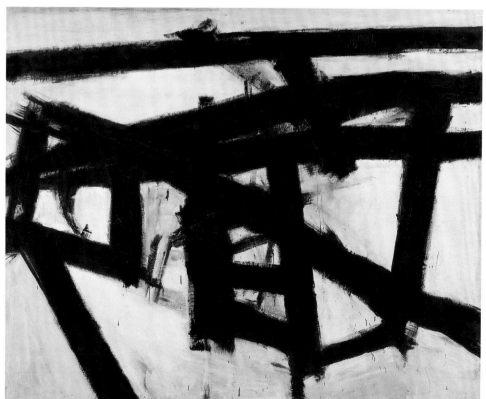

40. Franz Kline (1910–1962). *Mahoning*, 1956. Oil and paper collage on canvas, 80 × 100 in. (203.2 × 254 cm). Whitney Museum of American Art, New York; Purchase with funds from the Friends of the Whitney Museum of American Art.

of measurement so much as that elusive "spirit," or to put it in more contemporary terms, "feel."

A modern art movement that is allied with many of these concerns will serve as my final example of rhythmic artistic mark making and gesture that relates both Chinese ideas of rhythm and calligraphy.

Abstract Expressionism and Rhythm

It is not coincidental that among the first important works of Franz Kline, one of the American artists most closely associated with Abstract Expressionism, are paintings about jazz. *Hot Jazz* was painted in 1940 as one of the Bleecker Street Tavern murals (fig. 39). Here the emerging fluency in paint handling and the use of quick, rudimentary brush strokes to convey the improvisatory, fluid exchange of the jazz quartet with the singer and the dancers conceal the same angular, bold composition and structure that mark his mature abstract painting. His compositional ambitions developed under the influence of Cubism in such works as *The Dancer* (1946). That music and dancing should be central to Klein's development as a painter is not surprising, for despite his denial, his mature canvases, such as *Mahoning* of 1956, clearly relate Chinese brush calligraphy to the expanded physical gesture of dance (fig. 40).[25]

Such paintings are rhythmic intensification of manual movement, for in them the detail is made monumental. They have roots in Willem de Kooning's use of a Bell-Opticon projector, around 1948, to enlarge some of his drawings. As David Anfam has argued, these enlargements acted to support "Kline's growing awareness that the sketch could be expanded to dramatic effect. In this process the rawness, spontaneity and crude design associated with a small-scale sketch assumed a monumental *frisson*."[26] In *Wotan* (1950) and *Siegfried* (1958), for example, this aspiration to monumentality can be seen clearly in the Wagnerian subjects, the evocation of mythic significance. As Veit Erlmann has pointed out, Nietzsche saw Wagner as the "master of the very minute," the "great miniaturist," for his music is governed by "rhythmic ambiguity," because infinite melody is a form of "counterfeit" that lends an "appearance of continuity to what is essentially little more than a series of melodic fragments, gestures and formulas."[27] Whether this is true or not, it characterizes the tension between the macro and the micro that lies at the heart of modern art: the ambition for synthesis and the tendency toward atomization into media specificity—the tension I outlined at the beginning of this essay. Klein's paintings, in their rhythmical totality, amplify the gesture to the status of composition.

Understanding gesture as rhythm here depends on the possibility of rhythm without recurrence. To return to my earlier discussion,

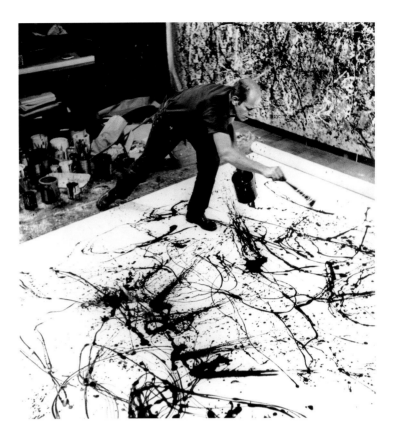

41. Hans Namuth (1915–1990). *Jackson Pollock*, **1950.** Gelatin silver print, 14⅞ × 9⅞ in. (37.6 × 25.1 cm). National Portrait Gallery, Smithsonian Institution.

this is a characterization of rhythm as flow or as drawing, because here drawing, line and color (even in black and white) are coterminous with composition. Another way of considering this issue of rhythm in gesture might be to rethink its cognate concept, melody. To return to Nietzsche, he argues that the ancient Greeks did not feel melody as a harmonic power, as it is inevitably felt by us. They were, he argues, alive to the spatial differences, the intervals, the passage from note to note. In this way, he maintains, melody, as we understand it, did not exist. Rhythm—the spaces—dominated, "temporal relations stretching across the horizontal expanses of space."[28]

Jackson Pollock unifies dance and gesture in another way. In his mature drip paintings Pollock unified, or at least coordinated, thought, action, drawing and painting into a single process (fig. 41). This is physical painting, where direct gesture is primary, where Pollock thought with his body. Here I am reminded of Henri Lefebvre's words: "to grasp a rhythm it is necessary to have been grasped by it; one must let oneself go, give oneself over, abandon oneself to its duration. . . . In order to grasp this fleeting object,

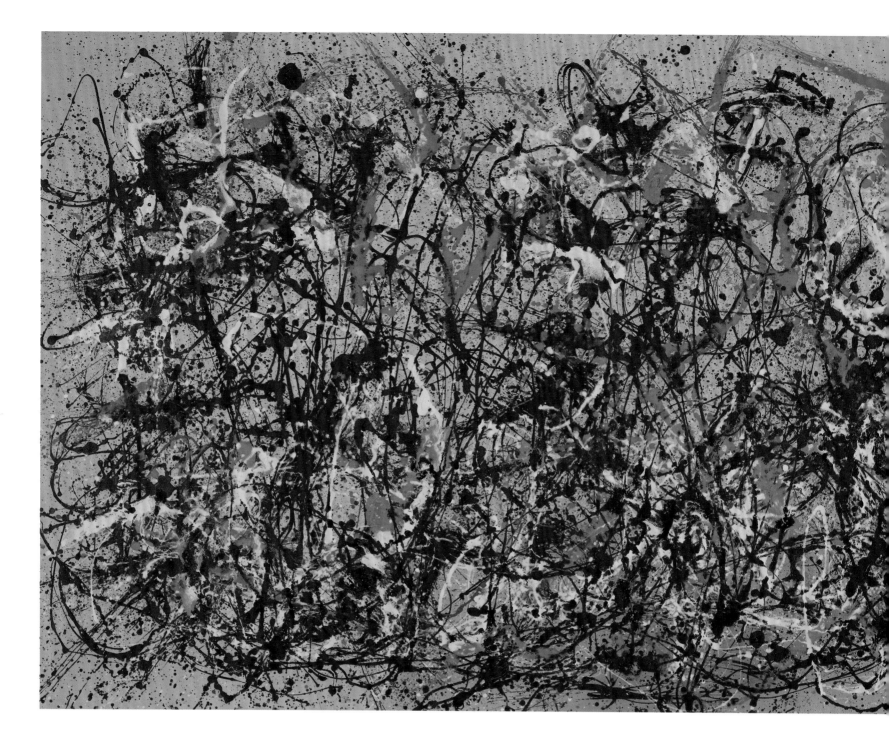

42. Jackson Pollock (1912–1956). *Autumn Rhythm*, 1950. Enamel on canvas, 105 × 207 in. (266.7 × 525.8 cm). The Metropolitan Museum of Art; George A. Hearn Fund, 1957.

which is not exactly an object, it is therefore necessary to situate oneself simultaneously inside and outside."[29] Like Klein, but rather differently, Pollock too mastered the relationship between the microstructure of rhythmic splatter, drip and drop, and the macrocosm which is unified to a degree that denies the possibility of dissolution or disintegration. In *Autumn Rhythm* (fig. 42) Pollock gets close to what the poet Clark Coolidge described in his essay on Jack Kerouac:

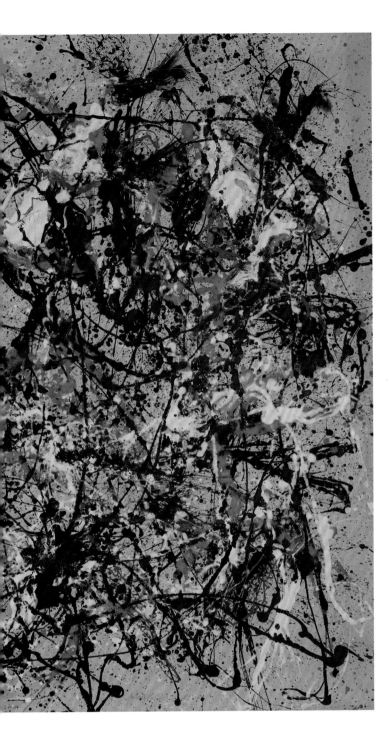

What is the relationship for the writer between what he hears of the words and what he sees once they're written down and fed back into the head that's hearing those words? To me there's an incredible generative cycling that's going on, but there's also a problem with the registration, which is always inexact, a bit like the notation of jazz.[30] If you write improvised jazz notes down in classical 4/4 or whatever measure, you're not going to get the nuances of the rhythm unless you divide it into so many micro-moments that it's nearly impossible to then read and play. Which has happened with some so-called modern classical composers. There are Elliott Carter scores, for example, that

as a drummer I've tried to read, which are so divided that I don't see how anyone could fluidly do it.[31]

This is an interesting final point on rhythm. Carter should, of course, be fluidly played. One can find the flow, or draw out the rhythm even in such complex music, but as with jazz, this true rhythm is not to be found simply by counting.

Multiplex, Multimedia and Mingling

I have been proposing a view of music that *sees* it as multiplex, its elements shared with the visual. Music has sights and sites, and this attracts artists as much as the counterview that it is, in fact, invisible and exists outside the world (a "music of the spheres"). This view of music, as something that is simply heard, is most prevalent in discussion of "classical" music, an art that has often aspired to the invisible,[32] to exist in a pure sonic state, to "sound alone," allowing it to provide the condition to which all arts should aspire, as the English critic Walter Pater put it.[33] This aesthetic model for artistic abstraction, for formalism away from the world, is a persistent and powerful trope, but the idea of absolute music is but a phase in music's history.

This state of concealment, and of the aspiration to an invisible music, is not an identity so-called popular music has often pursued. I have sought to critique this idea in "classical" music, to show that the harder music tries to hide the visual, the more it tends to seep out of the ideological cracks and crannies.[34] However, there are, of course, other musical paradigms that are less concerned with sounding alone; pop music has always been happy with its relationship to image, even when this proximity has seen it criticized for placing sight over sound. From the Moulin Rouge and Swinging London to the Sex Pistols and beyond, image, display and music play together to offer cultural and social critique, often twinned with rebellion (fig. 43).

An artist who plays with this boundary of popular music and art is the Swiss-American Christian Marclay, who seeks to undermine the purist aesthetic, its focus on sound alone and its concomitant fetishistic attachment to flawless recording technology. In his visually arresting Recycled Records series (1980–86), he carefully cut differently colored vinyl discs on a jigsaw, then painstakingly reassembled them into new, visually beguiling formats: miniature abstract paintings, or shallow-relief collages (fig. 44). Their musical content occurs purely as a consequence of the visual patterning, their sound an accidental consequence of the visual composition, so that the musical juxtapositions, skips and blurs are a result of visual choice. They are a kind of abstract revenge on the commercial picture disc,[35] which reached its peak in the same decade.

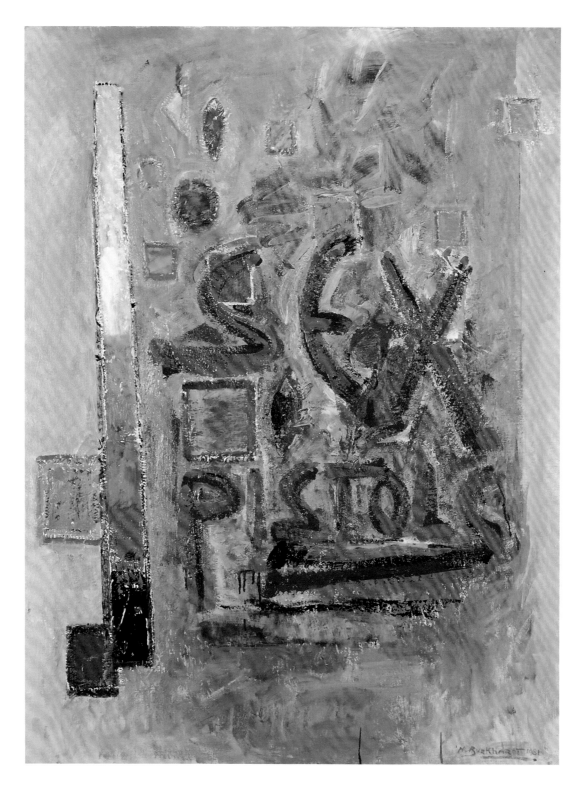

43. Hans Burkhardt (1904–1994). *Sex Pistols,* 1981.
Oil on canvas, 42 × 32 in. (106.7 × 81.3 cm). Courtesy
of Jack Rutberg Fine Arts, Los Angeles, and the
Hans G. and Thordis W. Burkhardt Foundation.

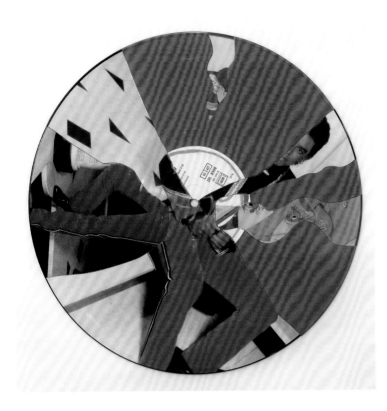

44. Christian Marclay (b. 1955). *Recycled Records*, 1984. Collaged vinyl records, D: 12 in. (30.5 cm). Courtesy Paula Cooper Gallery, New York.

While records without sleeves are interesting visual objects in their own right (and picture discs exploited and overlaid this visual appeal), the most common element of record art is dust-jacket design. Marclay's Body Mix series (1990s) plays with the body as imaged on album covers (figs. 45 and 46). One part of this series wittily stitches together images of that most visually dominant (but silent) musician in the classical symphonic repertoire, the conductor, with anonymous women's legs. These images literally undermine the rhetoric of the maestro with the latent sexuality of powerful music, bringing high and low culture together, returning the *komos* to the *tragoedia* in a new Dionysian dance that would have made Pan proud.

A work positioned in some ways between images of the record as surface and the sleeve as visual adjunct is Marclay's seemingly simple exhibition of the Simon & Garfunkel single "The Sound of Silence" mounted behind glass. It confounds Cage's *4'33"* of "silence" by being truly silent, quieter than Cage's performer, although full of music. But on closer inspection, the single turns out not to be a record, but only a photo of the record (a "record" of a record), and therefore never capable of sound, although the idea of the visual as silent is not so easy to presume. For as with Cage's direction *tacet*, in the score of *4'33"*, Marclay's title, seen as text on the image, is enough to make us sound the words in our head, and in *The Sound of Silence* most of us will even "hear" the song, and as an imagined sound it is more emphatically the true sound of silence. This work is quite literally a reproduction of a reproduction device, an image of music, to return us to the Seikilos epitaph.

We might posit at least two important roots for the idea of a multimedial aesthetic: one ancient root in Greek tragedy and the Aristotelian joining of *opsis, lexis* and *melos*, among others, in his *Poetics*; the other, more modern root lies in the "Art-Work of the Future," in the music dramas of Richard Wagner.

Of course, Wagner drew explicitly on ancient roots as well, and with the help of his friend Friedrich Nietzsche posited an understanding of ancient drama as a form of synthetic artwork (the so-called *Gesamtkunstwerk*) that allowed the arts of vision and sound (primarily) to work in harmony for the benefit of the *volk*. This tendency stands in contradiction to the purist model of art that I mentioned above: purity of form and means, immateriality, singularity of sensory address, music as the art of purist expression. Wagner considered purism (based on this ancient Greek model) to be enfeebling, and that in recent times this moving apart of the arts from each other meant that they were now so far from their root that they were in danger of withering on the bough. He thought the separate arts gained greatest power from "playing" together, not standing alone—a view he later modified under the influence

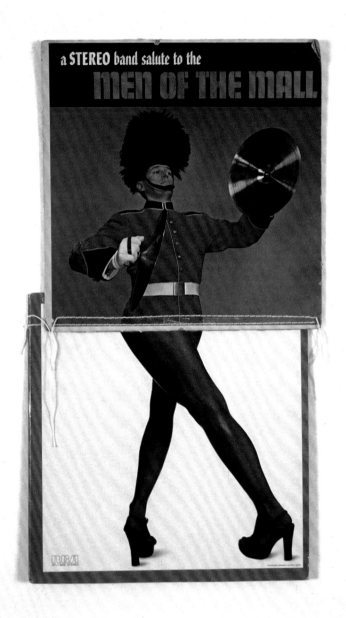

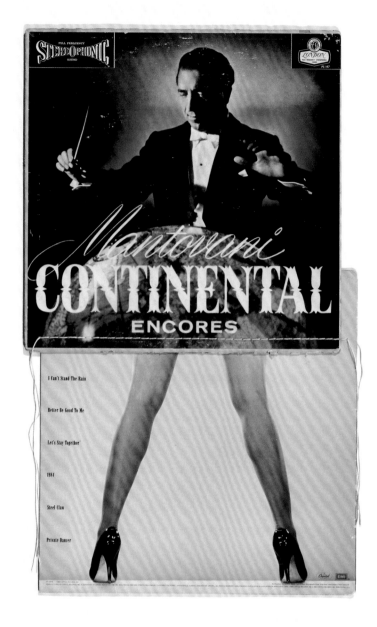

45. Christian Marclay (b. 1955). *Men of the Mall* (from the series "Body Mix"), 1991. Two record covers and cotton thread, 23⅛ × 13 in. (58.4 × 33 cm). Courtesy Paula Cooper Gallery, New York.

46. Christian Marclay (b. 1955). *Continental* (from the series "Body Mix"), 1991. Two record covers and cotton thread, 21½ × 13 in. (54.6 × 33 cm). Courtesy Paula Cooper Gallery, New York.

of Schopenhauer, so that although synthesis was still important, music became the leading art.

The view adopted in this essay has been one of union: that the arts of music and vision are, as Webern considered music and color to be, different in degree rather than in kind, and should be seen as essentially hybrid and contingent. The more recent concept of "multimedia" is both a term in opposition to the modernist idea of media specificity and purism, and one that reimagines the old "sister arts" dialogues of a post-Aristotelian aesthetic. As such it plays well into this hybrid conception of music as visual, and art as audible. These ideas come together in Roy Ascott's "Gesamtdatenwerk,"[36] an idea which, with a nod in Wagner's direction, relates these theoretical ideas to technological developments in the digital age, allowing possibilities of integration, mingling and mix impossible to imagine in a more analog(ue) world. Once media technology advanced to the state of representing both sound and image through the same binary code of numerical zeros and ones, the result was a fundamental transformation of sound and image into equivalents. As the Seikilos epitaph had it, music (information) could be image, as image (information) could be music.

In the 1960s, the cultural critic Marshall McLuhan wrote of a decisive shift from an ocularcentric to an audiocentric world view, for the ear, he wrote, "favors no particular 'point of view.' We are enveloped by sound. It forms a seamless web around us,"[37] and "Where a visual space is an organized continuum of a uniformed connected kind, the ear world is a continuum of simultaneous relationships."[38] Caught as we all now are in a world-wide web, this surround-sound model is perhaps more appropriate for us than that of the "enlightenment" idea of fixed perspectives. The digital world is one in which interpretation and selection are more exercising than access. As McLuhan pointed out, we don't have "earlids," we can't shut out sound in the same way as sight, so listening is more important than hearing; selecting what is true, relevant and interesting from the mass of media is more pressing. If we have moved from a paradigm of sight to one of sound, then the ubiquity of data is now approaching a new condition of music or noise, and selecting our focus against the background sonic hum is a real challenge.

I would want to place emphasis slightly differently, however, so that the question is not so much whether a new paradigm has replaced an older one, but whether fixity and certain positioning is itself the problem. The assumption that art and music are fundamentally different forms is not how they "look" from some "points of view." It is not that music is now visual, or vice versa, but rather that music always was visual and, conversely, that visual arts always were musical.

Synesthetic Transformations

In digital terms, the translation of audio data into visual data and vice versa is simply referred to as audio-visual transformation. This cross-art thinking and translation is, however, central to how we think about the arts more generally. This is a matter of metaphor, but should not be thought of, therefore, as "illusory or untrue." Metaphorical thinking is much more fundamental than that. As the cognitive scientist George Lakoff and the philosopher Mark Johnson have it, "metaphor is not just a matter of language. . . . On the contrary, human thought processes are largely metaphorical," and "The essence of metaphor is understanding and experiencing one kind of thing in terms of another."[39] Not only is this idea key to this exhibition, it is key to understanding all art. My task here has been to explore the relationship between art and music, but allow me to use the words of the philosopher William James to make a few concluding remarks:

> Experience, from the very first, presents us with concretized objects, vaguely continuous with the rest of the world which envelops them in space and time, and potentially divisible into inward elements and parts. These objects we break asunder and reunite. We must treat them in both ways for our knowledge of them to grow; and it is hard to say, on the whole, which way preponderates . . .

And in relation to our first experiences of the world into which we are born:

> The baby, assailed by eyes, ears, nose, skin, and entrails at once, feels it all as one great blooming, buzzing confusion; and to the very end of life, our location of all things in one space is due to the fact that the original extents or bigness of all the sensations which came to our notice at once, coalesced together into one and the same space. There is no other reason than this why "the hand I touch and see coincides spatially with the hand I immediately feel."[40]

"A blooming, buzzing confusion." The issue is not about the true nature of neonates and their experience of faces, chairs or flowers, but rather one of the sensorium and the arts. The relationship between sound and image has, throughout history, been one of shift and change. With the invention of recorded sound a schism between the auditory and visual was possible, but this only led to the possibility of new conjunctions. Digital culture has allowed us to see sound again in new ways. "Sonification" is the process whereby data is rendered as both digital video and audio, with each modality being represented by the same underlying dataset. Many artists have been captivated, but also critical, of the possibilities that digital culture presents. Through audio-visual transformations,

the material of art in a digital environment becomes less fixed to one medium. Electronic music has developed a particular reliance on the visual in the form of graphical user interfaces and analytic representations of audio wave-forms, for example. An artist who works in this way is the Berlin-based Japanese artist Ryoichi Kurokawa, who treats audio and video material as a single unit. His art aspires to an interactive experience where audio and video are in complete unison. In other words, he aims for synesthesia.[41]

Synesthesia can be, as I have written elsewhere, manifest at two levels of signification, the neurological and the cultural.[42] In the former case, synesthesia occurs when the stimulation of one sensory modality (such as hearing) instantly triggers a perception in a second modality (sight) in the absence of any direct stimulation of this second modality; the most frequent examples are people who see musical sounds (chords/intervals/pitches/etc.) as colors. The contemporary American composer Michael Torke is but one of a number of musicians and artists who have had, or do have, such real experiences, evident in his orchestral suite *Color Music* (1985−89).[43]

But although there are such clinical manifestations of cross-modal mixture, mingling of our senses in everyday encounter is fundamental to our body's full intercourse with the world. This cultural experience of synesthesia returns us to William James and his "blooming, buzzing confusion," in which we might see the digital overload of the world-wide web, the multimedia installations of contemporary digital artists or, more fundamentally and perhaps even more importantly, the metaphors of our ekphrastic gropings for contact with the best of art and music in our speech and our texts, even this one.

NOTES

1 See Egert Pöhlmann and M. L. West, *Documents of Ancient Greek Music* (Oxford: Clarendon Press, 2001), 88–91.

2 Ovid, *Metamorphoses*, trans. A. D. Melville (Oxford; New York: Oxford University Press, 1986), 133.

3 Ibid., 254.

4 Ibid., 255.

5 See Johannes Kepler, *The Harmony of the World*, trans. with notes by E. J. Aiton; Alistair Matheson Duncan; Judith Veronica Field (Philadelphia: American Philosophical Society, 1997), 423.

6 See ibid., 499–508.

7 Ibid., 446–8.

8 Quoted in Marcel Franciscono, *Paul Klee: His Work and Thought* (Chicago: University of Chicago Press, 1991), 365.

9 Vasily Kandinsky, *On the Spiritual in Art*, in *Kandinsky: Complete Writings on Art*, edited by Kenneth C. Lindsay and Peter Vergo (Faber, London, 1982), 1:114–219, 1:193.

10 For a more complete discussion of this see Thomas Puttfarken, *The Discovery of Pictorial Composition: Theories of Visual Order in Painting, 1400–1800* (New Haven: Yale University Press, 2000), 17.

11 Ibid., 30.

12 See "Documents" in Arnaud Pierre, *Frank Kupka in White and Black* (Liverpool: Liverpool University Press, 1998), 58.

13 Ann Harrell, *The Forum Exhibition: Selections and Additions*, exh. cat. (New York: Whitney Museum of American Art, 1983), 23.

14 Eugen Adolf Hermann Petersen, *Rhythmus* (Abhandlungen de Kön. Gesellschaft der Wissenschaften zu Göttingen, Phil.-Hist. Klass, n.f. 16, 1917), 1–104.

15 Susanne Langer, *Problems of Art* (London: Routledge & K. Paul, 1957), especially chapter 4.

16 For quotes see Paul Klee, *Pedagogical Sketchbook* (London: Faber & Faber, 1953 and reprints).

17 See J. J. Pollitt, *The Ancient View of Greek Art: Criticism, History and Terminology* (New Haven: Yale University Press, 1974), 218–28.

18 See Paul Klee, *The Thinking Eye: The Notebooks of Paul Klee*, ed. Jürg Spiller (London: Lund Humphries, 1961), 1:267.

19 See both Andrew Kagan, *Paul Klee/Art and Music* (Ithaca, NY: Cornell University Press, 1983) and Nancy Perloff, "Klee and Webern: Speculations on Modernist Theories of Composition." *Musical Quarterly* 69 (1983): 180–208.

20 Anton Webern, *The Path to the New Music* (1933), ed. Willi Reich and trans. Leo Black (London: Universal Edition, 1975), 11.

21 "Cancrizan" is the Latin term for a crab canon, two musical lines that are complementary and backward (therefore a musical palindrome).

22 Webern, *The Path to New Music*, 56.

23 My grateful thanks to Prof. Tim Barrett, Research Professor of East Asian History, School of Oriental and African Studies, University of London, for discussions regarding the nuances of translation.

24 The other five principles or laws are:

 2. "Bone Method," or the way of using the brush. This refers not only to texture and brush stroke, but to the close link between handwriting and personality. In his day, the art of calligraphy was inseparable from painting.

 3. "Correspondence to the Object," or the depicting of form, which would include shape and line.

 4. "Suitability to Type," or the application of color, including layers, value and tone.

 5. "Division and Planning," or placing and arrangement, corresponding to composition, space and depth.

 6. "Transmission by Copying," or the copying of models, not only from life but also the works of antiquity.

See also Osvald Sirén, *The Chinese on the Art of Painting* (New York: Schocken Books, 1963); James Cahill, "The Six Laws and How to Read Them," *Ars Orientalis* 4 (1961), 372–81; Lin Yutang, *The Chinese Theory of Art: Translations from the Masters of Chinese Art* (New York: Putnam Sons, 1967); Laurence Binyon, *The Flight of the Dragon* (London: J. Murray, 1911); Herbet Allen Giles, *Introduction to History of Chinese Pictorial Art* (1905; repr., London: Bernard Quaritch, 1918).

25 On his denial see David Anfam, "Klein, Franz," in *Grove Art Online* (Oxford: Oxford University Press), accessed 3 February 2015, http://www.oxfordartonline.com/subscriber/article/grove/art/T046894.

26 Ibid.

27 See Veit Erlmann, *Reason and Resonance: A History of Modern Aurality* (New York: Zone Books, 2010), 301–2.

28 See James I. Porter, *Nietzsche and the Philology of the Future* (Stanford, CA: Stanford University Press, 2000), 164.

29 Henri Lefebvre, *Rhythmanalysis: Space, Time and Everyday Life*, trans. Stuart Elden and Gerald Moore (London; New York: Continuum, 2004), 27.

30 Kerouac himself said significantly about the "bebop" inspired rhythm of his own writing: "The rhythm of how you decide to 'rush' your statements determines the rhythm of the poem in verse-separated lines, or an endless one-line poem called prose . . ." Quoted after Michael Horovitz on Jack Kerouac, http://www.timeout.com/london/books/beat-poets-michael-horovitz-on-jack-kerouac.

31 Clark Coolidge, "Kerouac," *American Poetry Review* 24, no. 1 (Jan/Feb 1995), repr. online, http://www.writing.upenn.edu/~afilreis/88v/kerouac-per-coolidge.html.

32 See Simon Shaw-Miller, *Eye hEar The Visual in Music* (Farnham: Ashgate, 2013) for a critique of this idea.

33 Walter Pater, "The School of Giorgione," *The Renaissance: Studies in Art and Poetry* (1893; repr., Berkeley: University of California Press, 1980), 106.

34 See Shaw-Miller, *Eye hEar The Visual in Music*.

35 The first modern picture disc is usually described as that designed by Mark Hanau for the British rock band Curved Air in 1970 (*Air Conditioning*).

36 See Roy Ascott, *Telematic Embrace: Visionary Theories of Art, Technology, and Consciousness* (Berkeley: University of California Press, 2003), esp. chapter 14.

37 Marshall McLuhan and Quentin Fiore, *The Medium is the Message: An Inventory of Effects* (New York: Bantam Books, 1967), n.p.

38 Ibid.

39 George Lakoff and Mark Johnson, *Metaphors We Live By*, rev. ed. (Chicago: Chicago University Press, 2003), 6.

40 William James, *Principles of Psychology* (New York: Henry Holt & Co., 1890), 462.

41 See the interview at http://thecreatorsproject.vice.com/en_uk/blog/video-sensory-overload-with (accessed Nov. 2014).

42 See Simon Shaw-Miller, "Synaesthesia," in *The Routledge Companion to Music and Visual Culture*, eds. Tim Shephard and Anne Leonard (New York; London: Routledge, 2014), 13–24.

43 Others are (although not all have been "tested"): Olivier Messiaen; György Ligeti; David Hockney; Helene Grimaud; Amy Beach; Vladimir Nabokov.

Richard Leppert

A Sound World Seen

Listening for Trouble

Hearing is biological and fundamentally involuntary. The organ of hearing, unlike the eyes (which can close or look away), cannot so conveniently be shut off from sound, ear plugs notwithstanding. Listening is also fundamentally cultural and social, even in situations where it's not voluntary. The French literary and cultural critic Roland Barthes points out that we listen *for*; that is, at its most basic listening is defensive, a means of self-protection against the unexpected, danger especially. But Barthes's interest is in something less obvious and more profound. Listening, he suggests, reveals what he terms the "secret" requiring interpretation: "to listen is to adopt an attitude of decoding what is obscure, blurred, or mute, in order to make available to consciousness the 'underside' of meaning (what is experienced, postulated, intentionalized as hidden)."[1] Expanding on the premise, he suggests that we listen in order to decipher the future, *and* we listen for transgression. By contrast, on the utopian side of the equation, Barthes points to the intersubjective nature of noncoercive listening as a kind of reaching out—or perhaps better, silently reaching back to—someone speaking to us. In this regard, consider the intensely reciprocal listening of lovers.

The entire history of Western civilization is marked by acute anxiety over what music is listened to. Listening for the transgressive—the disapproved or forbidden—covers many sins, such as violations of religious protocols or those associated with ideology and politics, among a host of other possibilities. In nearly any such violation one might imagine that music, directly or indirectly, has played a role and is accordingly listened to carefully. The ancient Greeks, like the early Church Fathers, expressed deep concern especially regarding the ill effects that listening to the wrong kinds

47. John Baldessari (b. 1931). *Beethoven's Trumpet (with Ear) Opus #127,*
2007. Foam, resin, aluminum, cold bronze, electronics, 84 × 120 × 84 in.
(213.4 × 304.8 × 213.4 cm). Courtesy of John Baldessari and Beyer Projects.

48. John Baldessari (b. 1931). *Person with Guitar (Red)*, 2005. Five-color screen print construction, 30 × 36¼ in. (76.2 × 92.1 cm). Hammer Museum, Los Angeles; Purchased with funds provided by Brenda R. Potter and Michael Sandler. Courtesy of John Baldessari.

of music enacted on the moral fiber of the young, even to the point (in Plato's view, channeling Socrates) of constituting a threat to the state.[2] The music that might be good for you (or at least not necessarily harmful) and the music that should never be tolerated shifts over time and by place. My principal focus here concerns Western European culture during the seventeenth, eighteenth and early nineteenth centuries, the broad swath of time associated with early modernity. Yet the issues surrounding socio-culturally approved and disapproved music and listening practices never go away. Indeed, it's as alive today as when Plato held forth in *The Republic*.

John Baldessari's *Beethoven's Trumpet (with Ear), Opus #127* (fig. 47), one of six related scupltures, envisions a "musical ear" of the highest order, except that the named composer's ear for much of his compositional career didn't work well and in the end not at all. Beethoven heard (listened) imaginatively from necessity, handsomely making the case that listening is not least an act of hearing oneself. The gigantic, nonfunctioning ear, seemingly desperate to hear something that the ear trumpet might concentrate, visually amplifies the silence that ensues: white ear/white noise/no-sound-in-space or however one might want to parse

the matter. Baldessari locates the centrality of hearing/listening to human experience by reference not only to what Beethoven "heard" in his imagination but also what he was keen to make audible and for others: music, certainly among the most deeply affective forms of intersubjective experience.

Baldessari's sculpture, referencing Beethoven, organizes a way of seeing revolving around a musician/composer whose music enjoys canonical status on the one hand, and an isolated (all but nonfunctioning) human sensory apparatus on the other. Hearing constitutes an absent presence: one sense only (the other four senses are not referenced) but one that no longer "works," rendering the isolation more profound. Nonetheless, the music still plays. The sculpture's title incorporates an opus number (#127) alluding to the first of Beethoven's six late string quartets; indeed, each of the six versions of the sculpture refer to the quartet series' individual opus numbers, referencing musical compositions of canonical aesthetic pedigree and ones composed when Beethoven was entirely deaf. Baldessari's ear sculpture is music for the eyes, which not coincidentally is not the worst way to think about visual art. At the same time, the piece can be interactive: if a viewer chooses to speak into the trumpet, "Beethoven" responds with a bit of the

string quartet named in the title, as if to break the silence and even to offer back a sonoric gift. Beethoven's ear trumpet in such an exchange becomes at once a microphone allowing "him" to hear, and a loudspeaker giving back when spoken to. The ear trumpet hears and it also speaks.

Looking Back

In the early seventeenth century, at a defining moment of early modernity, there developed an intense humanistic and scientific interest in the human senses, with principal interest centered on sight and hearing. The visual arts, literature and philosophy, as well as the new sciences of anatomy, biology and medicine, delved into the subject. This inquiry in particular addressed the senses as keys to human identity, principally as vehicles of our embodied "apparatus" for knowing. In northern European painting, the theme of the Five Senses received notably dramatic treatment.

The subject first established itself as a mirror reflecting, hence putatively reinforcing, long-established religious belief: the "old world" theory of knowledge according to which the here-and-now makes ultimate sense only in terms of the hereafter. The way to knowledge was described as a series of pathways defined by the senses—but the senses' role, as it were, was to confirm principles of religious orthodoxy.[3]

> An alphabet of images related to the Scriptures was established: Sight, symbolized by the eagle, was linked with the theme of the healing of the blind man by Jesus; the mirror, with the theme of the expulsion of Adam and Eve from Paradise; Hearing with the preaching of John the Baptist; Taste with the miracle of the bread for the five thousand; Smell with Mary Magdalen's anointing of Christ's feet, and Touch with the miracle of Christ walking on the waters.[4]

Among the most striking of Five Senses paintings, especially those produced by the Fleming Jan Brueghel the Elder[5] and, later, those by his son Jan the Younger, as well as collaborations by Jan van Kessel and Hendrik van Balen (fig. 49), something else comes to the fore. The radical abstraction of the senses as theological metaphors is abandoned. The senses as represented in these paintings sense *worldly* things made strikingly concrete and supercharged with a visually gorgeous materialism. Accordingly, the senses' more traditional role as pathways to theological knowing is shifted toward the secular. Indeed, these paintings effectively argue for the earthly pleasures available to be consumed by the sensing body, at the same time that they provide a direct opportunity to experience the potentiality of the sensual. Such Five Senses paintings, in other words, hail the body in the act of aestheticizing and valorizing sensibility and sensuality.

Hearing appeals to viewers by delivering "the goods": objects readily associated with sensory pleasures. The artists get us to look by giving us so much to look at. That we want to look in the first place is partly the result of the cultural value placed on worldly goods, products of human manufacture that in virtually every instance are luxury items and none a basic life necessity. To take in the myriad material contents of the painting we must look wholeheartedly. The act of visual consumption becomes a feast, not a snack; it requires time and even focused attention simply to make basic identifications—that is, to name the objects.

Not the least pleasure we are invited to experience is derived from the naked muse, presumably Euterpe. Her bare flesh attracts our eyes partly by its whiteness in contrast to the richly colored materials surrounding her, including the drapery that frames her body, thereby setting it off as a kind of special sight. The fact that she is naked marks the pleasure to be had as specifically erotic, that is, sensual (of the senses). Her body is made available as a sight in ways that profoundly exceed what is available for us to see in ordinary daily life. The painting's visual pleasures, in other words, are extraordinary, hence supplying all the more reason for us to look.

The painting illustrates a human sense (Hearing and, since it is a painting, Seeing as well). It also activates our own sensing bodies to the extent that it makes us *want* to look. In a culture where, already in these artists' own lifetime, seeing is believing, paintings of the human senses—no matter which sense is represented—mark the hold that looking as such enjoys in modernity. *Hearing*, accordingly, is Hearing for the eyes to the extent that the eyes can confirm hearing's function, even when there is literally nothing to hear.

The painting also confirms the agency—the social power—of looking, for what is made available for seeing in this image are the accoutrements of extreme privilege and power. What is here for the visual taking is one among the infinite variety of overdeterminations for modernity's claim that Man, in the Foucauldian sense of the modern We, is defined by what we have, or by what we are taught to desire: worldly goods. Van Kessel and van Balen's painting evokes extreme consumption as determinant of human worth. It also genders this worthiness as male by granting access to the stark nakedness of the woman whose body organizes the entire composition.

Since paintings are silent, what matters in this representation are not aural phenomena as such, but the social importance and function of certain kinds of sound and audition. The painting illustrates not simply things that make sounds, but things that make socially prestigious and principally *private* sounds. That is, the musical instruments illustrated are solely those of high-caste music; the

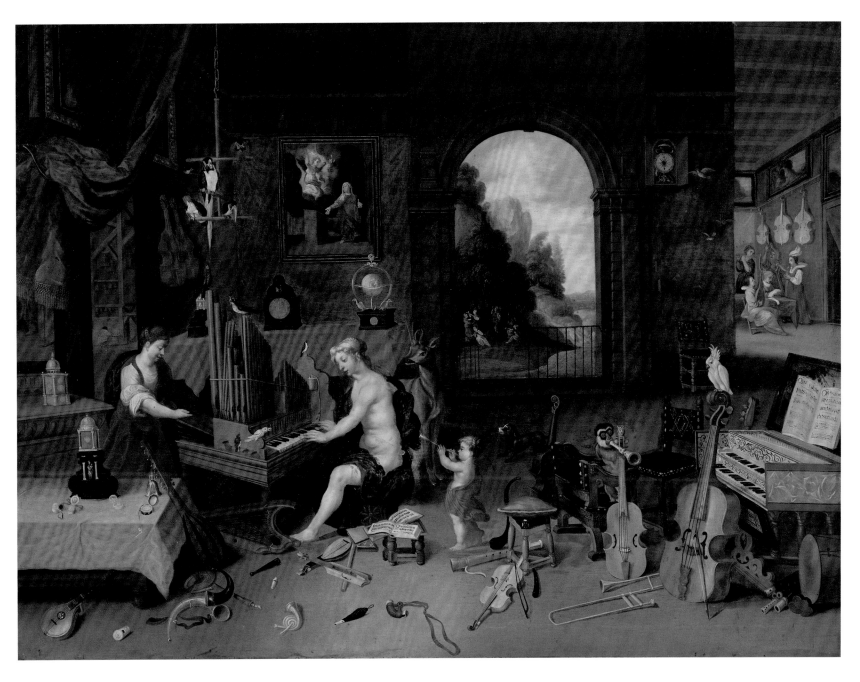

49. Jan van Kessel (1626–1679) and Hendrik van Balen (1575–1632), after
Jan Brueghel the Elder. *Allegory of Hearing*, 17th century. Oil on canvas.
Saint-Germain-en-Laye, Musée d'Art et d'Histoire.

hunting devices scattered on the floor at the left recall an activity restricted to the nobility; the timepieces placed here and there throughout the image were expensive collector's items at the time. All in all, human hearing is represented less as a natural phenomenon and more as one of high social position. Hearing, in short, is politicized, and its politics are made to appear beautiful.

The pleasures immanent to the picture are produced in part by the degree to which the accumulated objects make no functional sense, except as a kind of archive of related objects. As inventories, sound-making collections please by their function*less* excess. Their visual logic, so to speak, lies in their apparent lack of logic, the degree to which the inventory seems impossible, a mere fantasy, except for the fact that nearly all the objects in the room are not only painted with notable precision but also are objects of contemporaneous use. They occupy, in effect, a space out of time, at the same time they themselves are, as it were, at once time-bound and entirely timely. The fantasy, in other words, has its feet planted in a recognizable reality. The view through the open archway looks onto a fanciful Italianate landscape apparently hosting a Concert of the Muses (a popular northern-art subject at the time). But through the doorway at the left is something rather more mundane in the form of a carillon player at his keyboard who, judging from his costume, is a quite ordinary mortal busy earning his keep. Thus ancient myth and modern history cohabit. And the same can be said of space, broadly conceived, to the extent that the fauna in the foreground constitute both the utterly ordinary and the notably exotic—the local and the foreign. In other words, time and space are radically concentrated. (The stag, notable for its acute hearing, serves as a kind of internal label for the painting's subject.)

Norbert Schneider points out that Five Senses paintings work not so much to satisfy cravings as to produce them. In this regard, the seventeenth century witnessed the emergence of new wealth and the accompanying demand for things to buy—the great port at Antwerp, these painters' hometown, later in the seventeenth century could accommodate 2,000 ships at one time, bringing trade goods to northern Europe from the far corners of the already fast-shrinking globe. "The stimuli provided by the new range of luxury goods triggered off a compulsive urge in the viewer to enhance his own sensual pleasure and to keep increasing his long-term needs."[6] More to the point, these desires are both classified and structured in paintings of this sort. Our consuming pleasures are organized for us, and their import is pedagogical.

Five Senses paintings isolate each sense and hence parallel the practices of contemporaneous anatomy lessons that examine one discrete body part after another. This parallel is neither accidental nor trivial. At the same historical moment that such paintings

both visualize and valorize sense-derived physical pleasure, the viewer's own sensing body itself is in effect objectified, taken apart and appealed to in a kind of aestheticized science of pleasure. This science is structured as an inventory of the objects that reference and stimulate each sense in turn—wonderful sounds to "hear," exotic flowers to "smell," bountiful feasts to "taste," etc. Science meets and allies with consumption and the desires that drive consumption.

The same epistemology underwrites these pictures and contemporaneous scientific classificatory schemes generally. The images are doubly modern, despite the fact that their organizing principle is allegorical. They mark the pleasure of excess consumption, linking it directly to power, and they situate physical, embodied pleasure in a quasi-medical discourse about the *mechanics* of pleasure. Pleasure becomes something not simply to be enjoyed but something to be isolated into its component parts, and then appealed to.

Van Kessel and van Balen's painting invokes the pleasures of hearing, so far as music is concerned, principally by its actual absence, a lack made the more pertinent given the extraordinary possibilities for musical (and other) sonority visually evident. Paintings are perforce silent, but their silence itself becomes something of an issue when so much potential music remains unrealized, with reference to the many instruments scattered carelessly in the foreground. Were we to be within earshot, so far as the musical performances are concerned, it is hard to imagine that we would much want to listen. Two background ensembles perform, as does a bell ringer, the muse-organist, a child piper and the shawm-blowing primate. And this says nothing about the possible acoustic contributions of clocks chiming, a dog barking and exotic birds screeching. The painting invokes the possibilities accorded to hearing organized around the most privileged of sounds—accordingly, there is not a single instrument associated with the peasantry—but ones whose literal result, if we could somehow hear what is going on, would be cacophony. In other words, the beauty of the *visual* music exists in extreme tension with what is actually represented, namely, musical simultaneities that together produce noise: the price paid for too much of everything. But of course what matters most here is not reality, but the invocation to a fantasy of accumulated pleasure whose foundation is structured by an immense degree of social power and accumulated wealth.

It's no accident that Dutch art of this early-modern period represented musical subjects to a degree never previously equaled, and probably never since surpassed. The cultural reasons for employing music as a visual trope in the new age of the visual episteme (modern culture's so-called "visual turn") is explained best, I think, by music's evocation of, and dependency upon, the

aestheticization of time, at precisely the moment when modern time-consciousness becomes obsessive—and obsessively linear: the moment when human subjects increasingly stage their lives and experiences in self-reflexive relation to time. This is the pilgrim's progress to the secular heaven of worth, the form of self-worth that can be taken to the bank: time is money.

Modern time-consciousness helps account for the inclusion of timepieces in the painting. *Hearing* fetishizes time as a dimension of power and control. In this sense, time-consciousness formulates the ultimate mark of prestige in a society so generally unaware, except for a relative few, that modern time operates not in cyclical fashion, in sync with the agricultural seasons, but in a straight line, and that within that timeframe the world may be explained by its sounds, all of which are to be increasingly subject to external control. This adds up to a simple reality: the early moderns had figured out that time was worth *listening to*.

50. Giovanni Benedetto Castiglione (1609–1664). *Allegory of Vanity*, **1647–49.** Oil on canvas, 38¾ × 56¾ (98.4 × 144.1 cm). The Nelson-Atkins Museum of Art; Gift of the Samuel H. Kress Foundation.

A lavishly baroque *Allegory of Vanity* by Giovanni Benedetto Castiglione (fig. 50) advances a different argument about music and the time spent making it or hearing it. In this instance, time's expenditure is perceived as a moral issue, to the extent that earthly time, whether wasted or fetishized, runs the risk of earning one the eternal time of damnation. The tension between now-time and the non-time of eternity produced cultural ambivalence and moral contradiction, a dialectic that gave rise to a prominent genre of painting, the vanitas still life (often, as here, with human figures included), illustrating a verse in Ecclesiastes 1:2: "Vanity of

51. Giovanni Benedetto Castiglione (1609–1664). *Allegory of Vanity* (detail), 1647–49.

52. François Bonvin (1817–1887). *Still Life with Violin, Sheet Music, and a Rose*, 1870. Oil on canvas, 20 × 28 in. (50.8 × 71.1 cm). Fine Arts Museums of San Francisco; Museum purchase, Grover A. Magnin Bequest Fund.

vanities, saith the Preacher, vanity of vanities; all is vanity." Vanitas paintings transformed a rich array of textual allusions into emblems and attributes. Music featured prominently, typically by painting heaps of musical instruments and also by including musicians performing and people dancing, both activities prominently featured in Castiglione's picture.

The still-life objects represented were intended to encourage observers to contemplate the frailty and brevity of life: human skulls, instruments for measuring time (clocks, watches, hourglasses), candles burning or extinguished but still smoking, soap bubbles that exist only for an instant, flowers at their height of bloom hence about to fade, fruit ripe hence about to rot, etc. Luxury goods such as rare shells, jewelry, silver plates, gold coins, purses and deeds alluded to the vanity of earthly treasures. Musical instruments and music books fell among a related group of attributes referencing life's tastes and pleasures, the so-called *vita voluptuaria*, intended to be read as activities that waste precious time better spent saving one's soul.[7] Similarly, books and scientific instruments alluded to the *vita contemplativa*, and the inclusion of weapons and insignias of command to the *vita pratica*. Finally, as a putative antidote to the condemnation of things transitory, vanitas pictures often incorporated signs of the soul's eternal existence, such as a sprig of ripe wheat or ears of corn, which contain

seeds of new life that will sprout after planting/burial. (Few individual vanitas paintings reference all of these categories.) The most severe examples of the genre, leaving nothing to doubt, incorporated mottoes as internal labels: "Vanitas," "Vanitas, vanitatis," "Vanitas vanitatis et omnia vanitas," "Homo bulla" ("man is but a bubble"), "mors omnia vincit" ("death triumphs over everything"), "memento mori" and the like.

In the vanitas still life all *movement* ceases in favor of a concentrated sorting of data. In this process, all too easily the end falls victim to the means, and data as such quickly becomes the imagery's real subject. In short, vanitas still-life paintings privilege *information*. To be sure, each object represented "officially" meant something beyond its literal self, having "attached" an elaborate set of textual conceits, each properly didactic. But all that textuality was nonetheless external to the image, hence literally invisible. The challenge set before the viewer was to "see behind" or to "see through" what was visible to the eye—gorgeous material goods, commonly luxurious—to the elaborate moral critique first charted by Calvinist intellectuals in Protestant Holland. To achieve this didactic goal was no small feat; unquestionably, the moral challenge was commonly not met.[8]

Perhaps more than any other sort of painting, a vanitas reminds us of our own embodiment, to the extent that it so specifically

53. Statuette of Apollo. Greek, South Italy, ca. 300 BC. Terracotta and pigment, H: 8⅝ in. (21.8 cm). The J. Paul Getty Museum, Villa Collection; Gift of Barbara and Lawrence Fleischman.

connects us, as physical and sensory beings, to the material world represented. There's money, and what money will buy, including an acoustic richness provided by the range of musics referenced by the array of instruments in two separate piles on the ground in Castiglione's picture: at the left, the curled horn refers to hunting, and the folded trumpet to military life; the lute, cittern and violoncello at the right invoke the pleasures of leisure, taste and refinement but also sensuality, especially in a painting that includes dancing, a practice long condemned as an occasion for sensual improprieties. The dancing pose of the foreground central figure is echoed by a nearly naked dancer in the left background; both hold aloft a tambourine, an instrument often given to barely-clad nymphs in mythological subjects (typically bacchanals) produced throughout this period. As if to underscore music's connection to sensual impropriety, Castiglione adds a lutenist and bagpiper in the right background.

The picture provides pleasure—altogether too much pleasure, less in contemplating than in looking—via the myriad beautiful material objects.[9] In this picture, the things of this world are rendered less with suspicion than with an admiration akin to fetish; each is afforded a nearly obsessive degree of the painter's attention. Read against this grain, the vanitas issues a moral challenge by literally enacting a vanity.[10] In the end we're left to admit that the vanitas depends for its rhetorical impact on an irresolvable tension: the vanitas both represents, and itself is, what it condemns.

Music—For Keeps

The stakes attached to listening are well represented in Greek mythology in stories that enjoyed an exceptionally long half-life. For example, Orpheus, whose musical skills directly impacted fauna and flora alike, was a very popular subject in seventeenth-century Low Countries paintings, as were Apollo's musical doings, especially his contests against Pan or Marsyas. Apollo, the god of civilization and intellect, as such the enemy of barbarism, was, like Orpheus, a musician. His instrument (and attribute) was the kithara (fig. 53), otherwise the lyre,[11] which served as the visual label for his claims to the establishment of cosmic order or, to aestheticize the matter, to cosmic harmony, and thus to invoke the world of sound. The Platonic metaphor of cosmic harmony, understood as the inaudible but real music of the heavenly spheres, following in the wake of Pythagorean mathematics, clarifies the stakes of Apollo's musicianship.[12] If the universe holds together *musically*, so to speak, then the musician-deity himself, reasonably enough, has heavy responsibilities as a kind of intermediary between heaven and earth, macrocosm and microcosm. In brief, Apollo was in charge of what we might call a sonoric ecology.

Given his status as one of the twelve Olympian deities, Apollo was understandably earnest about his place atop the musical-aesthetic pyramid. Challenge to his acoustic authority, in essence, was a challenge to the order of things generally, and nothing seems to have irritated him more than challenges from below. Enter poor Marsyas, the musician satyr, who learned the lesson of *hybris* from Apollo the hard way, the result of losing to Apollo in a musical duel.[13] By most accounts, Marsyas's instrument, the aulos (fig. 54),[14] was invented by Pallas Athena (Minerva), who was much taken with it. But when she performed for the other gods, they laughed at how silly she looked with puffed-out cheeks.[15] Thus embarrassed, she tossed the instrument and for good measure laid a curse on it.[16] Marsyas found her discarded aulos and developed impressive skills playing it, such that he bragged he was a better musician than even Apollo. This news got round to the god, who promptly challenged Marsyas to make good on his claim in a kind of battle of the one-man bands, though with higher stakes than we have come to expect from such events. Longer story short, in a best-two-out-of-three contest, Marsyas lost (Apollo in fact cheated). For the choice of punishment, Apollo had Marsyas flayed alive. Two points matter: gods trump satyrs, and stringed instruments trump winds.

Greek art, unlike Roman, on the whole downplayed the violence enacted upon Marsyas, as on a fourth-century BC relief on the base of a statue to Artemis, where the event is reduced to the most minimal facets of the story (fig. 55). Apollo, relaxed, sits with his kithara and listens to Marsyas playing a double aulos. Marsyas strikes a defiant pose; his tensed muscles make emphatic his hubristic arrogance, just as his athletic physique lays visual-metaphorical claim to his status as a worthy challenger to the nearly delicate, even feminine, and fully robed Apollo. The seriousness of the outcome is specified by the man standing between the contestants, hand on hip, weight shifted to one leg, head appropriately inclined towards Marsyas in mid-tune. His right hand holds a prominently visible knife, as he awaits Apollo's orders.

The Apollo-Marsyas story, having reemerged during the *quattrocento*, by the seventeenth century reached full flowering in a considerable body of paintings that paid particular attention to the grisly torture-execution of poor Marsyas, employing the story as an allegory of civilization's triumph, rigorously enforced and heavily impacted by European politics in a heady mix of competing religious orthodoxies and state interests, usually involving Catholic/Protestant disputes commonly resolved in the end by war. Apollo stood for the good; Marsyas not so much. Whereas ancient representations of Marsyas commonly afford him the body of a man, Renaissance and later representations usually assigned him the

54. Statuette of a Satyr Playing the Pipes (aulos). Roman, 150–200 AD. Silver and gold, H: 1⅝ in. (4.2 cm). The J. Paul Getty Museum, Villa Collection; Gift of Barbara and Lawrence Fleischman.

55. Marble base for statue of Artemis by the Praxiteles Workshop. Musical Contest between Apollo and Marsyas. Greece, ca. 350 BC. Athens, National Archaeological Museum.

physical attributes of a hybrid, half man and half goat. In other words, in early-modern imagery, Marsyas was demoted in the natural hierarchy; in short, he was othered. In moral-ethical terms, it is one thing to flay a man, quite another to flay a hybrid; the two are not moral equivalents.

One of the most noteworthy visual aspects of Italian iterations of the Apollo-Marsyas story is the gigantic size of most—though not all—of these paintings. For example, the version painted in 1637 by Jusepe de Ribera, a Spanish painter long active in Naples,[17] is nearly three meters wide, almost absurdly dominating the space around it, something like an outsized billboard, aggressively proclaiming the dialectical relationship of order and chaos and clearly choosing sides (fig. 56). Repeatedly, period representations emphasize Marsyas's extreme agony by giving us plenty to imagine with regard to the method of his killing, and they do so with no particular regard for Marsyas's suffering, as if to proclaim it a just punishment. In Ribera's picture, Apollo has his hand in the bloody cut on the satyr's leg, its stark redness emphasized by the light that seems to emanate from its depths, all the more evident against the dark surrounding background. Common to these paintings, Marsyas's body is dramatically foreshortened; it also lies at an acute angle to the rectangular frame. Marsyas looks out from the picture plane, upside down, and calls out to us as if in the absurd hope that we might rescue him. Satyrs in back at the right look on helplessly.[18]

The aulos was a double-reed instrument. Illustrations on vases or in sculpture indicate both single and double pipes. Phallic-shaped, it was played not only by Marsyas but by satyrs generally, characters noted for their sexual potency that was often emphasized in vase paintings by the myriad numbers of them sporting about

nude and displaying exaggerated erections—indeed, some vase paintings illustrate satyrs ejaculating. Satyrs' (animal) sexuality was part and parcel of their general disposition toward Dionysian excess, precisely the opposite of the *mesure* associated with the super-civilized (if sometimes brutal) Apollo calmly plucking the strings of his lyre.

Not coincidentally, the earthly and indeed cosmic order associated with Apollo found its way onto other musical instruments, incorporated as part of a decorative scheme, sometimes in strikingly weird ways. Indeed, Apollo remains a presence, somewhat muted, long after the Baroque. By the nineteenth century, the embodied deity was mostly replaced by his attribute, the lyre, as well the sign of Orpheus. Pianos commonly incorporated the lyre as a decorative motif, in some instances insistently, even preposterously so, as with a so-named lyre-piano by the Berlin maker Schleip (fig. 57). Perhaps still more striking was the invention around the mid-eighteenth century of the lyre-guitar in direct homage to the aristocratic fashion for all things classical (fig. 58). Originally an instrument popular with women from the French upper classes, by the early nineteenth century the lyre-guitar was sought after by the middle social orders as well, and throughout much of Europe and Russia and even the United States. One English model was marketed in the early years of the nineteenth century as the "Apollo."

In our own time, the lyre outline continues to hold its own, here and there, including on what has emerged over the past half century as an instrument globally enjoying very high prestige, the electric guitar, in this example a remarkably beautiful instrument by Bruce BecVar, now in the collection of the Metropolitan Museum of Art (fig. 60). The instrument's lyre-like form is outlined by two

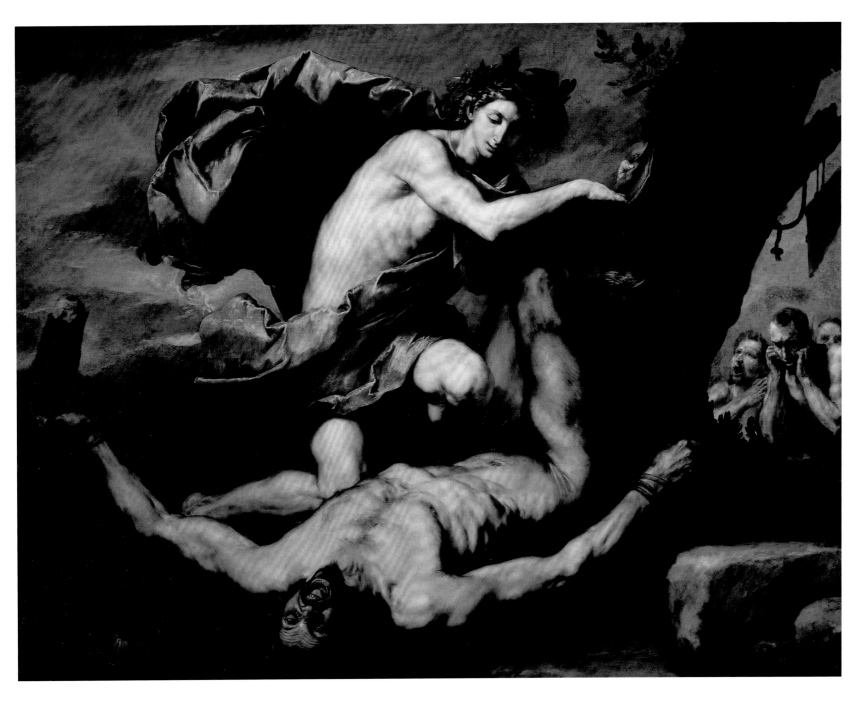

56. Jusepe de Ribera (1591–1652). *Apollo Flaying Marsyas*, 1637.
Oil on canvas, 71⅝ × 91⅜ in. (182 × 232 cm). Naples, Museo Nazionale
di Capodimonte.

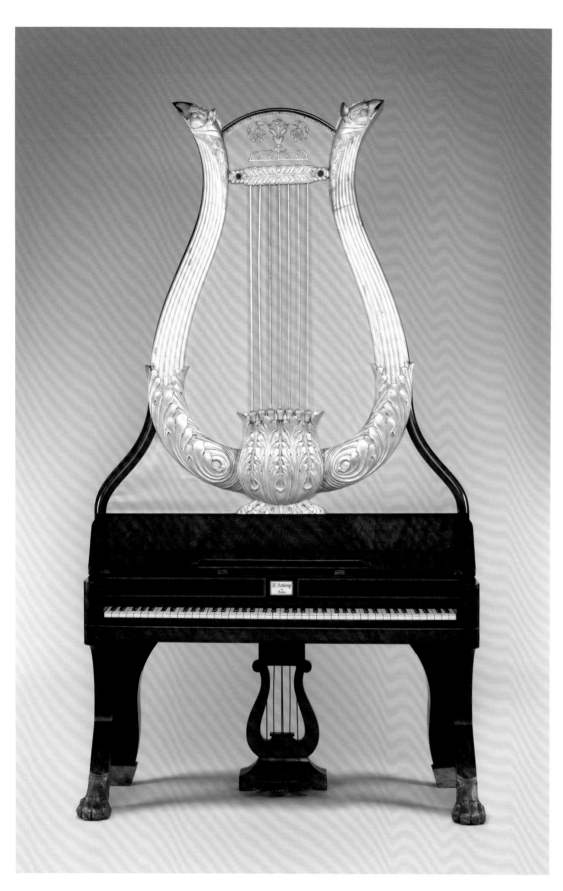

57. Johann Christian Schleip (1786–1848). Lyraflügel, ca. 1820–44. Wood, silk, gilt and ivory, H: 87⅝ in. (222.5 cm). The Metropolitan Museum of Art; Gift of Mr. and Mrs. Theodore R. Sayers, 1968.

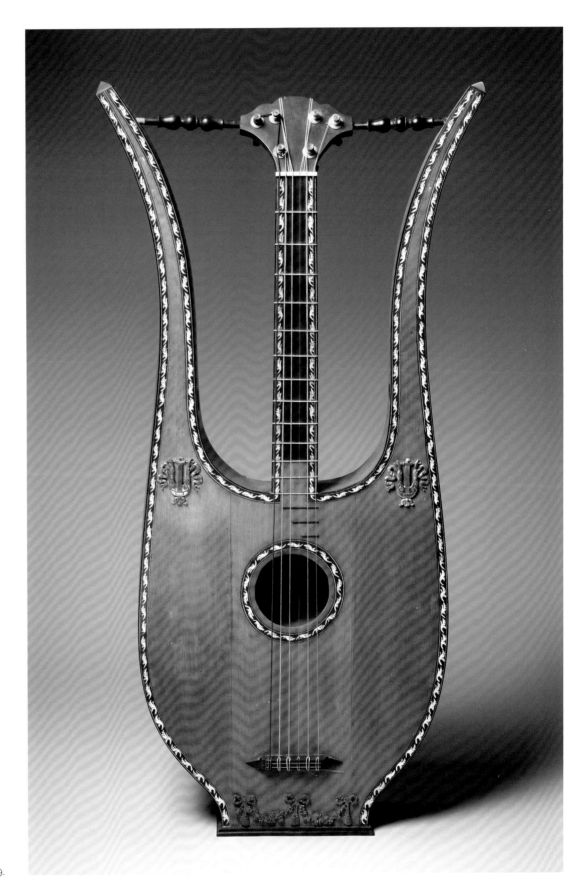

58. Lyre Guitar. France, early 19th century.
Various materials, L: 33½ in. (85.1 cm).
The Metropolitan Museum of Art; The Crosby
Brown Collection of Musical Instruments, 1889.

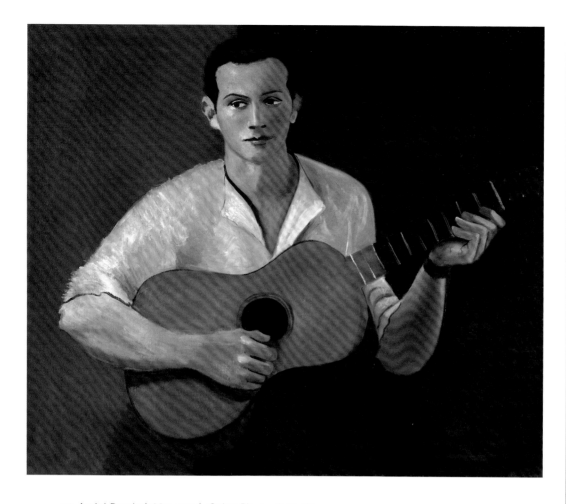

59. André Derain (1880–1954). *Guitar Player*, 1928. Oil on canvas,
32½ × 38⅜ in. (82.6 × 97.6 cm). The Nelson-Atkins Museum of Art;
Gift of Katherine Harvey.

60. Bruce BecVar (b. 1953). Electric Guitar, 1973–74. Wood, other
materials, L: 39⅛ in. (99.4 cm). The Metropolitan Museum of Art;
Gift of Arthur N. BecVar, 1980.

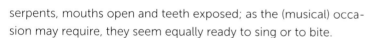

serpents, mouths open and teeth exposed; as the (musical) occasion may require, they seem equally ready to sing or to bite.

To simplify things a little, Greek mythology associated stringed instruments (kithara, lyre) with the intellect or mind (hence reason), and wind instruments (aulos) with the body. The body was appetitive, too easily and often driven by sexual desire in its out-of-control form of lust. The body, in brief, was animalistic. Clearly, this ancient hierarchy has not disappeared, and visual art not only reflects the fact but reinforces its longevity. No accident, the taxonomy was projected around class distinctions. Consider the order and tranquility of the van Kessel/van Balen *Hearing* reflecting and indeed honoring social prestige and privilege, even to the point that stringed instruments are prominently featured, in apt reflection of the civilized orderliness of what we might today refer

to as the 1%. The piles of horns in the foreground are there not to invoke music but hunting, highly policed as the exclusive right of the socially privileged, where they were used for signaling.

Music and Body

By means of comparison, consider the contemporaneous representation of the other end of the social spectrum, Pieter Brueghel's masterful (and quite typical) *Wedding Dance*, a subject he and his son after him painted many times, followed thereafter by numerous other artists (fig. 63). Paintings of peasant weddings were not intended as mementos for the lower social orders; rather, they were at once instructional, allegorical and amusing diversions for the social superiors of those actually represented. In this regard, the paintings are conceits concentrating myriad aspects of social

61. Lyre. Uganda or Kenya, 19th century. Wood, horn, gourd and skin, L: 28⅝ in. (72.7 cm). The Metropolitan Museum of Art; Gift of Miss Alice Getty, 1946.

62. Louis Lot (1807–1896). Transverse Flute in C, 1856. Wood, metal, L: 27⅞ in. (70.9 cm). The Metropolitan Museum of Art; Gift of Catherine C. Perkins in memory of Dr. Osborn P. Perkins, 1983.

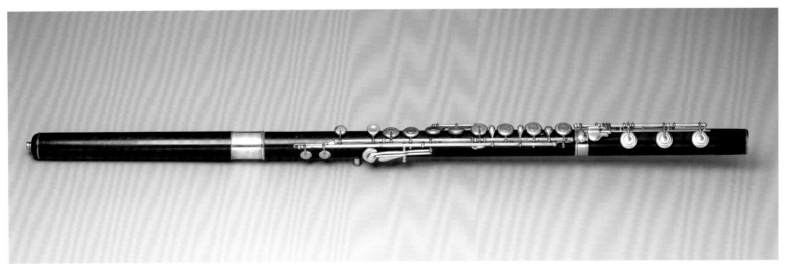

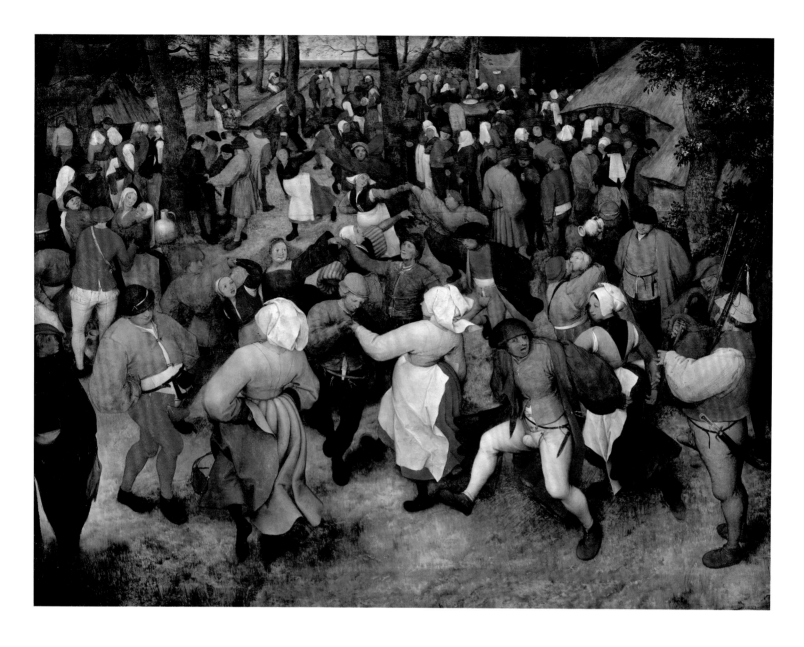

63. Pieter Brueghel the Elder (ca. 1525–1569). *The Wedding Dance*, ca. 1566. Oil on panel, 47 × 62 in. (119.4 × 157.5 cm). Detroit Institute of Arts; City of Detroit purchase.

beliefs as well as behaviors. Brueghel paintings invite a great deal of parsing, well more than I can deliver in the space of this essay; I'll restrict myself to just a couple of points.

This painting, and others produced in the region at the time, celebrates a presumed happy populace of the common folk—and never mind the actuality of the wars and famine that confronted the Low Countries for much of the period in question. Here it's happy time and then some: wild dancing to bagpipe(s) bleating, everyone involved, and with the assistance of general inebriation. But note the peasants' bodies: distinctly inelegant, most are rendered *lumpen*, close to the ground in every respect and perfectly reflecting how they tended to be viewed (earthy at best, dangerously chaotic at worst). Peasant movement, especially group movement, as with a village wedding dance, is invariably represented as frenetic. Gestures are wild; poses are commonly vulgar if not outright lewd. All present, an undifferentiated mass of

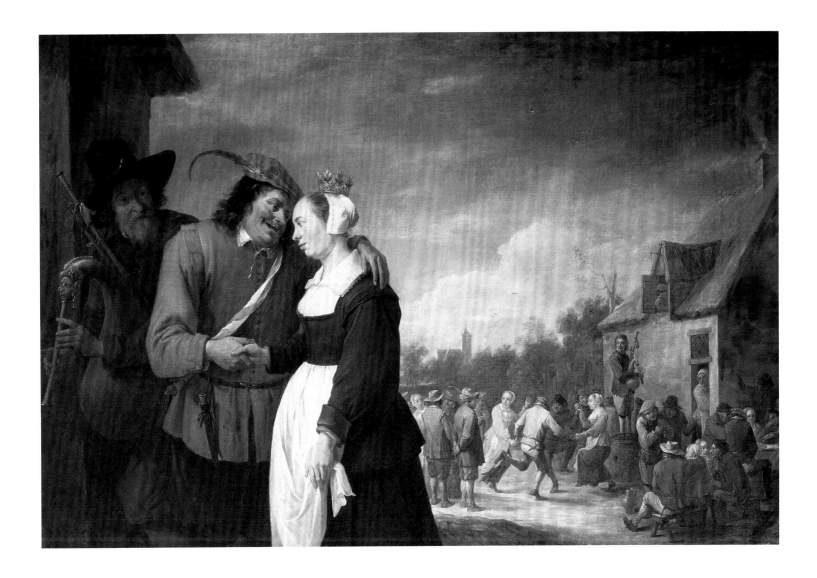

64. David Teniers the Younger (1610–1690). *A Peasant Wedding*, 1648.
Oil on canvas, 30⅛ × 44⅞ (76.5 × 114 cm). Kunsthistorisches Museum,
Vienna.

humanity, are typecast and commonly caricatured—precisely the opposite of portraiture. To spin the issue positively, however, it's also the case that the peasants seem to know how to genuinely enjoy themselves in a carnival atmosphere of letting go—"letting go" in the imagery of the upper orders is an extremely short visual suit.

The popular and prolific Flemish painter David Teniers the Younger repeatedly produced peasant dance and pub scenes (fig. 64). The bagpipe music as represented in these paintings is assertive (the sound of double-reed instruments penetrates), a matter emphasized by the wild dancing that commonly crosses the line separating earthiness from outright vulgarity, about which little is left in doubt. I don't mean that peasant musicians played poorly or that their instruments were incapable of producing pleasing sounds. Indeed, quite the opposite was undoubtedly true, though extremely few instruments of this sort have survived on which to base a judgment. The issue is not circumscribed by the skills of players or instrument makers. It develops instead from the ideological necessity to differentiate the sounds of the social

classes according to principles that delineate the socio-politically superior qualities of the one over those of the other as established by the particular group enjoying power. This is not a matter historically left to chance.

Teniers places a bagpiper together with the newlyweds. In Low Countries culture, the sexual associations attached to the bagpipe were well established on account of the instrument's shape: its chanter pipe and windsack together model the male genitalia, a fact not lost in contemporaneous Flemish proverbs, of which there are thousands: "Met een goed gevulde buik wil het zingen beter lukken" ("it's better to sing with a well-filled belly") alludes to the bagpipe's swelled windsack. The meaning of "sing" is preserved in another proverb: "Voor het zingen de kerk uit" ("Before singing

leave the church"), a sly reference to *coitus interruptus*. Further, the bagpipe is decorated with the head of Pan, whose lechery and fertility go hand in hand. The husband's coarse arousal is captured in his face; general incomprehension marks the bride's visage, shown in profile. Both peasants are good for a laugh, and that's pretty much the only point.

The bagpiper plays while standing directly next to the bride and groom, so that whatever affectionate whispering they might convey to one another could not be heard. But of course that doesn't matter. For in this image marriage is not temperate; it merely follows the guidance of biological rhythm, whereby the peasantry are reified as little more than animals that the upper classes have a noblesse oblige to control and enjoy a right to belittle. And it is the noise of peasants' music that provides their degraded identity and subjectivity. The political difficulty here, of course, is that only one side is empowered to represent these judgments in historical memory by preserving the image of the social order of sound long after the sounds themselves have decayed. The painting is clearly intended to furnish amusement to its viewers, who are not those represented. That said, and as is far too often the case with Teniers, the joke inhabits the cheap side of the practice.

Upgrading the Ordinary

An ideal way to understand the issue I'm describing is to consider another painting, a French portrait from the eighteenth century also involving a bagpipe, one known as the musette. Part and parcel of the Arcadian-pastoral fashion, adopted by the French aristocracy already in the seventeenth century but reaching its apogee during the waning decades of the *ancien régime* in the eighteenth, was the adaptation of behaviors imaginatively associated with the "natural-state" lives of the peasantry—practices best, if most absurdly, illustrated by the model peasant village built for Marie Antoinette in the back reaches of the park at Versailles, known as *Hameau de la Reine*, where the Queen and attendants dressed up in fashionable attire loosely modeled on the costumes of the *menu peuple*, shepherds and shepherdesses, and where Her Majesty, among other activities, milked cows, employing porcelain buckets painted to appear made of wood, the animals being appropriately cleaned up first by servants.

Music played a significant part of this revival, all of it ending abruptly with the French Revolution. Two musical instruments gained popularity with aristocratic amateurs, the hurdy-gurdy, otherwise an instrument associated almost exclusively with blind beggars, and the musette, distinct in nearly every way possible from the peasant bagpipe. Simply stated, neither instrument could be taken up by the French nobility without fundamental

transformation. First and foremost, both instruments were refashioned by use of materials entirely unavailable to ordinary people at the lower end of the social spectrum: ivory, silver, rare woods, expensive cloths, etc. Hurdy-gurdies in particular sported handsome marquetry and fine fittings to set them apart.

The musette required a more thorough transformation than the hurdy-gurdy. The delights of the pastoral court revival in relation to the common bagpipe were delimited by how its bag got filled with wind, namely, by blowing into a wooden tube attached to the windsack. So doing necessarily required a distortion of the face (commonly the player's cheeks are puffed out), to say nothing of the perceived vulgarity of having a wind instrument stuck directly into one's mouth. The musette solved the problem by eliminating the blow tube in favor of a small bellows worked by raising and lowering the arm to which it was attached. The elegant materials from which the instrument was made completed the "improvements": the windsack, for example, was covered by expensive cloths such as silk enriched with delicate embroidery; the chanter and drone pipes were often made from ivory; the bellows straps might be encrusted with jewels. In short, by every visual means possible, these instruments were upgraded in appearance as *objets d'art*.

The success of dramatically improved status is apparent from their inclusion in formal portraits, in this instance representing Gaspard de Gueidan, an advocate general and later president of the *parlement* of Provence (fig. 65). He's dressed up as Celadon, the distinctly courtly version of the rustic lover, enjoying the overstated elegance (precisely the point) of his velvet jerkin and britches, and his mantelet of faille. A man of Gueidan's status can pretty much dress up as he wants; to take up the flamboyant costume of a markedly improved-upon shepherd makes the point (variety: mythic, not French). He's a shepherd duly in command of a flock that moves on two legs. The musette, hence music, indirectly affirms that he holds this power (at once social and political) comfortably, assured.[19]

Be Temperate, Be Faithful

Visual representation, in effect, summarizes musical function by encapsulation. It encapsulates not a disinterested record of events but a coherent and discursive, commonly dialectical vision of the varied relations within the context that sound occurs and hence sound means. Reference to music appears in visual art not because musical sound exists but because music has meaning. As a topos in visual art, music itself is silenced, existing only as a remembrance of things past; all that remains of music in the image is its trace as a socialized activity. Music's effects and meanings, which in performance are produced both aurally and visually, in paintings or other

forms of visual representation must be rendered visually only. The way of seeing hence incorporates the way of hearing: the artist must produce images in such a way that their meanings will be congruent with those produced by sight and sound together in the lived experience of the original and intended viewer, and commonly (if hardly always) reflecting the point of view of whomever has ordered up the image or will otherwise be a likely buyer. To render the acoustic phenomenon of music visually meaningful, the artist engages semiotic codes that operate as a sight when music is actually made. The artist doesn't invent a visual code entirely divorced from life-practice, for the simple reason that there is no point in doing so. If artists failed in their endeavor, if their envisioning confused viewers, it is inconceivable that musical subjects could have been produced in the West for many centuries with such abundance as survives.

Roland Barthes nicely encapsulated the challenge confronting artists when representing anyone or anything located in time:

> In order to tell a story, the painter has only an instant at his disposal, the instant he is going to immobilize on the canvas, and he must thus choose it well, assuring it in advance of the greatest possible yield of meaning and pleasure. Necessarily total, this instant will be artificial, . . . a hieroglyph in which can be read at a single glance . . . the present, the past and the future; that is, the historical meaning of the represented action. This crucial instant, totally concrete and totally abstract, is what Lessing subsequently calls . . . the *pregnant moment*.[20]

A marriage portrait from 1633 by the Dutch artist Jan Miense Molenaer illustrates the richly meaningful potential of capturing a "pregnant moment," one in this instance structured around a singular physical gesture anchored in a musical event offered up as both a utopian and dystopian reading of the future (fig. 66). The painting represents a musical party as the visual device around which to organize an allegorical commentary promoting marital fidelity. The semiotic argument of the painting develops from one small vignette embedded in the figure of the woman sitting in the middle, holding a partbook, singing and marking time with her right hand, a gesture of self-restraint that serves to keep together an ensemble that includes a lutenist and cellist.[21] Her gesture marks musical *mesure* (measure) standing in visually as a referent for order, regulation and moderation. Her hand movement is subtle, so much so as to be difficult for her fellow performers to see. She displays her hand less for them than for us. But precisely because the gesture can explain itself solely as a musical, and not larger social, matter, Molenaer clarifies his intent by representing another arm gesture that is literally spectacular and quite impossible

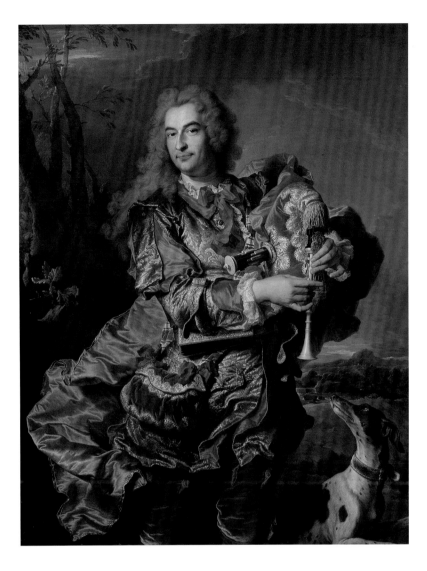

65. Hyacinthe Rigaud (1659–1743). *Portrait of Gaspard de Gueidan*, **1735.** Oil on canvas, 57⅛ × 44⅞ in. (145 × 114 cm). Aix-en-Provence, Musée Granet.

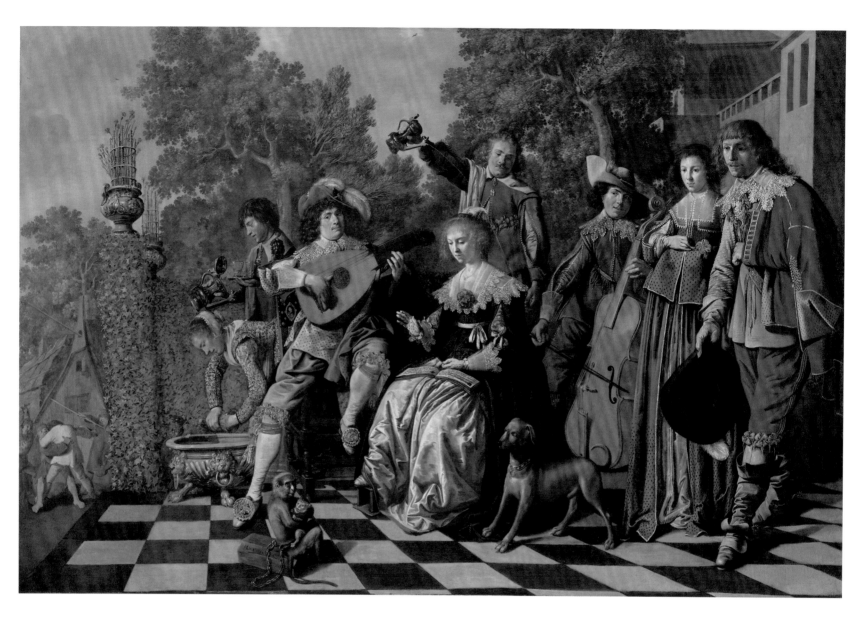

66. Jan Miense Molenaer (1610–1668). *Allegory of Fidelity*, 1633.
Oil on canvas, 39 × 55½ in. (99.1 × 140.6 cm). Virginia Museum of Fine Arts;
Adolph D. and Wilkins C. Williams Collection.

to miss. Its bizarreness marks its importance as a gloss clarifying the function of the image as a whole, and extending this meaning well beyond the obligation to fix for posterity the appearance of the well-heeled newlyweds at the far right—pushing them to the side amply illustrates the primacy of the main scene's function. I'm referring to the preposterous gesture of the man, standing behind the woman keeping time, who waters down wine held in a glass at his side by pouring from a jug held high above his head. Molenaer borrowed this visual detail from a contemporaneous emblem representing the virtue of Temperance.[22] The vignette's semiotic importance is evident not only from the singularity of the man's action, but also by the fact that the water pitcher is compositionally located at the upper center of the picture frame, thus making emphatic its sign value for the painting as a whole. That is, the woman's musical hand gesture, supported by the Temperance emblem, determines the complex allegory of the painting.

Art historian P. J. J. van Thiel suggests that the painting is formally organized around the proposal of a thesis (marital temperance) set against a subsidiary antithesis (intemperance). Antithesis is twice represented: in the background at the extreme left, in small scale, two men are in the act of stabbing each other with knives, referencing anger (*ira*); and in the foreground, lower left, a chained monkey absurdly embraces a cat, a reference to enslavement to the senses and, in particular, to lust (the cat being a common symbol of libidinous temperament). The cat and monkey are offset by the dog (*fides*, fidelity)—not coincidentally male—standing guard by the newlyweds. Van Thiel calls the picture a "mirror of virtue" for the husband and wife alike, what he terms a "key to an harmonious married life,"[23] however odd the whole might seem to modern eyes given its function as a marriage portrait.

But there's more to it. First, moderation or temperance is articulated as a class issue. Moderation is a possibility for, and the obligation of, the upper social orders by contrast with peasants who are prone to violence and who generally behave with anarchical excess. Accordingly, they are threats to themselves and to the social order whose calm they disturb. The painting's sights engender sounds in opposition: namely, the sounds of art music versus the sounds of brutality, of fights punctuated by animal-like grunts and groans and often by cries of pain. The painting invites, perhaps even compels, its viewers to envision and to *hear* the difference between order and chaos, the social and the antisocial.

Second, there's the matter of gender relations. Marriage portraits were characteristically commissioned by the groom and given as a gift to his bride, but in this instance it's a gift with strings attached to the extent of asserting the husband's expectations of his wife in all the permanence of the picture's visibility. In Molenaer's painting, the man wears outdoors garb—hat, cape and boots: he lives in the

larger world. Put differently, he's not always home.[24] The painting, however, unlike the husband, will be permanently at home, prominently displayed in the dwelling as a surveillance, ideally, intended to address the husband's prime anxiety produced by his absences: his wife's sexual fidelity,[25] which in Dutch culture was the cornerstone of domestic and social order.[26] In this regard, then, it is not going too far to suggest that the painting's musical metaphor stands in for the very possibility of Dutch culture itself.

You might notice that your eyes tend to dart about Molenaer's painting, taking in the binaries governing the whole: thesis/antithesis; order/chaos. The painting's compositional organization is complex and notably unstable, almost requiring us to shift our glance here, there and back. What Molenaer quite brilliantly encodes by this means constitutes another lesson that works to overdetermine the argument for *mesure*: namely, that its success is not only the product of will but also the product of watchfulness. The fact that the painting is a marriage portrait, intended to decorate the home, the wife's space, is to suggest that the ideal viewer for the image is the wife herself, who as a viewer must hence watch herself being watched.[27] Set within a context of surveillance is the implicit supporting argument according to which a certain kind of music—art music—frames the art of life.

It should be clear that the pleasure of music is not at issue in Molenaer's painting. Indeed, nothing in the picture seems to produce the slightest joy; all of the participants are uncannily serious for a wedding commemoration. For Molenaer's presumed patron, the husband, the absence of pleasure is useful for driving home an underlying fact of social organization: that the personal, including the personally pleasurable, is political, that politics is inevitably a serious business, and that "entertainment" and politics don't exist in separate spheres. The arts, music notably included, discursively "transliterate" the political process into an aesthetic chronicle, even—perhaps especially—when, as with Romanticism later, the arts are theorized under the guise of the philosophical rejection of the political. In the end, like it or not, music's pleasure (or its pain) is a sonoric account of the world, a form of truth-telling even when it is not telling the truth—that is, however paradoxically, the life that it enjoys as a lie is its truth.

In sum, the apparent simplicity of a hand gesture, on one level intended to keep an ensemble in time, marks the sign of more complex actualities. At a minimum the hand gesture is the constitutive element in a complex visual-sonoric pedagogy of both micro- and macro-social organization, articulated through the human body, in this instance the body as sign, a body that for the benefit of the viewer pays attention to a present and an imagined future through somatic comportment.[28] The viewer is invited to acknowledge the contingency of a moment frozen in time—one

rendered pregnant by an arc of water, stopped like the action captured in a sports photo. Within this split second hangs a future.

Gestures are by no means natural. Body comportment, as Norbert Elias describes in his history of manners, is both learned and inconstant.[29] The gestures and the placement of bodies in Molenaer's painting repeatedly denaturalize themselves in the modes of their strangeness—modes, as it were, of *estrangement*, precisely in the Brechtian sense: peasants fighting perhaps to the death (knives are involved) in a marriage portrait; pets behaving oddly; newlyweds standing off-center; servants tidying up. Brechtian gests, in the apt recent account by Joy Calico, "are stylized behaviors designed to reveal the socially constructed nature of human interaction,"[30] a definition that fits nicely with the impact of the Temperance emblem in Molenaer's painting, whatever the painter's specific intention. What clearly *is* Molenaer's intention is to estrange the painting's first-glance naturalism by rendering it quickly nonsensical in the absence of hermeneutical contemplation. Its meaning—what I'll call its allusion to its *being* meaningful —is a reality that must be thought and taught, in this instance through a world of distinctly competing sounds.

The early-modern sound world represented in these several images is not ours, to be sure, but what's at stake in them is readily familiar. Representing sound—*visualizing* what otherwise disappears without a trace the moment that a performance ends—was and remains a significant means by which we not only make sense of our world but also, and for better or worse, attempt to shape it.

NOTES

1 Roland Barthes, "Listening," in *The Responsibility of Forms: Critical Essays on Music, Art, and Representation*, trans. Richard Howard (New York: Hill and Wang, 1985), 249.

2 In *The Republic*, for example, see books III, IV. See further Eva Brann, with Peter Kalkavage and Eric Salem, *The Music of the Republic: Essays on Socrates' Conversations and Plato's Writings* (Philadelphia: Paul Dry Books, 2004); Edward A. Lippman, *Musical Thought in Ancient Greece* (New York: Columbia University Press, 1964); and Warren D. Anderson, *Music and Musicians in Ancient Greece* (Ithaca: Cornell University Press, 1994).

3 Norbert Schneider, *The Art of the Still Life: Still Life Painting in the Early Modern Period*, trans. Hugh Beyer (Cologne: Benedikt Taschen Verlag, 1990), 65; see further to p. 75.

4 Pierre Skira, *Still Life: A History*, trans. Jean-Marie Clarke (New York: Skira/Rizzoli, 1989), 100; see further his discussion of the sacred associations, 100–1.

5 Concerning the elder Brueghel's Five Senses paintings, see Klaus Ertz, *Jan Brueghel der Ältere (1568–1625): Der Gemälde, mit kritischem Oeuvrekatalog* (Cologne: DuMont Buchverlag, 1979), 328–62; Fritz Baumgart, *Blumen Brueghel (Jan Brueghel d. Ä.): Leben und Werk* (Cologne, DuMont Buchverlag, 1978), 121–31; and Hans Kauffmann, "Die Fünfsinne in der niederländischen Malerei des 17. Jahrhunderts," in *Kunstgeschichtliche Studien: Festschrift für Dagobert Frey*, ed. Hans Tintelnot (Breslau: Gauverlag, 1943), 133–57.

6 Schneider, *Art of the Still Life*, 65.

7 For other relevant Scriptural sources, as well as relevant secular literature and emblems relative to the vanitas topos, see Ingvar Bergström, *Dutch Still-Life Painting in the Seventeenth Century*, trans. Christina Hedström and Gerald Taylor (London: Faber and Faber, 1956), 155–6. For a general introduction to the vanitas theme, see 154–90, whence much of my basic information. Bergström is the best source in English for traditional interpretations of this genre. For an important revisionist view, see Svetlana Alpers, *The Art of Describing: Dutch Art in the Seventeenth Century* (Chicago: University of Chicago Press, 1983), 90–1, 103–9, 114–5.

8 For an excellent account of the tension between the visible and the invisible, the image and the unseen text in vanitas painting, see Norman Bryson, "In Medusa's Gaze," in Bernard Barryte, *In Medusa's Gaze: Still Life Paintings from Upstate New York Museums*, exh. cat. (Rochester: Memorial Art Gallery of the University of Rochester, 1991), 9–14.

9 On the matter of making a moral choice as a function of these images, see Anne Walter Lowenthal, "Response to Peter Hecht," *Simiolus* 16 (1986): 188–90; and by the same author, *Joachim Wtewael and Dutch Mannerism* (Doornspijk: Davaco, 1986), 57–60; and Bryson, "In Medusa's Gaze," 10–2.

10 Bryson, "In Medusa's Gaze," 11.

11 Post antiquity, other stringed instruments were also assigned to Apollo, including lira da braccio, violin and harp.

12 See James Haar, "Music of the Spheres," in *The New Grove Dictionary of Music and Musicians*, ed. Stanley Sadie (London: Macmillan, 2001), vol. 17, 487–8. On the Greek concept of harmony, see Lippman, *Musical Thought in Ancient Greece*, 1–44; and Edith Wyss, *The Myth of Apollo and Marsyas in the Art of the Italian Renaissance: An Inquiry into the Meaning of Images* (Newark, NJ: University of Delaware Press; and London: Associated University Presses, 1996), 27–9.

13 Concerning the seriousness with which hybris was treated in ancient Greek culture, see Maria Rika Maniates, "Marsyas Agonistes," *Current Musicology* 69 (Spring 2000): 139–40.

14 For a detailed account of the history, construction, performance history and different types of aulos, see Annie Bélis, "Aulos," in *The New Grove Dictionary of Music and Musicians*, ed. Stanley Sadie (London: Macmillan, 2001), vol. 2, 178–84.

15 Other narratives simply indicate that, while performing, she looked at her reflection in water and disliked how the playing distorted her face. See Maniates, "Marsyas Agonistes," 134. On the invention of the aulos in classical mythology, see 144–9.

16 Aristotle, *Politics*, Book 8, Part VI, trans. Benjamin Jowett, online at http://classics .mit.edu/Aristotle/politics.html.

17 Naples was under the often repressive and tyrannical control of Spain from the beginning of the sixteenth century through the seventeenth. Ribera's principal patrons were the Church and the nobility, including the viceroys, from whom he received numerous commissions and, during the popular uprising of 1647, physical protection.

18 Another, even larger version (1637) by Ribera of the flaying, compositionally very close to the painting in Naples, is in Brussels, Musées Royaux des Beaux-Arts.

19 For more information on the hurdy-gurdy and musette and the Arcadian revival at the French court, see Richard Leppert, *Arcadia at Versailles* (Amsterdam: Swets & Zeitlinger, 1978).

20 Roland Barthes, "Diderot, Brecht, Eisenstein," in *Image – Music – Text*, trans. Stephen Heath (New York: Hill and Wang, 1977), 73.

21 Molenaer's picture is the subject of an important essay by the art historian P. J. J. van Thiel, "Marriage Symbolism in a Musical Party by Jan Miense Molenaar," *Simiolus* 2, no. 2 (1967–68): 90–9, from which I have here borrowed freely.

22 Emblems, commonly published in large collections, consist of an image accompanied by a verbal gloss. Emblem illustrations, sans text, found their way into the cultural vocabulary of other discursive practices like painting (and, indeed, music). See further John Landwehr, *Emblem and Fable Books Printed in the Low Countries, 1542–1813: A Bibliography* (Utrecht: HES Publishers, 1988); Eddy de Jongh, *Zinne- en minnebeelden in de schilderkunst van de zeventiende eeuw* (Antwerp: Openbare Kunstbezit in Vlaanderen, 1967); and Mario Praz, *Studies in Seventeenth-Century Imagery*, 2nd ed. (Rome: Edizioni de Storia e Letteratura, 1964).

23 Van Thiel, "Marriage Symbolism," 99. For more on the broad range of symbols conventionally employed in Dutch marriage portraiture, see David R. Smith, *Masks of Wedlock: Seventeenth-Century Dutch Marriage Portraiture* (Ann Arbor, MI: UMI Research Press, 1982), 57–89.

24 Thus the famous Dutch emblematist, Jacob Cats: "The husband must be on the street to practice his trade / The wife must stay at home to be in the kitchen." Quoted from Simon Schama, *The Embarrassment of Riches: An Interpretation of Dutch Culture in the Golden Age* (New York: Knopf, 1987), 400.

25 See Simon Schama, "Wives and Wantons: Versions of Womanhood in 17th Century Dutch Art," *Oxford Art Journal* 3, no. 1 (April 1980): 5–13; "Woman, as the incarnation of caprice, vulnerable to the enticements of the world, had to be confined within a system of moral regulation. . . . Women in Dutch art were immediately encumbered with a massive baggage of secondary associations concerning their duties in the home and towards their husband. . . . These took the form of a comprehensive inventory of symbols and visual allusions. . . . Planted conspicuously in the middle of genre paintings, or portraits, they turned ostensibly anecdotal subject matter into visual disquisitions on human frailty" (7). The essay also includes information on misogynist literature, though much fuller treatment of this topic is provided in Schama, *Embarrassment of Riches*, 445–54.

26 Schama, *Embarrassment of Riches*, 384, 386: "The home was of supreme importance in determining the moral fate, both of individuals and of Dutch society as a whole. . . . In other words, the home was the irreducible primary cell on which, ultimately, the whole fabric of the commonwealth was grounded." See also Wayne E. J. Franits, *Paragons of Virtue: Women and Domesticity in Seventeenth-Century Dutch Art* (Cambridge: Cambridge University Press, 1995).

27 Whereas the husband, worldly, appears to look beyond the picture, as if towards where he is heading, out into the world; the woman looks inward, gazing slightly downwards, though I think not at anything specific. As regards the musical ensemble around which the image is constructed, what the viewer sees (i.e., ideally the wife looking from outside the picture in at herself) within the picture she (only) hears. She does not look; she listens. In other words, for the characters inside the painting music accrues meaning as a sonoric phenomenon, whereas from outside the painting, for the viewer, who can see but cannot hear the events represented, music means as a sight. For the one intended and ideal viewer, the wife, the two elements of the semiotic equation—sight and sound—converge.

28 See Thomas J. Csórdas, "Somatic Modes of Attention," *Cultural Anthropology* 8, no. 2 (1993): 135–56.

29 Norbert Elias, *The History of Manners*, vol. 1 of *The Civilizing Process*, trans. Edmund Jephcott (New York: Pantheon, 1982).

30 Joy H. Calico, *Brecht at the Opera* (Berkeley: University of California Press, 2008), 43. Brecht's articulation of gestus first appeared in 1930 with regard to his collaboration with Kurt Weill on *The Rise and Fall of the City of Mahagonny*. See p. 47.

Marika Sardar

Painting the Sounds of Music: A Study of Indian *Ragamala* Images

Myths, portraits, court scenes: these types of Indian paintings are easy to comprehend. They have texts and traditions to which they clearly relate and are expressions of universal human preoccupations. Indian paintings of music, in contrast, do not lend themselves so readily to interpretation. *Ragamala* paintings purport to illustrate the theoretical texts describing the modes, *raga*s, that are the building blocks of Indian classical music, but the relationship is complex and confusing. As a result, modern scholars have focused on questions quite apart from their basic goal: to give visual form to music, and to capture the emotional content of the ragas.

In fact, this leap is quite extraordinary, given that the concept of the raga would not seem to lend itself to pictorial illustration. Each raga is defined by a series of notes and a time measure (*tala*) that provide the fixed points on which its performance is based, but musicians are freed from playing a defined melody or sequence. Instead, they are guided in their performances by the emotional association of each raga—embodied in the name *raga* itself, a Sanskrit word that derives from the linguistic root meaning "to color."[1] This emotional content is expressed not only through the performance of the music itself, but also in an equally old tradition in literature that describes the different ragas as having divine or human form, and that assigns to each certain attributes. Rather than standing as a separate tradition, this body of literature was considered integral to the understanding of Indian music and as much a part of a musician's education as learning to play an instrument. Musicians study the descriptions of the ragas and, so informed, are able to create the atmosphere appropriate to the raga being played.

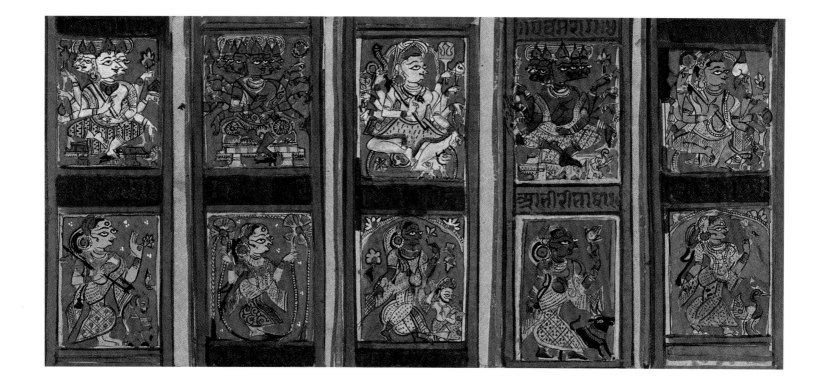

67. Ragamala figures in the *Kalpasutra*. India, Gujarat, ca. 1475. Formerly in the collection of the late Jain Acharya Jaya Simhasurji, Ahmadabad.

The *Natyashashtra* is considered the oldest such treatise, dated to between the second and third century AD. Other, later texts added further elements to this system, giving shape to our current conception of Indian writings on music. The *Raga Sagara* (ca. 7th century) is considered the source of the verses (*dhyana*s) that gave the ragas the form of a god or human, and the *Sangita Makaranda* (ca. 7th–11th century) introduced the notion of the raga, the main mode, as male, with female submodes. A near contemporary text, the *Panchama Sara Samhita*, gave these feminine submodes the name of *ragini*.[2]

Then, in the fifteenth or sixteenth century, there developed a tradition of making paintings that expressed the same content in pictorial form. A manuscript of about 1475, illustrating the Jain religious text the *Kalpasutra*, includes in its margins the figures of six ragas and thirty-six raginis which are the earliest known Ragamala illustrations (fig. 67).[3] At this stage, the iconography is simple. Each appears as a god or goddess, in much the form as he or she does in other representations. Thus the raga known as Bhairav (top row, third from left) is personified as Shiva, and as is standard for images of this deity, he wears an animal-skin loincloth, has matted dreadlocks and is accompanied by the bull Nandi. There is no difference in his appearance here, in the Ragamala context, rather than in a temple or a shrine. The other ragas are similarly represented by deities and are shown with their animal vehicles.

In the mid-sixteenth century, however, ragas and raginis came to be depicted in human form and their iconography deepened: the ragas and raginis became more individualized, and were shown performing specific activities. The paintings themselves developed from iconic images—in which the gods or goddesses are shown on their own, with no backgrounds—into narrative scenes that take place in landscape or architectural settings. These changes are roughly contemporary to a change in the writings on music. The most influential treatise of this period was written by Mesakarna in 1570. In this work, the six modes are assigned the submodes of six wives (raginis) and eight sons (*ragaputra*s). The ragas are given individual personalities and their sounds compared to the voices of animals (birds, insects, reptiles) or the sounds of daily activities (churning butter, grinding spices, washing clothes in a river).[4]

The chronology of the texts and the paintings has, however, been quite difficult to establish, since many of the Ragamala paintings do not closely follow any of the known written works, and it is not always clear which came first. Many have been the attempts to bring order to the paintings and identify the ur-text to which they belong.[5] Other problems arise in trying to determine what the

complete set of Ragamala paintings would comprise: a majority of the surviving paintings seem to come from sets of thirty-six (correlating to six ragas with five raginis each), but individual ragas and raginis hop and skip from one family to the next. And what are we to make of the sets of forty-two?

Leaving aside the question of an image-text relationship that has vexed studies of Ragamalas to date, it is perhaps more fruitful to ask what these artists had as their aim. How does one, in fact, depict the sound of music? Artists from many cultures have attempted to do this, and within the Indian tradition itself are numerous sculptures of gods and goddesses in thrall to a music that the images themselves do not generate, but that is implied by the ecstatic expressions on their subjects' faces (fig. 68). The god Shiva in particular is associated with the playing of music, which accompanies his dance to create, and then destroy, the universe. Wordlessly and soundlessly, Chola-era bronze sculptures of Shiva as the "Lord of Dance" brilliantly convey the celestial melody that drives the god, hair flying and body in motion.

Ragamala paintings do not take such a literal approach. At first glance, they might appear to represent the subjects typical of Indian painting: lovely ladies and youths of the court, the gods and their romantic dalliances. In this respect, they resemble many other court paintings in which the figures listen to music (fig. 69) or in which the activities—festivals, marriages, births—are accompanied by music (fig. 70). But in many of the Ragamala paintings, the figures do not listen to music. Melody and sound are instead

68. A Musical Gathering. India, Rajasthan, Harshagiri, ca. 970. Sandstone, 5¾ × 24¾ × 4⅝ in. (14.6 × 62.9 × 11.8 cm). Los Angeles County Museum of Art; Los Angeles County Fund.

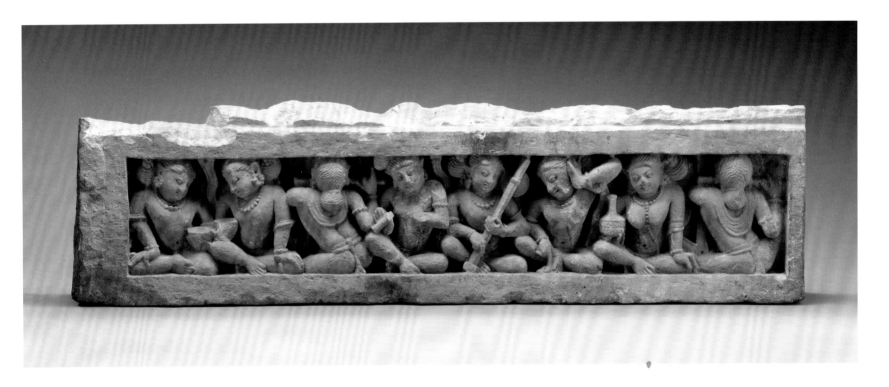

69. Maharana Sangram Singh with His Children and Courtiers. India, Mewar, ca. 1715. Opaque watercolor and gold on paper, 16⅛ × 26¾ in. (40.8 × 68 cm). The San Diego Museum of Art; Edwin Binney 3rd Collection.

expressed through the activities in which they are engaged. The viewer is meant to imagine the mood he or she might be in while participating in those events and the music that would correspond to such feelings.

Take for instance a painting of Madhumadhavi Ragini of Bhairav (fig. 71). Painted at the northern Indian court of Jodhpur in the early seventeenth century, the painting is the size of a piece of letter paper, meant to be held in the hand and viewed, perhaps during an intimate gathering with musicians playing in the background. While listening to the corresponding tune, the viewer contemplates the image of a woman, distressed, who rushes for the cover of a domed pavilion and its invitingly cushioned sofa. She is trying to find cover from the impending rain, implied by the storm clouds at the top of the frame. The change in weather will prevent her from meeting her lover at their appointed meeting place, and the tone of the music is mournful.

The style of the painting comes out of the place and time where the image was made, but its content had become standard by the time it was painted, drawn from earlier paintings of this theme and the accompanying literature about music. Excerpts from such texts are often included at the top of Ragamala paintings, as is the case here. The two lines of Sanskrit in the border of the painted image state: "Wearing on her body a blue bodice . . . in the morning . . . moving away from the foot of the tamala tree, this is Madhu-madhavi, fond of her beloved." Building on these sketches of personalities, the painting further conveys the season and time of day at which its musical melody would ideally be played.

Within a raga, or major mode, all of the submodes are related by the selection of notes to be played; in the paintings of each raga family, therefore, the images of the different members are also connected. Let us look, therefore, at the family of the Bhairava Raga to which Madhumadhavi belongs. The contemplative sound of the Bhairava Raga is associated with summer. Its seven characteristic notes are played at a stately pace, and the raga was given the name of a meditative manifestation of the god Shiva, whose form the head of the family always takes. The raga for Bhairava's first wife is performed at dawn, and this painting of Bhairavi Ragini

70. Ladies of the Imperial Harem celebrating Shab-i Barat. India, Delhi, ca. 1725–50. Opaque watercolor and gold on paper, 6⅛ × 8⅞ in. (15.5 × 22.4 cm). The San Diego Museum of Art; Edwin Binney 3rd Collection.

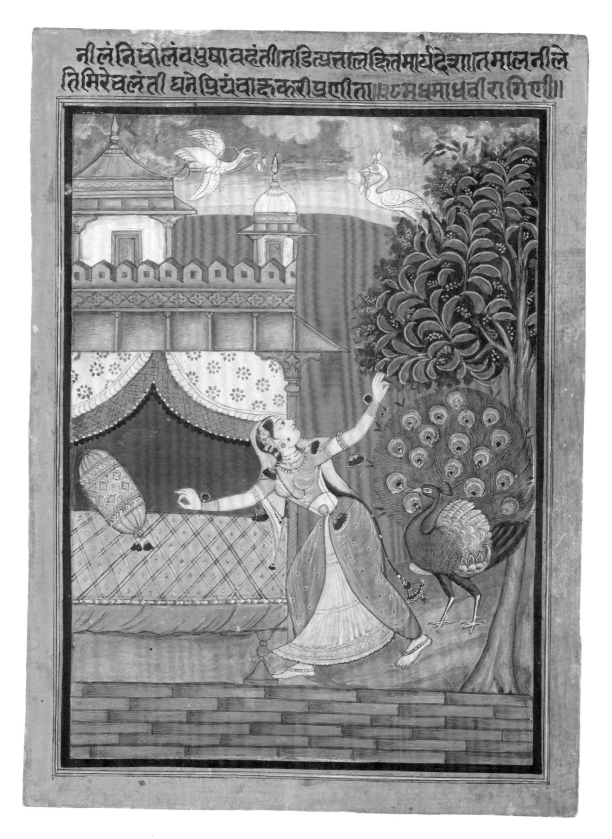

नीलंनिचोलंबपुषावदंतीतडिय्यलक्षितमार्यदेशातमालनीले
तिमिरेचलंती घने प्रियंवाद्भूकरीपलीता ⬚मधमाधवीरागिएशा

71. Madhumadhavi Ragini of Bhairav, a song to be played in
late summer in the late morning. India, Jodhpur, ca. 1610.
Ink and opaque watercolor on paper, 8⅞ × 6⅜ in. (22.4 × 16.2 cm).
The San Diego Museum of Art; Edwin Binney 3rd Collection.

72. Bhairavi Ragini, a song to be played in late summer at dawn. India, Delhi, ca. 1780. Opaque watercolor on paper, 9⅛ × 5⅝ in. (23 × 14.2 cm). The San Diego Museum of Art; Edwin Binney 3rd Collection.

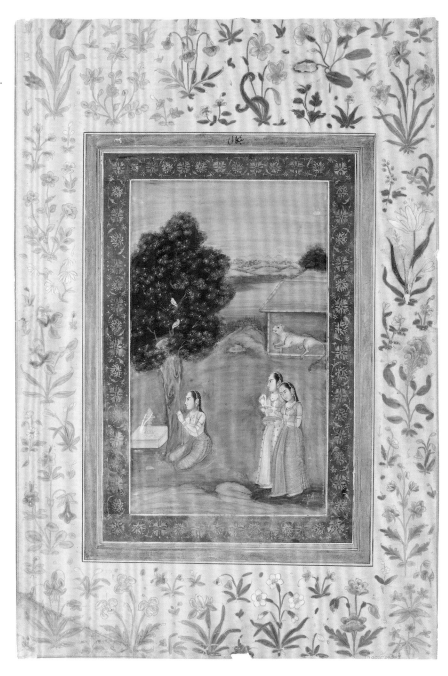

(fig. 72), made in Delhi in the late eighteenth century, is typical of the group. A young maiden worships at an outdoor Shiva shrine, the pink sky in the background indicating the rising sun of early morning. Two servants attend her. The viewer can imagine the smell of incense burning in front of the *lingam* and the garlands of fresh flowers the women bear. One might also imagine the sound of cymbals chiming as part of the recitation of prayers, and thus relate to the tune of this ragini and that moment of stillness before the day starts in earnest.[6]

Lalita, another ragini of Bhairava Raga, is also associated with the morning but is played slightly after dawn. In poetry Lalita is described as "Wearing many ornaments and garments, splendid,

the fair mistress lies exhausted upon her bed at dawn," meaning that she and her lover have just spent a passionate night together in which she has gotten very little sleep.[7] That fatigue is beautifully evoked in the paintings of Lalita, such as this example from seventeenth-century Kotah (fig. 73). A woman sleeps on the verandah of a palace building topped by domes and kiosks. Her lover has slipped on his clogs and is trying to creep soundlessly across the tiled courtyard. Birds swoop to land on a tree just beyond the palace walls, as the sun now comes into view above the horizon.

The second raga family is called Megha, meaning "cloud," and is associated with the monsoon season. The Megha Raga is a calming melody that can be likened to a landscape cooled and subdued

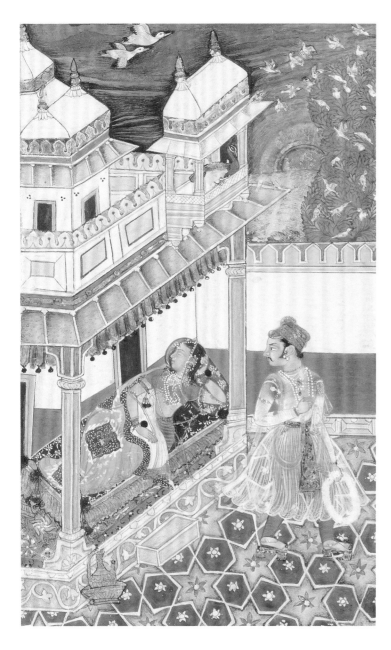

73. Lalit Ragini, a song to be played in late summer in the early morning. India, Kotah, ca. 1660. Opaque watercolor and gold on paper, 11⅞ × 9⅜ in. (30 × 23.9 cm). The San Diego Museum of Art; Edwin Binney 3rd Collection.

by the quenching rain. More staccato passages resemble the beating of raindrops on the ground or roof. The god Krishna represents the raga of this family, as he was born in the rainy season and has blue skin often compared in literature to a monsoon cloud.

Typically, the raginis associated with Megha in painting sets are Gujari, Gormalar, Kakubha, Vibhasa and Bangal.[8] In the extended version of the Ragamala genre produced in the Pahari region, the ragas are also assigned sons, such as Gajadhara Ragaputra (fig. 74).[9] The monsoon aura of the raga pervades this painting with its dark blue sky and rain clouds above the horizon. The theme of the rainy season and its attendant music is further carried out by action in the painting, in which two warriors in athletic attire hone their skills with the bow and spear. One can easily imagine the correlation between the rhythmic sounds of the Megha Raga, the pounding of the rain, and the warriors' stylized movements, likely timed by the beat of a drum.

The third raga family is Malkos, associated with the autumn and the cooling weather ushered in by the monsoon rains of the previous season. Crops of rice have been harvested and offerings have been made to Shiva, so the tone of the music is joyous and thankful. The raga of the family is thus depicted as a contented ruler with his lover, and the atmosphere is happier than in the many raginis in which the lovers are separated and the music anguished (fig. 75).[10]

Within this family is the Khambhavati Ragini (fig. 76), played at night. The dark sky sets the scene as a woman sacrifices to the four-headed god Brahma, burning her offering in a fire according to the ancient Vedic custom. A curious peacock peeks into the walled compound. The music itself is played at a slow or medium tempo, fitting for this last act of private piety, undertaken as night falls. The text above reads, "Clad as brightly as the autumn moon, dazzling as the jasmine, Khambhavati's Vedic devotions and manifold service to Brahma find acceptance by the Four-Headed One."

The fourth family is Sri, associated with the winter and solemn music. Sri himself always appears as a Krishna-like figure, seated with a lady listening to music in the early evening (fig. 77). In contrast to other performance scenes in Ragamala iconography, in which the participants dance or more actively react, a somber mood prevails and the figures listen in stillness; indeed, the figure is described as "perfectly concentrated in mind."[11] While this late seventeenth-century painting is typical in composition, it is unusual in its depiction of the young ruler as Ram Singh I, king of Amber from 1667 until 1688, for whom the painting was made. His skin is tinted blue, likening him to the mythic figure of Krishna, but Ram Singh's features are immediately recognizable from his known portraits. Another distinctive feature is the goat-headed performer at bottom left. He takes the form of a celestial musician who usually attends the gods but here performs for the king.

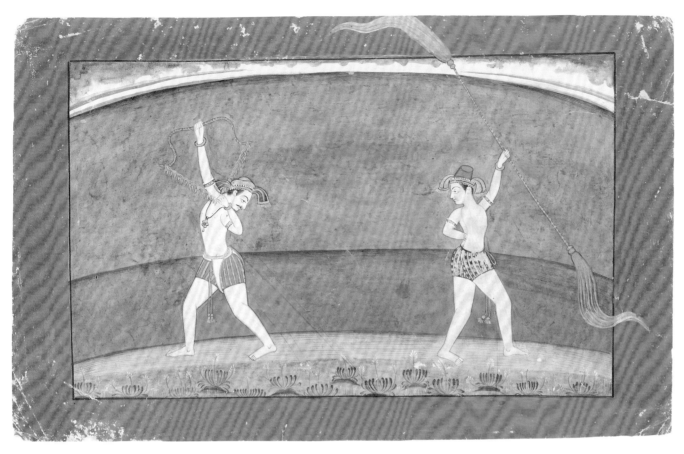

74. Gajadhara Raga, Putra of Megh Raga, a song to be played in the monsoon season. India, Bilaspur, ca. 1735. Opaque watercolor and gold on paper, 7¼ × 11⅝ in. (18.4 × 29.5 cm). The San Diego Museum of Art; Edwin Binney 3rd Collection.

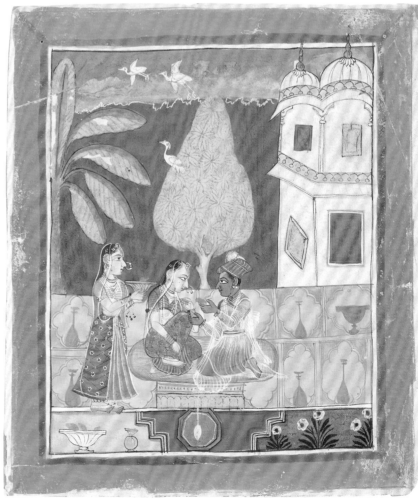

75. Malkos Raga, a song to be played in autumn in the evening. India, Sirohi, ca. 1700. Opaque watercolor on paper, 8⅝ × 7½ in. (21.9 × 19 cm). The San Diego Museum of Art; Edwin Binney 3rd Collection.

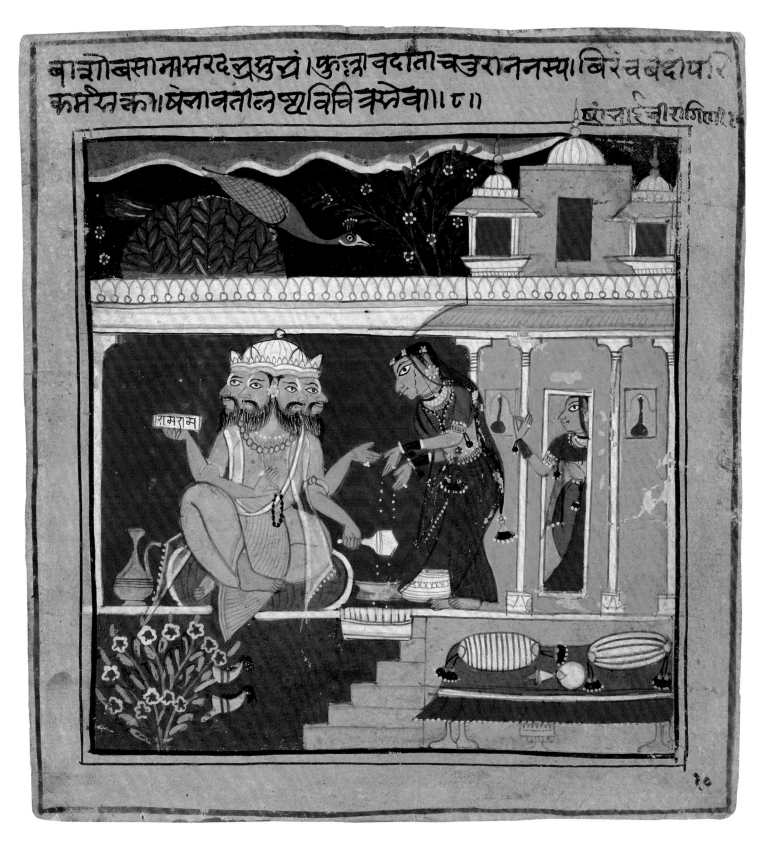

76. Nasir ud-Din. Khambhavati Ragini of Malkos, a song to be played in autumn at night. **India, Mewar, 1605.** Ink and opaque watercolor on paper, 7⅞ × 7¼ in. (19.8 × 18.3 cm). The San Diego Museum of Art; Edwin Binney 3rd Collection.

In contrast to Sri Raga is the up-tempo and light raga of Hindol, meaning "swing" and associated with the spring. The season of the painting here is indicated by the blossoming and blooming plants that fill the picture plane, up to the dark sky of its midnight-to-early-morning performance time (fig. 78). In the painting, Hindol Raga enjoys a ride on a swing with his consort, and the pair is attended by "fair-hipped maidens."[12]

Finally we come to the sixth family, Dipak, of the early summer (fig. 79). In writing, this raga is described as "The lover, youthful, well-adorned, in company with his fair one, [who] looks toward the flame, holding her right breast in an embrace." The raga is meant to be played at night, and the lamps (*dipak*) of the raga's title feature prominently in these scenes. The atmosphere of the music would be related to the quiet stillness of the dark night but also the quickening of pulses as the lovers embrace and prepare for lovemaking.

One ragini of this family takes a male form: Kanhada (fig. 80), played in the hours between midnight and the early morning. As the accompanying verses state:

In the form of Kanhada, Krishna has applied sandalwood
A *rao* (king) is standing in front of him
And a *sakhi* (female companion) in the guise of a man
Both of them have raised one of their arms
With his powers Krishna has taken over their pride
He has killed their ego and won their hearts
Like a lady dies in the period of separation from her lover
They have now been taken over in the beautiful aura (of Krishna)
This is how the raga goes in the best manner.

The one part of the painting's composition that does not match the written text is the elephant at the bottom of the image. Apparently the artist has included an element from a raga with a similar name, *kanada*, inspired by the elephant hunters of the Kannada-speaking region of southern India, who are said in verse to have the courage of Krishna.

Aside from tackling the task of representing sound rather than events or likenesses, Ragamala paintings are further unusual in that the written content is not an integral part of a typical manuscript. More traditionally, manuscripts were bound, with the full text copied onto pages either combining both text and image or with painting and writing on recto and verso. Rather than being incorporated into such books, the Ragamala paintings were instead collected in sets of individual, unbound folios without any intervening text pages. If it does appear, the text is subordinate to the image. Sometimes a few lines may appear at the top of the painting, describing the mode depicted, but in many cases no writing

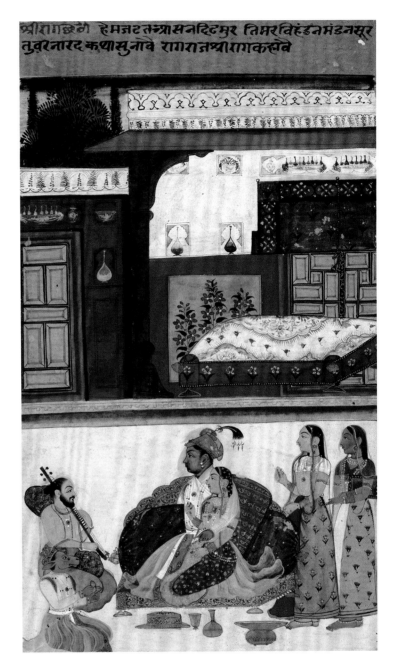

77. Sri Raga, a song to be played in winter in the evening. India, Amber, 1680. Opaque watercolor and gold on paper, 10⅛ × 5⅞ in. (25.8 × 15 cm). The San Diego Museum of Art; Edwin Binney 3rd Collection.

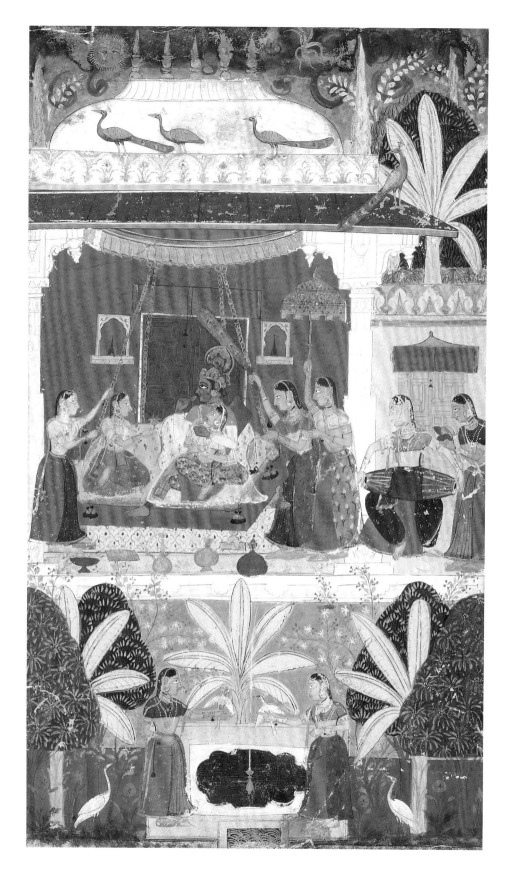

78. Hindol Ragini, a song to be played in spring after midnight. India, Mewar, ca. 1675. Opaque watercolor and gold on paper, 15⅛ × 11⅛ in. (38.4 × 28.3 cm). The San Diego Museum of Art; Edwin Binney 3rd Collection.

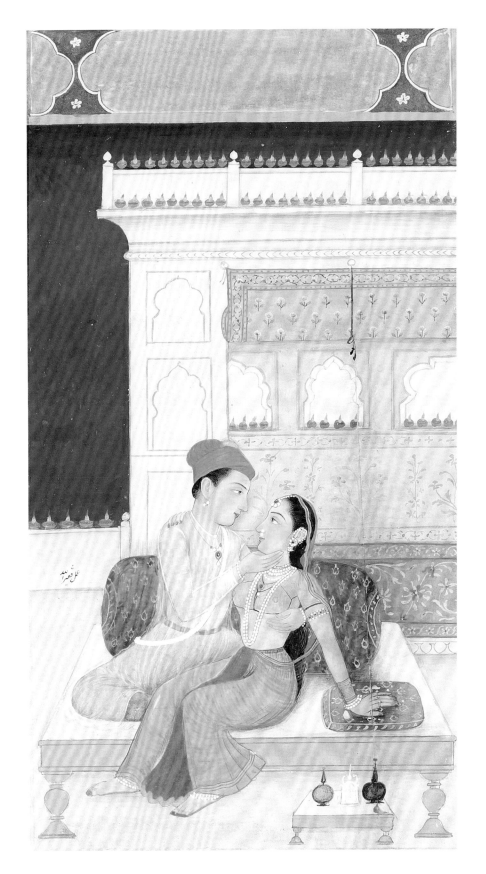

79. Faqirullah. Dipak Raga, a song to be played
in early summer at night. India, Delhi, ca. 1755.
Opaque watercolor and gold on paper, 5⅛ × 2⅛ in.
(13.2 × 7.5 cm). The San Diego Museum of Art;
Edwin Binney 3rd Collection.

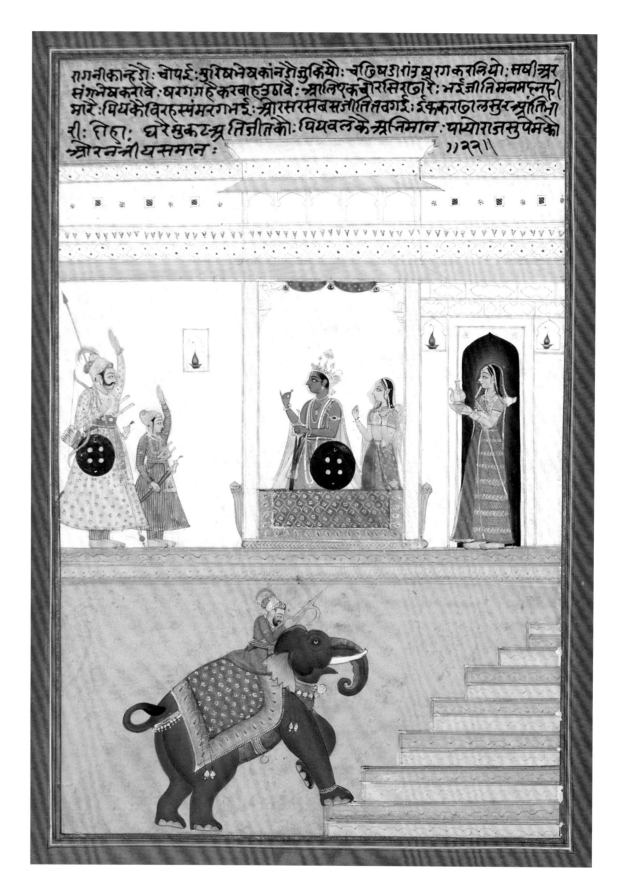

80. Kanhada Ragini of Dipak, a song to be played in
early summer after midnight. India, Jaipur, ca. 1755.
Ink, opaque watercolor and gold on paper, 11⅞ × 8⅞ in.
(30.2 × 22.5 cm). The San Diego Museum of Art;
Edwin Binney 3rd Collection.

81. Arthur Dove (1880–1946). *Fog Horns*, 1929. Oil on canvas, 18 × 26 in. (45.7 × 66 cm). Collection of the Colorado Springs Fine Arts Center; Anonymous Gift.

appears at all, emphasizing the direct correlation between listening to music and viewing the painted image, without the need for intervening words—further distancing this genre from the supremacy of the text that dictates most manuscript projects in the Indian sphere.

Untethered from a textual tradition, the paintings become an abstract representation of sound, the painter's musings on melody —subject matter that also intrigued twentieth-century artists. The circle of artists interested in the concept of synesthesia also attempted to give visual form to an aural experience; for artists like Arthur Dove, the challenge was to evoke the reactions we have to music, on both an emotional and a physical level. Dove listened to music while painting, letting the two experiences infuse each other. He also captured the sounds of daily life as transformed into musical experiences by the conditions in which they were heard. Dove's 1929 painting *Fog Horns* represents the sound of horns played in a shrouded and misty cove (fig. 81). The dark forms are

the center of the horn, from which the sound emanates, while the surrounding wavering bands of color represent the diffusion of the sound through the fog and cold. Much like a Ragamala painting, Dove's work grounds the experience of the sound in a specific time of day, season and type of weather.

Viewing Dove's painting in light of the Indian Ragamala images gives a historical depth to this artistic impulse which, as it happens, was not just an idea of our times. Long has been the desire to capture the experience of listening to an emotionally laden piece of music. In reverse, our notion of what the Ragamala paintings are attempting to do changes in regard to paintings like Dove's. They may appear in the guise of typical Indian narrative paintings but

82. Hindol Ragini (detail). India, Mewar, ca. 1675.

surely must be more like Dove's work in striving to capture something beyond what those figural images did. Since the concept of pure abstraction did not exist in the time and place where the Ragamala paintings were made, artists used the visual forms with which they were familiar, drawing not just on the descriptive texts of the *dhyana*s to depict the maidens and gods therein described, but bringing in literary tropes well known to their viewers that would heighten an emotional response.

Part of this strategy was the change to depicting the ragas and raginis in human rather than divine form (fig. 67). This notion may be related to larger intellectual trends in the sixteenth century, when works such as the *Rasikapriya* were written, placing a new emphasis on human affairs and passions, and making them as worthy a subject for literature as religion and the gods.[13] Works like the *Barahmasa* and *Vasanta Vilasa* further connected human love and emotion to the seasons and weather. The latter text is a celebration of spring, when Kama, the god of love, becomes active. The "twelve months" in the title of the former refers to the length of time a woman is separated from her lover, and the poetic cycle describes her activities and moods through the change of seasons. Between the illustrations of the Ragamala and the Vasanta Vilasa there are in fact twenty-two shared compositions.[14]

Thus a Ragamala artist, perhaps listening to music as he painted, expressed the resulting emotion in ways that would have been immediately understandable to a contemporary viewer of the sixteenth or seventeenth century. Steeped in the literature, myths and beliefs surrounding Krishna, Shiva and their female companions, the viewer of a Ragamala painting would have instantly made the connection with the emotional content of the painting and understood its relationship to the specified musical mode. By moving away from that iconography of religion into a realm of human passion, these artists made the first exploratory steps towards abstraction, led by the sounds of music.

NOTES

1 For more information see, for instance, Bonnie C. Wade, *Music in India: The Classical Traditions* (Englewood Cliffs, NJ: Prentice-Hall, Inc., 1979).

2 See the summary of this literature in Klaus Ebeling, *Ragamala Painting* (Basel, Paris, New Delhi: Ravi Kumar, 1973), 28.

3 S. M. Nawab, *Masterpieces of Kalpasutra Painting* (Ahmadabad, 1956), chapter 1. Ebeling, *Ragamala Painting*, 30, 150–1. Anna L. Dallapiccola, "Ragamala painting, a brief introduction," in Catherine Glynn, Robert Skelton and Anna L. Dallapiccola, *Ragamala Paintings from India from the Claudio Moscatelli Collection* (London: Dulwich Picture Gallery, 2011), 15–7.

4 Ebeling, *Ragamala Painting*, 28 and 64.

5 The foundational texts on this genre are O. C. Gangoly, *Ragas & raginis, a pictorial & iconographic study of Indian musical modes based on original sources* (Bombay: Nalanda Publications, 1948); Ebeling, *Ragamala Painting* (1973); Anna Dahmen-Dallapiccola, *Ragamala-Miniaturen vom 1475 bis 1700* (Wiesbaden: Otto Harrassowitz, 1975); and Ernst and Rose Leonore Waldschmidt, *Miniatures of Musical Inspiration in the Collection of the Berlin Museum of Indian Art: Part I, Ragamala-Pictures from the Western Himalaya Promontory* (Wiesbaden: Otto Harrassowtiz, 1967) and *Part II, Ragamala-Pictures from Northern India and the Deccan* (Wiesbaden: Otto Harrassowtiz, 1975).

6 The one unusual feature of this painting is the tiger in the background—usually that animal is shown with a young woman in depictions of the Bangali ragini.

7 Ebeling, *Ragamala Painting*, 177, 21, 60.

8 The ragas and raginis as ordered in the paintings differ slightly from the known texts. This grouping has been identified in Ebeling, 18, which deviates, for instance, from Dahmen-Dallapiccola, *Ragamala-Miniaturen*, 42.

9 For more information on the Ragamala sets particular to the Pahari region, see Waldschmidt, *Miniatures of Musical Inspiration*, 33–47. For a discussion of Gajadhara Ragamala, see Ebeling, *Ragamala Painting*, 296.

10 Ebeling, *Ragamala Painting*, 146

11 Ibid., 116.

12 Ibid., 138.

13 See the discussion in Anna L. Dallapiccola, "Ragamala painting, a brief introduction," in Glynn, Skelton and Dallapiccola, *Ragamala Paintings from India*, 13–22.

14 Ebeling, *Ragamala Painting*, 32.

Patrick Coleman

Music, Said and Scene: Encounters in Metaphor, Theory and Performance

Music, by its very essence, is not something that can flow inside a rigorous, traditional form. It consists of colors and of rhythmicized time.

—CLAUDE DEBUSSY[1]

Why should not I call my works "symphonies," "arrangements," "harmonies," and "nocturnes"? . . . As music is the poetry of sound, so is painting the poetry of sight, and the subject-matter has nothing to do with harmony of sound or of colour.

—JAMES MCNEILL WHISTLER[2]

There's a social life to exchanges between music and art. This dynamic asserts itself powerfully in the discourses *around* art, as used by artists (visual and musical), theorists, patrons and critics, as much as in the contexts in which artists experienced one another's work: studios, concert venues, galleries, private music rooms and lecture halls. Encounters in metaphor, theory and in live musical performance, each bringing the visual and aural into close contact, cast a light on the network of influences that give rise to different kinds of art–music interrelation, a murky set of relationships that makes tracing the influences between these two disciplines so complicatedly fascinating.

Conditions of Music

James McNeill Whistler, for all of his association with music by way of his Nocturnes and Symphonies, is often one of the first visual artists to come to mind. But he wasn't an especially music-minded man and didn't explore the possibility of deep, formal links between his painting and the audible arts; in fact, the idea of those musical titles came from a critic and a patron, respectively.[3] The analogy between music and painting, which underwent a major florescence in the nineteenth century, was of primary value to Whistler in defending his paintings from the vehement criticism they received. The analogy could only do this because of the cultural currency it already carried. One of these defenses, published in *The World* during his lawsuit for libel against critic John Ruskin, who described *Nocturne in Black and Gold: The Falling Rocket*

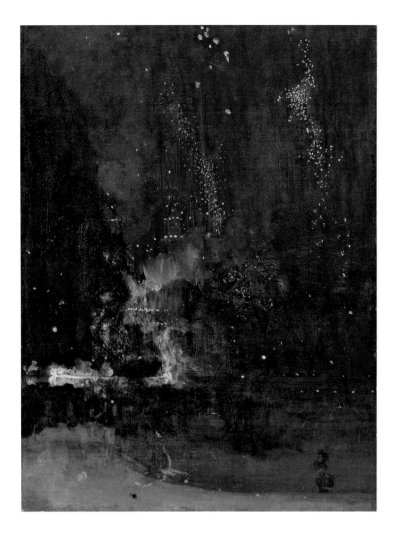

83. James McNeill Whistler (1834–1903). *Nocturne in Black and Gold: The Falling Rocket*, 1875. Oil on panel, 23¾ × 18⅜ in. (60.2 × 46.7 cm). Detroit Institute of Arts; Gift of Dexter M. Ferry, Jr.

as "flinging a pot of paint in the public's face" (fig. 83), supplies the epigraph above. The "musical" in painting was a metaphor to explain his disinterest in subject matter, to orient his detractors and supporters around the idea that color and form and painterly technique were the sole determinants of a good picture—a radical idea at the time. Music was understood as an acceptably nonrepresentational but sensual and emotionally resonant art, with only the formal relationships between notes for materials. That kind of resonance between viewer and a work of art—"resonance" itself an acoustical metaphor—was what Whistler was after.

Whistler's musical metaphor would make another appearance in his "Ten O'Clock Lecture" of 1885, which was translated into French by poet Stéphane Mallarmé (1842–1898) and would have profound effect on the compositional strategies of a young Claude Debussy (1862–1918). Debussy's use of "color"—a visual metaphor for an aural effect—is nearly always first in discussions of his work

(and often contrasted by way of another sensuous metaphor, to their relative "warmth" or "coolness"). It is tempting to hear something of Whistler's loose brushwork and blending of closely related tones in a work for orchestra like *Prélude à l'après-midi d'un faune* (1894), which is based on the poem of the same name by Mallarmé and eschews traditional melodic and structural development for a slow morphing of chromatic scales and a loose, fluid meter. That Mallarmé, Debussy and Whistler socialized at Tuesday evening soirées at Mallarmé's house and the fact that this composition would later be the impetus for one of the Ballets Russes' most lasting performances, visually inspired by Greek vase painting, only underscores the complex relationships at play.

Whistler's first use of this analogy predates Walter Pater's infamous maxim, "All art constantly aspires towards the condition of music,"[4] which supported the aims of later members of the Pre-Raphaelite Brotherhood and those who, like Whistler, associated with the Aesthetic Movement. This was the age of "art for art's sake," and music was the most suggestive muse. Music was an analogy for the independent effect of form and color, and at times it was also a pictorial theme. For Dante Gabriel Rossetti, paintings of female musicians were meant to evoke the creative act and the sensuous, languid rapture art inspires in a viewer. *Veronica Veronese* is emblematic of this approach: while the uncaged canary's beak is opened in song, the woman absent-mindedly fingers the violin strings with an expression of lyric melancholy on her face, her bow arm resting on her sheet music and near the quill (fig. 84). Taken together they are a reminder of the temporality of song and the need for visual means to recollect it and recreate it, to shape it artistically—through the mark making of musical notation or, as here, in oil on canvas. Being both a poet and painter, Rossetti also likely identified with the "poet-singers" of his musical pictures.[5]

Edward Burne-Jones was drawn to this appeal of music as well, visible in such paintings as *Laus Veneris* (1873–75, Laing Art Gallery), which draws on the Tannhäuser myth and Burne-Jones's adoration of Wagner, or *The Love Song* (1868–77, The Metropolitan Museum of Art), which was first sketched along with a *danse macabre* scene upon an upright piano that he received as a wedding gift (fig. 85). Here the bellows of the portable organ are pumped by Cupid, yet the woman playing it recalls none other than the patron saint of music, St. Cecilia (fig. 152).[6] Frederic Leighton (1830–1896) saw a deeper consonance between the two arts but one still rooted in analogy and representation, giving one painting of a languorous female a title borrowed from Mahler, *Lieder ohne Worte* ("Songs without Words," ca. 1861, Tate London). In *The Quartet, or a Painter's Tribute to Music*, Albert Moore freely conflated contemporary chamber practice and a scene of antiquity in order to lend

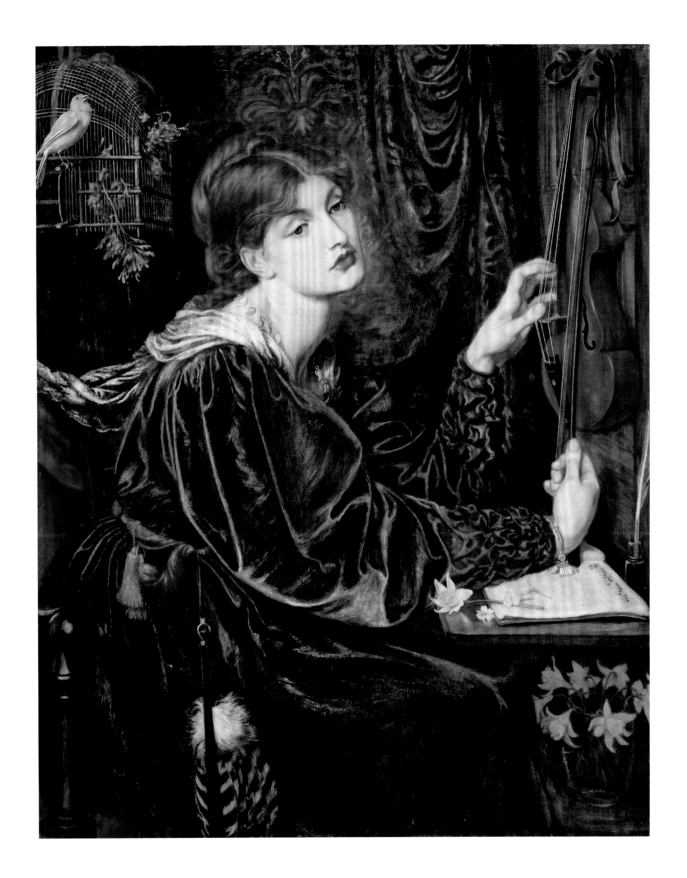

84. Dante Gabriel Rossetti (1828–1882). *Veronica Veronese,* 1872. Oil on canvas, 43¼ × 36¼ in. (110 × 92 cm). Delaware Art Museum; Gift of Samuel and Mary R. Bancroft.

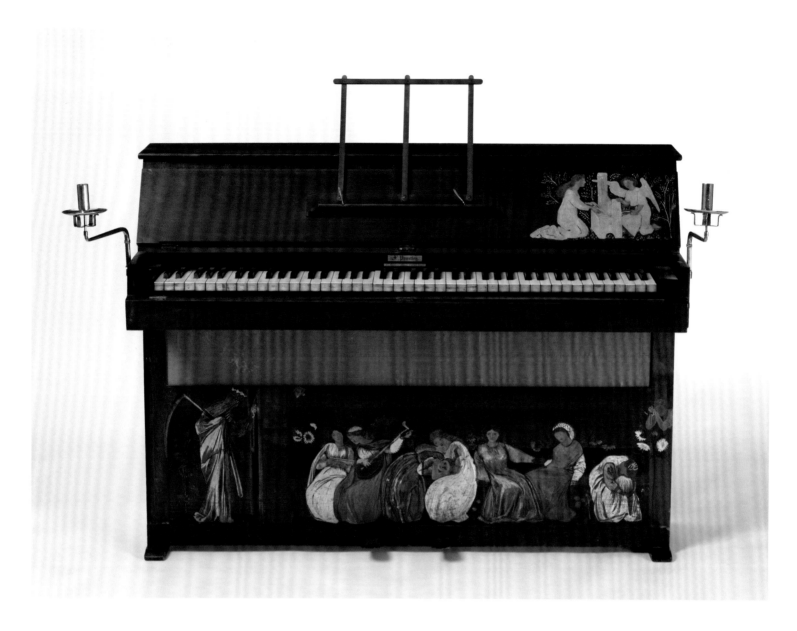

85. Piano made by Frederick Priestly with painted scenes by Edward Burne-Jones (1833–1898), ca. 1860. American oak case, painted with shellac varnish, 50 × 36⅞ × 18½ in. (127 × 93.5 × 47 cm). Victoria and Albert Museum, London; Given by Mrs. J. W. Mackail, daughter of the artist.

sensuous eroticism to the rhythmic patterning of instruments and bows, white linen and marble, and pale yellow flesh (fig. 86).

For these artists, music represented the freedom to revel lavishly in color and mood, though never abandoning representational means for evoking that musical effect. It suggested aesthetic ecstasy, an inward receptiveness to sensuous experience. In this sense, it is a forerunner of the early twentieth-century avant-garde's identification of music with the spiritual and abstract "inner resonance" (*innerer Klang*, in Kandinsky's phrasing) between artist and object, and between object and viewer.[7]

In truth, Whistler and other painters of the Aesthetic Movement were drawing on a relatively recent tradition of using an analogy to music to defend avant-garde tendencies. This was established enough that Eugène Delacroix, who was close friends with Chopin

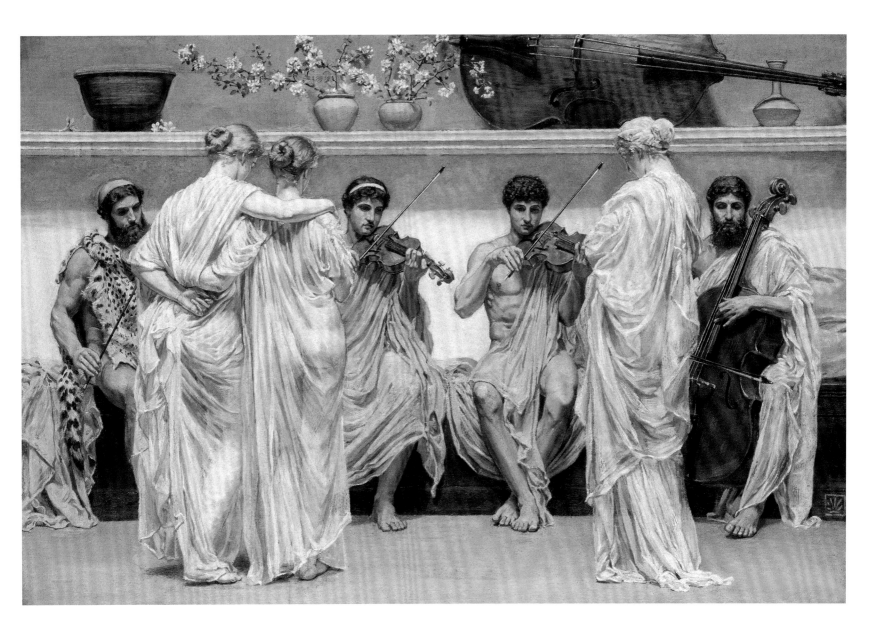

86. Albert Moore (1841–1893). *The Quartet, or a Painter's Tribute to Music,* **1868.** Oil on canvas, 24⅜ × 34⅞ in. (61.8 × 88.7 cm). Pérez Simón Collection, Mexico.

87. John William Godward (1861–1922). *The Muse Erato and Her Lyre*, **1895.** Oil on canvas, 28¾ × 32¾ in. (72.9 × 83.2 cm). Pérez Simón Collection, Mexico.

88. Harmony, from the first illustrated edition of Cesare Ripa's *Iconologia*, 1603.

and painted a stirring portrait of the prototypical musical virtuoso Niccolò Paganini (1831, Phillips Collection), could write that, "There is an impression that results from a particular juxtaposition of colors, lights and shades: what one might call the music of painting."[8] Charles Baudelaire, whose theory of "correspondances" would set the groundwork for a wave of synesthetic art, wrote of Delacroix's work, "[T]hese wonderful chords of color often make one dream of harmonies and melodies, and the impression one derived from his pictures is often, to a large extent, musical."[9] For these artists and many others of the era, the painted equivalent of music is one that prioritizes emotional or expressive effect.

Poussin, Ancient Music and Early Opera

Looking even further back, we can see the kernel of this in the paintings of Nicolas Poussin. The presence of the occasional musician in his work, upon first blush, may appear only to indicate a dependence on the traditional iconography of allegorical painters. Poussin was known to consult Cesare Ripa's *Iconologia* (1593), which advised depicting Scandal, for instance, as an open-mouthed man with a lute at his side and Harmony as a queen playing a bass viol (fig. 88). But Poussin's interests sought a correspondence, more intellectual or theoretical than formal, between several of the arts. He drew heavily on the ideas of Gioseffo Zarlino (1517–1590), the Italian music theorist and composer. It was Zarlino's *Istitutioni harmoniche* (1553), a landmark of musical theory that included an extended treatment of the Greek modes, with which Poussin was most familiar.

Unlike composers or poets, painters had no fully articulated ancient Greek theories to turn to for direction, so most followed Horace's dictum *ut pictura poesis*, or "as is painting, so is poetry." Poussin instead borrowed heavily from Zarlino's explication of ancient musical modes, in which there is some overlap with Horace, as ancient poetry was thought to be sung to musical accompaniment.[10] These singer-poets relied on the modes (Dorian, Phrygian, Aeolian, etc.) composed of distinctive sets of tonal intervals to provide order and structure to their compositions, each with an essential relationship to the emotional effect it was best at conveying. Poussin applied these ideas to painting, considering his pictures a kind of visual poetry or visual music—or, more likely, the ancient hybrid of the two in which imagery, narrative and emotional effect were harmonized.[11]

Each mode, as Poussin described in a letter to a patron, was "the ration or the measure and the form that we employ to do anything, which compels us not to go beyond it."[12] He associates (following Zarlino, somewhat) the Dorian mode with gravity and severity; the Phrygian with joy and pleasure but also the fury and awe appropriate to depict "frightful wars"; the Lydian with sorrow; the

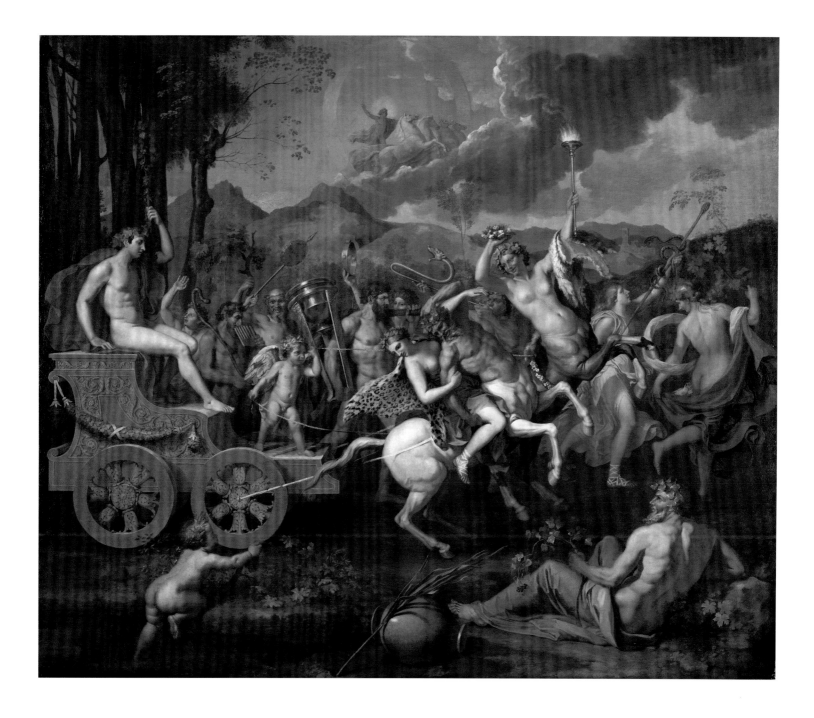

Hypolydian with sweetness, glory and divinity; and the Ionian with the cheerfulness of dance, bacchanalia and feasting. While relating these to actual paintings in Poussin's body of work has been difficult, it is perhaps easy enough to read the Ionian in *The Triumph of Bacchus* (fig. 89) or Eleanor Antin's postmodern re-staging of *The Triumph of Pan* (fig. 25), based on Poussin's painting of the same name at the National Gallery, London. In the former, the procession is whipped into its fervor by music—played on panpipes, serpent trumpet and tambourine, joined by shouts of "Evoe! Evoe!" that the standard emblazoned with the words is meant to evoke— and proceeds like music on a staff, laterally from left to right. The emotional effect is singular: Dionysian joy.

89. Nicolas Poussin (1594–1665). *The Triumph of Bacchus*, 1635–36.
Oil on canvas, 50⅜ × 59¾ in. (128 × 151.8 cm). The Nelson-Atkins Museum of Art; Purchase: William Rockhill Nelson Trust.

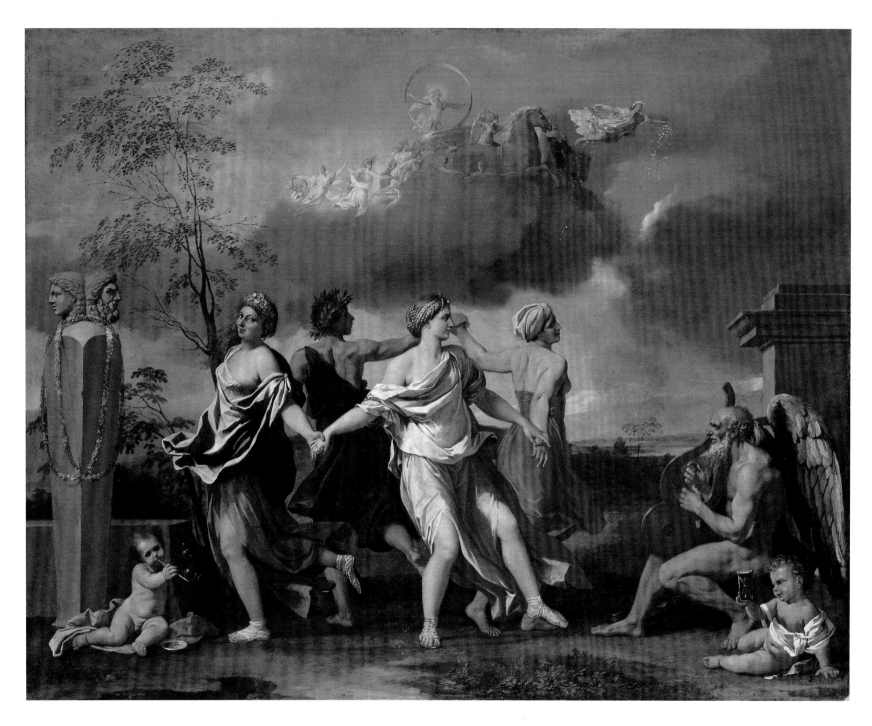

90. Nicolas Poussin (1594–1665). *A Dance to the Music of Time*, ca. **1634–36.** Oil on canvas, 32½ × 40⅞ in. (82.5 × 104 cm). Wallace Collection, London.

91. Engraving of *Il Sant'Alessio*, Act III, Scene 5. From the 1634 published score. Beineke Rare Book and Manuscript Library, Yale University.

Yet by looking at Poussin's *A Dance to the Music of Time* (fig. 90), a more enigmatic picture, we can find a window into how the visual arts, even at that moment, were intensely bound up with the past and with the capabilities and limitations of other artistic disciplines. The allegorical scheme of the picture was suggested by the patron who commissioned it, Giulio Rospigliosi. Later known as Pope Clement IX, Rospigliosi is remembered for his early support for the still-nascent art of opera and his authorship of several libretti, including the seminal *Il Sant'Alessio* (1631) composed by Stefano Landi. The performance of this opera at the Teatro delle Quattro Fontane on February 18, 1632, and Rospigliosi's close relationship with Barberini Pope Urban VIII secured continuing support for the emerging art form (fig. 91). The "invention" of opera represented a turn away from pure visual-musical spectacle to a more inherently dramatic form. Its use of music, stage and performance involved viewers in a cycle of relatable, reversible human fortune.

This is as true of *Sant'Alessio* as it is of operas based on the myth of Orpheus. Of the many composers who selected Orpheus as their protagonist in the first half of the seventeenth century, Claudio Monteverdi had the most impact through his landmark *L'Orfeo*, performed in Mantua in 1607 and published two years later. As Karol Berger has shown, *Orfeo* allegorically represents the argument among music theorists of the age over how to understand the "perfection" of ancient Greek music and the proper relation among its three elements as defined by Plato: *harmonia* (harmony), *rhythmos* (rhythm) and *logos* (word).[13] Some, like Zarlino, privileged harmony and complex counterpoint, mathematical in character and imitative of the divine in sound. This music allowed for harmony of the celestial and the terrestrial, just as the

92. Lorenzo Veneziano (active ca. 1353–1379). *Madonna and Child with Angels, the Crucifixion, and Twelve Apostles or Saints* (center panel, detail), ca. 1360. Tempera on panel, 20¾ × 8⅞ in. (52.7 × 22.5 cm). The San Diego Museum of Art; Gift of Anne R. and Amy Putnam.

performance of angelic musicians acting as the in-time agents of an outside-of-time God in Lorenzo Veneziano's *Madonna and Child with Angels, the Crucifixion, and Saints* marks the eternal and divine character of the event (fig. 92). Others preferred a more homophonic style, including Galileo's father Vincenzo Galilei (who publicly criticized Zarlino) and the Florentine Camerata who would bring about the birth of opera through the development of recitative. This was rooted in an understanding of ancient Greek tragedy as sung drama, what they called "monody." They held that this simpler style of composition, which joined a single singer with harmonically restrained instrumental accompaniment, would better communicate the passionate states of the characters. The complex harmonies of polyphonic music made the text incomprehensible and obscured the emotional and ethical force they believed ancient music had achieved so well.

The struggle between these two music styles, following Berger's argument, is allegorically embodied in the figure of Orpheus, the poet-musician whose failed rescue of Eurydice is an image of the Renaissance composer attempting to recover the antique musical tradition. Jacopo Peri's *Euridice* (1600), the earliest full opera to have survived, was largely homophonic, staying close to the style described by the Camerata. Breaking up the *stile rappresentativo* ("theater style" that was halfway between speech and song), Monteverdi's slightly later *Orfeo* included arias, dances and

choruses, incorporating counterpoint into the operatic reper- toire[14] as if wrestling with the debate in its construction.

In Poussin's *A Dance to the Music of Time*, Time himself holds Orpheus's lyre instead of his usual scythe. There are other sug- gestive consonances as well: In the first act of *Orfeo*, the chorus sings "Qui miri il sole / vostre carole" ("Let the Sun see / your round-dances"), echoing Poussin's quartet of caroling dancers that represent the seasons and the cycle of human fortunes in the garb of poverty, labor, wealth and pleasure. In the second act, before Orpheus knows Eurydice is dead, he sings of the cyclical nature of human happiness: "Dopo il duol viè più contento, / Dopo il mal viè più felice" ("After sorrow one is even more content, / After woe, one is even happier."). The changing fates of operatic protagonists like Orpheus are suggested by the dancers, each fleeing from one figure—wealth from labor, labor from poverty—and chasing after another figure—wealth after pleasure, an overindulgent pleasure back into poverty.

We can see the musical form of the canon in the dancers. A canon is a more strictly formalized version of a fugue, a term that comes from Latin roots for both "to flee" (*fugere*) and "to chase" (*fugare*).[15] The compositional style participates in a tradition of the *harmonia mundi*, the "music of the spheres," that goes back to Pythagoras and is based on an understanding of the universe in which the proportional distances between heavenly bodies were thought to have a musical though inaudible character. Zarlino was a major theorist of canonic counterpoint, writing about the subject along with mode in *Istitutioni harmoniche*, and Poussin's danc- ers are equally suggestive of the form: voices flee and chase one another in evocation of the divine, just as the dancers do in cele- bration of the cycles of human fate, which is repeated in the higher register by Apollo, in his sky-bound chariot, chasing after Aurora, goddess of the dawn.

In Time's hands, Orpheus's seven-stringed lyre is an echo of the heavenly lyre of divine harmony (fig. 95). Each string corresponds to one of the seven classical planets but also recalls the seven days of the Abrahamic creation.[16] Yet this music, as all music, must begin, must proceed in time, and must end. As much as it can be a figure for the divine and unchanging, music is equally and unavoid- ably an emblem for the natural process of death and decay. In the Dutch vanitas tradition, musical instruments were symbols of death, *memento mori*, for this reason as much as they represented vain and decadent pursuits. Music, dance and mortality have been associated since medieval times, especially in the allegorical genre the Dance of Death in which people of all walks of life are tunefully marched out of this life and into the next (fig. 93). The theme has often been taken up in music. Franz Liszt's *Totentanz*, S.126 (1849), Camille Saint-Saëns's *Danse macabre*, Op. 40 (1874), and Franz

93. Wenceslaus Hollar (1607–1677), after Hans Holbein the Younger (1497/98–1543). *Paradise Lost*, from the *Dance of Death*. Etching.
The Metropolitan Museum of Art; The Elisha Whittelsey Collection, The Elissa Whittelsey Fund, 1951.

Schubert's String Quartet No. 14, D.810 (1824, more well known as "Death and the Maiden") are three of the more recognizable exam- ples. The theme haunted Arnold Böcklin in the guise of a skeletal violin player in his self-portrait of 1872 (fig. 94). According to Alma Mahler, wife of composer Gustav Mahler, this painting inspired the second movement of his Symphony No. 4 in G major. Here the violin solo is played upon a *scordatura* ("mistuned") violin, lending it a "screeching and rough" tone, in Mahler's words, "as if Death would strike up [the music]."[17] The contrast between the orderli- ness of Poussin's *Dance* and the discordantly death-haunted yet alluring scene in Giovanni Benedetto Castiglione's *Allegory of Van- ity* (fig. 50) couldn't be greater, yet the dancing maenad, the lustful

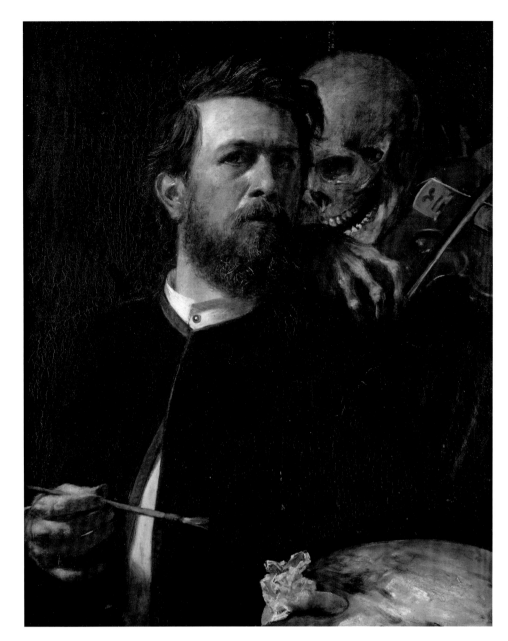

94. Arnold Böcklin (1827–1901). *Self-Portrait with Death Playing the Fiddle*, 1872. Oil on canvas, 29½ × 24 in. (75 × 61 cm). Alte Nationalgalerie, Berlin.

musicians who accompany her, and the bacchic revelry before a herm of Priapus (god of fertility) in the upper left suggest we look again.

In this light, the figure of Time playing Orpheus's lyre in Poussin's *Dance* is a reminder of Orpheus's death: forever separated from his beloved Eurydice and then torn apart by maenads. The putto below Time gazes into an hourglass and one at bottom left blows bubbles, another traditional symbol of life's ephemerality— human existence a breath of air blown into material form and all too easily burst. The comic-operatic version of the Orpheus myth with which Rospigliosi would perhaps have been most familiar was Landi's *La morte d'Orfeo*, performed in Rome in 1619; the two worked together on *Sant'Alessio* little over a decade later. This version begins *after* Orpheus's failed quest, depicts his death and

then follows him to a second failure in the afterlife, where Eurydice has drunk from the Lethe and no longer remembers him. A rousing celebration of the power of music and love over Hades this was not.

Commentators have often noted the staged and rhetorical qualities of Poussin's paintings, especially after 1630. But the complex orchestration of patterns, repetitions and figures in *Dance* isn't monodic. The recitative of Poussin's distinctive allegorical figures overlaps and is in tension with its context of celestial polyphony. A preparatory drawing for *Dance* (ca. 1640, National Gallery of Scotland) has Apollo and his divine escorts assuming much of the upper register of the composition. In the final version, the mythological charioteer had receded in space. The change to a wider sense of depth and staging of the figurative elements calls to mind the stage

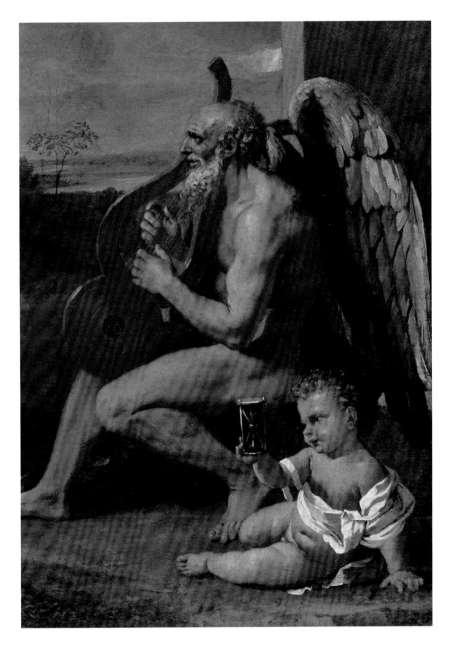

95. Nicolas Poussin (1594–1665). *A Dance to the Music of Time* (detail), ca. 1634–36.

of the 3,000-seat Teatro delle Quattro Fontane, designed by Gian Lorenzo Bernini, which allowed for mechanical scene changes, flying gods and illusions of deep spatial recession.[18] It also reduces Apollo to a context or pretext for the song-and-dance interplay of human fortune: a distinctly operatic turn.

Poussin's friendship with Rospigliosi and his immersion in the debates around antique music and poetry, opera and painting can be seen in *Dance* as much as his reading of Zarlino on mode and counterpoint. This situates his painting within a voluble context of cross-disciplinary artistic debate. Much as Monteverdi heralded a new expressive power for music in opera, above or beyond the meaning of the text, Poussin's painting includes the rhetorical gesture of allegory but extends beyond it to assert the independent emotional power of painting.

Composing in the Gallery, Painting in the Theater

While we can't say that Poussin attended one of the early operas in Rome, musical performance—participating in it, seeing it—was a significant site for the arts to influence one another directly by way of their technical expressions: paint or graphite, viola string or vocal chord. Musicians throughout history have had visual artifacts for their inspiration, often readily at hand. Franz Liszt comes to mind, racing through the galleries in Bologna to see Raphael's *St. Cecilia* and composing his symphonic poem *Hunnenschlacht*, S.105 (1857), after Wilhelm von Kaulbach's painting of the same name. Visual artists, in the world before recording technology, had only live performance or the memory of it. (This could be mitigated by a talent for playing or a talent for becoming friendly with those who did.) Representations of musical events in visual art are a vital historical record of performances that may otherwise be hard to reconstruct, as skeptical as we must be of them as pure reportage. While most artists learned from the study of their chosen medium, musical performance as a subject often served as a foil for self-definition, as consideration of arts other than one's own often is. Being a painter in the audience of home concerts, chamber performances, symphonies and especially opera was a ripe source for the artist, as Henry James put it, "on whom nothing is lost."

For William Hogarth, it occasioned what is one of the earliest depictions of a known stage performance and one of the then-engraver's first works in oils, a moment from *The Beggar's Opera* (fig. 96). John Gay's revolutionary opera, first performed in January 1728, subbed out the exquisite finery of Italian *opera seria* for a decidedly English scene, with popular English tunes in place of stately arias and commoners and lowlifes in lieu of gods and their attendants. It was an unqualified sensation upon its premiere and savagely satiric; the Latin on the ribbons in Hogarth's painting

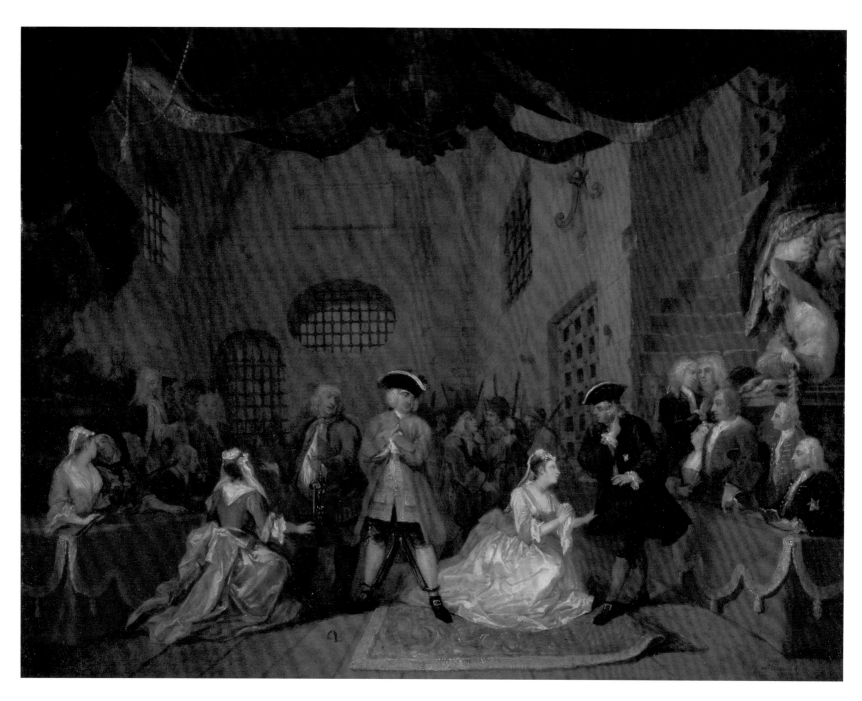

96. William Hogarth (1697–1764). *The Beggar's Opera*, 1729.
Oil on canvas, 23¼ × 30 in. (59.1 × 76.2 cm). Yale Center for British Art;
Paul Mellon Collection.

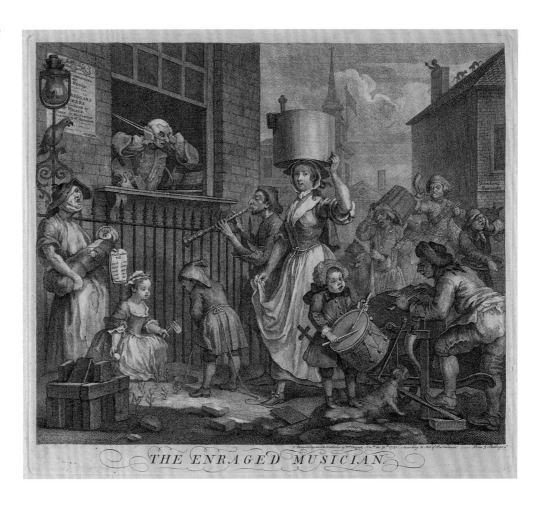

97. William Hogarth (1697–1764). *The Enraged Musician*, n.d. Engraving, 20½ × 22 in. (52.1 × 55.9 cm). Yale Center for British Art; Transfer from the Yale School of Music.

reads *veluti in speculum* ("as in a mirror") and *Omne tulit punctum qui miscuit utile dulci* ("He who joins instruction with delight carries all the votes"). That Hogarth would distinguish himself most through his witty and layered social critiques, as in *The Enraged Musician* (fig. 97), hints at the impact attending this performance had on the artist, though by this time he had already published his *Masquerades and Opera*, which mocked both music-rich events as morally suspect. His painted scene from *The Beggar's Opera* shows the hero, highwayman Macheath, between his two lovers, who each think him her husband. Highborn audience members in the surrounding boxes look on. At one of these performances, the Duke of Bolton, seated at the far right and wearing a blue coat, fell in love with actress Lavinia Fenton, who played Polly Peachum (in white). She would become his mistress and, after his wife died, the Duchess of Bolton. A lecherous, sculpted satyr holds back the curtain just overhead. This bit of decor, looming above the Duke's desiring gaze directed at Polly, is Hogarth's addition of another layer of satire to the spectacle.

Another significant example of the influence between visual artists and music at the nexus of the stage involves the confluence of several composers, performers, designers and visual artists, once again revolving around the mythic figure of Orpheus. After the Baroque interpretations of the theme by Peri, Landi and Monteverdi, it was memorably taken up by Christoph Willibald Gluck (1714–1787) in the opera *Orfeo ed Euridice* (1762), a version which, in its conclusion, kindly restores Eurydice to long-suffering Orpheus in honor of his constancy and faith. Through this Gluck also sought to restore a "noble simplicity" to the music of opera, something that had been lost in many of the bloated works of *opera seria*. The part of Orpheus, originally written for a castrato (speaking of suffering), was revised for the French version; castrati were not commonly used in France. When the opera was revived by Hector Berlioz in 1859 as *Orphée et Eurydice*, it featured female contralto Pauline Viardot in the titular role (fig. 98).

This was the first full production of the opera in Paris in over thirty years. More so than exclusively musical composition, the full experience of an opera must include its visual aspect; even the *Revue et Gazette musicale de Paris* would sound this note about the *Orphée* revival, noting, "We have been able to hear extracts of Gluck in certain concerts, particularly in those of the Société des

 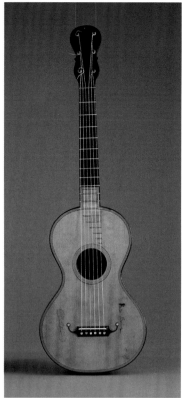

LEFT 98. Pauline Viardot as Orpheus. Bibliothèque nationale de France, Music Department.

CENTER 99. Nicolas Grobert (1794–1866). Guitar, given by Paganini to Hector Berlioz, signed by both, ca. 1830. Various materials. Collection Musée de la musique.

RIGHT 100. Yvon Adolphe (1817–1893). Tribute to Paganini and Berlioz at the Concert of December 16, 1838, ca. 1860. Oil on canvas. Collection Musée de la musique.

Concerts du Conservatoire, but we could no longer see a piece of Gluck performed; and yet, as everyone knows, the genius of Gluck was essentially dramatic, and his music produces its full effect only on the stage."[19] This included the stage designs but also the visual aspect of the performers. Viardot's physical presence was repeatedly likened to visual art; the critic Saint-Victor compared her to "the beauty of a statue that has been moved with emotion, of a sculpture that started to come to life and palpitate."[20] Viardot's husband, Louis Viardot, was a theater director and author of the essay "Ut pictura musica" (1859), a history of the relationship between painting and music.[21] Berlioz himself said of Orpheus that "his poses before Eurydice's tomb recall those of certain figures in Poussin's landscapes, or rather, certain bas-reliefs that Poussin took as models." This all conspired to make the production at the Théâtre-Lyrique an enormous success.

Corot, Orpheus and the Musical Landscape

It was this production that so enamored the painter Jean-Baptiste-Camille Corot. His love of Gluck's Orphée was not a singularly profound experience with music. His bedroom walls were decorated with prints of his favorite composers: Mozart, Gluck, Paer and Beethoven. He left money in his will for the purpose of having the music of Beethoven and Gluck performed at his funeral.[22] All of the commentators stress how regular an operagoer he was. But in this instance, Corot was so moved by his experience of Orphée et Eurydice and the highly praised sets of Charles-Antoine Cambon and Joseph Thierry (fig. 101) that he created a kind of landscape painting haunted, figuratively and in some sense literally, by the spirit of Orpheus.

That music and the pastoral should be linked is, of course, no surprise. In a vastly different context, Tuvan throat singers merge music and nature to such a degree that songs are performed next to—and accompanied by—particular rivers. Modern performers of this type of music, when abroad, often play recordings of the sounds of their home river as part of their concerts. In the Western tradition, the theme goes as far back as the pastoral of Hesiod's Works and Days and Virgil's Eclogues and into contemporary art, as in Alma Thomas's abstractions (fig. 247) and Su-Mei Tse's video installation L'Echo (2003) in which she accompanies herself on cello by way of her echo, returning from across a valley. One of Corot's immediate predecessors, the equally avid theater- and operagoer Jean-Antoine Watteau, who like Canaletto was

101. Charles Cambon (1802–1875). Sketch of stage design for *Orphée et Eurydice*, Act III, Scene 2. Bibliothèque nationale de France, Music Department.

probably a former scene painter, extended this link between music and the *paysage* in the *fête champêtre* painting tradition.

But while the pastoral was most often invoked for its rural agrarian ideals of man in humble harmony with nature, Corot—as if following the lead of Beethoven and his "Pastoral" symphony, Symphony No. 6 in F major, Op. 68—sensitively expressed in the blending of a narrow range of tonalities a unified emotional expression through the landscape itself. The result is more redolent of an inward and sensuous experience of the scene than the Platonic, anti-urban ideal. That he titled so many of his paintings *Souvenirs* underscores their inward conception in recollection and recomposition, not merely in illustration of the natural scene before him.

Corot's critics, too, were quick to praise or attack by way of a musical analogy: Théophile Thoré said at the 1847 salon that "the slightly mystical painting of M. Corot acts on the viewer rather as music affects the amateur music lover—indirectly and inexplicably."[23] Charles Lenormand acknowledged deficiencies en route to praising the overall genius by saying, "With a man like Corot, one overlooks the weakness of the figures, as one excuses the brevity of the melodies in Beethoven's *Fidelio*."[24] For Corot, whose entire career unfolded during and to some measure in response to the aesthetic supremacy and commercial success of Beethoven among artists of all disciplines, the landscape became the genre most receptive to composing with the intent of a similarly powerful, musical effect.[25]

One can register this even in Corot's comment on "an infinitely charming scene" from Berlioz's revival of *Orphée*: "[I]t's when [Orpheus] finds Eurydice again in the Elysian fields: you are truly transported to a heavenly world . . . it's the infinite and purest canopy, with intoxicating fragrances never before known," stressing the more rarely included sense of smell in the synesthetic delights the performance offered.[26] It cannot be a coincidence that Orpheus's entrance into the Elysian fields is occasioned by an idyllic, pastoral ballet (with a solo for flute in C minor and D minor that Berlioz described as "the most effective use of this pale coloring"[27]), followed by an aria in which the dominant melody is nature's, as voiced by an oboe, while Orpheus is left to interject his reaction to the overwhelmingly peaceful beauty of the scene:

What a new sky graces this land!
A sweeter day appears before my eyes.
Such harmonious sounds!
I hear the rustling of leaves,
The songs of birds,
The murmuring brook,
And the sighing of the winds.[28]

In a portrait of the artist (Orpheus) in humble delight with nature—despite, don't forget, his torturous and as-yet-incomplete journey to reach his lost love, Eurydice—it's tempting to speculate on how

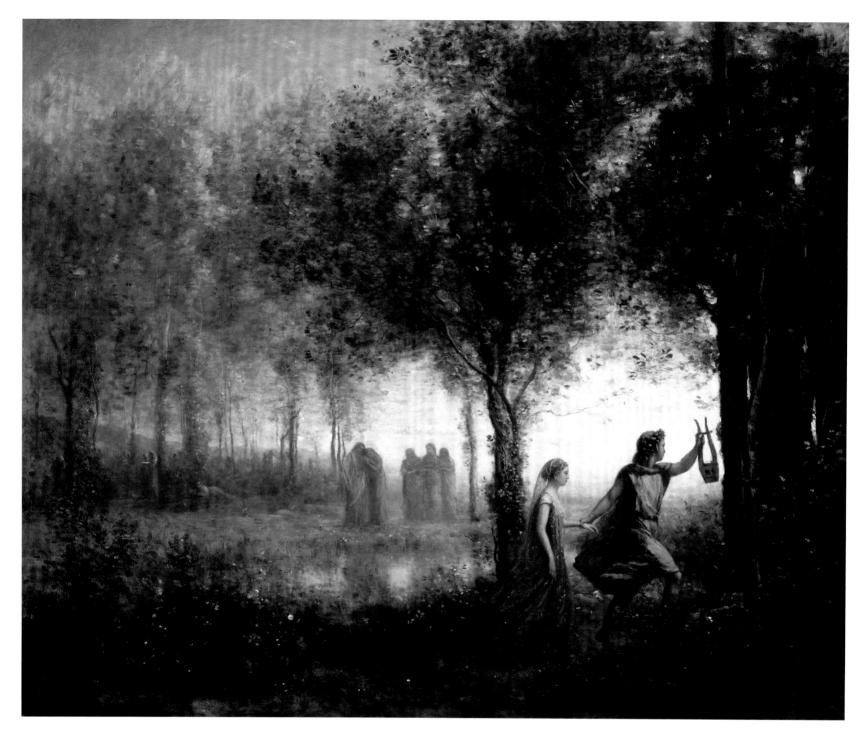

102. Jean-Baptiste-Camille Corot (1796–1875). *Orpheus Leading Eurydice from the Underworld*, 1861. Oil on canvas, 44 × 54 in. (111.8 × 137.2 cm). Museum of Fine Arts, Houston; Museum purchase with funds provided by the Agnes Cullen Arnold Endowment Fund.

Corot identified with the protagonist in this moment, as well as its composer.

Indeed, Gluck had compared music in opera to color in visual arts, saying that "music ought to do for the poetry what lively colors and the contrasts of light and shadow do for a correct and well-ordered drawing, animating the figures without modifying their contours."[29] Berlioz criticized Gluck's metaphor as underselling his compositional power, writing that the composer's music "contains both line and color, and to continue Gluck's analogy, the words form the *subject* of the painting, hardly more than that."[30] In short, the music—not the story or staging—carries the expressive force of opera. As Joël-Marie Fauquet noted, "For Berlioz, music first became expressive with Gluck."[31]

The presence of figures in *Orpheus Leading Eurydice from the Underworld* (fig. 102), moving away from the shades of Hades and towards the light of the upper world, gives a narrative—and through the connection to Gluck's *Orphée*, a performative—foothold to seeing Corot's landscapes as expressive, visual music. To gauge by engravings made after the performance Corot attended (fig. 103), this particular canvas is less a record of what the opera looked like and more an expression of the inward effect key moments of it had in Corot's mind, how song and scene lingered and evolved in memory.

Anyone who has watched a stirring scene from a film with the musical soundtrack removed (or substituted for humorous effect) knows that sound and especially music shape *how* we see, how we make meaning from what we see. Famously, Stanley Kubrick used Richard Strauss's *Thus Spoke Zarathustra* (*Also sprach Zarathustra*, Op. 30, 1896) as a temporary track for his grand opening to *2001: A Space Odyssey* but then kept it in the final film when the music written by Alex North for the scene proved underwhelming at best, if not making the sweeping view through space literally laughable.[32] It works in reverse, as well, as when *The Simpsons* or a pizza commercial can import the gravity and grandeur of that famous sequence to baser subjects simply by layering Strauss's tone poem over their visuals. Today, thanks to iPods and streaming music's promise of the entire catalogue of musical history accessible and playlist-able at all times, we soundtrack our lives, our walks and commutes, our views. Yet this extends to remembered music, too—"The Eye of the Tiger" comes to mind unbidden as we jog up the steps—and that this should be as true for Corot, perhaps hearing Berlioz's revival of *Orphée* as he painted his landscapes and *souvenirs*, should come as no surprise.

"Like his Orpheus," Theodore de Banville said of Corot, "when he sets foot on the land of the living, he returns from the land of dreams, where trees, brooks, horizons are only serene visions,

103. Engraving of *Orphée et Eurydice*, Act II, at the Théâtre-Lyrique. Stage design by Charles-Antoine Cambon and Joseph Thierry. Engraved by Jan and Lang. Bibliothèque nationale de France, Music Department.

floating souls that speak directly to our souls."[33] This direct communication from soul to soul, as we've seen, is typically associated with music, often through metaphors of harmony or resonance. If you replaced trees and brooks with bridges and the Thames, it could be a description of Whistler's Nocturnes (fig. 104). It is no small coincidence that four massive times of day paintings by Corot (ca. 1858, National Gallery, London), confidently done in a week to decorate the studio of fellow artist Alexandre-Gabriel Decamps, later made their way to the opulent residence of Victorian painter Frederic Leighton, where the dream-like qualities of the artists associated with the Aesthetic Movement would be explicitly linked to music by likes of Rossetti, Burne-Jones and Moore. The distance from the landscapes of Corot to those of Whistler is not as far as one might guess. Both artists worked outdoors, Corot sketching in the forest and Whistler getting rowed out onto the Thames after dark; both relied heavily on their memories of nature to invent their compositions; and for both the analogy to music wasn't structural, it was metaphorical—a metaphor for the artist's intent that Corot made explicit through secondary, allegorical musical figures and that Whistler applied through his titles: the "Symphonies" of brightly rendered beautiful women, the "Arrangements" of portraits in darker tones, and the "Nocturnes," in which views of the London cityscape became the foil for an art for art's sake at the closest to abstraction as then achieved in the West.

104. James McNeill Whistler (1834–1903). *Nocturne in Blue and Silver,*
1872–78, **butterfly added ca. 1885.** Oil on canvas, 17½ × 24 in. (44.5 × 61 cm).
Yale Center for British Art; Paul Mellon Fund.

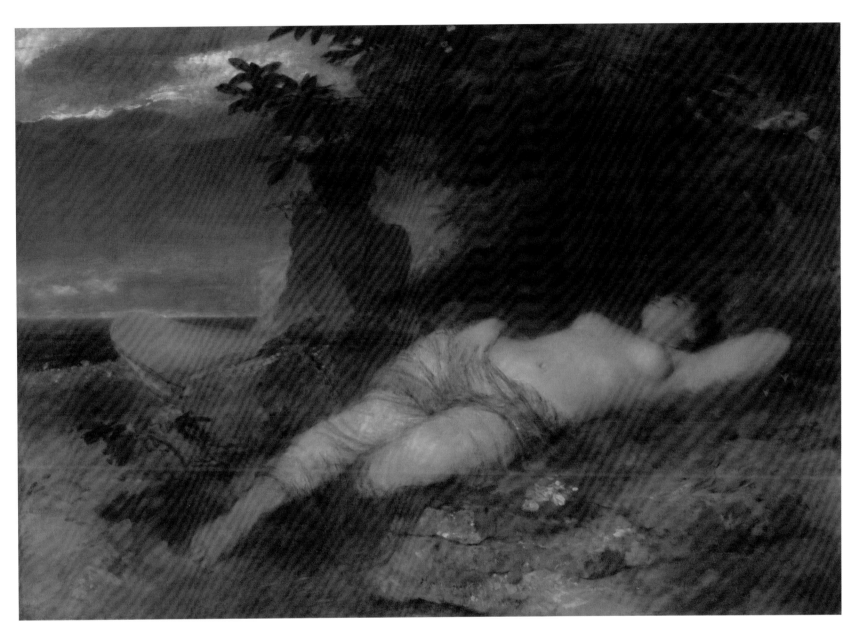

105. Arnold Böcklin (1827–1901). *Nymph and Satyr,* **1871.** Oil on canvas, 42½ × 61 in. (108 × 154.9 cm). Philadelphia Museum of Art; John G. Johnson Collection, 1917.

Swiss Symbolist Arnold Böcklin would also learn from Corot. Böcklin's *Isle of the Dead* paintings, as if reversing Orpheus's rescue, guide the viewer to an isolated final resting place where, as he said while painting it, "It shall become so quiet that you are frightened by a knock at the door."[34] This popular image—done as an etching by Max Klinger, among other reproductions—was the source of several musical compositions, including Rachmaninoff's symphonic poem of the same name (Op. 29). Debussy would link Böcklin's style to the tone poems of Richard Strauss,[35] and both constitute further influences upon the French composer's paean to the pastoral, *Prélude à l'après-midi d'un faune*. Böcklin's debt to Corot and relation to Debussy's faun-song are more easily seen in the earlier *Nymph and Satyr*, where the erotic musicality of nature is given shape through the moody landscape and the languid, nude nymph, lost in dreams brought on by a view of tree and sky and the sound of the satyr's song (fig. 105).

Corot's paintings, especially those that took his experiences at the opera as their starting point (and his sketchbooks are rife with drawings from performances), signal this direction that visual arts would take: increasingly untethered from representation in a bid for painting to work upon the viewer as music does upon listeners. Shortly after painting *Orpheus Leading Eurydice from the Underworld*, Corot was asked to paint two times of day for the dining room of Prince Anatole Demidoff, and he chose to revisit Orpheus. In *Orpheus Greeting the Dawn* (fig. 106), the quintessential poet-musician holds his instrument high but doesn't play. Instead he seems to be conducting, in the precise variations of tone in the crown of the tree, the Elysian music of the forest itself.

106. Jean-Baptiste-Camille Corot (1796–1875). *Orpheus Greeting the Dawn,* 1865. Oil on canvas, 78¾ × 54 in. (200 × 137.2 cm). Chazen Museum of Art; Gift in memory of Earl William and Eugenia Brandt Quirk, Class of 1910, by their children (E. James Quirk, Catherine Jean Quirk and Lillian Quirk Conley).

NOTES

1. Claude Debussy, *Debussy Letters*, ed. François Lesure and Roger Nichols; trans. Roger Nichols (Cambridge, MA: Harvard University Press, 1987), 184.

2. James M. Whistler, *The Gentle Art of Making Enemies* (New York: J. W. Lovell, 1890), 126–7.

3. The former from critic Paul Mantz (see Paul Mantz, "Salon of 1863," *Gazette des Beaux-Arts* 15 (July 1863): 60–61) and the latter, widely documented, from patron Frederick Leyland.

4. Walter Pater, "The School of Giorgione," *The Renaissance: Studies in Art and Poetry* (1893; repr., Berkeley: University of California Press, 1980), 106.

5. See Elizabeth Helsinger, "Listening: Dante Gabriel Rossetti and the Persistence of Song," *Victorian Studies* 51, no. 3 (Spring 2009): 409–21.

6. See Suzanne Fagence Cooper, "Playing the Organ in Pre-Raphaelite Paintings," *Music in Art* 29, no. 1/2 (Spring–Fall 2004): 151–70.

7. See Patrick Coleman, "Echoes of a Dark and Deep Unity: Exchange, Collaboration and Innovation," in the present volume.

8. Quoted in Peter L. Schmunk, "Artists as Musicians and Musical Connoisseurs: Musicians, Mélomanes, and Ideas of Music among Nineteenth-Century Artists," in *The Routledge Companion to Music and Visual Culture*, eds. Tim Shephard and Anne Leonard (New York; London: Routledge, 2014), 268.

9. Quoted in Peter Vergo, *The Music of Painting* (London; New York: Phaidon, 2010), 69.

10. Gioseffo Zarlino, *On the Modes: Part Four of L'Istitutioni Harmoniche*, 1558, ed. Claude Palisca (New Haven and London: Yale University Press, 1983), 2.

11. For discussions of the relationship between Poussin and these theories, see for example Peter Vergo, *That Divine Order* (London; New York: Phaidon, 2005), 178–217; Naomi Joy Barker, "'Diverse Passions': Mode, Interval, and Affect in Poussin's Paintings," *Music in Art* 25, no. 1/2 (Spring–Fall 2000): 5–24; and Sheila McTighe, "Poussin and the Modes," in *The Routledge Companion to Music and Visual Culture*, 238–45.

12. Letter from Poussin to Paul Fréart de Chantelou, 24 November 1647, in *Correspondance de Nicolas Poussin*, ed. by Charles Jouanny (Paris: J. Schmit, 1911), no. 156, 370–5, trans. by Anthony Blunt in *Nicolas Poussin* (New York: Bollingen Foundation, 1967), 367–70.

13. See Karol Berger, *Bach's Cycle, Mozart's Arrow: An Essay on the Origins of Musical Modernity* (Berkeley: University of California Press, 2007).

14. Eve Barsham, "The Orpheus myth in operatic history," in *C.W. von Gluck: Orfeo*, ed. Patricia Howard (Cambridge; New York: Cambridge University Press, 1981), 4–5.

15. *Concise Oxford English Dictionary*, 11th ed., s.v. "fugue."

16. As codified by Franchino Gaffurio, *De harmonia musicorum instrumentorum opus* (Milan: Gotardus Pontanus, 1518), bk. 1, ch. 4, described in Berger, *Bach's Cycle, Mozart's Arrow*, 25.

17. Constantin Floros, *Gustav Mahler: The Symphonies Paperback*, trans. Vernon Wicker (Pompton Plains, NJ: Amadeus Press, 2000), 122.

18. See Maria Rika Maniates, *Mannerism in Italian Music and Culture, 1530–1630* (Chapel Hill: University of North Carolina Press, 1979), 466.

19. Quoted in Flora Willson, "Looking at History," *Opera* (June 2012): 34–6. http://opera.archive.netcopy.co.uk/article/june-2012/34/looking-at-history.

20. Ibid.

21. Therese Dolan, *Manet, Wagner, and the Musical Culture of Their Time* (England; Burlington, VT: Ashgate, 2013), 12.

22. Michael Clarke, *Corot and the Art of Landscape* (New York: Cross River Press, 1991), 7.

23. Quoted in Gary Tinterow, Michael Pantazzi and Vincent Pomarède, *Corot*, exh. cat. (New York: Metropolitan Museum of Art, 1996), 153.

24. Quoted in ibid.

25. See Kermit S. Champa, "Concert Music: The Master Model for Radical Painting in France," *Imago Musicae* 16–17 (1999): 207–21.

26. Quoted in Tinterow, *Corot*, 290.

27. Eve Barsham, "Berlioz and Gluck," in *C.W. von Gluck: Orfeo*, 89.

28. Act II, Scene II: "Quel nouveau ciel pare ces lieux! / Un jour plus doux s'offre à mes yeux! / Quels sons harmonieux! / J'entends retentir ce bocage / Du ramage / Des oiseaux, / Du murmure des ruisseaux / Et des soupirs de Zéphire." My thanks to Ariel Plotek for the translation.

29. Enrico Fubini, *Music and Culture in Eighteenth-Century Europe: A Source Book*, trans. Bonnie J. Blackburn (Chicago: University of Chicago Press, 1994), 364.

30. Hector Berlioz, "The Alceste of Euripides," in *The Art of Music and Other Essays*, trans. Elizabeth Csicsery-Rónay (Bloomington: Indiana University Press, 1994), 102.

31. Joël-Marie Fauquet, "The Grand Traité d'instrumentation," in *The Cambridge Companion to Berlioz*, ed. Peter Bloom (Cambridge: Cambridge University Press, 2000), 167.

32. Excerpts of the Alex North–scored *2001: A Space Odyssey* can be found on YouTube.

33. Tinterow, *Corot*, 290.

34. Quoted and translated in *German Masters of the Nineteenth Century: Paintings and Drawings from the Federal Republic of Germany*, exh. cat. (New York: Metropolitan Museum of Art, 1981), 189.

35. See *Debussy on Music*, ed. François Lesure and trans. Richard Langham Smith (New York: Alfred A. Knopf, 1977), 270.

James Grebl

The Power of Music in Classical Myth and Art

Golden lyre, rightful joint possession of Apollo
and the violet-haired Muses. . . . You quench
even the warlike thunderbolt of everlasting fire.
And the eagle sleeps on the scepter of Zeus. . . .
Even powerful Ares, setting aside the rough
spear-point, warms his heart in repose; your shafts
charm the minds even of the gods.

—PINDAR, *FIRST PYTHIAN ODE*

The myths of the Greco-Roman world speak eloquently of the magical powers that were attributed to music in ancient times, as the passage from Pindar suggests.[1] Myths dealing with the power exerted by music on gods, mortals and nature itself, from the Greek Archaic period (sixth century BC) through the end of the Roman imperial era (fifth century AD), address a wide variety of themes ranging from the invention of various instruments and modes of music to the moral and social dimensions of their use. As with most myths, it is unlikely that these stories were taken literally by most people, but rather they reflect primitive superstitious attempts to explain complex phenomena, vestigial memories of historical events, regional conquests or migrations, and metaphorical expressions of societal norms and practices.

The belief that certain modes of music and certain instruments have the power to calm spirits, to uplift morals and to improve mental abilities was prominent in some myths and in their depictions in art. Another strain of myths hyperbolically addressed the hazards of offending the gods through musical hubris, perhaps as metaphoric lessons on the pitfalls of human pride in a broader sense. A final collection of tales explored the power of certain types of music to affect people in a negative way, driving out reason and impelling them to harmful actions. In considering these myths, it is essential to be aware of their dynamic nature. Most myths originated as oral literature in the bardic tradition, and as such developed many local variations and inconsistencies which survived as the texts were gradually written down, to the consternation of scholars both ancient and modern. Some versions of the myths were in fact created by later compilers and exegetes attempting

107. Attic red-figure calyx krater by the Villa Giulia Painter. Apollo and Muses. Greece, Attica, ca. 460–450 BC. Terracotta, H: 13⅜ in. (34 cm). Staatliches Museum Schwerin, Germany.

In Greek society music was considered one of the liberal arts and thus was valued for the beneficial effects it had on the development of the intellect. As such, it was an important element in the education of elite citizens and their children.[2] It was also appreciated for its pleasurable nature, which refreshed the mind for further study and work. For these reasons, aristocratic adults were encouraged to practice music in their daily lives, though it was important not to stray from the status of virtuous amateur to that of vulgar professional.[3] There were also biases regarding which instruments and modes of music were appropriate for respectable citizens to play. The *chelys* lyre, a stringed instrument with a soundbox made from the shell of a tortoise (fig. 109), was perhaps the most respectable instrument for the aristocratic amateur, while other stringed instruments such as the *kithara*, *barbitos* and harp, and more particularly wind instruments such as the *aulos*, pipe and *syrinx*, often had negative associations of professionalism, debauchery or femininity, which discouraged their use by well-born males.[4]

One of the chief motivations for designating certain types of instruments and music as inappropriate for aristocratic practice was the power that they exerted over the listener. Philosophers, echoing the mythographers, drew sharp distinctions between the intellectually elevating sound of the chelys lyre, on one hand, and the stimulating, sensuous sounds of the other instruments, especially the aulos and pipes. Similar distinctions were made between the edifying effects of epic poetry, which sang in a stately manner of the noble deeds of heroes and gods, and the baser effects of lyric or erotic verse of the sort that might be performed at symposia or revels. A number of myths that lend the authority of the gods to these strictures were created or embellished during the late Archaic and Classical periods (fifth and fourth centuries BC), and many of these will figure in the discussion that follows. By the Hellenistic and Roman eras (third century BC through fourth century AD) most of these ethical prejudices had faded, and in fact the value placed on musical education for the elites was substantially diminished.

Divine Inventions

It may be an indication of the importance the ancient Greeks, and to a lesser extent the Romans, attached to music that they created myths ascribing the invention of the major musical instruments to the gods. For example, the invention of the oldest string instrument, the lyra or chelys, a three-stringed lyre with a soundbox made from a tortoise shell, was attributed to Hermes, the son of Zeus.[5] Some sources also credit Hermes with inventing the syrinx or panpipe,[6] a bucolic instrument made of five to seven reeds of the same length held together with beeswax. The ends of the

to reconcile discrepancies and rationalize illogical traditions. Since many of these myths also found expression in the visual arts, it is useful to consider both the verbal and pictorial sources when examining the theme of the power of music in the classical world.

That music was an essential component of Greek civic and private life is evident in the important roles it played in sacred rituals, religious festivals, social gatherings, literature and education. Broadly speaking, music served primarily as an accompaniment to poetry that was chanted or sung by a solo performer or a chorus, and often provided rhythm for dancers, whether in the theater, the temple precinct or the private home. In the private sphere, music often fulfilled a social role as entertainment at banquets and symposia (male drinking parties), and such scenes, appropriately enough, were depicted frequently on vessels used for mixing, serving and drinking wine (fig. 108).

108. Attic black-figure stamnos attributed to the Michigan
Painter. Reclining Banqueters and Revelers. Greece, Attica,
ca. 500 BC. Terracotta, H: 13½ in. (34.1 cm). Los Angeles County
Museum of Art; William Randolph Hearst Collection.

reeds were stopped with plugs of wax at graduated lengths, thus rendering different pitches.[7] However, another tradition attributed the invention of the panpipe as well as cymbals and kettledrums to the Phrygian goddess Cybele.[8] More commonly, the creation of the syrinx was ascribed to Pan, the son of Hermes, a shepherd-god from rustic Arcadia.[9]

There is also disagreement over the invention of the aulos, a pipe with a reed mouthpiece sometimes mistakenly called a flute.[10] Athena is generally credited with its invention, though some attribute the instrument to Apollo.[11] The story of Athena's invention of the aulos has the goddess discarding the instrument because playing it distorted her face and caused the other goddesses to mock her (fig. 110). She placed a curse on the pipes, which were later picked up by Marsyas, a story that will be discussed more fully below.

Pacification and Enchantment

Some of the earliest mythological demonstrations of the power of music relate to its ability to pacify, charm and command humans,

nature and even the gods. A prime example is found in the story of the invention of the lyre told in the *Homeric Hymn to Hermes,* a work of the late sixth or early fifth century BC.[12] The son of Zeus and the nymph Maia, Hermes was an extremely precocious infant who escaped from his crib on the day of his birth and deviously captured the cattle of Apollo. While concealing his prizes in a cave, Hermes spied a tortoise whose shell he used to fashion the first lyre. When confronted by Apollo and Zeus over the theft of the cattle, Hermes played his lyre, and the sweet music calmed Apollo's anger and charmed him so greatly that he gave the cattle to Hermes in exchange for the lyre. Thus Apollo acquired one of his most enduring attributes and assumed one of his chief roles as the patron of music.

Like Hermes before him, Apollo's playing of the lyre had great power over man, nature and other gods. The passage from Pindar cited at the beginning of this essay testifies to his lyre's ability to charm wild animals, silence Zeus's thunderbolt and restrain warlike Ares.[13] Other poets elaborated on this theme, crediting Apollo with great skill in playing the syrinx or panpipe as well as the lyre:

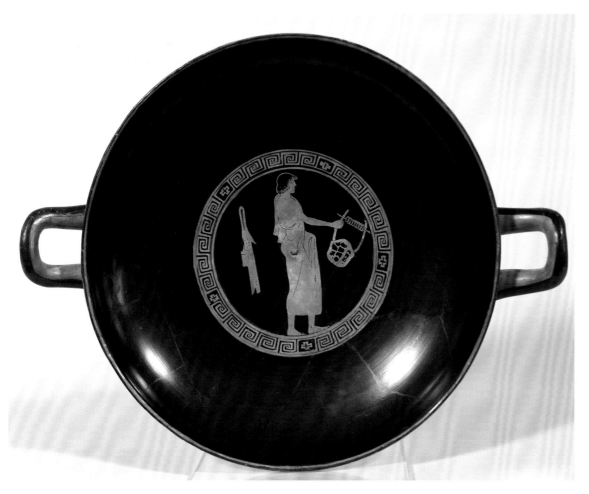

109. Attic red-figure kylix by the Boot Painter. Youth Holding a Tortoise-Shell Lyre (interior). Greece, Attica, ca. 470–460 BC. Terracotta, 3⅞ × 12⅜ × 9½ in. (9.8 × 31.5 × 24 cm). The J. Paul Getty Museum.

110. Attic red-figure oinochoe attributed to the Codrus Painter. Athena Discarding the Pipes. Greece, Attica, 3rd quarter of the 4th century BC. Terracotta, H: 8⅞ in. (22.5 cm). Staatliche Museen zu Berlin, Antikensammlung, Berlin, Germany.

On the slope of the hillsides
He played melodies of mating
On the Pipes of Pan to his herds.
And the dappled lynxes fed with them
In joy at your singing . . .[14]

While depictions of Apollo holding his lyre or kithara are quite common in Greek art, few illustrate the god actually playing the instrument (figs. 6 and 107), and fewer still represent his use of music to charm or pacify.

The charming of animals through music is a power ascribed to several mortals in Greek myths. One of the lesser-known examples is Arion, a renowned bard of the seventh century BC.[15] According to legend, when Arion was sailing from Sicily to Corinth, the ship's crew attempted to rob him and toss him into the sea.[16] Arion persuaded them to let him sing a hymn to Apollo before carrying out their plan. The bard's music attracted a number of dolphins, enchanted by his voice and lyre. When he finished the song, he leaped into the sea and was carried safely to land by one of the charmed dolphins. A statue depicting Arion on the back of a dolphin stood at Cape Taenarum in Laconia, where legend says the dolphin carried him.[17] While this myth isn't known to appear on Greek pottery, it was depicted on a number of coins minted at Arion's home island of Lesbos and in a large floor mosaic in the Villa Romana del Casale at Piazza Armerina in Sicily dating to the early fourth century AD (fig. 111).

Another mortal musician whose musical power was legendary was Orpheus, a mythical Thracian minstrel whose talents were strikingly similar to Apollo's and who was arguably the human most closely associated with music in Greek myth. Indeed, some versions of Orpheus's story give Apollo as his father, though most agree that he was the son of the Thracian king Oeagrus and the

111. Mosaic with Arion Playing the Lyre (detail). Roman Italy, Sicily, Room 41, apsidal hall called "Hall of Arion," Piazza Armerina, 1st quarter of the 4th century AD. Polychrome mosaic. Museo Regionale Villa Romana del Casale, Piazza Armerina, Sicily.

Muse Calliope.[18] Orpheus had a marvelous voice and great skill with the lyre and, like Apollo, was able to exert great power through his music. In fact, some claim he was given the lyre by Apollo himself and taught to play by the Muses.[19] His singing was such that he could captivate ferocious beasts, mesmerize men and women, and make the very stones and trees move.[20] Although apparently unknown in Greek art, the theme of Orpheus charming the animals enjoyed popularity in the Roman era, especially on floor mosaics (fig. 112) and frescoes. However, depictions of his power over stones and trees are unknown in the visual arts of antiquity.

A mythological figure who mirrored Orpheus's power to affect inanimate nature was Amphion, a king of Thebes. Amphion and his twin brother Zethus were the sons of Antiope by Zeus.[21] Although twins, the brothers had very different natures. Zethus, a cattle herder and warrior, mocked his brother's devotion to the lyre, which Hermes had given him. However, after succeeding to joint rule of Thebes, Amphion was able to use his music to charm the heavy stones the brothers were using to build walls around their city so that they floated through the air and fell effortlessly into

112. Mosaic with Orpheus among the Animals. Roman Italy, Sicily, Piazza della Vittoria, Palermo, ca. 200–250 AD. Polychrome mosaic, terracotta. Museo archeologico 'Antonio Salinas' di Palermo.

113. Wall painting of Ulysses and the Sirens. Roman Italy, Pompeii, mid-1st century AD. Polychrome fresco, 13⅜ × 13⅛ in. (34 × 33.5 cm). British Museum; Blacas Collection.

place.[22] This myth does not appear to have inspired visual depictions in Greek or Roman art.

Returning to Orpheus, there are further demonstrations of his musical power in the saga of the Argonauts' quest for the Golden Fleece. As a member of Jason's crew, Orpheus frequently employed his musical skills to aid the heroes throughout their adventure.[23] In one instance, echoing Apollo's ability to bring calm through music, Orpheus's singing resolved a serious quarrel between two of the Argonauts. On another occasion Orpheus saved the Argonauts from disaster when, sailing between Sicily and Italy near the island of Anthemoessa, they encountered the Sirens, bird-women whose enchanting songs made sailors forget their homes and languish on the island until they died.[24] Orpheus quickly played a tune on his lyre, overpowering the Sirens' songs and saving his companions. While the exploits of Orpheus as one of the Argonauts are well attested in literary sources, pictorial representations are quite rare.[25]

The dangerous power of the Sirens' song figures in another important tale set long after Orpheus saved the Argonauts. Odysseus (Ulysses in Roman myth) also saved his men from the treacherous voices of the Sirens, in this case not by music but by plugging the ears of his crew with wax so that they would not be seduced by the sound. Having himself tied to the ship's mast allowed him to listen without succumbing to the fatal sounds, so that he and his men passed Anthemoessa in safety. This story is depicted in a number of Greek and Italiote red-figure vessels of the sixth through fourth centuries BC, as well as frescoes and mosaics from Pompeii of the first century AD (fig. 113). As a tragic consequence of Odysseus's wily ploy, however, the Sirens were doomed to die, since it had been fated that they would live only until someone who heard their singing was able to pass them by unscathed.

The power of Orpheus's music affected not only rocks, trees, animals, men and magical creatures such as the Sirens, but also was able to sway a deity such as Pluto (Hades), god of the Underworld, as Orpheus's attempt to rescue his wife Eurydice demonstrates.[26] When Eurydice died of a snake bite, Orpheus was so distraught that he descended to Pluto's realm determined to retrieve her. Charmed by his magical playing and singing, Pluto and his consort, Persephone, agreed to allow Eurydice to return with him to the land of the living. Unfortunately, the strength of Orpheus's faith did not match the power of his music. Anxious that his beloved wife might not be following him, Orpheus glanced back—in violation of Pluto's instructions—and Eurydice tragically reverted to a shade trapped forever in the Underworld. Depictions of Orpheus playing before Pluto and Persephone in Hades do not appear until the fourth century BC, when the theme became popular on pottery made in Apulia (fig. 114).

114. Apulian red-figure volute krater by the Underworld Painter. Orpheus Playing before Persephone and Hades (detail). Italy, Apulia, Canossa, ca. 330–320 BC. Terracotta. Antikensammlungen, Munich, Germany.

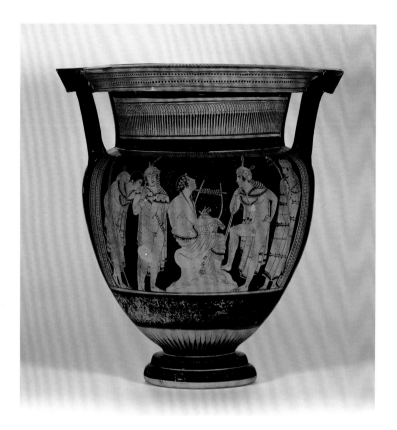

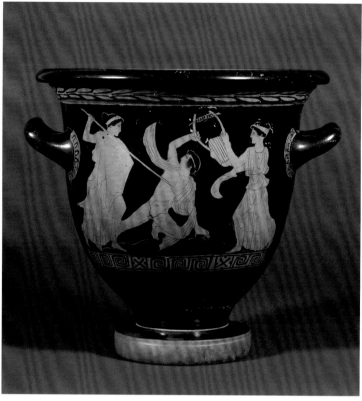

115. Attic red-figure krater by the Orpheus Painter. Orpheus among the Thracians. Greece, Attica, ca. 440 BC. Terracotta, H: 20⅛ in. (51 cm). Staatliche Museen zu Berlin, Antikensammlung, Berlin, Germany.

116. Attic red-figure bell krater by the Curti Painter. Death of Orpheus. Greece, Attica, ca. 440–430 BC. Terracotta, H: 11⅞ in. (30 cm). Harvard Art Museums, Arthur M. Sackler Museum.

In some versions of the Orpheus story, his music even led to his own death.[27] One common tradition asserts that the bard was slain by Thracian women who were incensed that his music held their men spellbound, causing them to neglect their duties (fig. 115). Another variant holds that the Thracian women were enraged because Orpheus, deeply mourning the death of his wife Eurydice, spurned their advances. A third tradition claims that Orpheus offended Dionysos by failing to honor him in song along with the other gods. This act of impiety provoked the god to incite his maenads to exact the terrible punishment of tearing Orpheus limb from limb.[28] Whatever the reason for Orpheus's death, scenes of his murder tend to depict him ineffectually wielding his lyre as a weapon or shield as he falls (fig. 116), thus negating the power that his music once exerted and underscoring the double-edged power of music to calm or to inflame passions.

Impiety and Hubris

The Sirens also figure in a myth that demonstrates the hazards of musical hubris. The story tells how Hera induced the Sirens to compete with the Muses in a singing contest.[29] Naturally the Muses were victorious and plucked the Sirens' feathers in revenge for their hubris, making crowns of the plumage for themselves. This incident is not widely known in art, but it is depicted on several late Roman marble reliefs including a third-century sarcophagus, which gives more detail than the surviving textual sources (fig. 117). On the sarcophagus, Athena, Zeus and Hera preside over the contest while the defeated Sirens are violently stripped of their garments as well as their plumage.

A similar tale of musical hubris was told involving a contest between the Muses and the Pierides, the nine daughters of the legendary Macedonian king Pierus (grandfather of Orpheus) and his wife Euippe.[30] Pierus, who was closely associated with the worship of the Muses, called his daughters "children of the Muses," perhaps inspired by the coincidence that both his daughters and the Muses numbered nine. The girls became expert singers, and in their boastful pride challenged the Muses to a competition. When inevitably they were defeated, the Pierides were transformed by the Muses into magpies chattering endlessly with hideous voices.

117. Sarcophagus with the Contest of the Sirens and the Muses. Roman, 3rd quarter of the 3rd century AD. Pentellic marble, 21¾ × 77¼ × 22½ in. (55.3 × 196.2 × 57.2 cm). The Metropolitan Museum of Art; Rogers Fund, 1910.

118. Attic red-figure hydria attributed to the Group of Polygnotos. Punishment of Thamyris. Greece, Attica, ca. 440–430 BC. Terracotta, H: 11 in. (28 cm). Ashmolean Museum, Oxford.

This myth had only minor importance in the literary tradition and so far no extant examples have been identified in the visual record of the classical era.

The theme of the Muses punishing hubris recurs in the myth of Thamyris, a skilled bard from Thrace who was the son of the poet Philammon and the nymph Argiope.[31] Several versions of the myth are known. In one, Thamyris loved the beautiful youth Hyacinthus, who was also desired by Apollo. To punish his rival, Apollo told the Muses of the bard's boast that his singing was superior to that of the nine goddesses. In another version, Thamyris's pride caused him to challenge the Muses to a contest in which he was defeated. In both cases, the Muses exacted their revenge by depriving Thamyris of his sight and his musical skill. Although relatively rare, depictions of Thamyris are known in Greek vase painting of the fifth century BC (fig. 118).

The most striking tale of tragedy resulting from musical hubris is found in the myth of Marsyas, briefly mentioned above in connection with Athena's invention of the aulos.[32] There are several contradictory accounts of Marsyas in various myths, but the main tradition identifies him as a Phrygian satyr who claimed the pipes for his own after Athena discarded and cursed them.[33] He became so adept at playing that he challenged Apollo to a musical contest. The different sources vary in the details of the competition, but most of the versions end with Apollo exacting a terrible punishment for Marsyas's hubris by flaying the satyr alive. This was the aspect that was emphasized in both the Hellenistic and Roman

literary treatments of the myth. Depictions of Marsyas first appear in Greek art in the fifth century BC, primarily focusing on his acquisition of the pipes from Athena and on the contest with Apollo. Representations of the satyr's punishment didn't begin until the fourth century, and in the Roman era it became a popular theme in a variety of media ranging from decorative arts, such as terracotta lamps, metalwares, cameos, mosaics, stucco work and frescoes, to sculpture, including free-standing statuary, as well as architectural reliefs and sarcophagi (fig. 119).

119. Sarcophagus panel with Apollo and Marsyas. Roman, from Tuscany, Italy, ca. 290–300 AD. Marble, 41¼ × 86½ × 38½ in. (105 × 220 × 98 cm). Louvre Museum.

Ecstasy and Madness

The power of music to inflame passions was touched upon briefly in connection with the story of Orpheus, but the figure most closely associated with using music to cause madness or ecstasy is Dionysos, also called Bacchus. The many myths relating to Dionysos appear to reflect two separate traditions which became conflated over the centuries, one involving an ancient Greek fertility deity and the other an exotic foreign god from Phrygia or Thrace who was credited with inventing wine and imposing orgiastic rites of worship on lands from India to Greece, often with great violence.[34] The artistic record seems to reflect this dichotomy as well, with Archaic and early Classical Greek depictions of the god in a mature, bearded form while works of the later Classical and Hellenistic periods picture him as a beautiful, sensuous, androgynous youth.

The relationship of Dionysos to music was likewise very complex. In contrast to Hermes, Apollo, Athena or Cybele, for instance, Dionysos was not credited with inventing any instrument, nor for that matter with playing music himself, yet he was closely associated with music and dance. This is because his followers, or bacchanals —the satyrs and maenads who made up the god's *thiasos*, or retinue—often made orgiastic music using a variety of instruments

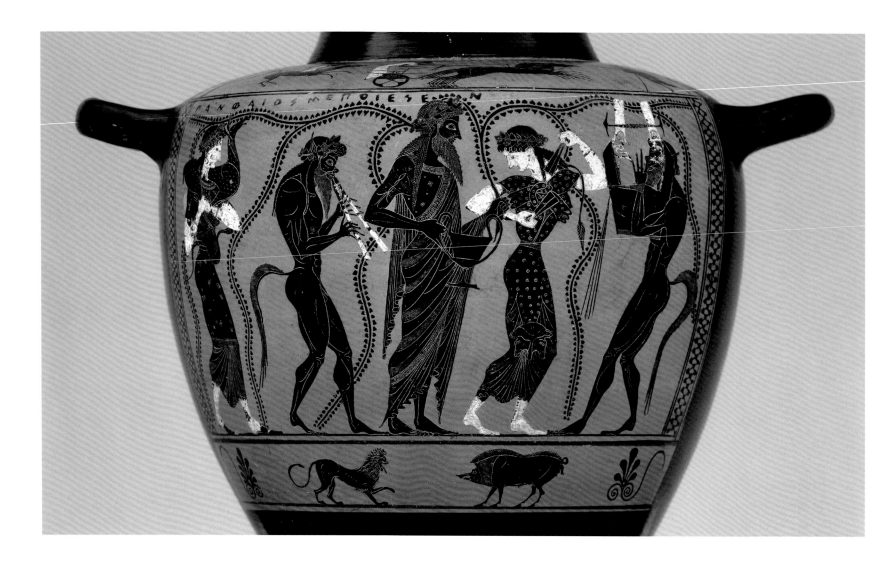

120. Attic black-figure hydria attributed to the Euphiletos Painter. Dionysos with Satyrs and Maenads. Greece, Attica, found at Nola, Italy, ca. 520 BC. Terracotta, H: 16 in. (40.6 cm). British Museum.

as they accompanied the god in his woodland revels (fig. 120). These instruments included seemingly random combinations of the lyra, kithara, auloi (pipes), syrinx (panpipes), *tympanon* (tambourine), *kymbala* (cymbals) and *krotala* (rattles). The music made by these bacchanals drove them to ecstatic heights of passion and, when directed at opponents of Dionysos, had the power to cause madness. A well-known myth tells of a crew of Tyrrhenian pirates who abducted Dionysos. When they attempted to violate him, Dionysos called forth a variety of magical manifestations, including twining the ship's mast with grapevines and ivy and causing ferocious lions, tigers and bears to appear. These drove the pirates so mad that they jumped into the sea and were changed into dolphins. At least three sources add that magical sounds of flute or chanting caused or helped the sailors go mad,[35] though the extant depictions of this myth do not make the musical connection explicit.

**121. Attic red-figure kylix by Douris. Death of Pentheus.
Greece, Attica, ca. 480 BC.** Terracotta, D: 11½ in. (29.2 cm).
Kimbell Art Museum, Fort Worth, Texas.

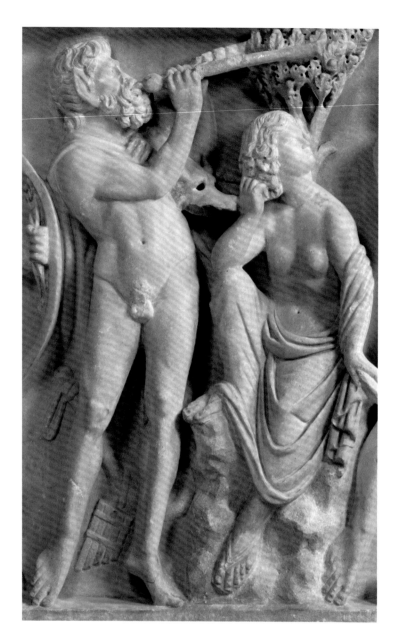

Perhaps the most prominent victim of Dionysiac frenzy and madness was Pentheus, a king of Cadmeia (Thebes) who was horribly murdered by the frenzied followers of Dionysos, including his own mother, Agave, and aunts, Ion and Autonoe, because of his opposition to the god's rites.[36] This story achieved great fame through Euripides's tragedy *The Bacchae*,[37] and like the destruction of Orpheus by followers of Dionysos, it was a popular subject in Greek vase decoration and also known in Pompeian frescoes. One vase in particular, a red-figure kylix of the fifth century BC by Douris, depicts Dionysos drinking wine to the accompaniment of a satyr playing the pipes while maenads brandish Pentheus's bloody torso and dismembered limbs (fig. 121).

Epilogue

The preceding discussion demonstrates how the Greeks, followed by the Romans, embodied the importance of music in their myths, many of which were then depicted in the visual arts. While the earliest manifestations of all these stories may have functioned on several levels—as expressions of primal religious beliefs, as statements of ethical norms and as entertaining folk-tales—it seems likely that in later centuries the stories evolved into mere literary anecdotes from a bygone era popularly used to adorn walls, floors and decorative wares. As such, many of the more prominent of these myths survived through the Middle Ages and reached renewed levels of popularity in Renaissance, Baroque and Neoclassical art.

122. Sarcophagus panel with Apollo and Marsyas (detail). Roman, from Tuscany, Italy, ca. 290–300 AD.

NOTES

1 Pindar, "First Pythian Ode," in *Odes*, trans. Diane Arnson Svarlien (1990). Perseus Digital Library, 5–12. http://www.perseus.tufts.edu/hopper/text?doc=urn:cts:greekLit:tlg0033.tlg002.perseus-eng1:1.

2 On the role of music in Greek education see Edward A. Lippman, *Musical Thought in Ancient Greece* (New York: Columbia University Press, 1964), 126–9, and "Literate Education in Classical Athens," in *Classical Quarterly* 49.1 (1999): 46–61. For Roman education, see Stanley Bonner, *Education in Ancient Rome* (Berkeley: University of California Press, 1977), 44.

3 Plato's *Republic* (ca. 375 BC) and Aristotle's *Politics* (ca. 350 BC) to some extent reflected classical attitudes toward the proper role of music in Athenian society. Among the elites, the role of the amateur who plays for pleasure and intellectual stimulation was extolled, while seeking to entertain others and to gain approval or fame, the goal of the professional, was condemned. See Sheramy D. Bundrick, *Music and Image in Classical Athens* (Cambridge: Cambridge University Press, 2005), 35–6.

4 A full discussion of the range of instruments used in fifth-century Greece and their relative social appropriateness is found in Bundrick, 13–48.

5 The *Hymn to Hermes*, 4.20–60 (written down ca. 520 BC).

6 The *Hymn to Hermes*, 4.512; Apollodorus, Library, 3.10.2 (ca. 140 BC).

7 With Roman panpipes the reeds themselves were of decreasing lengths.

8 Diodorus Siculus, *Library of History*, 3.58.1–3 (ca. 60–30 BC).

9 Sources do not agree on the identity of Pan's mother. For his invention of the syrinx, see Pausanias, *Description of Greece*, 8.38.11 (ca. 160–150 BC); Ovid, *Metamorphoses*, 1.689–712 (AD 2–8).

10 The flute was a reedless pipe whose sound was made by blowing across a hole in the pipe. Two auloi were generally played in tandem by an individual musician, effectively making the aulos a double-reed instrument.

11 Pindar, "Twelfth Pythian Ode," 15–20, and Hyginus, *Fabulae* 165 (compiled ca. 50 BC–AD 15) credit Athena while Pausanias, 5.7.10, associates Apollo with the aulos. Pseudo-Plutarch, *De Musica* 1135–1136 (probably late second–third century AD), cites Hyagnis, a mythical Phrygian musician considered by some to be the father of Marsyas, as inventor of the art of pipe-playing.

12 See note 5.

13 See note 1.

14 Euripides, *Alcestis*, 575–587 (written ca. 438 BC).

15 Arion, who was born at Methymna on Lesbos and was attached to the court of Periander, tyrant of Corinth, was credited with inventing the dithyramb, a choral song in honor of Dionysos.

16 Herodotus, *The Histories*, 1.23–24 (ca. 450–420 BC); Hyginus, *Fabulae*, 194; Hyginus, *Poetica Astronomica* (compiled ca. 50 BC–AD 15), 2.17.

17 Pausanias, 3.25, 4–7.

18 Some sources say that Apollo was his father: Pindar, "Fourth Pythian Ode," 176–7; Asclepiades of Tragilus, *Fragmente der griechischen Historiker*, 12F6. Among the sources naming Oegrus are Apollodorus, 1.3.2; Apollonius Rhodius, *Argonautica*, 1.23, 4.905 (ca. 295–215 BC); Hyginus, *Poetica Astronomica*, 2.7.

19 Hyginus, *Poetica Astronomica*, 2.7.

20 See Apollonius Rhodius, 1.23–34; Apollodorus, 1.3.2; Ovid, 11.1–84.

21 Hyginus, *Fabulae* 9 and 10; see also note 22.

22 Apollodorus 3.5.5; Apollonius Rhodius, 1.735–741; Pausanias, 9.5.7–8.

23 Pindar, "Fourth Pythian Ode," 176; Apollonius Rhodius, 1. 28–31; Apollodorus, 1.9.25.

24 The Sirens (three in number according to most sources) were the daughters of Achelous, a river god, and one of the Muses, either Terpsichore or Melpomene. See Homer, *Odyssey*, 12.39–54, 12.158–200; Apollonius Rhodius, 4.891–921; Hyginus, *Fabulae*, 14, 125, 141; Ovid, 5.552–563; Pausanias, 9.34.3. In Apollodorus 1.3.4 the Sirens not only sing, but two of them play the lyre and the flute.

25 The earliest image of Orpheus with the Argonauts is a carved stone metope from the Sikyonian Treasury at Delphi, dated ca. 570–550 BC. This image, however, cannot be identified with any specific episode in the Argo saga. The metope, which is fragmentary, is part of a series that illustrates the story of the Argo on the Treasury's frieze. Although this metope depicts Orpheus and a companion playing lyres aboard the Argo, the presence of a figure on horseback near the prow of the ship (identified as one of the Dioscuri), indicate that the ship is docked and thus it cannot illustrate the narrative moments discussed here.

26 Euripides, *Alcestis* 357–62 (ca. 438 BC); Pausanias, 9.30.1; Ovid, 10.1–8.

27 Hyginus, *Poetica Astronomica*, 2.7; Ovid, 10.1–85; Virgil, *Georgics*, 4.453–527 (completed 29 BC); Pausanias 9.30.5.

28 Ovid, 11.1–85; Hyginus, *Poetica Astronomica*, 2.7.

29 Pausanias, 9.34.3.

30 Ovid, 5.294–678; Apollodorus 1.3.3; Pausanias 7.29.3–4, 9.30.4.

31 Homer, *Iliad*, 2.594–600; Euripides, *Rhesus* 916–25; Apollodorus 1.3.3; Pausanias 4.33.3, 4.33.7.

32 Apollodorus 1.4.2; Hyginus, *Fabulae* 165; Ovid, 382–400.

33 Hyginus, *Fabulae* 165, identifies Marsyas's father as a satyr called Oeagrus, which is also the name given to the Thracian king who was Orpheus's father. This may be the result of confusion by the mythographers, or there may have been two different figures with the same name. Pseudo-Plutarch, *De Musica*, gives Hyagnis as the father of Marsyas.

34 The sources on Dionysos are numerous but the most extensive accounts are found in Apollodorus, 3.4.3–3.5.3 and Diodorus Siculus, 4.2.5–4.4.4.

35 Apollodorus, 3.37–38; Hyginus, *Poetica Astronomica*, 2.17; Philostratus the Elder, *Imagines*, 1.19 (3rd century AD). The latter source is significant because it ostensibly describes a painting depicting the subject of Dionysos and the Tyrrhenian pirates that was seen by the author.

36 For the death of Pentheus, see Theocritus, *Idylls* 26 (probably 3rd century BC), and Ovid, 3.692–733.

37 *The Bacchae* was probably first performed in 405 BC.

Christina Yu Yu

Music and the Arts in East Asia

The seventeenth-century painting catalogue *History of Silent Poetry* (*Wusheng shishi*) records more than four hundred painters known throughout Chinese history. The catalogue's title suggests an intrinsic connection between art forms that are acoustic (poetry) and visual (painting). Across thousands of years of civilization in East Asia, such a connection has provided inspiration to artists and artisans who developed unique languages to document and illustrate the importance of music in society. The brief introduction below looks at three music forms and their representations in the visual arts in East Asia before the twentieth century—ritual music in Confucian societies, the *qin* zither music practiced by scholars, and the Kabuki theater. They demonstrate the creators' strategies and solutions to translate ephemeral performances into permanent visual forms. More importantly, they provide a glimpse of the political, social and cultural meaning of music to the society that nurtured its development.

Confucius and the Ritual of Music

In 1978, Chinese archaeologists discovered a tomb that yielded a great number of bronze and lacquer wares.[1] These findings reveal the identity of the tomb occupant as Marquis Yi of Zeng (died ca. 433 BC), head of a subordinate state to the powerful Chu. Distributed in four chambers were lacquer coffins, bronze and lacquer ritual artifacts, and a large ensemble of musical instruments including percussion, string and woodwind instruments. Among them, the most striking was a set of sixty-four bronze bells (*bianzhong*) hung on a lacquered wooden structure, each bell inscribed with music notations (fig. 124). It would take a crew of five musicians using wooden mallets to strike the bells. Many similar bell sets, although smaller in size, were produced for ceremonial uses

123. Qiu Ying (ca. 1495–1552). Two Scholars Playing the Qin and Erhu under a Pine Tree (detail). China, Ming dynasty (1368–1644). Ink and color on silk, 39¾ × 16⅞ in. (101 × 43 cm). Private collection.

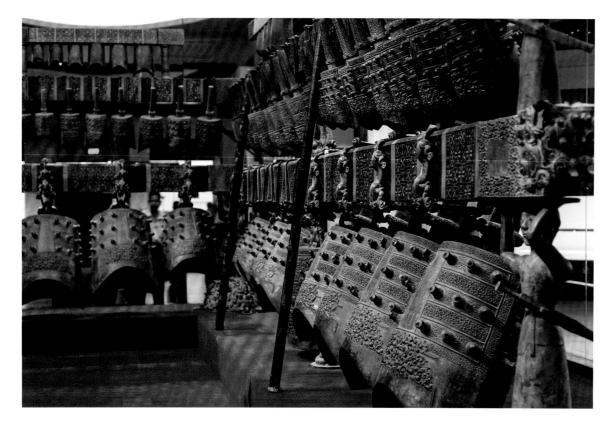

124. Bells (*bianzhong*) from the tomb of Marquis Yi. China, Warring States Period (475–221 BC). Bronze and wood, H: 107½ in. (273 cm); long rack: 294½ in. (748 cm), short rack: 131⅞ in. (335 cm). Hubei Province Museum.

during the Zhou dynasty (1046–256 BC). Their lens-shaped body has four groups of nine protruding bosses, and each group is arranged in three rows of three. In between the rows are bands of continuous square spiral decorations. At the bottom is a *taotie*, a zoomorphic mask motif omnipresent on early Chinese bronze objects.

The possession of such monumental musical instruments was no doubt a strong statement of the owner's wealth and power, as their production required access to vast material resources and control of labor and technology. At the same time, they testify to the importance of rites and rituals to the ruling class in ancient China. Among the most influential of the classics of Confucian literature are three books: *The Rites of Zhou* (*Zhouli*), *The Book of Etiquette and Ceremonial* (*Yiji*), and *The Book of Rite* (*Liji*). These elaborate upon sacrificial rites, ceremonial formalities, social behaviors, and responsibilities of government officials as established and formalized during the Zhou dynasty. Included in *The Book of Rite* is a section on music, known as *Yueji* (*Annotations of Music*). It emphasizes the significance of music, particularly ceremonial orchestra and ritual dance, and its role in governance. "When music flourishes, human relations are clarified, eyes and ears are made more susceptive, body and mind are in balanced harmony, good customs prosper and morals are improved, and peace reigns everywhere under Heaven."[2] On a cosmological level, music transmits the harmony of nature and the universe,

connecting heaven and earth. On a personal level, it unites an individual with the state.

The prosperity of the Zhou dynasty was partly attributed to the implementation of codes and standards prescribed in the three books. However, the power of the Zhou kings waned over the years, and by the Spring and Autumn period (771–476 BC), regional lords and fiefdoms were competing for power and land. It was in this environment that Confucius (551–479 BC), or Kongzi, studied Zhou rituals and rites and traveled to different states to persuade rulers to revive them from neglect for the purpose of regaining order, only in vain. The frustrating official career turned Confucius to scholarship and teaching.[3] Remembered today mostly for the moral values he laid down for individuals and society, Confucius and his teaching have been the philosophy of governance in China for more than two millennia. Fundamental to this philosophy is a set of ethics, based in maintaining proper relationships and cultivating personal perfection, that would lead to supreme harmony of all under heaven. Rituals, with music being an essential component, were given an irreplaceable role in the search and maintenance of such harmony.

Music aims at harmony, it belongs to the higher spiritual agencies, and it follows heaven. Rites aim at the distinction of differences, they belong to the lower spiritual agencies, and follow earth. Therefore the Holy Sages composed Music in order that it might correspond to

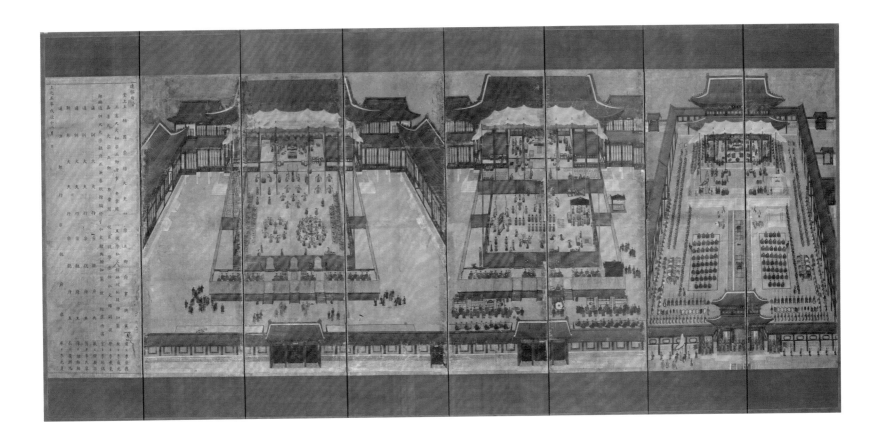

Heaven, and they instituted Rites so that they might correspond to Earth. When Rites and Music are manifest and perfect, Heaven and Earth will be regulated.[4]

Music is a mediator of the harmony between Heaven and Earth, and humans manifest this supreme harmony through rituals.

With the adoption of Confucian philosophy in Korea during the Goryeo dynasty (918–1392), proper ritual and ceremony were also followed, with the understanding of their importance to assist rulers and demonstrate their benevolent governance. A large screen painting dated to the nineteenth century of the late Joseon dynasty (1392–1897) documents the elaborate ceremonies performed on the sixtieth birthday of Dowager Queen Sinjeong (1808–1890) (fig. 125). The celebration took place at the Gyeongbok Palace in the twelfth month of 1868 and lasted several days. Starting from the right, the first two panels depict the orderly procession of officials. Following the procession are two screens showing the Queen Mother, the King and other attendants watching dance and musical performances. Banquets are held at night, as indicated by candles and lamps.[5] Seven versions of this screen were painted to document the occasion and were displayed in several palace buildings. They all follow the official *Ceremonial Regulations* (*Uigwe*), books that state details of imperial ceremonies including architectural setting, number of staff and their responsibilities, and the arrangement and expenditure for events.[6] The message

125. Sixtieth Birthday Banquets for Dowager Queen Sinjeong in Gyeongbok Palace. Korea, Joseon dynasty (1392–1910), dated 1868. Eight-panel screen, ink, color and gold on silk, 70½ × 148 × ½ in. (179.1 × 375.9 × 1.3 cm). Los Angeles County Museum of Art; Purchased with Museum Funds.

126. Artist unknown (traditionally attributed to Zhou Wenju, fl. 942–961).
United by Music (details). China, Ming dynasty (1368–1644). Handscroll, ink
and colors on silk, 16½ × 72½ in. (41.9 × 184.2 cm). The Art Institute of Chicago;
Kate S. Buckingham Endowment Fund.

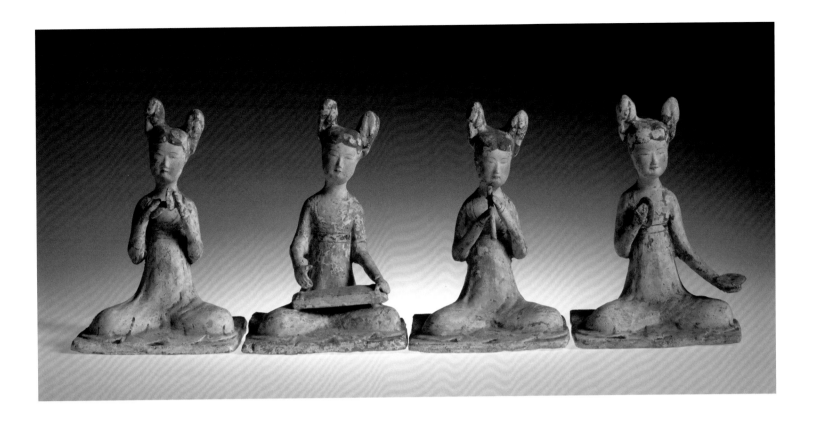

127. Seated musicians, set of four. China, Shaanxi province or Henan province, Tang dynasty (618–906), ca. 700–750. Low-fired ceramic; each 7¼ × 5 × 4⅜ in. (18.4 × 12.7 × 11.1 cm). Asian Art Museum, San Francisco; The Avery Brundage Collection.

is simple: proper rituals guide filial and social behavior, aid governance and ensure peace and harmony to the empire.

While music played an indispensable role during rituals and ceremonies, not all music and dance conducted at court bore an official function. Musicians also performed to entertain at public and private occasions. In a colorful handscroll traditionally attributed to Zhou Wenju (fl. 942–961), an ensemble performs in front of a scholar-official relaxing at home (fig. 126). The all-female orchestra on the right resembles figurines excavated from Tang dynasty tombs (fig. 127). The four musicians here play cymbals, a string instrument and a flute. Their elaborate hairstyles and colorful dresses indicate their status as entertainers at the court or high offices. Much as a harmonious governance system could be obtained through proper rituals and ceremonies, melodic music, even in less official settings, also reflects a harmonious society. Entertainment such as that provided by this female ensemble has a Central Asian flavor, no doubt reflecting the active cultural and economic exchanges along the Silk Road. It also testifies to the prosperity brought by the worthy and capable Tang imperial house, whose court music would be introduced and popularized in Japan during the Heian period (794–1185). Known as *gagaku* (elegant music), it is still performed today at religious ceremonies.

The Qin and Scholarly Ideas

According to Confucian philosophy, there are two values fundamental to harmonious relationships: *li* (rites), as discussed above, and *ren* (benevolence). Being benevolent means not only embodying a humanistic outlook but also seeing to one's own self-cultivation (*xiushen*). While there are many ways to develop and cultivate oneself, playing the qin zither (also known as *guqin*) is one of the most recognizable means. Exemplifying aesthetic elegance and moral perfection, the qin also embodies the ideal of intellectual advancement and erudition. It is not an exaggeration to say that no musical instrument claimed more cultural capital in China than the qin.

Legends attribute the creation of the qin to Fuxi, the first of three mythological sovereigns at the beginning of Chinese dynasties. The earliest excavated qin are dated to more than 2,500 years ago, including one with ten strings found in the same tomb of the Marquis Yi of Zeng. By the Han dynasty (206 BC–220 AD), the shape and structure of the qin were already established, and the modern qin still follows the same standard. Its body is approximately in the shape of a tapered rectangular box with round edges at the narrower end (fig. 128). It is made of two wooden boards—the top one Chinese parasol wood (*wutong*) and the bottom Chinese catalpa (*zi*). The top board is slightly convex, and two openings of different sizes at the bottom board make the body a sound box. Seven

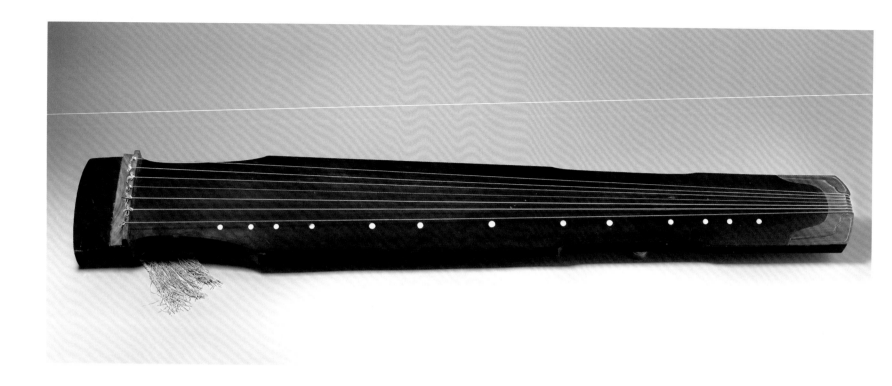

128. Qin. China, 19th century. Wood, horn, silk and mother-of-pearl,
L: 48⅜ in. (122.8 cm). The Metropolitan Museum of Art; The Crosby Brown
Collection of Musical Instruments, 1889.

twisted silk strings are fastened to knobs. Along one side of the top board are thirteen dots (typically made of mother-of-pearl) to mark harmonic positions. In later times, the qin's bottom board was often decorated with inscriptions and seals of luminary cultural figures to enhance the instrument's value and prestige.

Part of the orchestra for court rituals during the Zhou dynasty, the qin was an auxiliary instrument to percussion such as bells and chimes. A major shift took place in the Han dynasty, when ritual gave way to entertainment and portable instruments replaced heavy bronze ones. The independent status of the qin became clear in the Six dynasties (220–589), when it experienced a fundamental change from merely a musical instrument of ceremony and entertainment to a symbol of spiritual refinement and cultural supremacy. The Seven Sages of the Bamboo Grove were a group of scholars and musicians who gathered in nature in order to escape politics, corruption and intrigues at court. Instead they enjoyed a simple and rustic life, and praised each other's writing and music. Among the Seven Sages is Ji Kang (224–263), a thinker and musician who wrote *Rhapsody on the Qin* (*Qinfu*), one of the most famous passages on the instrument. Ji emphasized that music is not autonomous from the player but rather a means for expressing his emotion. Together with an eighth person, Rong Qiqi (571–474 BC), they came to symbolize a carefree spirit and moral superiority during a time of constant warfare and political intrigue. Being able to appreciate and play the qin is a manifestation of such unusual and lofty characteristics.

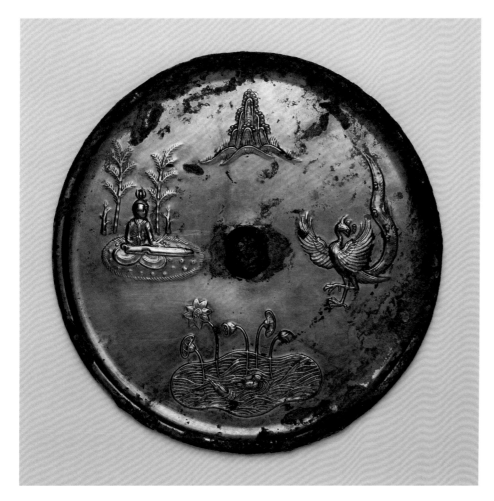

129. Mirror with Images of Purity and Immortality: Mount Penglai, Boya Playing the Qin (Zither), Lotus Pond, and Dancing Phoenix. China, Tang dynasty (618–907), 8th century. Bronze, 6¾ in. (17.4 cm). The Art Institute of Chicago; Samuel M. Nickerson Endowment.

The qin produces a clear and lingering sound, a quality that has led to many poetic and symbolic interpretations. Decorating the back of a Tang dynasty mirror is the portrayal of an immortal land (fig. 129). At the bottom is a lotus pond with a pair of ducks swimming happily. On the top is a mountain with vegetation. On the right, a phoenix with a long tail opens her wings and raises her leg. She dances to the qin music coming from the left, played by a seated figure, probably an immortal.[7] This paradise-like landscape is reminiscent of the famous qin piece *High Mountains and Flowing Waters* (*Gaoshan liushui*). Still one of the favorites among qin players today, the music is attributed to Boya, who is believed to have practiced in the immortal lands. The story of Boya composing *High Mountains and Flowing Waters* goes:

Boya was good at playing the qin. Zhong Ziqi was good at listening to the qin. When Boya's will was towards high mountains in his playing, Zhong Ziqi would say, "How towering like Mount Tai!" When Boya's will was towards flowing water in his playing, Zhong Ziqi would say, "How vast are the rivers and oceans!" Whatever Boya thought of,

[Zhong] Ziqi would never fail to understand. Boya said, "Amazing! Your heart and mine are the same!" When [Zhong] Ziqi died, Boya broke the strings [of his qin] and vowed never to play again. Thus, there was the melody of High Mountains [and] Flowing Water.[8]

Not merely a praise of Boya's skills, the narrative transforms the qin into a metaphor of friendship built on a shared appreciation of music. In *Playing the Qin in a Secluded Valley*, painted by Wen Zhengming in 1548, two scholars—one playing the qin and the other listening—are dwarfed by soaring mountain ridges and cascading waterfalls (fig. 130). There is no doubt Wen had Boya and Zhong Ziqi in mind when he created this hanging scroll. A leading figure in the sixteenth-century literati circle, Wen not only captured the harmony between the two friends but also the harmony between human and heaven and earth as advocated by Confucius more than a thousand years ago.

The qin, through its sound, is transformed into a medium of communication, expressing the mind of its player without words. The fourteenth-century novel *Romance of the Three Kingdoms* is

130. Wen Zhengming (1470–1559). *Playing the Qin in a Secluded Valley* (detail). **China, Ming dynasty (1368–1644), 1548.** Hanging scroll, ink and light color on paper, 51⅞ × 19⅞ in. (132 × 50.5 cm). Cleveland Museum of Art; John L. Severance Fund.

based on the history of the Western Han dynasty when three kingdoms (Wu, Wei and Shu) were fighting for power. A chapter tells the story of the Shu protecting a city from an attack. Overwhelmingly outnumbered by Wei army forces, the master strategist Zhuge Liang of the Shu staged the "empty fort strategy" (*kongchengji*). Sitting on the city wall, Zhuge casually played the qin. When the Wei general heard the music, he interpreted the calm melody as the player's confidence in winning the coming battle. Not willing to risk a defeat, the general chose to retreat.[9]

Through the centuries, the qin became increasingly important among Confucian scholars. Its clear and lingering sounds are often interpreted as being "leveled" (*ping*) and "bland" (*dan*), qualities particularly favored by the literati. By the Song dynasty, it had become omnipresent in literati painting (*wenrenhua*), often

used to symbolize one's scholarly status. In *Listening to the Qin by Candlelight*, a man plays the qin to entertain his female companion (fig. 131). The candle, the large screen behind them and the cushion they sit on indicate a rather intimate environment. The only indicator of his being a Confucian scholar is the musical instrument, prominently featured in the exquisite album leaf. Not all scholars depicted with the qin are shown as playing it. In fact,

131. Artist unknown. *Listening to the Qin by Candlelight*. China,
17th century. Album leaf, ink and color on silk, 8¾ × 10¾ in. (22.2 × 27.3 cm).
The Nelson-Atkins Museum of Art; Purchase: William Rockhill Nelson Trust.

132. Kano Motonobu (1476–1559). *The Four Accomplishments*. Japan, Muromachi period (1392–1573), mid-16th century. Pair of six-panel screens; ink and color on paper; each 67 × 150 in. (170.2 × 381 cm). The Metropolitan Museum of Art; Dr. and Mrs. Roger G. Gerry Collection, Gift of Dr. and Mrs. Roger G. Gerry, 1991.

the musical instrument is often depicted as being wrapped. Holding a wrapped qin became such a popular motif in painting that the *Mustard Seed Garden Manual of Painting*, the most widely circulated printed manual since its publication in the early eighteenth century, includes a demonstration on how to draw it "properly" and gives the motif the name "form of holding the qin."

The flourishing book printing industry since the seventeenth century helped to disseminate knowledge to a much broader audience. Many cultural activities that used to be limited to the scholarly class became accessible to the merchant class and beyond. Books aimed at the general public were compiled and produced, ranging from encyclopedia to manuals on cultural pursuits such as painting and the qin. What was once a symbol of cultural elitism was passionately copied and pursued by the society at large. Several manuals on the qin were printed in this period, including the *Pine String Hall Manual of the Qin* (*Songxuanguan qinpu*, 1614), the *Clear Mirror Hall Manual of the Qin* (*Chengjianguan qinpu*, 1686) and the *Five Knowledge Studio Manual of the Qin* (*Wuzhizhai qinpu*, 1721). A qin manual often starts with prefaces by the author and his circle of friends and disciples. A history of the qin follows, as well as various elaborations on shapes and terminologies. It also offers theories of notes and tones. Methods of playing the qin are always incorporated, including proper settings for playing the instrument. For example, it is advised that "when the scholar is playing [the qin] in his garden pavilion, a couple of cranes should be leisurely stalking about. Their graceful

movements should inspire the rhythm of the finger technique, and their occasional cries direct the thoughts of the player to unearthly things."[10] Finger technique also occupies a large portion of the qin manuals. To enhance the qin's scholarly association and prestige in addition to providing a better explanation, finger techniques are often given poetic names and accompanied by illustrations. These drawings not only illustrate hand postures and finger positions, but also visually and metaphorically explain corresponding movements and sound. One page demonstrates the left hand playing a quick slide, a finger movement compared to a cicada flying from one tree branch to another.

While the publication of qin manuals popularized the musical form, it also made the instrument an easy cliché, often merely a pretense to suggest learning and culture. Gradually, the ability to play the musical instrument became unimportant. Instead, the qin was often used as an ornament to decorate a library or a garden pavilion. The procession of the qin became a sufficient manifestation of one's participation in a literary life that used to be accessible only to the social and cultural elite. The function of the qin changed from being played to being displayed. It was also around the mid-Ming to Qing dynasties that *Qinqi shuhua* (commonly translated as *Four Accomplishments*, the four being the qin zither, *qi* chess, calligraphy and painting) became a fixed painting genre. It was introduced to Japan, and beginning in the Muromachi period (1392–1573) became a commonly used motif for Japanese artists to depict Chinese scholars. For example, in a

pair of screens painted by Kano Motonobu, a qin was placed on a stone table waiting to be played after the scholars finished a game of qi chess (known as *go* in Japanese) (fig. 132).[11]

Kabuki and the Art of Prints

The qin in Japan was only appreciated by a very small segment of society, particularly Zen Buddhist monks. Kabuki theater, however, had possessed a much broader appeal to the general population in the Edo period since the eighteenth century. The history of Kabuki can be traced to 1603, when Izumo no Okuni began to perform a new style of dance in Kyoto. It became immediately popular, and all-female troupes were quickly formed to meet the demand. In the middle of the seventeen century, female performers were banned due to problems with prostitution. The popularity of Kabuki didn't dwindle because of the new restriction. Male actors soon played both male and female roles. By the end of the seventeenth century, the structure of Kabuki plays was established and character types were formalized. Theaters designed only for Kabuki plays, including Nakamura-za, Ichimura-za and Kawarazaki-za, were also built.

The lively Kabuki world was vividly captured in the art form of *ukiyo-e*, or "images of the floating world," which flourished between the seventeenth and nineteenth centuries. They depict the bustling city scenes in the capital of Edo (modern Tokyo) and other metropolitan cities such as Osaka. Including both woodblock prints and paintings, ukiyo-e's themes are diverse, including Kabuki

theater, beautiful women (*bijin*), sumo wrestlers, landscapes, tales and many others. Kabuki and ukiyo-e were both new genres that emerged in the Edo period, and both appealed to the increasingly affluent merchant class.

Utagawa Hiroshige, one of the most celebrated print makers in Japan, presented the theater row at the opening day of a new season (fig. 133). Along the street of Nichomachi, banners and flags advertise plays of the new season. On the street, city dwellers try to push their way through the crowd. Some observe the commotion from the second floor of the theaters. A master of indicating specificity within generalization and anonymity, Hiroshige presents the excitement and anticipation of a new season through simple lines and flat colors. Utagawa Toyoharu's print shows the interior of a typical Kabuki theater (fig. 134). Audience seats are arranged on two floors at three sides of the stage. Vendors are selling food and drink among the audience, who walk in and out from their seats freely during a play. Musicians occupy a back corner of the stage, playing instruments including the *shamisen* (a three-stringed instrument), drum and flute. A signature of a Kabuki stage

133. Utagawa Hiroshige (1797–1858). *View of the Kabuki Theater at Sakai-cho on Opening Day of the New Season* (*Sakai-cho Shibai no Zu*), from the series "Toto Meisho." Japan, ca. 1838. Woodblock print, 10⅛ × 14⅞ in. (25.7 × 37.8 cm). The Metropolitan Museum of Art; Purchase, Joseph Pulitzer Bequest.

is the *haramichi* (flower path), a narrow passageway that extends into the seating area. Plays often utilize the haramichi for dramatic entrances; it exists in order to highlight stories and to create a sense of participation and interaction with the audience.

With the increasing popularity of Kabuki, formal lineages of actors were established to distinguish origins and performing styles. Each lineage was passed down by blood or adoption and marked by its stage name, a recognition of accomplishment that has been carefully preserved. Among the most celebrated stage names is Ichikawa Danjuro, with the most recent player being the twelfth in succession. An actor's lineage is recognizable by its emblem (*mon*),

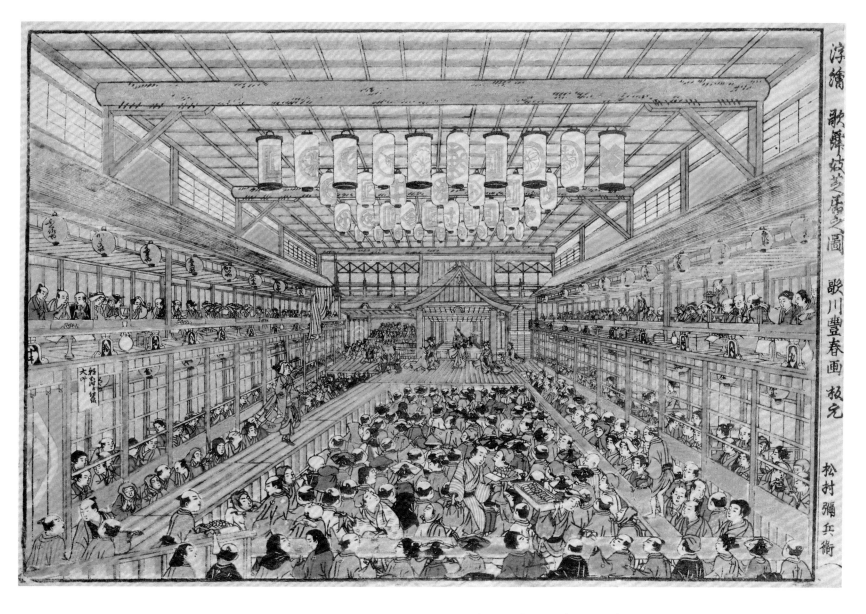

134. Utagawa Toyoharu (1735–1814). *Perspective Picture of a Kabuki Theater* (*Uki-e Kabuki shibai no zu*). **Japan, ca. 1776.** Woodblock print, 10⅛ × 15¼ in. (25.6 × 38.6 cm). The Art Institute of Chicago; Gift of Mr. and Mrs. Harold G. Henderson.

135. Utagawa Toyokuni II (1777–1835). The Actor Ichikawa Danjuro VII in the play *Shibaraku*. Japan, ca. 1823–25. Woodblock print, 8⅜ × 7⅛ in. (21.3 × 18.1 cm). The San Diego Museum of Art; Anonymous donation.

which is always prominently featured on his robe. For example, the emblem of the Ichikawa Danjuro lineage is a set of three squares, as seen in the print made by Utagawa Toyokuni II of Ichikawa Danjuro VII in the play *Shibaraku* (fig. 135). Many Kabuki actors enjoyed the social status of celebrities. Among the first ukiyo-e prints created were those portraying Kabuki actors on stage, including those made by Torii Kiyonobu (1664–1729). Known as actor prints (*yakusha-e*), they typically highlight a particular actor in one of his most known performances. Often dramatic and intense, actor prints often blur the distinction between an actor and his stage role. *Mie*, meaning "visible," is a distinctive component of Kabuki performance in which an actor strikes a pose and freezes for a few seconds. The dramatic body position and emotional facial expression frozen in a mie are among the favorites to be selected for artistic re-creation. By the middle of the eighteenth century, some artists such as Katsukawa Shunchō made subtle depictions to capture the psychological state of a character (figs. 136 and 137). Also emerging were images of actors behind and off stage in casual and relaxed settings. They offer a glimpse into the personal side of an actor, and no doubt would advance his celebrity status.

136. Katsukawa Shunchō (active ca. 1783–95). Ichikawa Komazo II in the Role of Ouchinosuke Ujiyasu, from the play *San ga no Sho mutsumi no hanayome*. Japan, 1787. Woodblock print, 15 × 10 in. (38.1 × 25.4 cm). The Metropolitan Museum of Art; The Howard Mansfield Collection, Purchase, Rogers Fund, 1936.

137. Katsukawa Shunchō (active ca. 1783–95). Ichikawa Danjuro V, from the play *Shida yuzuri wa horai Soga*. Japan, 1775. Woodblock print, 11⅞ × 5⅜ in. (30.3 × 13.7 cm). The San Diego Museum of Art; Museum purchase.

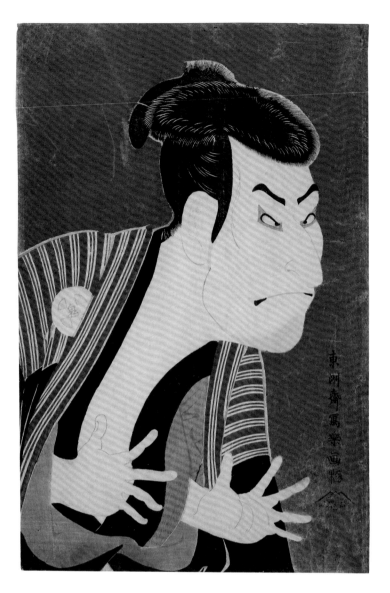

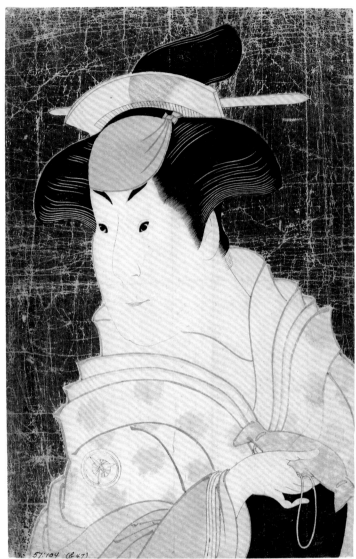

138. Tōshūsai Sharaku (active 1794–1795). The Actor Ôtani Oniji III as Edobei. Japan, 1794. Woodblock print, 14⅞ × 9⅞ in. (37.9 × 25 cm). The Art Institute of Chicago; Clarence Buckingham Collection.

139. Tōshūsai Sharaku (active 1794–95). The Actor Iwai Hanshiro IV as Shigenoi, the Wet Nurse. Japan, 1794. Woodblock print, 14¾ × 9⅝ in. (37.5 × 24.5 cm). The San Diego Museum of Art; Bequest of Mrs. Cora Timken Burnett.

Actor prints were often produced in large quantities and sold at affordable prices. They were like pinups that the audience would buy before or after watching a play and bring home to decorate their residence and to distill their memory.

No introduction to actor prints would be complete without mentioning the enigmatic Tōshūsai Sharaku. Even today the identity of Sharaku is mysterious, and it seems that his artistic career only lasted for ten months, during which he produced about 140 prints of Kabuki actors and sumo wrestlers. Distinctive of Sharaku's design is the removal of the stage background. Jumping out from the blankness is usually an upper torso with slightly miniaturized hands and an unflattering face (figs. 138 and 139). It is believed that the abrupt disappearance of Sharaku was due to the poor reception of his prints among his contemporaries. Ironically, he is among the most celebrated ukiyo-e artists today.

In addition to actor prints, a large portion of Kabuki prints are devoted to specific plays. Like most theatrical pieces, a Kabuki play is performed in different productions with different players and musicians. Variations in stage and costume design also affect a Kabuki production. Even the same play would be rendered differently by different artists. From visual clues, modern scholars have been able to identify a play, an actor, a role, a theater and sometimes even a date of a performance. Included here are different renderings of the same play *Chūshingura* (*The Treasury of Loyal Retainers*). Based on a historical event taking place between 1701 and 1703, *Chūshingura* is among the all-time favorites of Kabuki and *bunraku* (puppet) plays. It tells the story of forty-seven *ronin* (samurai without a master) seeking to avenge the death of their master.[12] The theater version places the story in the Muromachi period in order to avoid censorship. It has eleven acts, some with double scenes. The following prints illustrate Act VII, the Ichiriki Teahouse at Gion. Yuranosuke, one of the ronin, reads a letter related to the vendetta, completely unaware of the courtesan Okaru's presence. Okaru reads the secret letter as it is reflected in her mirror. Neither of them notice the existence of Kudayū, who is assigned the task of testing Yuranosuke's intention of revenge. The multiplicity of the act, with complex layers of hiding and peeping, made it appealing to artists to experiment with different visual compositions and strategies. In the 1779 version designed by Torii Kiyonaga, the artist stacked the three players in an elongated composition, using architectural details such as a veranda and a floor to separate them (fig. 140). Kudayū hides underneath the veranda at the bottom of the composition and holds the end of the secret letter in her hands, adding a comic element to the scene. Kitagawa Utamaro chose to focus on the two main characters (fig. 141). A veranda once again serves as a separating device to suggest Yuranosuke's obliviousness to being spied upon. Most famous for

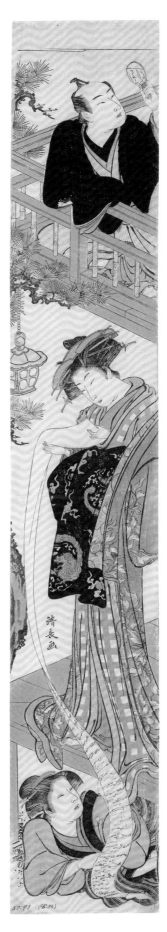

140. Torii Kiyonaga (1752–1815). Couple Spying on a Courtesan Reading a Love Letter, Act VII from the play *Treasury of Loyal Retainers* (*Chūshingura*). Japan, 1779. Woodblock print, 28¼ × 4⅞ in. (71.8 × 12.4 cm). The San Diego Museum of Art; Bequest of Mrs. Cora Timken Burnett.

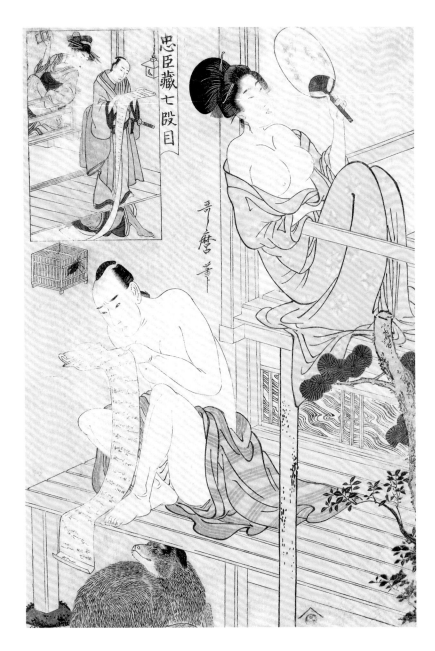

141. Kitagawa Utamaro (ca. 1753–1806). Act VII of the play *Treasury of Loyal Retainers* (*Chūshingura*). Japan, ca. 1798–1800. Woodblock print, 14⅞ × 10⅛ in. (37.9 × 25.6 cm). The San Diego Museum of Art; Bequest of Mrs. Cora Timken Burnett.

his *bijinga* (image of beautiful women), Utamaro exposed the bodies of the ronin and courtesan to add an element of sensuality. Interestingly, a tableau in the top left corner includes an almost mirror composition of the ronin and the courtesan, but with both fully clothed.

Conclusion

An integral part of all strata of society, music played a fundamental role in cultural production in East Asia—it legitimized the ruling class, maintained social order, enhanced one's cultural status and entertained the masses. Artists eternalized ephemeral performances in visual forms, and the examples cited here provide only a glimpse into the rich and diverse intersection between visual and acoustic arts. In recent years, many artists have experimented with new ways to bring the two forms together. Among them, composer Tan Dun (b. 1957) developed "organic music," in which he incorporates sounds from natural material such as stone, paper and water into his music scores. Similarly, musical instruments, in particular an abandoned piano, appear in his installations. The artist best summarizes the intrinsic and organic connection between the two arts in saying that "there are no boundaries between the visual and the audio in art creation itself. They constitute a unified yet circular realm for . . . thinking."[13]

NOTES

1 To follow the convention, "bronze" instead of "copper alloy" is used in this article.

2 R. H. van Gulik, "The Lore of the Chinese Lute," *Monumenta Nipponica* 1, no. 2 (July 1938): 117.

3 A great thinker and teacher, Confucius gathered around him seventy-two close disciples and three thousand more followers.

4 Van Gulik, "The Lore of the Chinese Lute," 126.

5 For a more detailed discussion of this painting, see Burglind Jungmann, "Documentary Record Versus Decorative Representation: A Queen's Birthday Celebration at the Korean Court," *Arts Asiatique* 62, no. 62 (2007): 95–111.

6 *In Grand Style: Celebrations in Korean Art During the Joseon Dynasty*, ed. Hyonjeong Kim, exh. cat. (San Francisco: Asian Art Museum, 2014).

7 Although lotus ponds are usually associated with the Western Paradise of Amida Buddha, they sometimes are conflated with the immortal lands.

8 *Liezi*, Tang Wen in *History of Qin*.

9 *Romance of the Three Kingdoms*. Chapter 95.

10 R. H. van Gulik, "The Lure of the Chinese Lute: An Essay in Ch'in Ideology," in *Monumenta Nipponica* 3, no. 1 (Jan. 1940): 149.

11 Further discussion on the qin can be found in the following publications: Stephen Addiss, *The Resonance of the Qin in East Asian Art* (New York: China Institute, 1999). J. P. Park, "Instrument as Device: Social Consumption of the Qin Zither in Late Ming China (1550–1644)," *Music in Art* 33, no 1/2 (Spring–Fall 2008): 136–48.

12 David Bell, *Chushingura and the Floating World: The Representation of Kanadehon Chushingura in Ukiyo-e Prints* (Japan Library, 2001).

13 John Tancock, "Tan Dun—Composer as Visual Artist," in *Tan Dun: Organic Music* (New York and Beijing: Chambers Fine Art, 2008), 15.

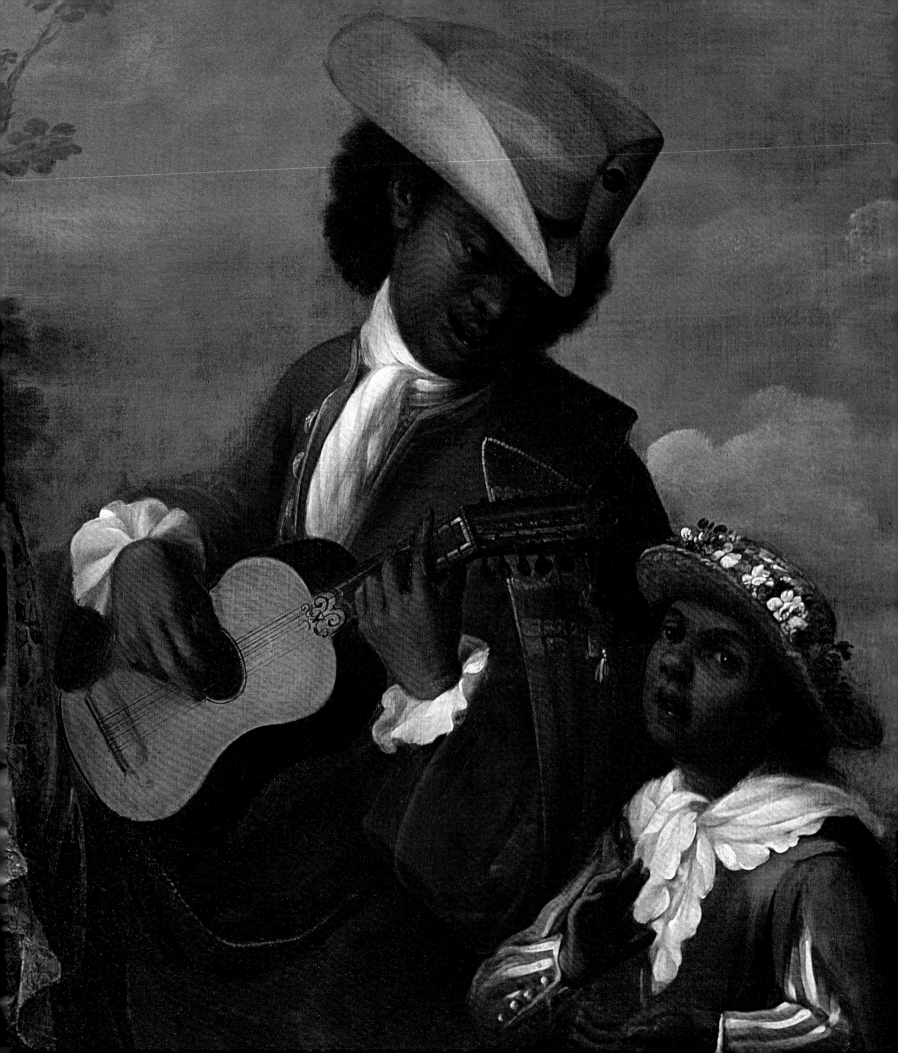

Michael A. Brown

Portraits, Music and Enlightenment in the Atlantic World

Overture

In Angelica Kauffman's magnificent *Self-Portrait Hesitating between the Arts of Music and Painting* (fig. 142), the dramatic gesture with open hand toward the muse's palette alerts the viewer that the choice has been made. In fact, the allegorical figure points upward to the Olympian heights in store for the fledgling artist, creating a dynamic diagonal composition that implies movement, even dance and music itself. It is an autobiographical moment of entirely convincing joy, one in which the decision is not between high art and low, but between two paths of nearly equal virtue. Clearly, painting wins out, but the fact that the choice is portrayed as a legitimate one for a sophisticated and virtuous young woman reflects the dramatic social shift that had begun to take place in the later eighteenth century.

The significance of this shift is illustrated in the rather stark contrast between Kauffman's pursuit of painting and the career of the celebrated vocalist and musician Ann Ford (fig. 143). In a general sense, the portrait fits into a long-standing tradition of depictions of female musicians, from early Renaissance and Baroque Italy, to the colonial Americas and on into modernity. In his magnificent portrait of 1760, Ford's friend Thomas Gainsborough (himself an accomplished musician) captured the future Mrs. Philip Thicknesse in a remarkably self-assured pose and disposition for a woman in her early twenties. Despite her father's violent protests, the young Miss Ford became a short-lived star of the professional stage, selling out a series of subscription performances and garnering critical acclaim. However, in the male-dominated world of the musical stage, she also emerged as one of the most scandalous figures in

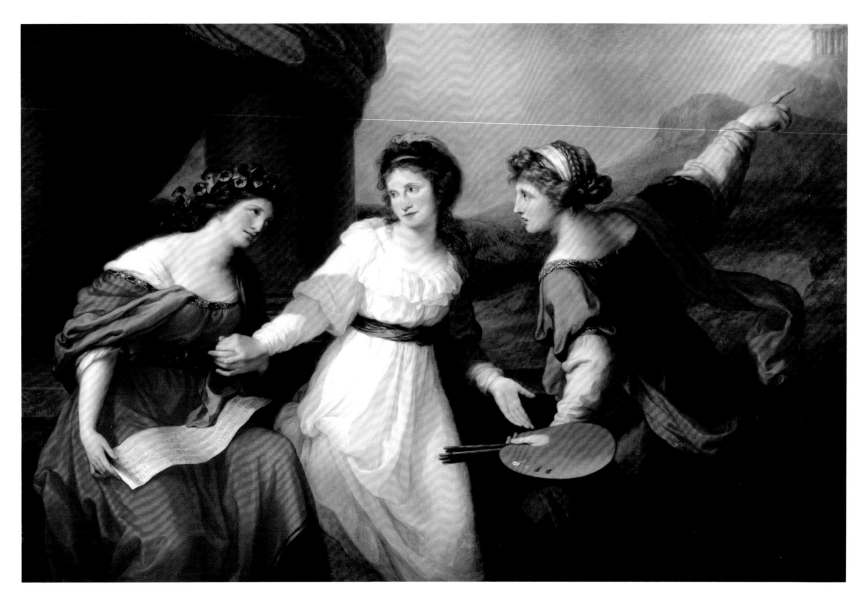

142. Angelica Kauffman (1741–1807). *Self-Portrait Hesitating between the Arts of Music and Painting,* 1794. Oil on canvas, 57⅞ × 84⅝ in. (147 × 215 cm). The St Oswald Collection, Nostell Priory, UK; The National Trust.

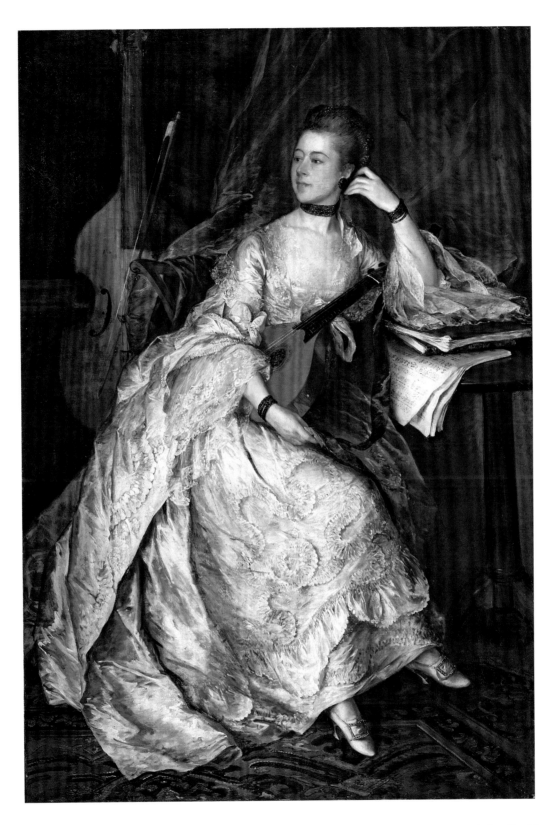

143. Thomas Gainsborough (1727–1788). *Ann Ford (later Mrs. Philip Thicknesse)*, 1760. Oil on canvas, 77⅝ × 53⅛ in. (197.2 × 134.9 cm). Cincinnati Art Museum; Bequest of Mary M. Emery.

144. Bartolomeo Veneto and workshop (died 1531, active 1502–1555). *Lady Playing a Lute*, ca. 1530. Oil on panel, 22 × 16¼ in. (55.9 × 41.3 cm). The J. Paul Getty Museum.

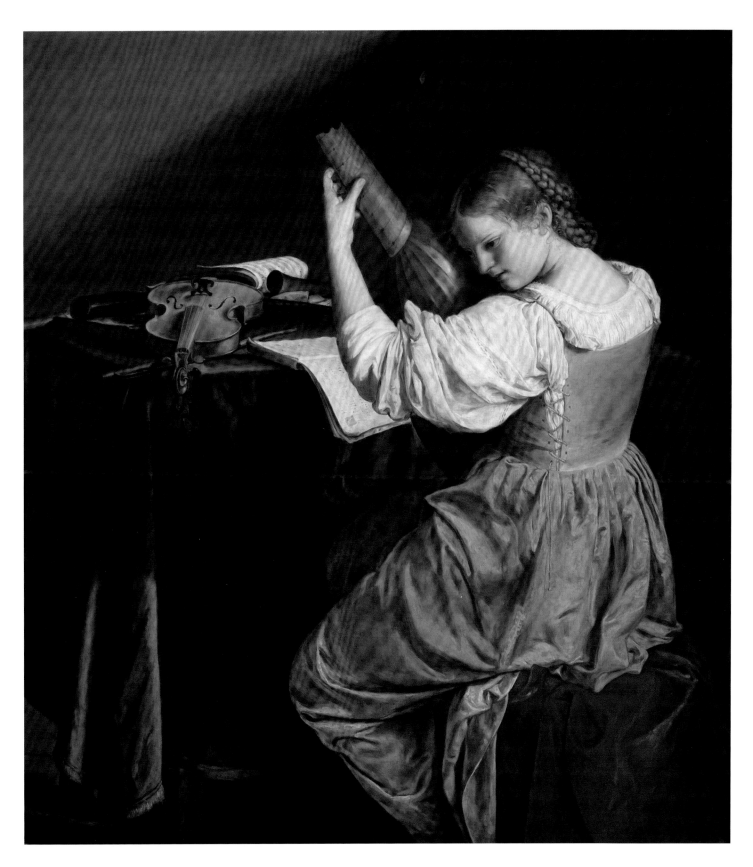

145. Johann Baptist Reiter (1813–1890), after Orazio Gentileschi
(1563–1639). *The Lute Player*, ca. 1850. Oil on material, 55½ × 49¼ in.
(141 × 125 cm). Collection of Frank and Demi Rogozienski, San Diego.

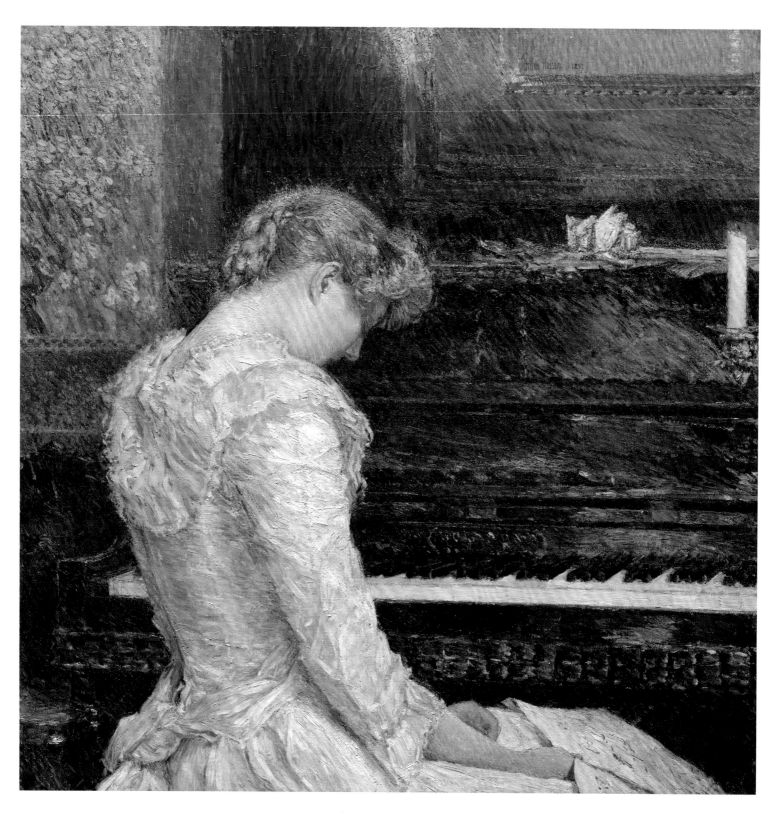

146. Childe Hassam (1859–1935). *The Sonata,* 1893. Oil on canvas, mounted on board, 32⅛ × 32⅛ in. (81.4 × 81.4 cm). The Nelson-Atkins Museum of Art; Gift of Mr. and Mrs. Joseph S. Atha.

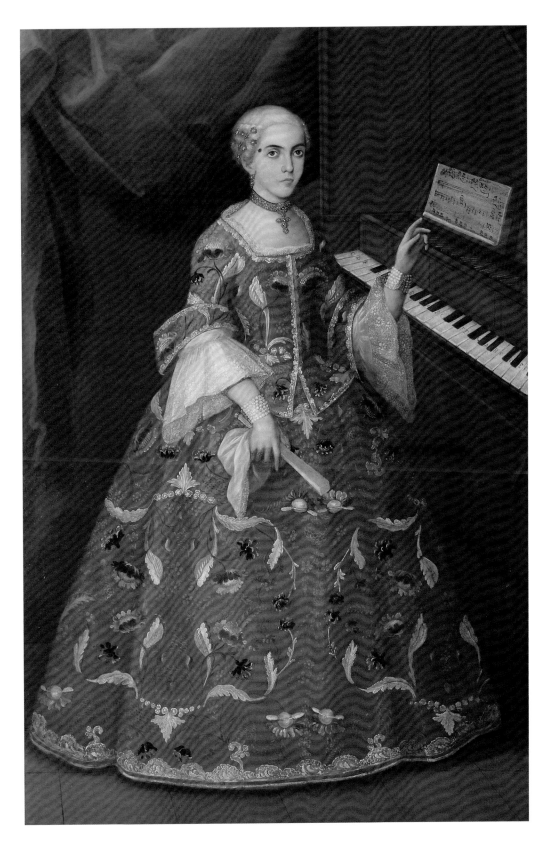

147. Unknown Mexican artist. *Young Woman with a Harpsichord*, ca. 1730. Oil on canvas, 72⅛ × 50⅞ in. (183.4 × 129.2 cm). Denver Art Museum; Collection of Frederick and Jan Mayer.

148. Thomas Wilmer Dewing (1851–1938). *Lady with Lute,* 1886.
Oil on wood, 20 × 15¾ in. (50.8 × 40 cm). National Gallery of Art;
Gift of Dr. and Mrs. Walter Timme.

149. Albert Belleroche (1864–1944). *Lili with a Guitar,* ca. 1905.
Oil on canvas, 31⅞ × 25⅝ in. (81 × 65.1 cm). The San Diego Museum of Art;
Gift of George C. Kenney II and Olga Kitsakos-Kenney.

London society by performing as a professional (which had up to
this period been viewed as improper for women) and carrying on
a publicly spiteful affair with the Earl of Jersey.[1] Thirty years after
Gainsborough's groundbreaking depiction of Ford's "progressive
femininity," Angelica Kauffman, only four years younger than Ford,
would nonetheless find herself free to choose between the twin
virtues of music and painting, portraying herself clearly having
already made the fateful decision.[2]

No such choice presented itself to José Campeche, the Puerto
Rican virtuoso of painting and music who was born to a freed
slave and a Spanish woman in San Juan Bautista in 1751. His por-
trait of *Doña Maria de los Dolores Martínez de Carvajal* (fig. 150),
painted the same decade as Kauffman's self-portrait, presents his
fashionable sitter standing before a *piano organizado,* a keyboard
instrument related to the organ that was momentarily popular in

150. José Campeche y Jordán (1751–1809). *Doña Maria de los Dolores Martínez de Carvajal*, 1791–92. Oil on wood panel, 17¾ × 12⅝ in. (45 × 32 cm). Private Collection, San Juan, Puerto Rico.

the Spanish world. The prominence of the instrument reflects the importance of music in Latin American society, especially in centers like San Juan where the prime venues would have been the cathedral and other religious institutions, while private concerts could take place within the urban palaces of the elite. Campeche was not only the most accomplished and celebrated artist of the Spanish Caribbean, he was also among its most celebrated musicians.

At an early age, Campeche studied at the Dominican college, where he learned to play the organ, eventually performing at the church of San Fernando and the Carmelite monastery. His earliest documented position at the cathedral was his appointment as

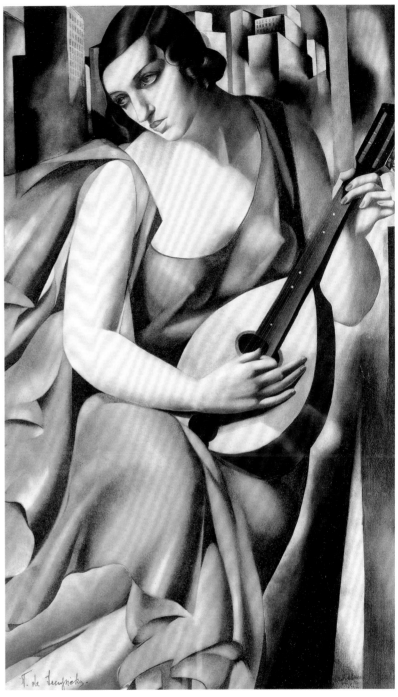

151. Tamara de Lempicka (1898–1980). *Woman with a Mandolin*, 1930. Etching and aquatint on paper, 22⅜ × 13⅞ in. (56.7 × 35.2 cm). Pérez Simón Collection, Mexico.

152. Attributed to Justus Sustermans (1597–1681). *Saint Cecilia Playing the Organ*, 17th century. Oil on canvas, 25½ × 18¾ in. (64.8 × 47.5 cm). Stourhead, Wiltshire; The National Trust.

principal oboist and deputy organist in 1783, and it appears likely that he began composing music himself.[3] Campeche went on to serve as organist and choirmaster of the cathedral of San Juan, not to mention music instructor to patrons like doña Maria de los Dolores de Carvajal and others. The quality of music performed in the cathedral was at times monitored by church authorities to limit the colloquial and popular native traditions in order to preserve orthodox Spanish traditions.[4] Campeche's crucial role as *maestro* and reformer of sacred musical performance influenced generations of choir singers and musicians in San Juan.[5] Out of a combination of necessity, civic duty and religious devotion, Campeche embraced both arts in equal measure, allowing each to occupy equal space within his identity.[6]

Libretto: Music and Early Modern Iconography

Before turning to look more closely at the unusual case of José Campeche, we should consider the broader context of the role that music played in the spiritual, artistic and courtly life in Europe and the Americas. In the seventeenth century, on both sides of the Atlantic, music was an integral part of the Roman Catholic liturgy and was an important part of most religious celebrations. Saint Cecilia was revered as the patron of the musical arts and is commemorated in countless images playing the organ, the type exemplified by Justus Sustermans of about 1650 (fig. 152), or several highly innovative allegories by Orazio Gentileschi, most notably that in the National Gallery of Art, Washington, D.C. In the two panels in The San Diego Museum of Art's permanent collection illustrated here (figs. 153 and 154), music occupies the heavenly realm, performed by angels for sacred audiences. The monumental Signorelli lunette, commissioned in 1508 for the Filippini Chapel in the church of San Francesco in Arcevia, Umbria, was intended to hang in a music-filled milieu, with the performances of angels and mortals mirroring one another.[7] The power of music to promote faith and elevate spirituality is embodied in such images.

The same cannot be said of Orazio's several versions of the *Lute Player* (fig. 145).[8] While perhaps portraying an allegory of music, or perhaps even one in which music becomes Harmony, the composition has also been interpreted recently as a solicitation to more carnal endeavors.[9] Certainly throughout the early modern period music was just as easily bound up with the profane as it was with the divine, as we see in the *Village Kermesse* by David Teniers the Younger (fig. 155), in which the earthy peasants sing, dance, play music and imbibe. Such musical celebrations were certainly not limited to Europe; the virtuoso *casta* painting from the circle of Mexican master Juan Rodríguez Juárez (fig. 156) depicts a lively family performance, indicating the sophistication of New Spain's racially diverse populace.

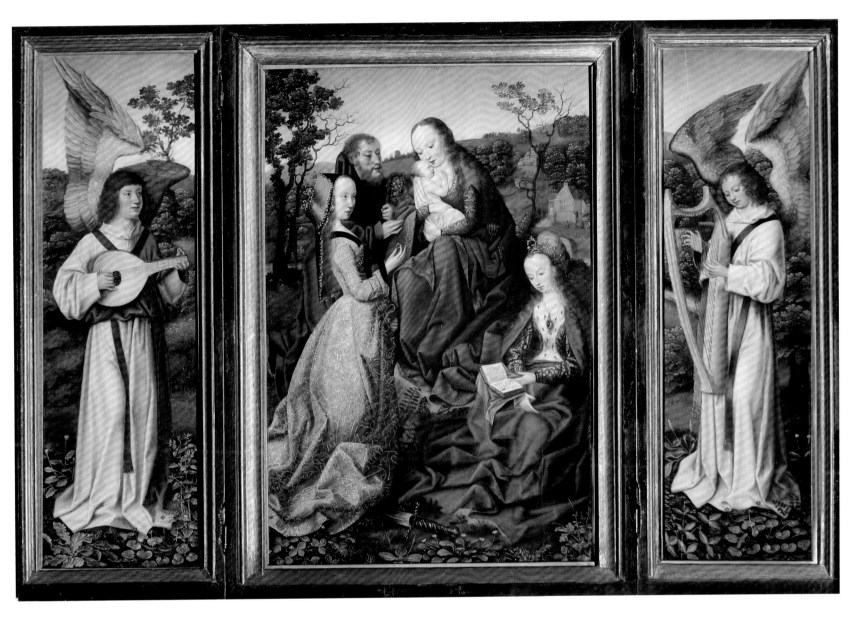

153. **Workshop of the Master of Frankfurt (ca. 1460–1533).** *Mystical Marriage of Saint Catherine with Saints and Angels,* ca. 1500–10.

Oil on panel, 27½ × 18¾ in. (69.9 × 47.6 cm). The San Diego Museum of Art; Gift of Mrs. Cora Timken Burnett.

154. Luca Signorelli (1450–1523). *The Coronation of the Virgin,* 1508. Oil and tempera on panel, 50 × 87¾ × 5¾ in. (127 × 222.9 × 14.6 cm). The San Diego Museum of Art; Museum purchase through the Gerald and Inez Grant Parker Foundation, Dr. and Mrs. Edwin Binney 3rd and Museum Art Purchases Funds.

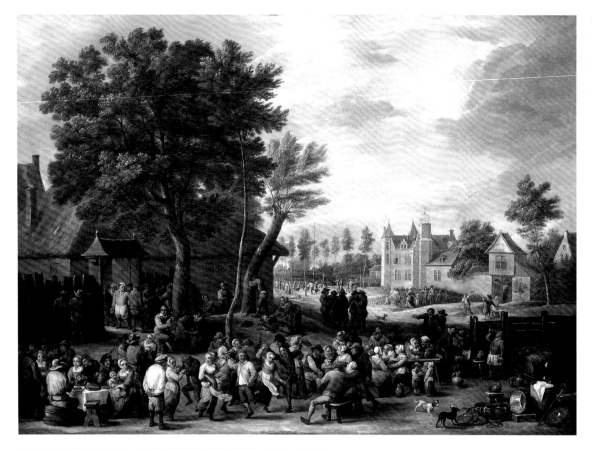

155. David Teniers the Younger (1610–1690). *A Village Kermesse,* ca. 1650. Oil on canvas transferred from wood, 23⅜ × 31⅛ in. (59.3 × 78.9 cm). Pérez Simón Collection, Mexico.

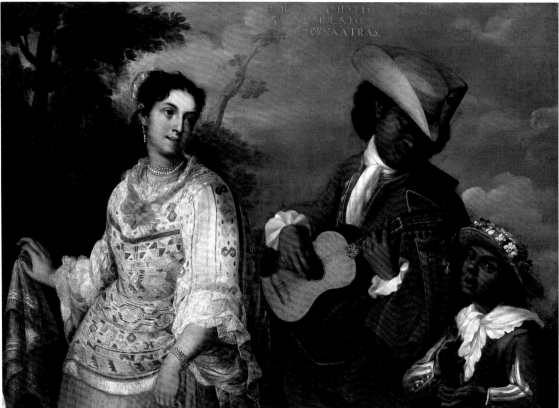

156. Circle of Juan Rodríguez Juárez (1675–1728). *From Mulatto and Mestiza Comes Mulatto, a Step Back,* ca. 1720. Oil on canvas, 40½ × 56¾ in. (102.9 × 144.1 cm). Pérez Simón Collection, Mexico.

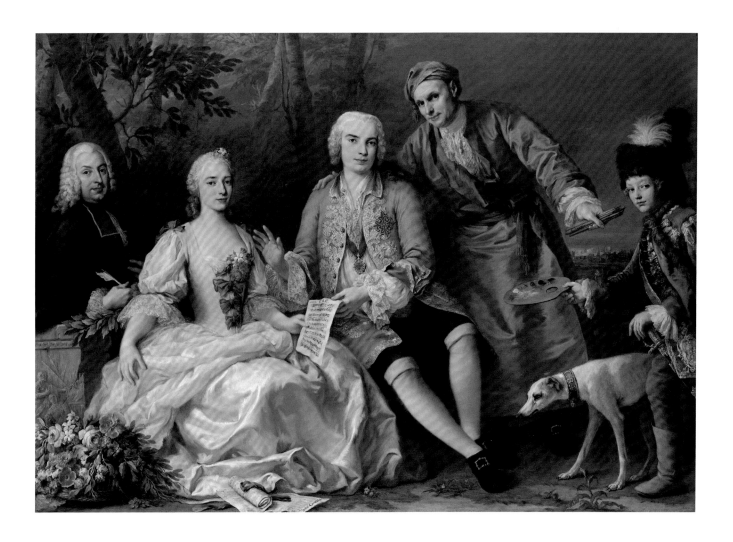

Aria: José Campeche y Jordán as Virtuoso

The earliest biography of José Campeche, which was published in 1946 but composed in the mid-nineteenth century, mentions the artist's mastery of the oboe, flute and organ.[10] According to historian Arturo Dávila, music and painting together shared the artist's primary occupation.[11] While much is left uncertain about the artist's early life, we know that his father, Tomás Campeche, was a slave freed by his owner, don Juan de Rivafrecha, a canon of the cathedral of San Juan.[12] Through Rivafrecha, the younger Campeche had access to musical training, academic learning and the libraries of various religious institutions, not least of which was the cathedral itself. He is known to have read widely, especially about artistic trends in Spain through the writings of Palomino, an early biographer of Velázquez, and Anton Raphael Mengs, whose *Letters* was among the holdings of Campeche's own library. José received his artistic training from his father, a painter, gilder and decorator of some local renown. By 1783, he is recorded as principal oboist of the cathedral, having become a master painter at least a decade earlier.

Perhaps the most important event in Campeche's artistic career came in the arrival to Puerto Rico of the exiled Spanish court

157. Jacopo Amigoni (ca. 1685–1752). *The Singer Farinelli and Friends*, ca. 1750–52. Oil on canvas, 68 × 96½ in. (172.8 × 245.1 cm). National Gallery of Victoria, Melbourne; Felton Bequest, 1950.

painter Luis Paret y Alcázar, who had been relieved of his painterly duties by Charles IV for enabling the scandalous endeavors of the king's brother, don Luis de Borbón. While the precise relationship between Paret and Campeche remains hazy and should not be understood as that of a traditional master and pupil, the Spaniard surely imparted his knowledge of current artistic trends at the Spanish royal court.[13] These tastes are most clearly characterized in an international group of painters working in Madrid just after mid-century, such as the Bohemian Anton Raphael Mengs (active 1769–76), and the Italians Corrado Giaquinto (resident 1753–1761) and Jacopo Amigoni (resident 1747–1752), all of whom served as directors of the Royal Academy of San Fernando. The cultivated atmosphere at the Spanish court is perfectly captured by Amigoni's pastoral portrait *The Singer Farinelli and Friends* (fig. 157), painted in Madrid around 1750, in which the arts of music and painting are

158. José Campeche y Jordán (1751–1809). *El niño Juan Pantaleón Avilés de Luna Alvarado*, 1808. Oil on canvas, 27⅛ × 19⅜ in. (69 × 49 cm). Collection of the Instituto de Cultura Puertorriqueña.

inexorably intertwined in the figures of the renowned castrato and Amigoni himself (in shimmering green taffeta). The complementary color scheme and kinetic, score-like composition both reflect Amigoni's understanding of operatic arrangement and *coloratura* singing. Carlo Broschi (Farinelli was his stage name), the most famous opera singer in Europe, resided at the court in Madrid from 1737–59, serving as performer, courtier, and singing and harpsichord instructor to Ferdinand and his queen, Barbara of Portugal. Farinelli was also responsible for bringing Italian *opera seria* to Madrid, from which it then quickly spread to Mexico City, site of the first opera performances in the Americas. In Amigoni's portrait, the artist, his page boy and even Farinelli's whippet pay homage to the great voice. Clearly, music and painting were two of the most significant components of court culture in the Spanish world.

News of the alliance of opera and painting at the court in Madrid surely would have delighted the musician in José Campeche, who featured musical instruments prominently in at least three of his paintings, two of which are portraits of his patron-students. Though there was no royal court in San Juan, the court of the archbishop and his entourage, centered within the physical spaces of the cathedral and the Palacio Archiepiscopal, was the closest counterpart. Both these buildings, as well as the Carmelite and other monasteries, served as venues for liturgical musical performances. In Campeche, then, the figures of Farinelli and Amigoni were united: he was both court musician and court painter to the elite of San Juan.

Coda: Young Juan Pantaleón de Avilés

Like Angelica Kauffman, the Puerto Rican master José Campeche y Jordán was both an extraordinary painter and a gifted musician. In his most affecting work, the portrait of *El niño Juan Pantaleón Avilés de Luna Alvarado* (fig. 158), music is not overtly present in the painting but rather implied by the function of the work of art itself, and by the roles played by its author, patron and subject. The painting is an *ex voto*, a genre common throughout the Catholic world, in which the image is offered in gratitude as a visual prayer. The inscription identifies the boy and his parents, who came from Coamo in the foothills near Ponce to the cathedral at the behest of the archbishop, Juan Alejo de Arizmendi, who officiated at the afflicted boy's confirmation. The confirmation and Campeche's commemorative ex voto reflect a celebrated chapter in the history of Puerto Rico, one in which charity, enlightened compassion and scientific advances became synonymous with both bishop Juan Alejo and the broader ambit of the Church itself.[14] The painting depicts the young invalid with unflinching naturalism, without clothes so as to lay bare the extent of his infirmities; in this likeness, he appears as an angel without wings. While most of the works

of art discussed here have served as depictions of music in one way or another, the nature of the ex voto, including the prayers that would be offered (possibly sung) during the ceremony and the artist's dual role as painter and musician, all converge to suggest that Campeche's image may be understood as painting as music.

The expenses of the boy's transport to San Juan from Coamo and his medical treatment, along with the commission of the painting and the musical performances surrounding his confirmation, were all financed by the archbishop. José Campeche played an active role as author of the painting (which as an ex voto was likely exhibited in the cathedral for some time) and as a performer within the context of the confirmation. At this moment of celebration within the sacred architectural space of the cathedral, both the music and the painting shared a unifying purpose, which was to inspire devotion and acts of charity, and to offer thanks for the boy's renewed health. The musical power of the painting reaches new heights in this fully understood context. The image occupies the moment of confluence between art and music, in which incomparable beauty, emotional power and painterly brilliance give way to an angel's song.

NOTES

I would like to acknowledge my UC San Diego intern, Ashley Bryan Marin, and my colleague Dr. James Grebl for assistance in securing bibliographic sources for this project.

1 The later Victorian biographies of Ford make much of her playing the viola da gamba correctly positioned between her knees, but this has been convincingly refuted as the predominant source of her scandal. See Peter Holman, "Ann Ford Revisited," *Eighteenth Century Music* 1, no. 2 (September 2004), 157–81.

2 Benedict Leca, *Thomas Gainsborough and the Modern Woman* (London: Giles, 2010).

3 René Taylor, *José Campeche y su tiempo* (Ponce, PR: Museo de Arte de Ponce, 1988), 65.

4 Daniel de Mendoza de Arce, "Panorama of the Music in the Cathedral of San Juan, Puerto Rico, 1749–1857," *Latin American Music Review / Revista de Música Latinoamericana* 10, no. 1 (Spring–Summer, 1989), 53–6.

5 Arturo V. Dávila, "José Campeche, Maestro de Música," *InterAmerican Music Review* (1960), 16.

6 Ibid., 15.

7 John Marciari, *Italian, Spanish, and French Paintings before 1850 in The San Diego Museum of Art* (San Diego, CA: The San Diego Museum of Art, 2015), 128.

8 See Keith Christiansen and Judith Walker Mann, *Orazio and Artemisia Gentileschi*, exh. cat. (New York: Metropolitan Museum of Art; New Haven: Yale University Press, 2001).

9 Ibid., 113 and 114n4.

10 Alejandro Tapia y Rivera, *Vida Del Pintor Puertorriqueno Jose Campeche* (San Juan, PR: Imprenta Venezuela, 1946), 12–3.

11 Dávila, "José Campeche, Maestro de Música," 15.

12 Taylor, *José Campeche y su tiempo*, 83.

13 For this relationship, see ibid, 85–7.

14 The bishop, through his biographies and portraiture, sought to emphasize charity as his predominant virtue. See Álvaro Huerga, *Biografía de Juan Alejo de Arizmendi (1760–1814)* (Ponce, PR: Pontificia Universidad Católica de Puerto Rico, 1992), 94–5.

Sandra Benito

Seeing Music in Latin America

The Latin American art that serves as the focus of this essay bears several interdisciplinary facets, thus affording diverse readings and exchanges. Painting, dance and music all merge together here in a harmonious interplay that is integral to our cultural past. When discussing the art of Latin America, this geographic designation, though relative to overarching discussions of work produced in Europe or the United States, obscures many potential complexities encompassed by the large number of countries it denotes, spanning North, Central and South America as well as the Caribbean. A historiographical approach can yield a more nuanced understanding, conducted by viewing artistic creation as intrinsically linked to the economic development of each country, the careers of individual artists and how works of art may have been inspired by specific themes—in this case music. To understand more clearly how music evolved in the region, we need to reflect upon a successive layering of at least three historical and cultural elements: the indigenous, the European (primarily Spanish and Portuguese) and, in many instances, the African.

History, archaeology and ethnomusicology can provide us with a rather clear idea of the actual contours of pre-Columbian music. For example, present-day Mexico was once the home to a tremendous variety of indigenous cultures (e.g., Maya, Mixtec, Zapotec, Tarahumara and Otomi). These peoples fashioned single-duct flutes and panpipes, trumpets, percussive calabashes and vertically and horizontally played drums (including *teponaztli*s, or tree-trunk drums, which were equipped with anywhere from two to four slits, sometimes with heads fashioned from animal skins at each end). They also used a wide range of rattles and idiophones that were either shaken or scraped (figs. 159 and 160).

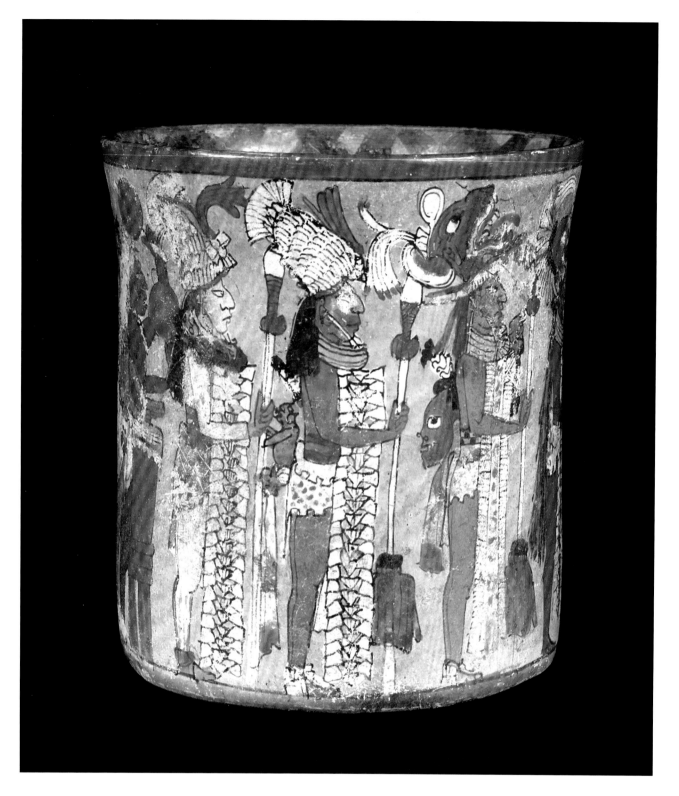

159. Polychrome Vase. Maya, Late Classic, 650/750–900 AD.
Ceramic, 8 × 7¼ in. (20.3 × 18.4 cm). Dumbarton Oaks Research
Library and Collection.

The teponaztli was played with two resin-tipped mallets by a musician either seated on the ground with the drum resting on a braided tule-grass mat or standing with the drum positioned on a wooden stand. These instruments evidence a high level of musical sophistication, since they are capable of producing refined intervals in major seconds, major or minor thirds, fourths or fifths. The teponaztli was often accompanied by singing and dancing, and was played to honor ancestors and elders or as a tribute to warriors who were slain or captured for sacrifice. The instrument provided the percussion for many community songs and was often lavishly decorated with zoomorphic and human motifs (figs. 161 and 162).[1]

After the Spanish conquest, officials of the Catholic Church fomented the dissemination of religious music, painting, sculpture and architecture, which were viewed as essential elements in the evangelization of the New World. Religiously inspired works were used in an attempt to eradicate indigenous forms. However, hybrid works of art would inevitably emerge as a reflection of the mixing of both cultures. With the onset of independence from their European colonizers, the nations of Latin America eventually sought out their indigenous roots, which would in turn surface in the form of artistic creation. The art produced during the Colonial period, which reflected a European world of tremendous wealth, was repudiated for many years until the arrival of modernism.[2]

In the early twentieth century, when many of the countries in Latin America were celebrating the centennial of their independence from Spain or Portugal, artists began to question the very nature of the culture and art that had evolved within their own borders. With the rise of great cities and the unfolding of massive economic development, a need arose to seek out forms that could be used to forge a new aesthetic language. The responses to this need would take on different forms in each country and, more importantly, in the works of each artist. Different strategies emerged in this common quest for modernity without eschewing issues of national identity.

A common trait that can be seen in all of these artists, regardless of their discipline, was that they were drawn to complete their education in Europe, particularly in Paris. Prior to the end of World War II, Paris was the center of the Western art world. Beginning in the nineteenth century, artists from Latin America would attempt to establish contacts with their European counterparts and immerse themselves in the latest artistic movements. They embarked with certain idealistic preconceptions regarding Europe and the latest stylistic trends, which they sought to embrace, only to be confronted by a reality that was quite different from what they had imagined. They inevitably began to create interpretations and adaptations based also on the art of their homelands. This process of reformulation did not end in Europe, however. Once

160. Drum in the Form of a Warrior. Proto-Nazca period, ca. 300–100 BC. Incised and slip-decorated ceramic, 13¼ × 8 × 8 in. (33.7 × 20.3 × 20.3 cm). Kleinbub Collection.

they returned to the Americas, they would embark on a process of creating an "unprecedented art" as heralded by Uruguayan artist Joaquín Torres-García.

This transmigration of ideas, which occurred to varying degrees throughout Latin America, was adapted to the particular contexts of each art movement that emerged in the region. In this regard, Mexico possessed certain unique conditions for the development of its own conception of artistic modernity. Following the Mexican Revolution (1910–20), the government drafted legislation aimed at fostering artistic creation, which was based on an integrated model that would be used to build a new nation. The most famous example of this strategy can be seen in the development of Mexican muralism. This movement also attracted a wide range of artists in all disciplines coming from Europe and the United States, as well as intellectuals who wished to study this phenomenon, which was considered exemplary.[3]

In Latin America, visions of the future have never been entirely disengaged from inquiries into the past. These two elements were

161. Teponaztli. Mexico, Mexica culture, Central Altiplano region, ca. 1500. Wood, 10⅛ × 8⅞ × 27¼ in. (25.6 × 22.6 × 69 cm). National Museum of Anthropology, CONACULTA-INAH, Mexico City, Inv. 10-78329.

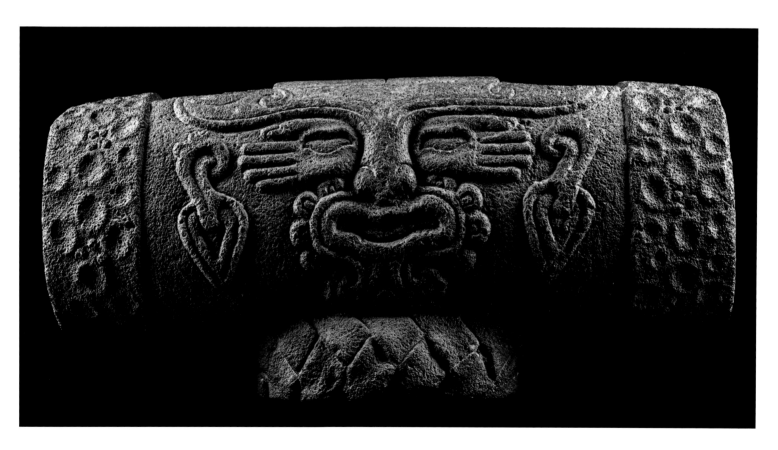

162. Teponaztli macuilxochitl. Mexico, Mexica culture, Mexico City, ca. 1500. Stone (andesite), 13⅛ × 9⅝ × 28⅛ in. (33.5 × 24.5 × 71.5 cm). National Museum of Anthropology, CONACULTA-INAH, Mexico City, Inv. 10-222373.

not envisioned as antagonistic but as part of the same active and configurative discourse. In this regard, the works of Rufino Tamayo and Carlos Mérida are worthy of consideration since their own very modern iconography palpably draws from the pre-Hispanic past. Their approach is not to copy the past but rather to breathe new life into it.

Carlos Mérida's career runs parallel to these phenomena in intriguing ways that link the visual with the musical. Raised in a household where culture was held in high esteem, he began to acquire artistic skills at a very young age, particularly in the fields of music and painting. He initially hoped to pursue a career as a pianist, but due to the early onset of hearing loss he focused his attentions on painting. Given his musical predilections, he was drawn to the rhythmic abstractions of various modern masters such as Kandinsky and Klee.

For Mérida, abstraction was a precocious interest. In 1920 he wrote his first newspaper article, which was devoted to the Simultaneism of Robert Delaunay (fig. 203). The subject at the time was seen as somewhat eccentric in Mexico. By the 1940s, however, Mérida was applying Delaunay's theories of abstraction to his own work, which he would continue to define and even expand over time. In 1927 he began a two-year sojourn in Paris, where he came into contact with Paul Klee and Joan Miró and the avant-garde art movements of the period. He soon abandoned political representation and entered a phase marked by formal abstraction based on indigenous themes and motifs. Mérida always referred to his own hybrid Spanish and Maya-Quiché background as a source of great pride.

Music and dance served as inspirational languages for Mérida. From 1932 to 1935, he was in particularly close contact with these disciplines due to his involvement as the director of the Ministry of Public Education's School of Dance in Mexico City. Mérida's contributions to dance in Mexico were grounded in popular expressions and were essentially twofold: In 1933 he created a Mexican Ballet that was inspired by the most famous regional dances, yet it was also directly linked to his own visual style and conceptions. Though one of the nation's great pioneers of the field, Mérida's participation in Mexican popular dance occurred during a highly propitious period. He worked together with librettists Nelly Campobello, Martín Luis Guzmán, Miguel Bueno and Celestino Gorostiza; musicians Silvestre Revueltas, Blas Galindo, Luis Sandi, Carlos Chávez and Eduardo Hernández Moncada; and choreographers Gloria and Nelly Campobello, Graciela Arriaga, Anna Sokolow, Gloria Contreras, Evelia Beristáin and Rosa Reyna, as well as his own daughter Ana Mérida. Mérida's second contribution arose through his work in set and costume design. His creations were largely inspired by regional indigenous arts and crafts—in the form of popular toys, animal masks and costumes, which he fashioned principally from cardboard—as well as his own geometric references as an abstract artist.[4]

One of Carlos Mérida's masterworks is undoubtedly *In a Major Key* (*En tono mayor*), in which he gracefully synthesizes the rhythms of music and dance with a consummate use of color and abstraction (fig. 163). The title might refer to either pictorial or musical works. In art, tone is understood as representing the quantity of lightness or darkness in a given color, which, broadly defined, can be the result of the amount of black or white added. In music, a major key is created by the use of major chords or a major scale, which is generally understood as producing a melodic/harmonic modality associated with uplifting, exuberant music. Major tones are used to create a positive, luminous or joyous mood. Mérida's skill in integrating a synthesis of associations is obvious in this image.

In the case of Rufino Tamayo, he was part of the generation noted for its opposition to the political tenets of the muralists when he enrolled in the Escuela Nacional de Bellas Artes, Mexico City, in 1917. This was a difficult moment; the country was in the midst of revolution and the Academy was in decline. Tamayo was able to remove himself from the nationalist painting styles. As a young man he brought an innovative treatment to still lifes, portraits and, above all, his use of color and tone as the principal subject of his painting. There is no color that Tamayo used for which he did not know how to take complete advantage of its tones, effects and textures. As in the majority of his works, *Sleeping Musicians* (*Músicas dormidas*)[5] (fig. 164) "uses a code of forms and symbols that are related to the existential interests of humanity, with its vital anxieties and satisfactions; he has exposed all of this in a poetic way, or within a realism in which the magical is not absent."[6] Nudes appear with some frequency in his work, and he uses them with great subtlety and in significant situations, as in the couple in *Sleeping Musicians*. Solitary figures in the middle of the sky—that is, man in his relationship with the cosmos and its mysteries—are another recurrent subject in his pictorial repertoire, here depicted as musicians potentially able to conjure the Pythagorean harmony of the spheres.

Many visual artists also worked in other disciplines, which they employed to develop their own new forms of expression. In other countries, modernizing impulses were not articulated by the state but by specific catalysts within society, with the corresponding national differences being framed by conceptions of cultural identity. Examples of painters whose talents extended into the fields of music and dance include Mario Carreño, Pedro Figari, Miguel Covarrubias and Fernando Botero. Whenever music and dance are

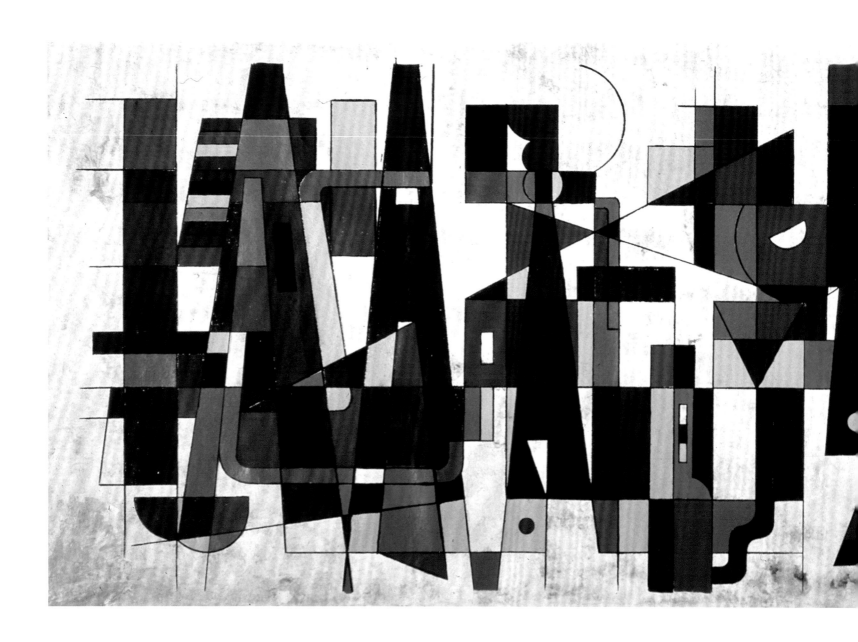

163. Carlos Mérida (1891–1985). *In a Major Key* (*En tono mayor*), 1981.
Serigraph, 31½ × 94½ in. (80 × 240 cm). Collection of Susana Pliego.

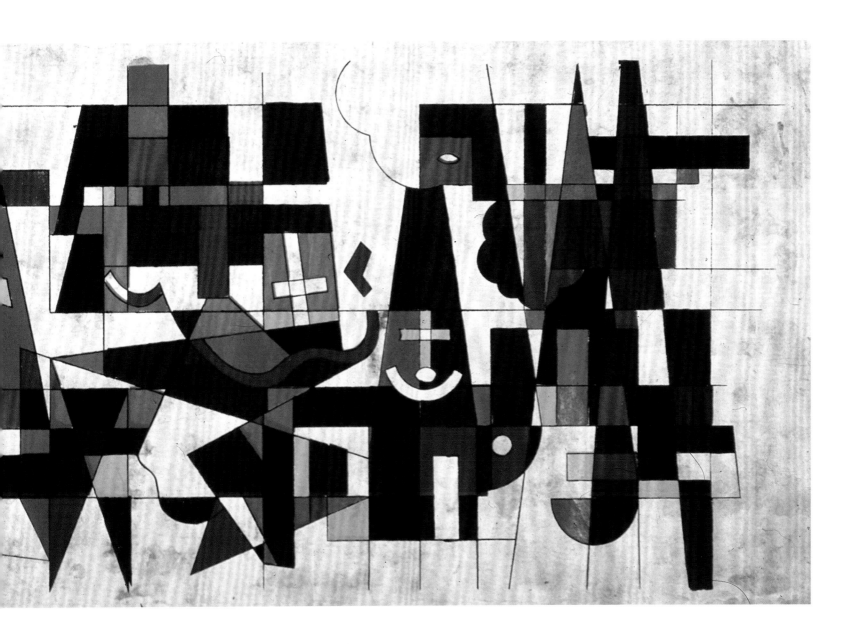

represented in painting, an attempt is made to weave some theoretical, historical or contextual framework into the forms. These elements can be essential for decoding the thoughts of the artist and should not be seen as the simple rendering of a stereotypical or folkloric scene. This is the case with the highly distinctive representations of dance found in the work of Pedro Figari, who focused much of his painting on the popular musical forms found among the various ethnic groups who made up the urban fabric of Uruguay (fig. 165).

Botero's paintings are most readily understood as reinterpretations of the works of the great Renaissance and Baroque masters. There are, however, other themes that form an important element in his work, most notably music and dance. An analytical approach to these themes began to surface in the paintings of

this Colombian artist in the 1950s. The wide range of subjects and themes in his work includes the appearance of corpulent dancers and large-scale musical instruments. Botero's most obvious talent lies in his approach to forms, which are impossible to avoid in his paintings. By playing with disproportion, we come to differentiate these exaggerated forms from a more "uniform" reality—his figures are extraordinary, even if they are shown engrossed in rather ordinary tasks.[7]

Eschewing any strict use of synesthesia or classical musical iconography, Botero nonetheless manages to create a groundbreaking and transformative vision of musical elements, even through the ingenious mutations of musical instruments found in his compositions. In Botero's 1980 painting *Dancing in Colombia* (*Baile en Colombia*), we find a musical group accompanying a dancing

164. Rufino Tamayo (1899–1991). *Sleeping Musicians* (*Músicas dormidas*), **1950.** Oil on canvas, 50¾ × 76⅜ in. (129 × 194 cm). Museo de Arte Moderno.

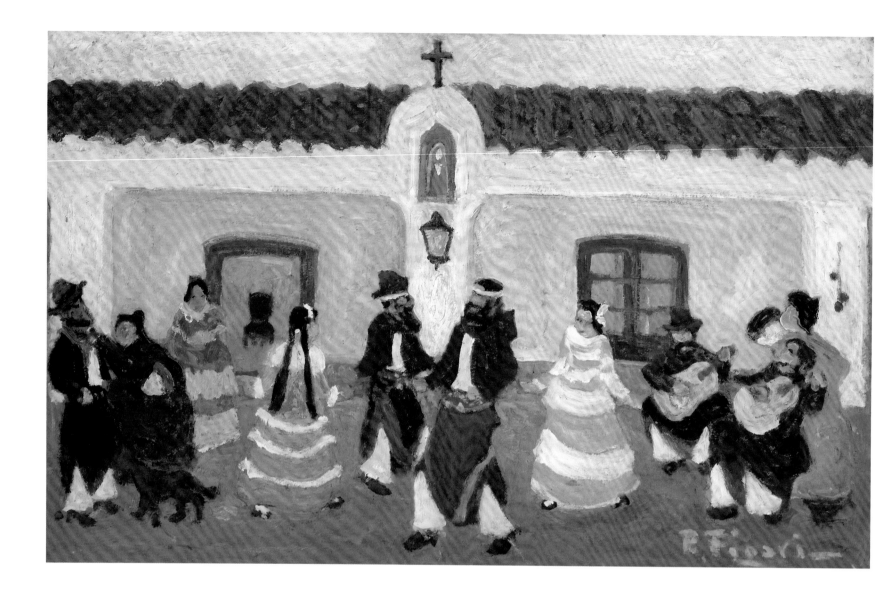

couple who form the very center of the composition (fig. 166). These dancers, who are far smaller than the musicians surrounding them, suggest movement through the positioning of limbs and the woman's fluttering coif, despite the otherwise static nature of the work. Seven massive poker-faced musicians occupy the background (a double bass player, a flautist, two guitarists, two clarinetists and a tuba player). As in other works that feature musical instruments, the artist's representations suggest a level of distortion. The tuba player, for example, is clearly seen blowing into the mouthpiece and embracing the tuba with both hands, yet it is virtually impossible for him even to touch the valves of the instrument, which would obviously control the musical tones emitted. We also find the representation of certain musical forms that reflect other more academic references, specifically drawn from the Renaissance and the Baroque. In the double bass, we see that the more traditional, contemporary f-shaped sound holes are depicted as "C" holes. During the High Renaissance and Baroque periods, one of the most popular musical instruments—also depicted in many

165. Pedro Figari (1861–1938). *Gato,* **n.d.** Oil on board, 19¾ × 32 in. (50.2 × 81.3 cm). Collection Pérez Art Museum, Miami; Gift of Darlene and Jorge M. Pérez.

works of art—was the viola da gamba, which was equipped with c-shaped sound holes. It is likely that this instrument served as a model for Botero's depiction. A similar phenomenon can be observed in the guitars, which, unlike contemporary models, are not rendered with a pronounced waist.[8]

Rafael Coronel's metaphorically sophisticated works of art—no element can be seen as merely spontaneous or gratuitous—often reflect ideas and iconography from traditional dance and music. Coronel grew up in a family of artists. His brother Pedro is a prominent painter in his own right, and Coronel's grandfather employed his own creative energies decorating churches. As a child, Coronel moved from Zacatecas to Mexico City and devoted himself

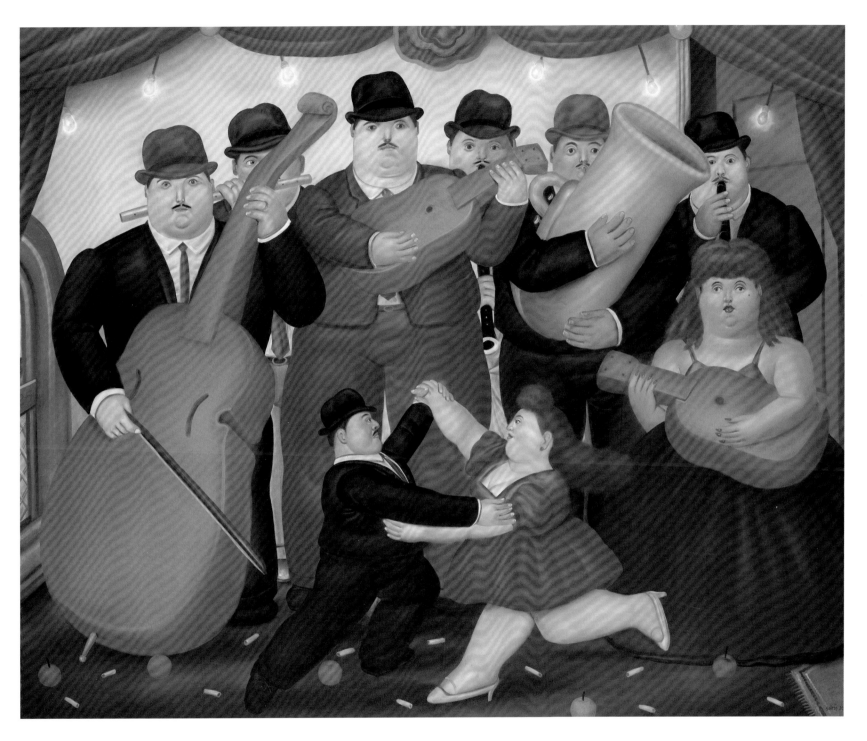

166. Fernando Botero (b. 1932). *Dancing in Colombia (Baile en Colombia),* **1980.** Oil on canvas, 74 × 91 in. (188 × 231.1 cm). The Metropolitan Museum of Art; Anonymous Gift, 1983.

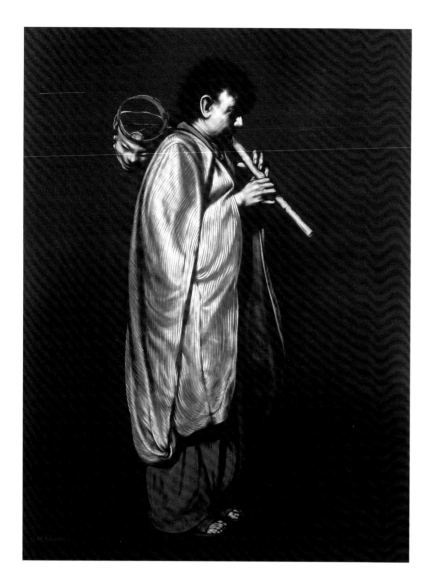

167. Rafael Coronel (b. 1931). *The Flute Player* (*El flautista*), 1979. Oil on canvas, 78¾ × 59⅛ in. (200 × 150 cm). Pérez Simón Collection, Mexico.

to architecture and drawing. By 1954, Coronel had already gained access to the local art market and gallery scene, largely through the help of Carlos Mérida. Mérida introduced him to Inés Amor, a gallery owner who worked with some of the major Mexican artists of the time, including Rufino Tamayo, Gunther Gerzso and Diego Rivera. Throughout his career, Coronel amassed a vast collection of Mexican folk art, including an astonishing number of regional masks, considered by many to be the largest mask collection in the world. In 2011, the Rafael Coronel Museum was inaugurated in the city of Zacatecas, Mexico, in a late sixteenth-century building that formerly served as the Convent of San Francisco, one of the oldest structures of its kind in northern Mexico. The museum houses Coronel's collection.[9]

Coronel's painting *The Flute Player* (*El flautista*) is suffused with an aura of sacred mysticism, yet the work also contains certain farcical elements and is linked to a traditional Mexican dance with its own libretto and narrative (fig. 167). The piece was created for an exhibition titled *The Anonymous Face* (*El rostro anónimo*) along with a series of other paintings depicting people from daily life. His son said of this series, "My father always spoke of those people who expend so much energy in life yet never wind up in the mainstream, even though they're contributing to culture, as is the case with folk art."[10] The work represents one of the figures in the *Danzas de Moros y Cristianos* from the tradition of *pastorelas*. Given the details on the mask—one of the artist's major areas of interest—we know that Coronel is referring to the dances performed in the states of Guerrero, Mexico, Puebla and Veracruz. The pastorela is a form of religious street theater that originated in medieval Europe. It was brought to the Americas by the Franciscans, who felt that it was suitable for the purposes of evangelization since it could be readily grafted onto preexisting indigenous traditions of ritual dance, singing and theater. The *Danza de Moros y Cristianos* symbolizes the struggle between the faithful (Christian Spaniards) and the unfaithful (the ruling Moors they rebelled against), in which the indigenous actors play the role of the *Moros*. Instead of being expelled, however, these Muslims are eventually "saved." The tradition of Conquest-era *danzas* continues to this day.[11]

Kazuya Sakai is a later example of an artist whose music-related interests were integral in the development of his aesthetic. Sakai was born in Buenos Aires to Japanese parents. After being involved in various projects aimed at disseminating Japanese culture and literature in Argentina, he spent three years in New York City, where he came into contact with the Pop art scene and, like Korean-American artist Nam June Paik, became enthralled with the experimental soundscapes of John Cage. He later moved to Mexico City, where he lived from 1965 to 1977, eventually working as a graphic designer for the cultural and literary review *Plural*, moving among the circle of intellectuals that surrounded the publication's editor, Nobel Prize–winning author Octavio Paz. Sakai slowly began to adopt a signature style of abstract painting that embraced geometric forms, brilliant colors and a rhythmic affinity drawn from music.

Filles de Kilimanjaro III (Miles Davis) is part of a series of works that Sakai created in the 1970s paying tribute to avant-garde musicians, particularly those who devoted their careers to various forms of experimental music, most notably jazz (fig. 168). The title of this piece pays homage to Miles Davis's eponymous recording. What is especially striking is how Sakai methodically attempts to incorporate musical ideas based on improvisation and spontaneity.

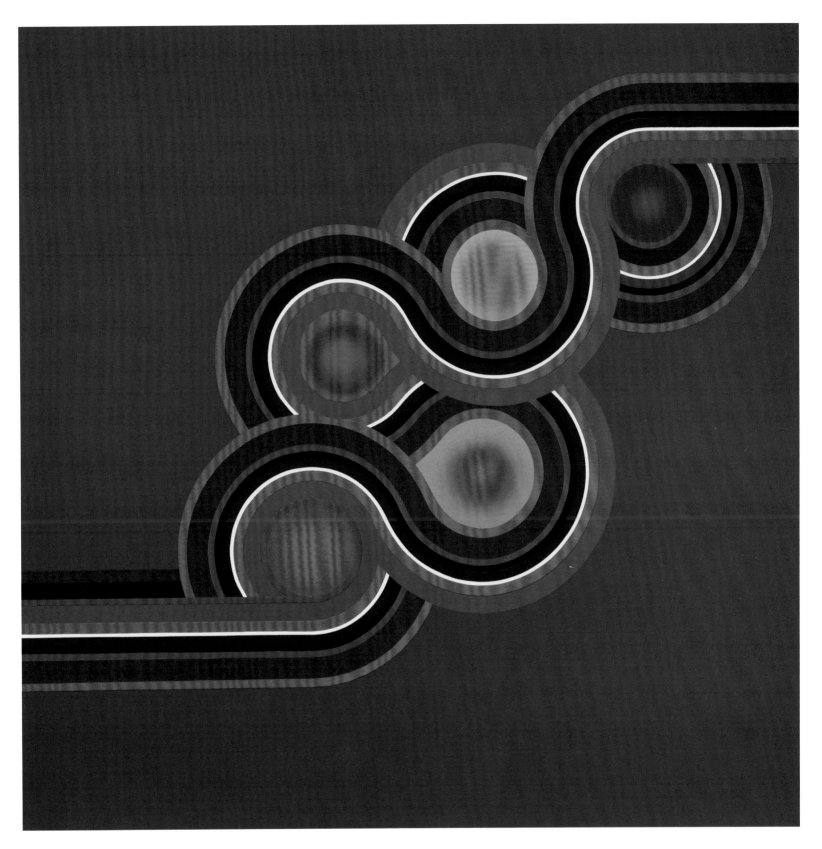

168. Kazuya Sakai (1927–2001). *Filles de Kilimanjaro III (Miles Davis)*, 1976.
Acrylic on canvas, 79 × 78¾ in. (200.6 × 200 cm). Blanton Museum of Art, The
University of Texas at Austin; Archer M. Huntington Museum Fund, 1977.

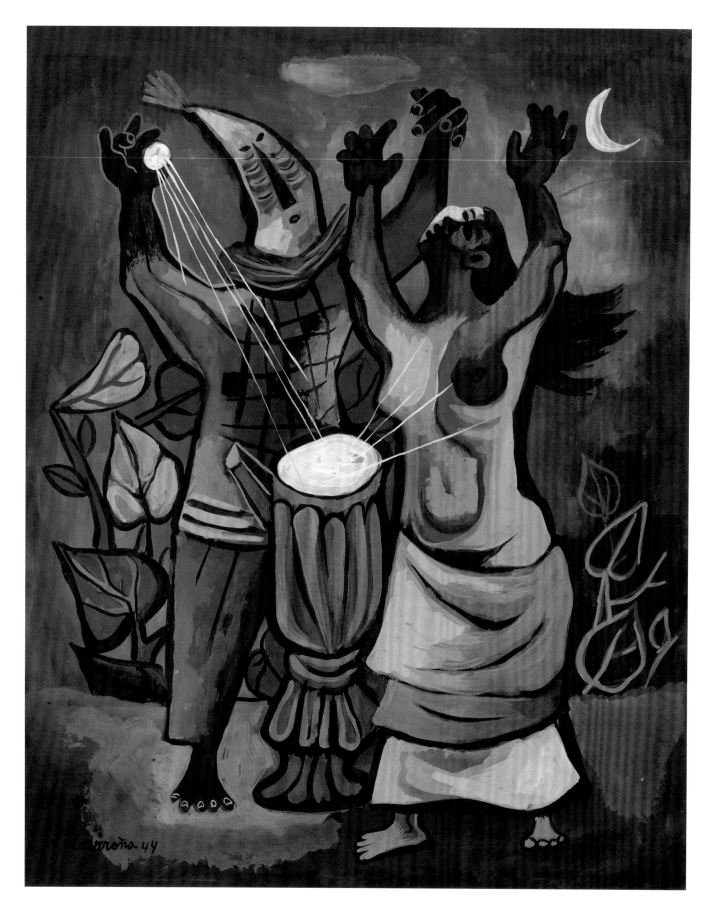

169. Mario Carreño (1913–1999). *Afro-Cuban Dance*
(*Danza Afrocubana*), 1944. Gouache on paper, 23½ × 19 in.
(59.7 × 48.3 cm). Collection OAS Art Museum of the Americas.

Of his work he said, "As in jazz compositions, where the musician improvises over a rhythmically structured base (however minimal it may be), the asymmetry of the circles on the solid and constant plane of the background suggests the controlled spontaneity, at once free and restricted, of that musical genre."[12]

The project of visual and musical modernity envisioned in twentieth-century Latin America also included the participation of important sectors of the population that had not been previously represented—the indigenous and black communities. Representation of black culture in the visual arts was virtually nonexistent prior to the abolition of slavery. Black cultural and religious influence began to gain greater visibility, however, as the new republics in the region evolved. Cuba, Brazil, Colombia and Venezuela have been at the forefront of this trend, due, of course, to the important role that black communities play in the general social fabric of these nations. Like the Mexican muralism movement, *Indigenismo* in Peru, for example, attempted to uncover the various possibilities for indigenous representation while also seeking to reduce any aspects of exoticism by examining actual socioeconomic and cultural conditions.

Cuba, unlike Mexico, Guatemala, Argentina and Uruguay (and to a lesser degree Colombia), has very strong African roots. Given that the island's indigenous population of Taínos and Ciboneys, and their music, disappeared such a long time ago, Cuban popular music is largely African in origin, particularly in terms of percussion, rhythms and sensuality. It was not until well into the eighteenth century that European classical music was cultivated on the island. By the nineteenth and twentieth centuries, Cuba's impact on Latin American music in terms of repertoire and overall influence was already considerable. Mario Carreño's modernist rendering of an Afro-Cuban dance speaks to this history (fig. 169).[13]

All of the narratives of identity discussed in this brief essay are nourished to varying degrees by the region's rich musical forms, particularly in terms of contrast and tension. The diverse languages employed by these artists derive from unique ways of seeing and interpreting, yet they are also articulated as part of a search for a new common identity, one that can harmoniously link together these former European colonies while also drawing upon their indigenous past.

NOTES

1 Most of this information is taken from the writings of Fr. Bernardino de Sahagún (Spain, ca. 1499–Mexico, 1590), one of the most renowned Franciscan missionaries from Spain. Sahagún left an invaluable legacy of works written in both Nahuatl and Spanish, including the *Historia general de las cosas de la Nueva España* (translated as *General History of the Things of New Spain*), a compendium of twelve illustrated volumes written between 1540 and 1585, shortly after the Spanish conquest of Mexico. The most famous manuscript of this work is referred to as the Florentine Codex, since it is held in the Laurentian Library in Florence, Italy.

2 I do not wish to make any authoritative, sweeping generalizations. These observations are merely meant to provide a contextual framework for the pieces presented in this brief overview of the relationship between the visual arts and music, as evidenced through a sampling of renowned artists.

3 See Jean Charlot, *The Mexican Mural Renaissance, 1920–1925* (New Haven: Yale University Press, 1963).

4 Mérida is credited with participating in a total of twenty-two theatrical works—three of which were never staged—from 1940 through 1979.

5 Originally, the title of the painting was *Músicos dormidos* (male), as referred to in a letter sent by Olga Tamayo in November 1950. See *Rufino Tamayo*, exh. cat. (Paris: Galerie Beaux-Arts, 1950).

6 Xavier Moyssen, "Tamayo, Mérida, Paalen y Gerzso," in *El arte mexicano*, SEP-Salvat, México, Vol. 14: 2090.

7 Eduardo Serrano, *Un lustro visual. Ensayos sobre arte contemporáneo colombiano.* (Bogotá: Museo de Arte Moderno y Ediciones Tercer Mundo, 1976), 71.

8 Anton Radevsky, et al., *Enciclopedia ilustrada de los instrumentos musicales. Todas las épocas y regiones del mundo.* (Barcelona: H. F. Ullmann, 2009), 203.

9 This museum is not to be confused with the museum dedicated to his brother Pedro, which was founded in 1983, also in Zacatecas, and which contains collections of art from various cultures.

10 Taken from my interview with Juan Coronel Rivera, January 2015.

11 See Demetrio E. Brisset Martín, "Fiestas hispanas de moros y cristianos. Historia y significados," in *Gazeta de Antropología* no. 17 (2001), article no. 3. Facultad de Ciencias de la Información. University of Málaga, Spain. http://hdl.handle.net/10481/7433.

12 Interview with Rodrigo Alonso Kazuya Sakai, *La Pintura desde el Espíritu de la Música*, exh. cat. (Buenos Aires: Museo de Arte Contemporáneo de Buenos Aires, 2013).

13 See Alejo Carpentier, *La música en Cuba* (Mexico: Fondo de Cultura Económica, 1946).

Patrick Coleman

Echoes of a Dark and Deep Unity: Exchange, Collaboration and Innovation

By working in common, the art forms each attain the capacity to be and to do the very thing, which of their own and inmost essences, they long to do and be. Each, where her own capacity ends, can be absorbed in the other, . . . proving her own purity, freedom, and independence as that which she is.

—RICHARD WAGNER, *THE ART-WORK OF THE FUTURE*[1]

In the second half of the nineteenth century, Richard Wagner came to supercede Beethoven as the artist *par excellence* to admire and emulate across all of the arts, though not without a struggle. Concerts of his music and performances of his operas were often accompanied by vehement public controversy and spirited defenses. His influence cut across all artistic disciplines, spread through direct exposure to his "music dramas" as well as his theoretical writings like *Art and Revolution* (*Die Kunst und die Revolution*, 1849) and *The Art-Work of the Future* (*Das Kunstwerk der Zukunft*, 1849). The composer's ideals were traded in fervent dialogues between poets, novelists, critics, painters, sculptors, dancers and other composers alike—something made uniquely possibile by the density and freedom of cosmopolitan urban centers like Paris in the mid- to late nineteenth century. The *Révue wagnérienne*, founded by the writer Édouard Dujardin, was dedicated entirely to Wagner's defense and celebration. This direct exchange of ideas and techniques between visual and musical artists in a close community allowed for the sister arts of music and painting to exert a strong mutual influence.

In Édouard Manet's *Music in the Tuileries Garden* (fig. 170), we find some of the young Wagnerians gathered in the park for a concert, including Manet himself. There, too, is Charles Baudelaire, whose influential poem "Correspondances" figured the synesthesia of sound, color and scent as echoes overlapping in a "dark and deep unity,"[2] along with composer Jacques Offenbach (composer of the operetta *Orphée aux enfers*, or *Orpheus in the Underworld,* which satirized Gluck and whose overture is the source of the music popularly known as the "can-can"), Théophile

Gautier (novelist, poet and critic apt to make connections between painting and music in his reviews) and Henri Fantin-Latour (best remembered for his floral still lifes and his resolute realism despite his friendship with so many Impressionists). This dense milieu of artistic exchange is what allowed for new, revolutionary and often utopian ideas to take hold quickly and be put into practice.

The notion of a visual art made in emulation of music's abstract, expressive and affective aspects—the *ut pictura musica* to Horace's *ut pictura poesis*—became a foundational concept for many of the innovations in the nineteenth and twentieth centuries, and Wagnerism was a major part of that shift. It signaled the transition of visual artists from depicting a highly finished view of the world-out-there to how that world registered on the interior, sensing self, which would run through Impressionism, Cubism, Synchromism and nearly every other modernist movement. Not only in subject but in perspective and facture—especially his sensual, subjectivizing handling of paint—Manet's *Music in the Tuileries Garden* presages much of what is to come at the intersection of these

170. Édouard Manet (1832–1883). *Music in the Tuileries Gardens*, 1862. Oil on canvas, 30 × 46½ in. (76.2 × 118.1 cm). National Gallery, London; Sir Hugh Lane Bequest, 1917.

sister arts. In fact, Therese Dolan, expanding upon the opinion of Clement Greenberg, has argued that this painting and Wagner's *Tannhäuser*, which premiered the year before, launched modernism itself.[3]

The Musical Print

Fantin-Latour's passion for the German composer was frustrated when *Tannhäuser* premiered in Paris in 1861: controversy over the production led to its being canceled after three nights, and he had a ticket for the fourth.[4] In response, he made *Tannhäuser on the Venusberg*, first prepared as a lithograph the same year Manet painted *Music in the Tuileries Garden*, and later reprised in

oils (fig. 171). The composition is based on music he had heard in concert and second-hand knowledge of the staging. The scene it depicts was the most radical and controversial of the performance, signaling Fantin-Latour's identification with the iconoclastic and expressive aspects of Wagner—aspects that bridged the Romantic and modern artist. This inaugurated an extensive series of music-themed prints throughout the rest of his career, most executed after a pilgrimage to the Wagner Festival at Bayreuth in 1876 to see the complete *Ring* cycle (figs. 172–5).

"The soul," Fantin-Latour once explained, "is like music playing behind the veil of flesh; one cannot paint it, but one can make it heard or at least try to show what you have thought of it."[5] The airy style Fantin-Latour adopted for his Wagner paintings and the rough, scratched lines of the lithographs are antithetical to the polished realism of his flower paintings. These are technical shifts meant to express his experience of listening to music,

171. Henri Fantin-Latour (1836–1904). *Tannhäuser on the Venusberg*, 1864. Oil on canvas, 47¼ × 60¼ × 3 in. (120 × 153 × 7.6 cm). Los Angeles County Museum of Art; Gift of Mr. and Mrs. Charles Boyer.

172. Henri Fantin-Latour (1836–1904). *The Evening Star* (*L'Etoile du Soir*), 1877. Lithograph, 11¾ × 8⅝ in. (29.7 × 22 cm). Jack Rutberg Fine Arts.

173. Henri Fantin-Latour (1836–1904). *Tannhäuser: Act III, The Evening Star* (*Tannhäuser: Acte III, L'Etoile du Soir*), 1887. Lithograph, 14⅞ × 9 in. (22.8 × 14.9 cm). Jack Rutberg Fine Arts.

174. Henri Fantin-Latour (1836–1904). *Prelude to Lohengrin*, 1898.
Lithograph, 19⅜ × 13⅝ in. (49 × 34.6 cm). Jack Rutberg Fine Arts.

175. Henri Fantin-Latour (1836–1904). *Evocation of Kundry* (*Évocation de Kundry*), 1898. Lithograph, 16¼ × 19 in. (41.2 × 48.3 cm). Jack Rutberg Fine Arts.

176. Henri Fantin-Latour (1836–1904). *To Johannes Brahms* (*À Johannes Brahms*), 1900. Lithograph, 23½ × 17⅞ in. (59.7 × 45.4 cm). Jack Rutberg Fine Arts.

to "make it heard" visually, inspired primarily by Wagner but also Berlioz, Schumann and Brahms (fig. 176).[6] In this attempt to evoke in visual terms the experience of listening, Fantin's musical prints have much in common with Max Klinger's "Evocation," from his series *Brahms Fantasy* (*Brahms-Phantasie*). The German artist printed musical scores for several of Brahms's compositions—he and Brahms would become close friends, as well—including the *Schicksalslied* (*Song of Destiny*), Op. 54, for chorus and orchestra, alongside Symbolist imagery redolent with musical associations: the composer at the piano, calling up with his song the exulting sea nymph and the battling Titans in the sky (fig. 177). For Klinger, as well as Fantin-Latour, prints were better suited to darker, more ethereal expressions—those closer to music.

The artist's book has often been considered a "musical" form, allowing one to create structure and form across time much in the way of musical notation—more than a single painting or drawing ever could. It's certainly true of Vasily Kandinsky's poems and woodcuts in *Sounds* (discussed below) but can be registered as well in William Blake's music-indebted *Songs of Innocence and of Experience*. Not only does the title frame the etchings as songs,

177. Max Klinger (1857–1920). "Evocation," plate 19 from *Brahms Fantasy* (***Brahms-Phantasie***), 1894. Etching, engraving, aquatint and mezzotint, 14⅝ × 17⅜ in. (37 × 44 cm). Fine Arts Museums of San Francisco; Gift of R. E. Lewis, Inc.

178. William Blake (1757–1827). "The Voice of the Ancient Bard,"
plate 25 from *Songs of Innocence and of Experience*, 1789–94.
Relief etching with pen, ink and watercolor, 4¼ × 2½ in. (10.8 × 6.4 cm).
Yale Center for British Art; Paul Mellon Collection.

but the form and content of the poems and the designs of the illustrations return to music. The introduction to *Songs of Experience* begins, "Hear the voice of the Bard!" and the book ends with "The Voice of the Ancient Bard," shown plucking a harp (fig. 178). It should come as no surprise, then, that these poems not only received musical exegesis at the hands of innovative contemporary composer William Bolcom (in a monumental composition process undertaken from 1956 to 1981) but were sung in delightful, warbling, quasi-period style with English folk accompaniment by none other than Allen Ginsberg in 1969.[7]

Fantin-Latour's musical fantasies show most his passion for music and the lessons he took from painters of Arcadian concerts including Titian and Corot. Like his friend James Whistler, he was equally influenced by Japanese ukiyo-e printmaking; Whistler wrote to him in 1867 to say, "Look how the Japanese understand this! They never search for contrast, but on the contrary for repetition."[8] Edo Japan was undergoing its own radical urbanization, and the role of music performance and the depiction of it by visual artists find intriguing parallel with European capitals in the nineteenth century, Paris especially.[9] The prints of the "floating world" granted European artists a license to depict everyday life, and concert- and opera going were a major aspect of the Parisian social fabric. This is clearly true in the works of Henri de Toulouse-Lautrec, whose images of solitary singers and dancers likewise show the influence of Japanese prints in rendering the vivid yet ephemeral gestures of famous nightclub singers in iconic and static visual form (fig. 179).

Moving in Concert

Manet's garden concert prefigured Degas and others taking to the dancehalls, sketchbooks in hand (figs. 180–3). Like the opera, the ballet and popular café-concerts were both a venue for social mixing between artists of different backgrounds and a site where the potent combination of visual and musical display could inspire new art, especially where it merged with physicality, movement and visual form through dance. Dancers, as well, took inspiration from the visual and musical artists whose company they enjoyed and whose work suggested new aesthetic values and choreographic forms.

Renowned dancer Isadora Duncan (1877–1927) based her choreography on the figures on antique Greek vases and bas-reliefs she saw in the British Museum and later the Louvre. Attempting to reconstruct or re-present some aspect of ancient art was never out of vogue and served her well in elevating dance, considered a lowlier form at the time.[10] More importantly, her inauguration of modern dance practice embodied—literally—avant-garde notions of the unconscious expressiveness of music. She danced to the work of Chopin, Tchaikovsky and Beethoven as often as to Gluck,

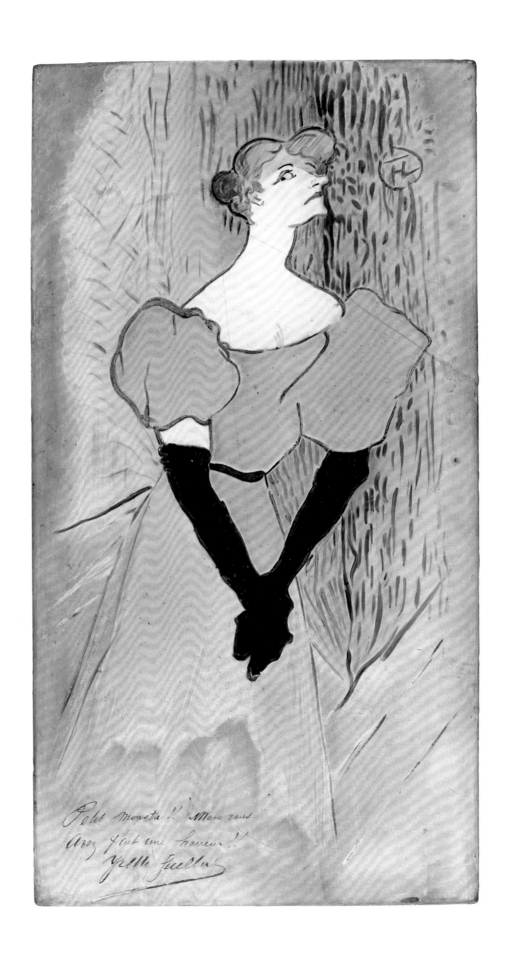

179. Henri de Toulouse-Lautrec (1864–1901).
Yvette Guilbert, 1895. Ceramic, 20½ × 11⅛ × ⅞ in.
(52 × 28.3 × 2.1 cm). The San Diego Museum of Art;
Gift of Mrs. Robert Smart.

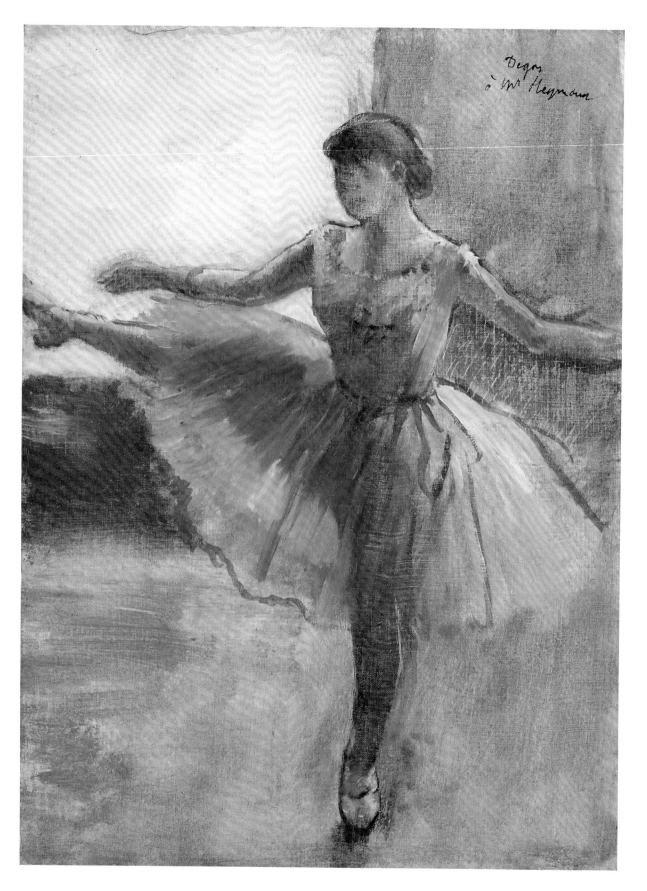

180. Edgar Degas (1834–1917). *The Ballerina,* ca. 1876.
Oil on canvas, 12⅝ × 9⅜ in. (32.1 × 23.8 cm). The San Diego
Museum of Art; Museum purchase through the Earle W.
Grant Acquisition Fund.

181. Henri Matisse (1869–1954). *Dancer*, 1925–26. Lithograph proof, 9⅞ × 16½ in. (24.9 × 41.9 cm). The San Diego Museum of Art; Gift of Mr. and Mrs. Leslie L. Johnson.

182. Henri Matisse (1869–1954). *Dancer Reflected in the Mirror*, 1927. Lithograph, 15½ × 10¾ in. (39.4 × 27.3 cm). The San Diego Museum of Art; Gift of Dr. Leonard and Betty Kornreich.

183. Everett Shinn (1876–1953). *Stage Costume*, 1910. Pastel and gouache, 7⅝ × 9⅝ in. (19.4 × 24.5 cm). The San Diego Museum of Art; Bequest of Mrs. Inez Grant Parker.

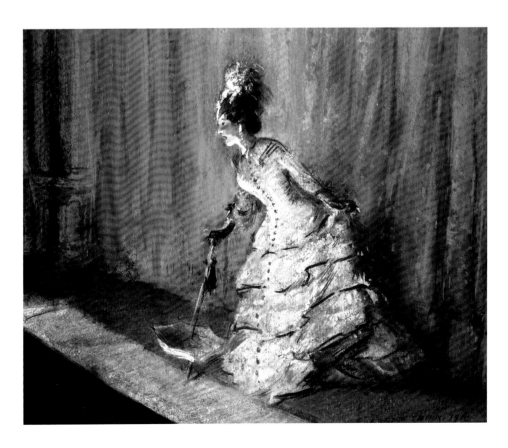

184. Isadora Duncan in an outdoor theater at the Acropolis.
Jerome Robbins Dance Division, New York Public Library for the
Performing Arts, Astor, Lenox, and Tilden Foundations.

185. Carl Jennewein (1890–1978). *Greek Dance*, 1925. Bronze on
polychromed wood base, 20½ × 16⅜ × 6½ in. (52.1 × 41.8 × 16.5 cm).
The San Diego Museum of Art; Gift of Mrs. Henry A. Everett.

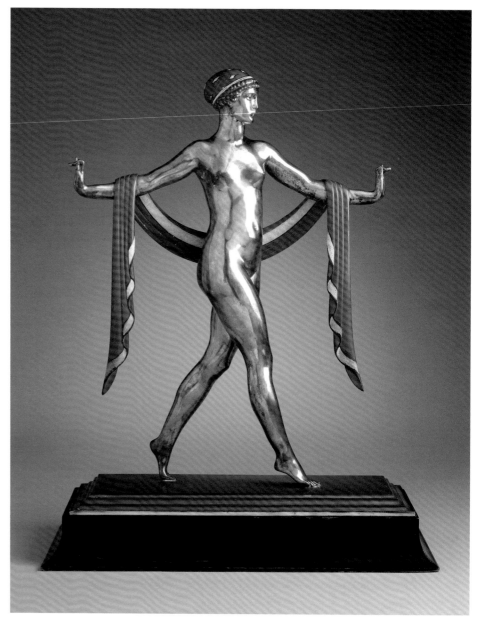

Wagner and César Franck. In all "[s]he penetrated into the realm of
music," her adopted daughter Maria-Theresa waxed in language
likely inherited from her mother, "danced its strains, danced the
inner life, permeating her psyche with its pulsating ebb and flow.
Her whole body became the bearer of the musical idea. . . . The
outer form was classical and the inner form was musical."[11] It is
no surprise, then, to find sketches and prints of her dancing in the
ouevres of many artists, often showing her in her signature Grecian
dress (fig. 184). To John Sloan, whose *Italian Procession, New York*
featuring a music-led parade through Greenwich Village was an
important foundation to The San Diego Museum of Art's American
collection (fig. 186), the San Francisco-born Duncan was emblem-
atic of a new American art modeled on expressive, Whitmanesque
simplicity (fig. 187). There was an element of sexual freedom to her

186. John Sloan (1871–1951). *Italian Procession, New York*, 1913–25. Oil on canvas, 24 × 28 in. (61 × 71.1 cm). The San Diego Museum of Art; Museum purchase with funds provided by Mr. and Mrs. Appleton S. Bridges.

187. John Sloan (1871–1951). *Isadora Duncan*, 1915. Etching, 8⅞ × 7⅜ in. (22.5 × 18.6 cm). The San Diego Museum of Art; Bequest of Earle W. Grant.

performance and public persona, too; Sloan adored her "great big thighs . . . her full solid loins."[12]

But for Abraham Walkowitz, a Russian-born member of the coterie gathered around Alfred Stieglitz's gallery 291,[13] drawing Isadora Duncan bordered on obsession. Duncan and Walkowitz first met in the studio of Auguste Rodin in 1906, and she danced to Schumann and Schubert at a salon afterward.[14] In the years that followed, Walkowitz made some 5,000 images of her, in pencil, ink, watercolor and crayon. "She had no laws," he later said. "She didn't dance according to rules. She created. Her body was music."[15] When taken collectively—they were often presented in sets, as shown in his book *Isadora Duncan in Her Dances*— the images possess a sense of the motion and possibilities of dance (fig. 188). As a collaborative production between artist and dancer, these images are the most varied and vital visual record of Duncan's performances. An apocryphal story has her seeing an exhibition of these works in 1916 and exclaiming, "Walkowitz, you have written my biography in lines without words."[16] It is a cross-genre formulation if there ever was one, extended when one reads Gertrude Stein's portrait-in-prose of Duncan, titled "Orta or One Dancing" (ca. 1910–11), which in an early draft contained the line: "she was then resembling some one, one who was not dancing, one who was writing."[17] Like many artists associated with Stieglitz

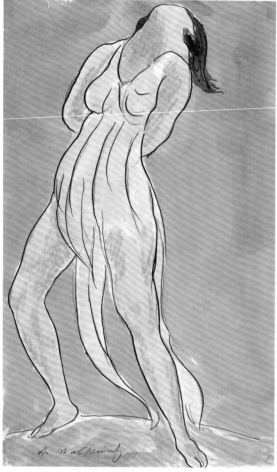

188. Abraham Walkowitz (1878–1965). *Dance Abstraction: Isadora Duncan*, 1931. Pen and ink, watercolor and graphite on paper, 14 × 8½ in. (35.6 × 21.6 cm). Yale University Art Gallery; Gift of Katherine S. Dreier to the Collection Société Anonyme.

189. Abraham Walkowitz (1878–1965). *Isadora Duncan*, 1912. Graphite on paper, 10½ × 7¾ in. (26.7 × 19.7 cm). The San Diego Museum of Art; Gift of Mr. and Mrs. Norton S. Walbridge.

and 291 in the 1910s, Walkowitz even saw the potential for abstraction drawn from Duncan's movements (fig. 189), which recalls Maria-Theresa's ode to Duncan's arms "bending upward, seeking the sun like a branch in its curve toward the light, all-embracing, world-entwining, a full gesture, fertile and endless!"[18]

Duncan was by no means the only dancer to inspire ekphrastic praise in which music was melded into the mode of expression. Anna Pavlova's popular ballroom dance, the Gavotte, was performed to "The Glow-Worm" by German composer Paul Lincke and was described as "like the creation of sculpture, thought out, felt, modeled, perfected down to the last detail."[19] Malvina Hoffman sculpted it in wax to give the garments and flesh a suppleness well suited to Pavlova's style (fig. 191). Pavolva danced in the original Ballets Russes production of *Cléopâtre* (1909), with sets and costumes by Léon Bakst, later reinterpreted in Orphic style by Sonia Delaunay-Terk and Robert Delaunay. Pavlova was also to star in *The Firebird* (*L'Oiseau de feu*, 1910), but between Sergei Diaghilev's preference for male dancers and the "nonsense" (in her words) of the music by twenty-eight-year-old Igor Stravinsky, she refused to perform it and soon struck out on her own. Both Pavlova and Ballets Russes choreographer Michel Fokine borrowed from Duncan's technique and her preference for dancing barefoot.[20] These productions of the Ballets Russes were occasions not only for painters to find subjects or ideas in dancers, or vice versa, but for visual artists, scenographers, choreographers, composers, dancers, musicians and, of course, impresario Sergei Diaghilev to collaborate on a single artistic product—another extension of the cross-arts mingling heralded by Wagner and taken as an imperative by the avant-garde.

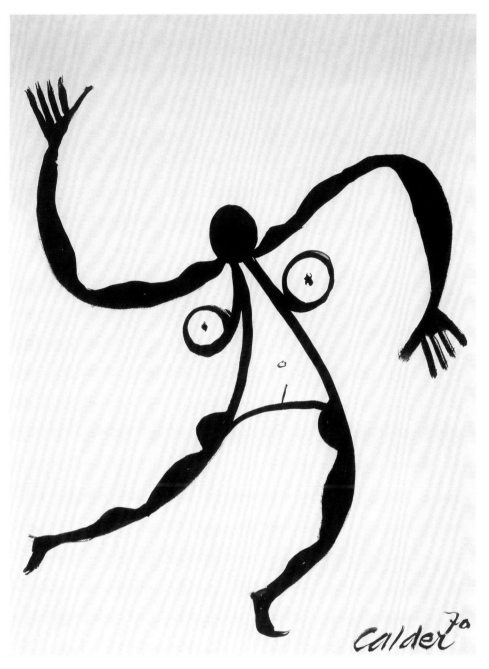

190. Alexander Calder (1898–1976). *Evelyn*, 1970. Gouache on paper, 30⅝ × 22⅞ in. (77.8 × 58.1 cm). Pérez Simón Collection, Mexico.

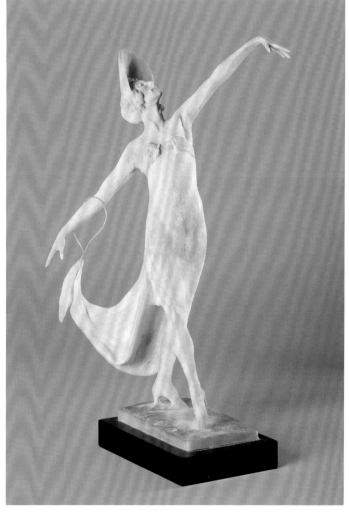

191. Malvina Hoffman (1887–1966). *Pavlova Gavotte*, 1915. Wax, 13½ × 8¾ × 6¾ in. (34.3 × 22.2 × 17.2 cm). The San Diego Museum of Art; Gift of Mr. and Mrs. Richard Reeve.

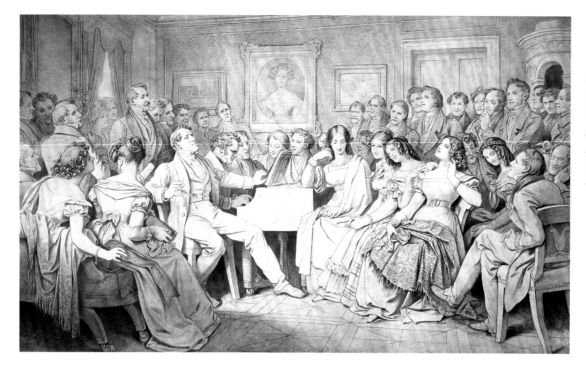

192. Moritz von Schwind (1804–1871). *An Evening at Baron von Spaun's: Schubert at the Piano among his friends, including the operatic baritone Johann Vogl*, 19th century. Pen and ink on paper. Wien Museum Karlsplatz.

In the Music Room

Among the Romantics who presaged much of this turn from *ut pictura poesis* to *ut pictura musica*, we find other important relationships. Franz Schubert, the pianist and composer of "Death and the Maiden" (String Quartet No. 14 in D minor, D 810, 1824), was an intimate friend of the painter Moritz von Schwind. While they were part of a larger circle of friends that included musicians, artists, writers and publishers, this relationship was the deepest and most mutually fruitful. Through Schwind, who was devoted to Schubert's music long after the composer's untimely death at thirty-one, we can see what a contemporary *Schubertiade* (or evening of music and poetry to celebrate Schubert's work) looked like, with the man himself at the piano (fig. 192). Through Schubert, Schwind kindled a lifelong passion for Mozart, which he hoped to develop into a series of paintings of *The Magic Flute* (*Die Zauberflöte*, 1791). This sketch depicts the Queen of the Night, moon rising behind her, with a mix of classical allusion and a sublimity of vision characteristic of the Romantic ethos of art and music (fig. 193). It is one of Schwind's designs for the foyer of the Vienna State Opera—some of the only parts of the building not destroyed in bombing during World War II—which would, with an additional commission to paint the lunettes, extend his depictions to scenes from other operas.

The collusion of the sister arts during the Romantic era was also expressed in work made for music rooms. Schwind painted one, *A Symphony* (1852, Neue Pinakothek), that mimics the musical structure indicated in the title by way of four narrative vignettes telling the story of a young man who falls in love with a singer. Philipp Otto Runge, the German artist and theorist who corresponded

with Johann Wolfgang von Goethe on music's relationship to color theory, also conceived of a project for a music room which was a suggestive precursor to Wagner's *Gesamtkunstwerk* (Total Work of Art), in which synthesis across several artistic disciplines was the utopian ideal. In Runge's plans for the *Times of Day—Morning, Evening, Day, and Night*, the harmony between man, nature and the divine—and also music, mathematics and color—was treated in a profound and complex way (fig. 194). Originally intended to be a set of four paintings, the project was left uncompleted upon Runge's death at age thirty-three. Two finished paintings of *Morning* (one cut apart and later reconstructed), a set of four prints in two editions and his notes toward the final plan emphasize a sense of harmony that is circular, rising—a canon for the eyes.

The symphonic treatment of time across the four engravings is our only record of the full visual program of the series. Runge envisioned these, in their final painted form, being installed in a specially designed sanctuary-like space, where they would be accompanied by music and poetry. Balance and order in painting is best expressed as music, according to Runge, because "music, after all, is always that which we call harmony and serenity in all three arts. There must be music through words in a beautiful poem, just as there must be music in a beautiful picture, and in a beautiful building, or in the divers ideas expressed through line."[21] The final effect of a *Times of Day* chapel, charting a progression of creation, growth, decay and death—of the divine and the earthly given a proportioned and balanced visual, musical and poetic expression—are suggested by Goethe, who hung the four prints in his music room. He reportedly entreated a visitor vigorously, "Just look at it: it's enough to drive you crazy, beautiful, and mad at the

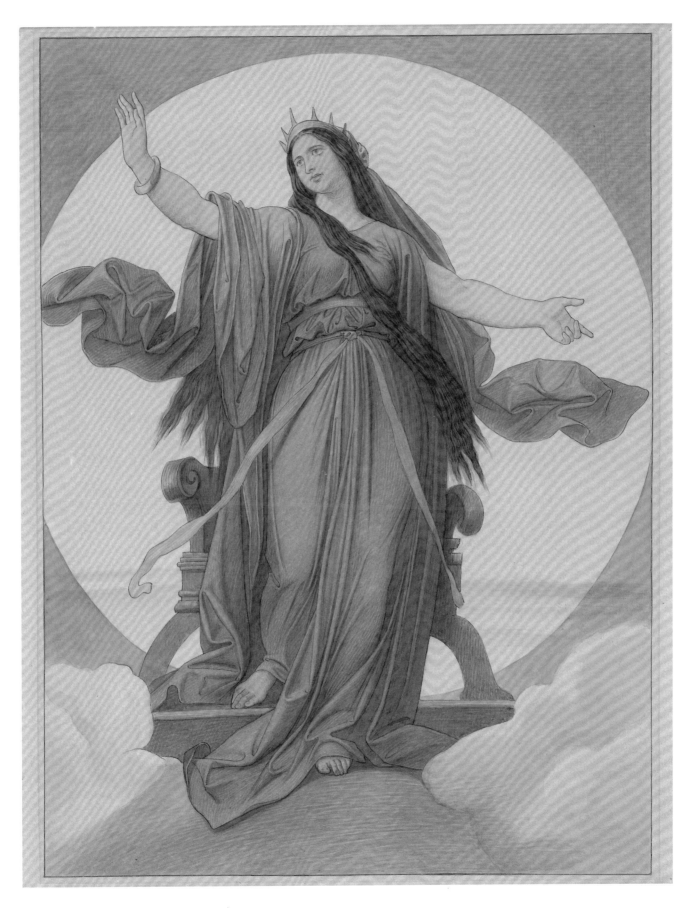

193. Moritz von Schwind (1804–1871). *Queen of the Night,*
ca. 1864–67. Watercolor over graphite, 16⅛ × 12¼ in. (41 × 31.1 cm).
The J. Paul Getty Museum.

194. Philipp Otto Runge (1777–1810). *Times of Day—Morning, Evening, Day, and Night*, 1805. Etching and engraving, each: 34½ × 23⅝ in. (87.5 × 60 cm). Printmaker: Johann Gottlieb Seyfert. The Getty Research Institute.

same time." The visitor replied, "Yes, just like the Beethoven that is being played."[22] The prints hint at what a sumptuous and profound experience the finished project would have been and how ahead of its time it was.

Collaborative Kandinsky

The frequent contact between artists and the increased credence given to aesthetic frameworks linking visual arts and music are no doubt a major aspect of their frequent collusion—in spirit and in practice—in support of advanced aesthetic agendas. In the beginning of the twentieth century, no visual artist would take Wagner's lead to delve deeply into the synthesis of aesthetic, spiritual and psychological influences within artistic production as seriously as Vasily Kandinksy.

Despite later rejecting Wagner, it was at a performance of his opera *Lohengrin* at the Bolshoi Theatre that Kandinsky experienced an overwhelming synesthesia which, along with his first encounter with Monet's haystacks, prompted him to abandon law for art. Of the performance Kandinsky said:

> The violins, the deep tones of the basses, and especially the wind instruments at that time embodied for me all the power of that pre-nocturnal hour. I saw all my colors in my mind; they stood before my eyes. Wild, almost crazy lines were sketched in front of me. . . . It became, however, quite clear to me that art in general was far more powerful than I had thought, and on the other hand, that painting could develop just such powers as music possesses.[23]

His innovations thereafter depended upon music as a model of nonrepresentational art that produces a direct, emotional effect on the soul through purely formal means. But he also proposed that a stimulus taken in by one sense organ "sets up vibrations along the corresponding paths leading away from the soul to other sensory organs,"[24] so that color can, by way of "inner resonance," directly stimulate hearing just as much as music can cause visual forms to appear in the mind's eye. This synesthesia, springing from his own experience of it at the performance of *Lohengrin*, forms the essential core of much of his art theory.

There's an echo of that experience in his often-quoted synesthetic metaphor for painting, how to make it and how to see it: "Color is the key. The eye is the hammer. The soul is the piano with its many strings. The artist is the hand that purposefully sets the soul vibrating by means of this or that key. Thus it is clear that the harmony of colors can only be based upon the principle of purposefully touching the human soul."[25] He had specific, schematic ideas of what effects certain forms and colors had, leaning heavily on the theories of Goethe (who in turn was influenced by Runge,

much as Paul Klee would be, as well). In describing these, he often appealed to musical metaphors: The geometric point was "the ultimate and most singular union of silence and speech,"[26] recalling his description of black as "an eternal silence, without future, without hope."[27] Yellow was trumpet-like and representative of madness. Red was reminiscent of a tuba-heavy fanfare when warm and bright, the lower registers of a cello when cool and dark. Orange was more a viola or alto voice. Violet was an English horn or a bassoon. Green was "the expansive middle register of a violin" or, more unusually, "a fat, extremely healthy cow, lying motionless, fit only for chewing the cud, regarding the world with stupid, lackluster eyes."[28] But blue, "the typical heavenly color," was the most important to him:

> Blue unfolds in its lowest depths the element of tranquility. As it deepens toward black, it assumes overtones of a superhuman sorrow. . . . The brighter it becomes, the more it loses in sound, until it turns into silent stillness and becomes white. Represented in musical terms, light

195. Vasily Kandinsky (1866–1944). Motif from "Improvisation 25," folio 16 from *Sounds* (*Klänge*), reprinted in *XXᵉ Siècle*, no. 3, 1938. Woodcut on paper, 12½ × 9¾ in. (31.8 × 24.8 cm). The San Diego Museum of Art; Museum purchase.

blue resembles a flute, dark blue the 'cello, darker still the wonderful sounds of the double bass; while in a deep, solemn form the sound of blue can be compared to that of the deep notes of the organ.[29]

Unlike the nineteenth-century painters, who asked audiences to consider their paintings as being *like* music, Kandinsky's revolutionary paintings *were* music. The senses of sight and sound were synesthetically linked, inextricably so. The conductor of this visual art directs color and line as sonorous elements, chords and melodies, in pursuit of "inner resonance" between viewer and image. Considered this way, the sonic effect of Kandinsky's abstractions can become overwhelming in their intensity, their carefully modulated dissonances and sudden harmonies.

It is crucial to register to what degree these innovations depended upon close relationships and frequent collaborations as the means of great formal revolution. Kandinsky's theories criticized an individualistic, commercially driven conception of modern art in which the artist's "aim becomes the satisfaction of his own ambition and greed. Instead of close collaboration among artists, there is a scramble for these rewards."[30] By reorienting art on the spiritual, Kandinsky placed the emphasis not only on inward revelation but on working in community. Even this has a musical cast: the harmonious chamber group or orchestra over the single virtuoso has been a figure for social cohesion in many allegorical renderings of musical performance (as in Jan Miense Molenaer's *Allegory of Fidelity*, fig. 67). Collaboration and cooperation were elements of Kandinsky's revision of what art was and how it was made, as much as the relationship between the arts and how they were integrated into society at large.

The *Blue Rider Almanac*, edited by Kandinsky and Franz Marc, suggests this. In it were reproductions of art not only by members of the Blue Rider group but also the wider European avant-garde (Gauguin, van Gogh, Cézanne, Rousseau, Picasso) and the "primitive" African and Persian art that German Expressionists were enamored of. There is music by members of the Second Viennese School (Arnold Schoenberg and his protégés Alban Berg and Anton Webern), essays by Schoenberg and the Russian composer Thomas de Hartmann, another on Alexander Scriabin's *Prometheus* (which had a part composed for a chromatic "light-keyboard") and Kandinsky on stage composition, as well as the published version of Kandinsky's early stage work *The Yellow Sound* (*Der Gelbe Klang*, 1912). In its composition, the almanac was aimed at multiple senses and, as Peter Vergo has noted, was a kind of Gesamtkunstwerk itself.[31]

This collaborative aspect comes to the fore in considering Kandinsky's works for the stage. For example, his play *The Yellow Sound* was developed with assistance from de Hartmann

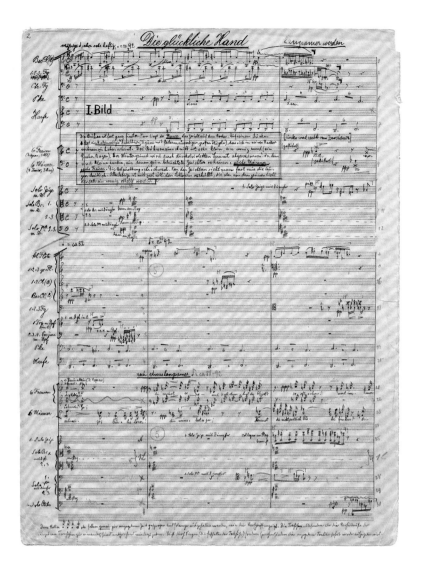

196. Arnold Schoenberg (1874–1951). Autograph manuscript of the first edition of *The Lucky Hand* (*Die glückliche Hand*). Arnold Schoenberg Center, Vienna.

(Kandinsky's neighbor). Choreography was handled by fellow Russian Alexander Sacharoff, a painter as well as dancer and a student of Isadora Duncan, whom Kandinsky would hail as a kindred spirit in *On the Spiritual in Art* for her vision to create a "dance of the future" (as her 1903 speech in Berlin was titled). Instead of scenes, the stage piece was made up of six *Bilder*, or "pictures." Of the creative process that generated *The Yellow Sound*, Kandinsky later said:

I myself experimented while abroad together with a young musician and a dancer. The musician picked out from a series of my watercolors the one that seemed the clearest to him with regard to music. In the absence of the dancer, he played this watercolor. Then the dancer joined us, the musical work was played for him, he set it as a dance and then guessed the watercolor he had danced.[32]

197. Arnold Schoenberg (1874–1951). Stage design sketch for *The Lucky Hand* (*Die glückliche Hand*), Scene 1, 1910. Oil on cardboard, 8⅝ × 11⅞ in. (21.8 × 30.3 cm). Arnold Schoenberg Center, Vienna.

It is a radical illustration of his theory of the Monumental Artwork of the Future (*Bühnengesamtkunstwerk*) in which motion and color and sound have independent, often contrary effects (the musical tempo increases while the choreography slows, etc.) and possess cryptic symbolism. Words are used sparingly, suspiciously, and often repetitively in a way to detach them from their relationship to sense, a technique that Kandinsky had used in his prose poems gathered in *Sounds* (*Klänge*, 1913), the "musical album" that joined poems with woodcuts in a book that he felt traced his evolution "from the 'figurative' to the abstract" (fig. 195).[33]

The Yellow Sound was never performed during Kandinsky's lifetime because of the onset of World War I, yet the plans for it embed the strategies of *Sounds* into a fully staged merging of artistic forms, an abstract combination of theater, dance, text, music, lighting effects, and stage and costume design. As Shulamith Behr has argued, this play represents the culmination of Kandinsky's interest in not only a musical but a theatrical model of artistic synthesis,[34] illustrative of just how the theoretical and the theatrical, the aural and the visual, the inwardly individualistic and the outwardly collaborative were all integrated in Kandinsky's radical aesthetic.

Schoenberg and Kandinsky

In this way, *The Yellow Sound* had much in common with Arnold Schoenberg's *The Lucky Hand* (*Die glückliche Hand*, Op. 18, 1913). This opera combined visual and aural effect not only through stage designs made by Schoenberg himself (figs. 197–9) but through his plan for chromatic lighting effects that would mirror the changing orchestral colors. Composition of *The Lucky Hand* had begun before he met Kandinsky but was completed well into the period of their most intense artistic and intellectual comradery. During three crucial years, from 1911 to 1914 when the war separated them, each gave the other critical encouragement.

Their first encounter occurred when Kandinksy, along with Franz Marc, Gabrielle Münter, Alexej Jawlensky and Marianne Werefkin, attended a concert of Schoenberg's music in Munich on January 2, 1911. On the program was his String Quartet No. 1 (Op. 7) and String Quartet No. 2 (Op. 10), five songs taken from Op. 2 and Op. 6, and the Three Piano Pieces (Op. 11), this last composition commonly seen as one of Schoenberg's most important, almost entirely atonal early works. Kandinsky had been working on his Composition series, which suggested his drive towards abstraction yet remained punctuated by recognizable, often apocalyptic forms—horsemen and angels in rich patches of color. But in the progression from the sketches of that concert (fig. 200) to the

198. Arnold Schoenberg (1874–1951). Stage design sketch for
The Lucky Hand (*Die glückliche Hand*), Scene 2, 1910. Oil on cardboard,
8⅝ × 11⅞ in. (22 × 30 cm). Arnold Schoenberg Center, Vienna.

199. Arnold Schoenberg (1874–1951). Stage design sketch for
The Lucky Hand (*Die glückliche Hand*), Scene 3, 1910. Oil on board,
7⅛ × 10⅝ in. (18 × 27 cm). Arnold Schoenberg Center, Vienna.

painting that followed (fig. 201), it is clear how the free tonality of Schoenberg's music gave Kandinsky permission to implement more fully his theories for purely abstract painting.

When the two men began to correspond, it was their mutual celebration of the unconcious and the spiritual in art that united them. In his first letter to Schoenberg, Kandinsky wrote, "In your works, you have realized what I, albeit in uncertain form, have so greatly longed for in music. The independent progress through their own destinies, the independent life of the individual voices in your compositions, is exactly what I am trying to find in my paintings."[35] In his reply, Schoenberg wrote, "Every formal procedure which aspires to traditional effects is not completely free from conscious motivation. But art belongs to the *unconscious*! One must express *oneself*! Express oneself *directly*!"[36] For both, this drive asserted itself in the creation of new systems to structure their iconoclastic expressions and those of their followers: Schoenberg's twelve-tone system of composition for music and the formally rigorous theories of nonrepresentational composition as encapsulated in Kandinsky's writings at the Bauhaus in the 1920s.

Schoenberg was a prolific if inconstant painter before giving it up in 1914, though serious enough to have considered it as a career over music at one point. His paintings have a coloristically

200. Vasily Kandinsky (1866–1944). Sketch for *Impression III* (*Konzert*),
1911. Chalk on paper, 3⅜ × 5¼ in. (10 × 14.8 cm). Musée National d'Art Moderne, Centre Georges Pompidou.

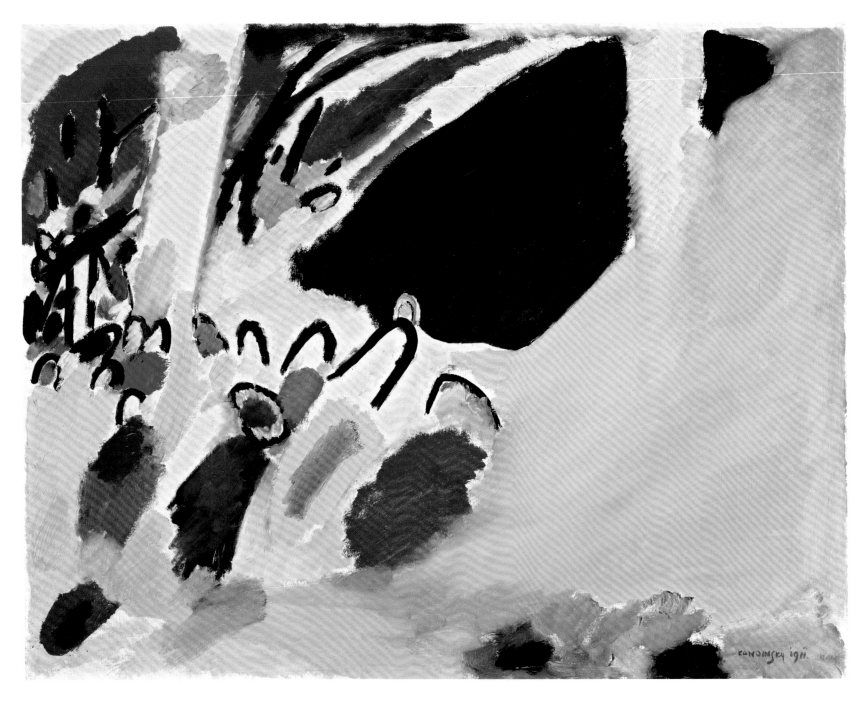

201. Vasily Kandinsky (1866–1944). *Impression III* (*Konzert*), 1911. Oil on canvas, 30⅞ × 39⅝ (77.5 × 100.5 cm). Städtische Galerie im Lenbachhaus, Munich.

202. Arnold Schoenberg (1874–1951). *Blue Gaze* (*Blauer Blick*), 1910. Oil on cardboard, 7⅞ × 9⅛ in. (20 × 23 cm). Arnold Schoenberg Center, Vienna.

bold, symbol-laden quality that cannot help but put one in mind of that other titan of Vienna, Sigmund Freud, though Schoenberg was more interested in Symbolist and Expressionist antecedants (fig. 202).[37] As in the third movement of Five Pieces for Orchestra (*Fünf Orchesterstücke*, 1909), Op. 16, which he titled "Farben" ("Colors"), his series of painted "gazes" like *Blue Gaze* (*Blauer Blick*) work by way of minor variations in tone and little-to-no narrative content. "A painter," he said, ". . . grasps with one look the whole person—I, only his soul."[38]

Reverberations

Kandinsky's influence on artists of the early twentieth century is hard to overstate but mostly made its mark by way of his writings. Through his books and essays, Kandinsky transmitted his theories far and wide; copies of them are recorded in the libraries of nearly every major modern painter in Europe and are responsible for spreading music-modeled abstraction. Hans Richter and Ezra Pound acknowledged his seminal role by respectively naming him the father of Dada and mother of Vorticism.[39] Marcel Duchamp acquired his copy of *On the Spiritual in Art* in Munich in 1912 and

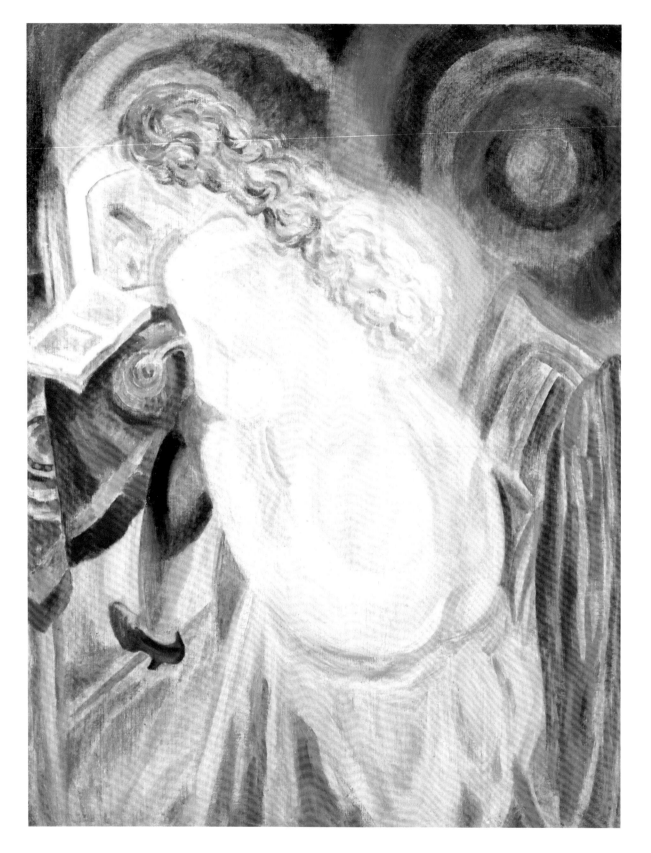

203. Robert Delaunay (1885–1941). *Female Nude Reading*, 1915.
Oil on canvas, 54 × 42⅜ in. (137.2 × 107.6 cm). The San Diego
Museum of Art; Museum purchase through the Earle W. Grant
Acquisition Fund.

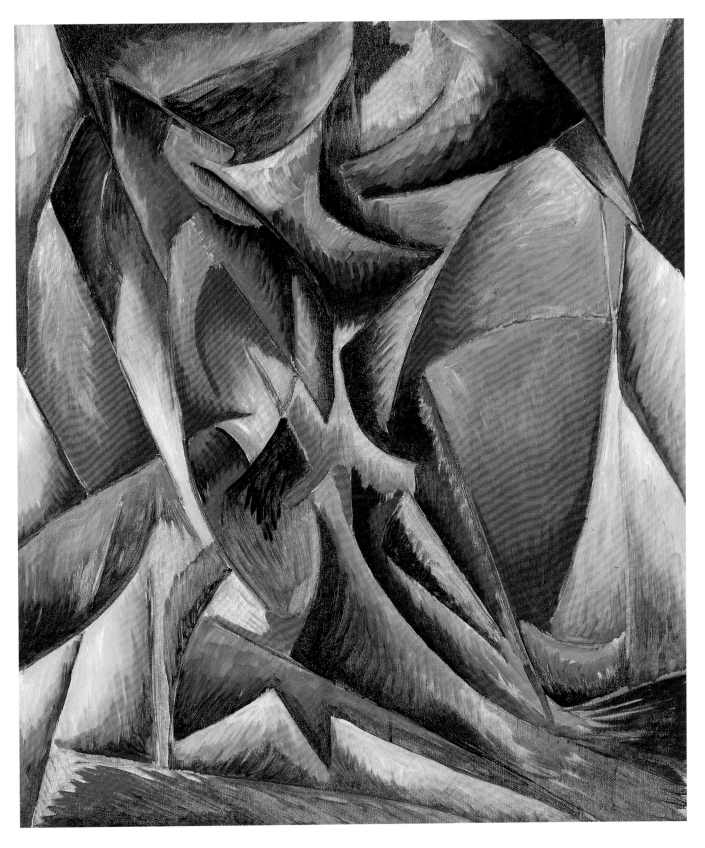

204. Konrad Cramer (1888–1963). *Improvisation,* 1912. Oil on canvas, 30 × 26 in. (76.2 × 66 cm). The San Diego Museum of Art; Museum purchase through the Earle W. Grant Acquisition Fund.

205. Robert Delaunay (1885–1941). *Female Nude Reading* (detail), 1915.

annotated it heavily.[40] Sonia Delaunay-Terk (with Barbara Epstein)[41] would translate the same volume into French, where it would have a profound effect on her husband, Robert Delaunay, whose work was often interpreted, despite his objections, through a musical analogy—notably associated with Orpheus when grouped with the abstract work of Kupka under the heading "Orphism" by Guillaume Apollinaire (fig. 203).

His impact among Americans was even more profound: German ex-pat Konrad Cramer, the first of the American modernists to put Kandinsky's ideas to use, became acquainted with Kandinsky and other members of the Blue Rider while in Munich in 1910. He was very much in the thrall of these ideas when he painted *Improvisation* in early 1912 (fig. 204). Marsden Hartley, after devouring the German edition of *On the Spiritual in Art*, made a pilgrimage to Munich in 1912 to meet him.[42] Gertrude Stein was introduced to the prose poems and prints of *Sounds* through her friendship with Hartley and Arnold Rönnebeck, which may have influenced her experiments in word repetition.[43] Arthur Dove also owned the original *On the Spiritual in Art* in German.[44] Walkowitz heavily annotated his English edition. Alfred Stieglitz had an extract of it translated and published in his journal *Camera Work* in 1912, made sure everyone in his circle was familiar with the *Blue Rider Almanac*, and purchased the painting *Improvisation No. 27* (1912, The Metropolitan Museum of Art) from the Armory Show of 1913 to hang in his gallery, cementing the deep strain of indebtedness to Kandinsky in American art. The milieu around Stieglitz, though not as unified and close-knit as sometimes portrayed, is evidence of Kandinsky's call to collaborate on bringing about a spiritual revolution of the arts based, in part, in music.

NOTES

1 Quoted and translated in Juliet Koss, *Modernism after Wagner* (Minneapolis and London: University of Minnesota Press, 2010), xii.

2 "Comme de longs échos qui de loin se confondent / Dans une ténébreuse et profonde unité," from Charles Baudelaire, "Correspondances," in *Les Fleurs du mal*, originally published in 1857.

3 See Therese Dolan, *Manet, Wagner, and the Musical Culture of Their Time* (Surrey, England; Burlington, VT: Ashgate, 2013).

4 Lisa Norris, "Painting Around the Piano: Fantin-Latour, Wagnerism and the Musical in Art" in *The Arts Entwined: Music and Painting in the Nineteenth Century*, ed. Marsha Morton and Peter L. Schmunk (New York: Garland, 2000), 143–75.

5 Quoted in Dolan, *Manet, Wagner, and the Musical Culture of Their Time*, 161.

6 See also Anne Leonard, "Picturing Listening in the Late Nineteenth Century," in *The Art Bulletin* 89, no. 2 (June 2007): 266–86.

7 This can be found at http://writing.upenn.edu/pennsound/x/Ginsberg-Blake.php.

8 Letter from Whistler to Fantin-Latour, written from 30 September to 22 November 1868, in *The Correspondence of James McNeill Whistler, 1855–1903*, edited by Margaret F. MacDonald, Patricia de Montfort and Nigel Thorp, online edition: http://www.whistler.arts.gla.ac.uk/correspondence.

9 See Christina Yu Yu, "Music and the Arts in East Asia," in the present volume.

10 See Samuel N. Dorf, "Dancing Greek Antiquity in Private and Public: Isadora Duncan's Early Patronage in Paris," *Dance Research Journal* 44, no. 1 (Summer 2012): 3–27.

11 Marie Theresa, "Isadora, the Artist: Daughter of Prometheus," in Abraham Walkowitz, *Isadora Duncan in Her Dances* (Girard, KS: Haldeman-Julius Publications, 1945), 4.

12 John Sloan, *New York Scene, 1906–1913* (New Brunswick, NJ: Transaction Publishers, 2013), 352.

13 In his book *A Demonstration of Objective, Abstract, and Non-objective Art*, Walkowitz wrote, "ART IS CREATION AND NOT IMITATION . . . one received impressions from contents or objects and then new forms are born in equivalents of line or color improvisations," the terms "equivalents" and "improvisations" illuminating a debt to Stieglitz and Kandinsky, respectively.

14 Ann Cooper Albright, *Modern Gestures: Abraham Walkowitz Draws Isadora Duncan Dancing* (Middletown, CT: Wesleyan University Press, 2010), 2.

15 Oral history interview with Abraham Walkowitz, 8–22 December 1958, Archives of American Art, Smithsonian Institution.

16 Quoted in Martica Sawin, "Abraham Walkowitz," *Arts Magazine*, March 1964, 45.

17 Catharine R. Stimpson and Harriet Chessman, "Note on the Texts," in *Getrude Stein, Writings, 1903–1932* (New York: Literary Classics of the United States), 930.

18 Marie Theresa, "Isadora, the Artist," 5.

19 Quoted in Janis Conner, "The Ethereal Icon: Malvina Hoffman's Worshipful Imagery of Anna Pavlova," in *Perspectives on American Sculpture before 1925*, ed. Thayer Tolles (New York: The Metropolitan Museum of Art, 2003), 141.

20 Lynn Garafola, *Diaghilev's Ballets Russes* (New York: Oxford University Press, 1989), 40.

21 Quoted in Karin von Maur, *The Sound of Painting: Music in Modern Art* (Munich, London, and New York: Prestel, 1999), 10.

22 As recounted in the letter from Sulpiz Boisserée to M. Boisserée from Weimar, 4 May 1811, in *Goethe on Art*, ed. and trans. John Gage (Berkeley and Los Angeles: University of California Press, 1980), 226.

23 Vasily Kandinsky, "Reminiscences," in *Kandinsky: Complete Writings on Art*, ed. Kenneth C. Lindsay and Peter Vergo (New York: Da Capo, 1994), 364.

24 Peter Vergo, *The Music of Painting* (London; New York: Phaidon, 2010), 175.

25 Kandinsky, *On the Spiritual in Art*, in *Complete Writings*, 160.

26 Kandinsky, *Point and Line to Plane*, in *Complete Writings*, 538.

27 Kandinsky, *On the Spiritual in Art*, in *Complete Writings*, 185.

28 Ibid., 183.

29 Ibid., 182.

30 Ibid., 130.

31 Vergo, *The Music of Painting*, 148.

32 Quoted in Birgit Haas, "Staging Colours: Edward Gordon Craig and Wassily Kandinsky," in *Textual Intersections: Literature, History and the Arts in Nineteenth-Century Europe*, ed. Rachael Landford (Amsterdam, New York: Rodopi, 2009), 46.

33 Kandinsky, quoted in Peg Weiss, *Kandinsky and Old Russia: The Artist as Ethnographer and Shaman* (New Haven: Yale University Press, 1995), 110.

34 Shulamith Behr, "Kandinsky and Theater: The Monumental Artwork of the Future," in *Vasily Kandinsky and the Total Work of Art: From Blaue Reiter to Bauhaus*, exh. cat. (Ostfildern: Hatje Cantz, 2013), 65.

35 Letter, 18 January 1911, in *Arnold Schoenberg, Wassily Kandinsky: Letters, Pictures, and Documents* (London, Boston: Faber & Faber, 1984), 23.

36 Letter, 24 January 1911, in ibid., 23.

37 See Alexander Carpenter, "Schoenberg's Vienna, Freud's Vienna: Re-Examining the Connections between the Monodrama *Erwartung* and the Early History of Psychoanalysis," in *Musical Quarterly* 93, issue 1 (2010): 144–81.

38 Quoted in Joseph Auner, *A Schoenberg Reader* (New Haven: Yale University Press, 2003), 79.

39 Leah Dickerman, "Inventing Abstraction," in *Inventing Abstraction*, ed. Leah Dickerman, exh. cat. (New York: Museum of Modern Art, 2012), 50.

40 Though this is subject to some debate. See Herbert Molderings, "The Discovery of the Mind's Eye: Marcel Duchamp in Munich 1912," in *Marcel Duchamp in Munich 1912*, eds. Helmut Friedel, Thomas Girst, Matthias Mühling and Felicia Rappe, exh. cat. (Munich: Schirmer/Mosel Verlag in cooperation with the Städtische Galerie im Lenbachhaus, 2012).

41 Dickerman, "Inventing Abstraction," 16.

42 See Patricia McDonnell, "'Dictated by Life': Spirituality in the Art of Marsden Hartley and Wassily Kandinsky, 1910–14" and "Marsden Hartley's Letters to Franz Marc and Wassily Kandinsky, 1913–14," *Archives of American Art Journal* 29, nos. 1–2 (1989): 27–44.

43 See Gail Levin, "Wassily Kandinsky and the American Literary Avant-Garde," *Criticism* 21, no. 4 (Fall 1979): 347–61.

44 Sandra Gail Levin, *Wassily Kandinsky and the American Avant-Garde, 1912–1950*, Ph.D. dissertation (New Brunswick, NJ: Rutgers University, 1976), 52.

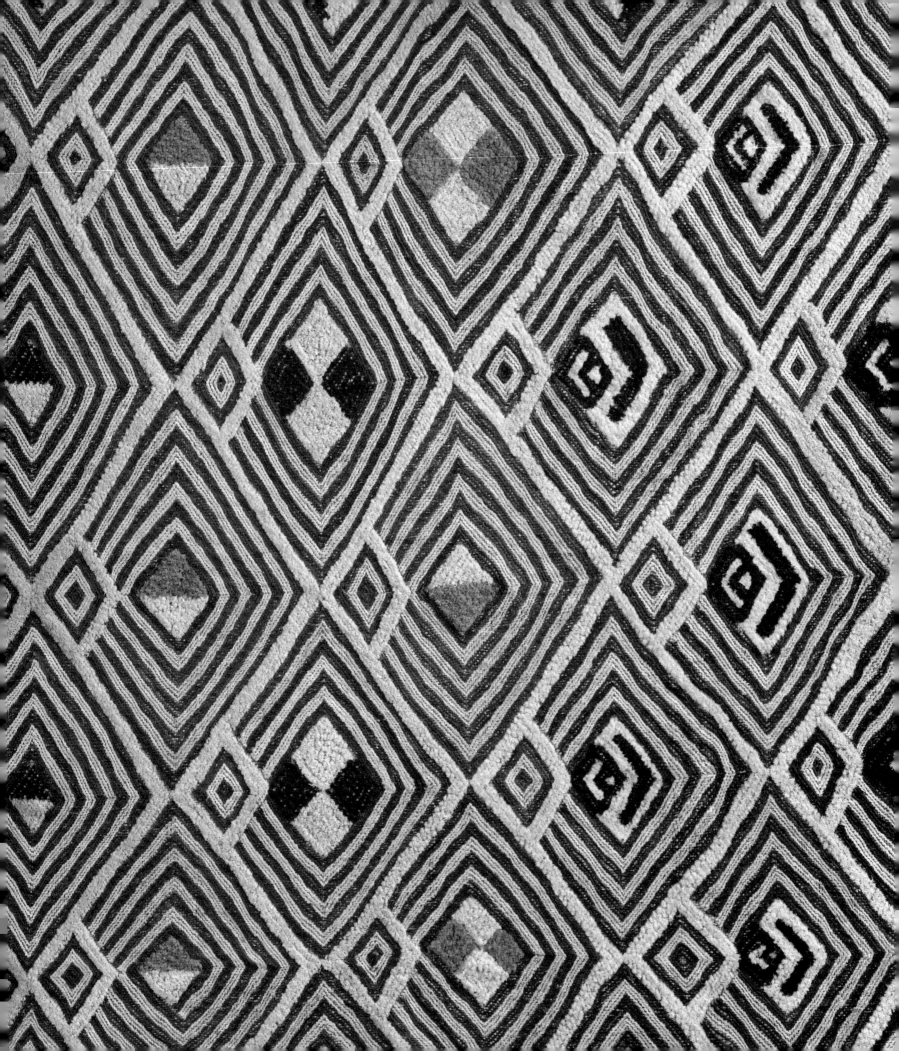

Gemma Rodrigues

The Art of Music in Africa

The haunting sounds of whistles engage in an intricate pattern of call-and-response, signaling to and fro in a coded language. They settle over the dense forest like a net of sound as the hunters move through the trees in search of game. This "sonic net," empowered by the ancestors, protects the hunters and helps to lure game. A spirit medium's iron gong sends a low, resonant ring through a rural community as its reverberant sounds entice one of the nature spirits from the surrounding bush to descend. In another part of the continent, as sunlight breaks through a clearing in the rainforest canopy, its slanted columns illuminate a small band of hunter-gatherer families giving thanks to the forest for its bounty. Their captivating song, one of the most distinctive and celebrated voice-based musical traditions in the world, is matched in its complexity and vitality by the graceful, rhythmic drawings that embellish their limbs, faces and clothing.

The varied relationships of the musical and visual arts to a people's culture, environment, needs and livelihood are the subject of this exhibition and essay. Thinking, talking and writing about African art and music in the West, however, entail a number of epistemological challenges. Africa is home to fifty-four nation states and thousands of heterogeneous communities, religious systems and language groups as well as diverse artistic and musical traditions. Much African art emerged and continues to function in social and historical contexts very different from those familiar to most people living in the US today. In addition, the arts of Africa are dynamic and continually reinventing themselves, ever responsive to social and historical change or generating new currents of thought. Information gathered, say, in 1980 about a particular artistic or associated religious practice may not necessarily hold true for the present or for the deeper past. This means that all the

206. Tappers (*iroke Ifá*). Yoruba peoples, Nigeria, late 19th/early 20th
century. Ivory; left: H: 19½ in. (49.5 cm), right: H: 11½ in. (29.2 cm).
Fowler Museum at UCLA; Gift of Mrs. Maurice Machris; Anonymous Gift.

information we have at hand needs to be regarded not with suspicion but with the understanding that many gaps in our knowledge still exist, as scholars and researchers of many stripes—both within Africa as well as from elsewhere—work to build a more coherent understanding of how the arts in Africa have changed, and continue to change, over time.

Rather than offer a survey of music and art in Africa, or propose any commonalities of aesthetic preference or philosophical approach that might underpin artistic production on the continent, this essay thus pursues the more modest goal of offering readers a partial context for understanding and interpreting the small group of African artworks on display in *The Art of Music*. Though in every instance the nexus between art and music, or sight and sound, is closely intertwined, each object type embodies a different kind of relationship between the visual and the acoustic realms of experience. This selection of works of art from Africa thus gestures toward the diversity of approaches to art making and to the ways it is incorporated into society that exist on the continent.

Soundscapes for the Spirits

Invisible, intangible and ephemeral, music is an ideal medium for connecting humans with spiritual powers that lie beyond the visual experience of daily life. In many African societies, music and the instruments that produce its sounds define sacred space by summoning the benevolent presence or intervention of specific deities or ancestral spirits. Certain kinds of rhythmic and melodic sound may also act as a bridge between the sacred and secular realms by unlocking access to spiritual forces or catalyzing specific mystical processes. In many ritual contexts, the care with which an instrument is crafted, the beauty of its ornament and embellishment, and the particularities of its iconography speak as much to an instrument's efficacy as do the sounds that it produces. Hunting, healing, spirit possession and divination are among the diverse contexts of use and performance that can lend African instruments and their music particular potency and significance in people's lives. The objects represented here include percussion instruments (ivory tappers, gongs made with forged iron, and wooden bells) and aerophones (whistles made from wood and horn). These instruments come from countries across the belt of the continent, from Côte d'Ivoire in West Africa to Zambia in southern Africa—countries which, if superimposed upon Europe, span a distance greater than that between Lisbon and Moscow.

Tap, tap, tap, tap—*tap, tap, tap* goes the sound of ivory on hardwood made by a *babalawo*, or priest-diviner of the Yoruba peoples of southwest Nigeria, rhythmically tapping his *iro* at the center of his divination board (figs. 206 and 207). Although many Yoruba have turned to Christianity, a Yoruba person who continues

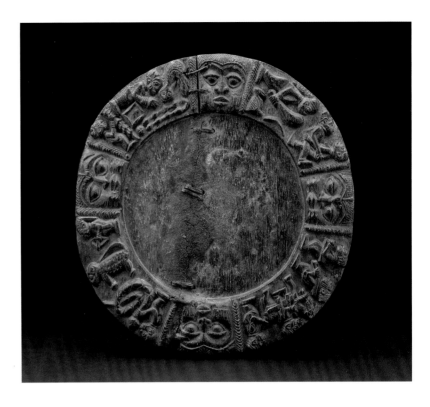

207. Divination tray (*opon Ifá*). Yoruba peoples, Nigeria, 19th century. Wood, chalk, metal, D: 14⅞ in. (38 cm). Fowler Museum at UCLA; Gift of the Ralph B. Lloyd Foundation.

to practice his or her traditional religion may consult a priest-diviner to seek instruction and advice from Olòrún, the supreme deity, through a divination system known as *Ifá*. A priest's expertise lies partly in his knowledge of the vast oral literature of Ifá, a literary corpus that consists of sixteen major "books," or *Odù*, each of which contains thousands of verses addressing a range of human social concerns, such as the use and abuse of power, the trials of disease and death, and conflict in familial relationships.[1] The divination system is named for the god Ifá, Olòrún's chief counselor, who embodies wisdom, reason and balance in all matters.[2] Among the paraphernalia belonging to a priest-diviner is the *iro Ifá*, a finely sculpted tapper with a cavity and a clapper inside it at one end. The priest uses this to summon the presence of Ifá by striking the center of his divination board at the outset of a consultation with a client. The sound is made louder by the clapper inside the cavity.[3]

Iro Ifá are typically made in the form of a tusk, either from wood or ivory, and embellished with a bas-relief representation of a seated or kneeling nude woman holding her breasts—a motif that in traditional Yoruba art refers to fecundity, nurturing and regeneration.[4] Field research grounded in close study of Yoruba language

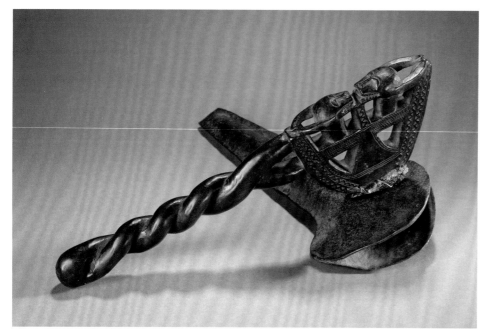

208. Mallet and gong. Baule peoples, Côte d'Ivoire, late 19th/early 20th century. Wood, iron; mallet: L: 11 in. (28 cm), gong: L: 10 in. (25.5 cm). Fowler Museum at UCLA; Gift of Barbara and Joseph Goldenberg.

and philosophical concepts also suggests that her pose, which evokes the posture of kneeling in pain at childbirth, may be read as one of utmost supplication and reverence intended to "soften" the gods and solicit their support. In the same vein, the tip of the tapper may be read as symbolizing the *ori*, or every individual's "inner spiritual head," and the essence of his or her personality as well as his or her destiny. The kneeling woman thus symbolically beseeches Ifá, on a client's behalf, for divine insight into and guidance in fulfilling his or her destiny.[5] As an expensive material, ivory's use was historically confined to the elite in Yoruba society and, in this context, signaled a babalawo's role as a sacred mediator between people and the gods.[6] Unseen, fleeting and incorporeal yet audible and insistent, the sounds made by the tapper issue forth from the world of men and women into the domain of the gods, both communicating with Ifá and forming a conduit that channels his presence and insights to the diviner and his client.

Rhythmic, percussive sound is also a privileged medium for connecting the world of the living to the world of the spirits among the Baule peoples of Côte d'Ivoire. For the Baule, the world of the spirits (*blolo*, or "the village of truth") directly impacts the world of the living. Crops, rainfall, health, wealth and fertility—or their lack— may all be outcomes of ancestral intervention or neglect. Should problems arise, an individual or a community may call upon a trance diviner (*komien*) to diagnose the root cause of misfortune and suggest appropriate ritual or other remedies.[7] A trance diviner uses percussion to attract the attention of nature spirits (*aye usu*) and draw them down to earth, where they communicate their insights into the problems at hand by speaking through him or her. Among the most important ritual objects owned by a Baule diviner are her iron gong and wooden mallet (*lowre*) (fig. 208). When a

Baule spirit medium wishes to go into a trance state, she beats the gong with the mallet while still in her private shrine room. Waiting clients can hear the beating and anticipate the diviner's arrival.[8] The diviner may continue to beat the gong if the trance state begins to wear off or if he or she wishes to deepen the trance.[9] The beautifully made accoutrements that belong to a Baule diviner not only charm and seduce the nature spirits but suggest to clients and the community at large a diviner's prestige and success as an intermediary with the spirit world.[10]

Larger forged-iron gongs with beautiful figurative handles have been attributed to but never documented among the Baule peoples (fig. 209). Similar gongs may be found in societies across West and Central Africa, including in Ghana, Nigeria, Cameroon and Gabon. Based on the scarification on the woman's cheeks in this example, it has been suggested that the object was made and used by peoples living in the northern reaches of Baule territory.[11] Though there is little information on the gongs' contexts of use, the beauty and refinement of their manufacture suggest they too may have been used to produce sounds intended to appeal to the spirits or catalyze specific processes relating to spiritual forces. Similar gongs used by members of Evóvi, a men's professional association prevalent among the Tsogo peoples of Gabon, are said to produce a sound that resembles the rhythmic beating of the human heart.[12] Members of the association serve as judges, diplomats, lawyers and orators.[13]

Bells (*dibu*) made from wood, or from the husks of fruit from the Borassus palm tree, were among the standard accoutrements of the ritual experts and healer-diviners (*nganga*) of the Kongo peoples of the present day Democratic Republic of the Congo (fig. 210).[14] Similar but less elaborately fashioned bells were also

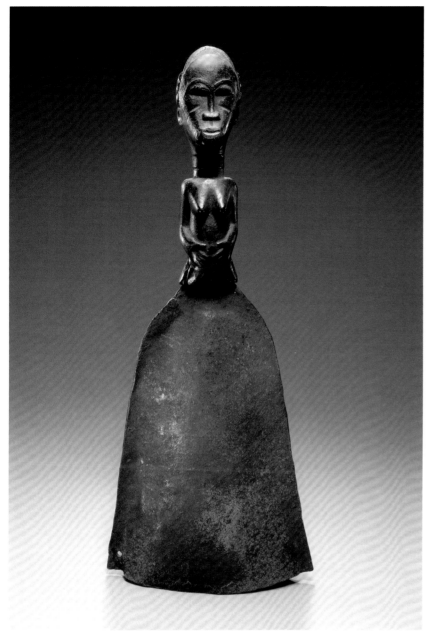

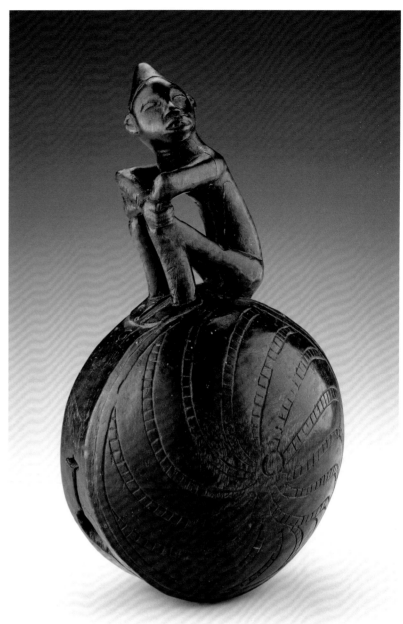

209. Gong. Baule peoples, Côte d'Ivoire, late 19th/early 20th century. Wood, iron, H: 16 in. (40.6 cm). Fowler Museum at UCLA; Gift of Helen and Dr. Robert Kuhn.

210. Bell (*dibu*). Kongo peoples, Democratic Republic of the Congo, late 19th/early 20th century. Wood, stone, 8⅝ × 4¾ × 4⅛ in. (21.8 × 12 × 10.5 cm). National Museum of African Art, Smithsonian Institution; Gift of Lawrence Gussman in memory of Dr. Albert Schweitzer.

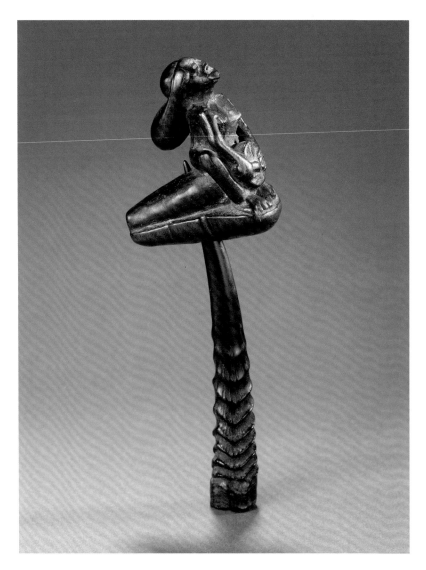

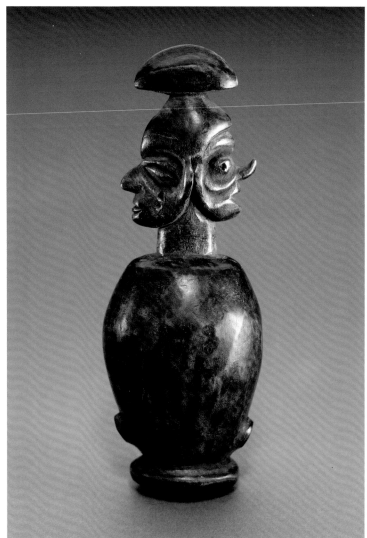

211. Whistle. Kongo peoples, Democratic Republic of the Congo, late 19th/early 20th century. Wood, horn, H: 6½ in. (16.5 cm). Fowler Museum at UCLA; Gift of Barbara and Joseph Goldenberg.

212. Whistle. Yaka peoples, Democratic Republic of the Congo, late 19th/early 20th century. Wood, H: 5¼ in. (13.3 cm). Fowler Museum at UCLA; Gift of Helen and Dr. Robert Kuhn.

worn by hunting dogs who ventured deep into the forest to help men track and kill game.[15] According to Kongo belief, dogs could see and hear supernatural presences as well as see and scent animals or people.[16] A nganga's bell was thus associated with hunting both literally and figuratively: just as dogs hunted down animals in the forest so was a nganga skilled in "hunting down" the source of a problem or "sniffing out" a culprit or other evildoer, whether otherworldly or human.[17] In many societies, dogs are regarded as liminal creatures—creatures who move easily between the forest and the village as well as above and below ground. Kongo society was no different. A nganga's bell thus had other, related associations with dogs and their special powers: as dogs could move between realms, so too could a nganga and the rhythmic sounds

made by his bell mediate between the human and the spiritual worlds. Such bells were also thought to aid a nganga in his search for a solution or a cure for a particular problem, as he navigated nfinda, "the forest of the ancestors," during a divinatory session.[18]

In Kongo society, music was and is still thought to facilitate communication with the ancestors, usually through spirit possession.[19] Sound, song, dance and performance were therefore not an aesthetic extra but an integral component of the ritual processes of the Kongo peoples, and their ritual experts were usually also musicians and dancers.[20] Kongo ritual experts and hunters both made use of small, delicate whistles made from wood or from the horn of a forest duiker, a small antelope no larger than a beagle (fig. 211). Hunters used the whistles to signal to one another and to their dogs

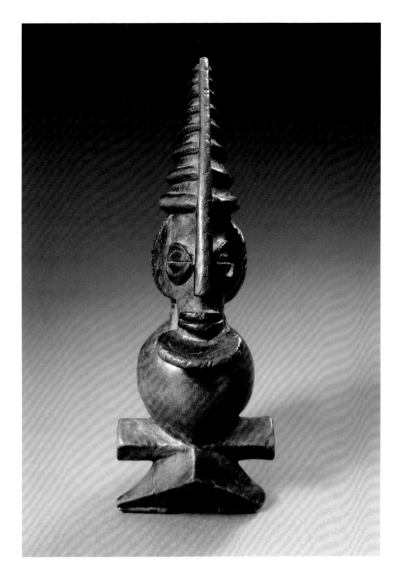

213. Whistle. Chokwe peoples, Democratic Republic of the Congo, Angola, late 19th/early 20th century. Wood, H: 4¾ in. (12.1 cm). Fowler Museum at UCLA; Gift of Helen and Dr. Robert Kuhn.

were worn by the leader of a hunt to communicate with his fellow hunters and to signal his dogs,[23] and both whistles and flutes were used to announce an upcoming hunt to the members of a village community.[24] Similar to police sirens, whistles were also blown at particular rituals to provide warning or to call attention, for example when a community searched for a thief or when a farmer sought help from his ancestors to safeguard his crops.[25] The upturned nose on one of the faces of this Janus-faced whistle is an iconographic motif that also occurs widely in Yaka masks and figurative sculpture (fig. 212). Its significance, which is a secret divulged during male initiation, is likely associated with fertility, procreative sexuality and male leadership.[26]

The figurative carving on a Chokwe whistle typically represented the individual identity of a particular ancestor, one whose "voice" could be heard through the sounds the whistle made.[27] Whistles were made to commemorate and channel the presence of both male and female ancestors, and the tonal sounds produced by the whistle varied accordingly.[28] Women are associated with regeneration and fertility in Chokwe thought, and men often sought the protection of a female ancestor.[29] Whistles were private possessions, usually worn about the person, for example on a leather thong around the neck. As among the neighboring Kongo peoples, sometimes whistles were given additional spiritual potency by inserting a very small antelope horn filled with medicines inside the whistle. These medicinal substances helped to attract a particular ancestor's presence and activate his or her speech through the whistle.[30]

This Chokwe whistle depicts a powerful tutelary ancestor known as Chikunza, who remains important to men's initiation rites today and is notable for his power to promote human fertility and success in the hunt (fig. 213). The figure's tall, ridged headpiece references the towering, conical mask used to represent Chikunza in masquerade performances, and the figure's disc-shaped beard is associated with royalty. Together, these attributes suggest the presence of an ancestor of great power and prestige.[31] Although the sounds made by a whistle were interpreted as voices of the ancestors, people also blew on whistles to make specific requests: soldiers might use a whistle to call on a spirit for guidance or protection during times of war, and a chief might use a whistle to advertise ancestral support for his actions or office. Hunters also used whistles to communicate with one another during the hunt or during battle, using secret musical codes.[32]

while moving through thick vegetation. The whistles are typically capped with a finely carved, diminutive figure, which represents a specific problem or illustrates a proverb. Ritual conventions often determined which instruments a nganga would play, so for example a nganga might play a particular whistle to contemplate the solution to the particular problem or dilemma presented by his client.[21] Kongo musical instruments were sometimes transformed into "medicines" in their own right by the addition of "power packs" that contained secret plant, animal or mineral ingredients.[22]

Whistles that produce sounds with apotropaic or other sacred functions were also used by hunters among the neighboring Yaka peoples, also in the Democratic Republic of the Congo, and the Chokwe peoples of present-day Angola and Zambia. Yaka whistles

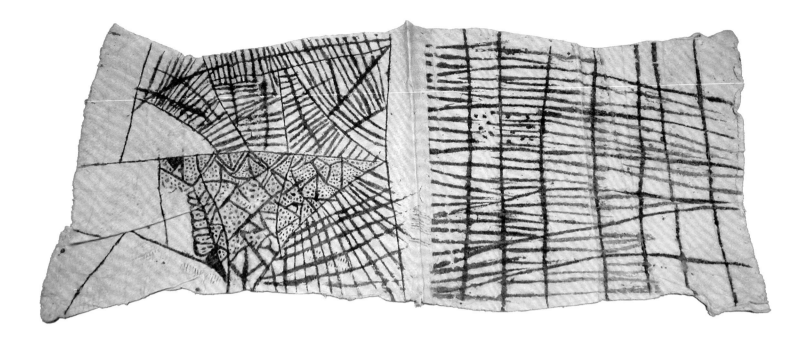

214. Drawing on barkcloth. Mbuti peoples, Democratic Republic of the Congo, 20th century. Bark, pigment, 15¾ × 40½ in. (40 × 103 cm). Peabody Museum of Archaeology and Ethnology at Harvard University; Gift of Renée Bertrand in memory of Diane Dixon-Daniel.

Rhythm and Abstraction in African Art and Music

The diverse hunter-gatherer or forager peoples who inhabit the Ituri Forest in the northeast Democratic Republic of the Congo also developed ways to communicate with spiritual forces through sound. The Mbuti, the Efe and the Bayaka are among those forager groups whose complex, voice-based music has been the most studied and documented by musicologists. Also described as "wordless singing," the musical traditions of the Ituri Forest are particularly distinguished by three features: yodeling, hocketing and polyphony. Yodeling may be defined as the rapid transitioning from a "head tone" to a "chest tone." Hocketing involves the shared singing of a single melody by two or more people, each of whom sounds alternate notes while the other singer rests. Polyphony refers to the complex interlocking of multiple patterns of rhythm or melody. In the Mbuti language, yodeling is known by the term *kanga beere,* meaning "to cancel words."[33] This suggests an understanding of voice-based Ituri Forest music as an antiverbal, abstract form of aestheticized sound.

Many religions around the world use music aesthetically and others eschew it. The music these Ituri Forest techniques produce is understood not just as sacred and associated with ritual but infused with spiritual force. As Luemba-Mavioka, a community historian from the Loango region in northern Kongo, explains: "It is a pure sound, a sound that enchants, a vocal return to nature; yodelized syllables are vibrations in rapport with forest powers."[34] Singing is used to give thanks to the forest for the sustenance it provides and to communicate mystically with the spirits that inhabit it. When the forest spirits hear singing, they are more likely to "release" the game and bestow good luck in the hunt.

As Bayaka women explained to the art historian Robert Farris Thompson, who conducted field research in the Ituri Forest in the 1990s, "even when the forest spirits are far away, they will understand our yodeling."[35] Singing is also used to navigate the dense forest and to avoid becoming lost by signaling one's location to fellow hunters and unseen spiritual presences.

The women of the Ituri Forest are not just musicians but also visual artists. The women use dyes and pigments gathered in the forest to create dynamic yet delicate and often ephemeral drawings on both the human body (fig. 215) and on soft cloth made from the pounded inner bark of trees. The anthropologist Barry S. Hewlett notes that the abstract imagery that forms the basis for Ituri Forest drawing recalls the total environment of the forest, which is "vibrant and full of energy."[36] The drawings blend abstract motifs drawn from the observation of everyday life including, for example, dotted ant trails, spider's webs, lianas and other forest vines, the zigzag markings of a python's skin, or leopard spots, as well as man-made items such as hunting nets, combs or houses. Like Ituri music, Ituri drawing is considered sacred and infused with spiritual force and intent. Body painting and wearing or using clothing made from decorated barkcloth typically only occur in ritual or celebratory contexts, for example at the "comings out" that follow initiation, at funerals, or at festivities that follow a big hunt. Finely decorated, the soft barkcloth is also used to receive and wrap newborn babies, symbolizing the child's ultimate dependence on the forest, "the mother and father of us all."[37]

Robert Farris Thompson has described women's yodeling in the Ituri Forest as the "aural icon" of their life and their art. In this vein, Ituri design motifs may be perceived as being combined in ways that parallel the yodeling, hocketing and polyphony of Ituri music. Typical features of Ituri drawing include asymmetric, "off-beat" compositions; rapid, contrastive transitions from one design motif to another; and combinatory, multi-voiced approaches to design based in the participation of two or more artists to create a single drawing. Thompson also observes that Ituri song and Ituri graphic traditions closely resemble one another performatively as well as compositionally, each sharing similar aesthetic structures as well as approaches to production. Thompson describes the participation of more than one artist to create a drawing as a form of "visual hocketing," during which two women alternate or commingle different patterns and motifs in order to create a drawing that emerges as a single, cohesive whole.

The word "hocket," which comes from the French *hoquet,* meaning a shock, sudden interruption, hitch or hiccup,[38] also offers a vivid analogy for the sudden interruptions and qualities of interpenetration and dramatic juxtaposition that characterize Ituri graphic arts. Many Ituri drawings are composed of two distinct

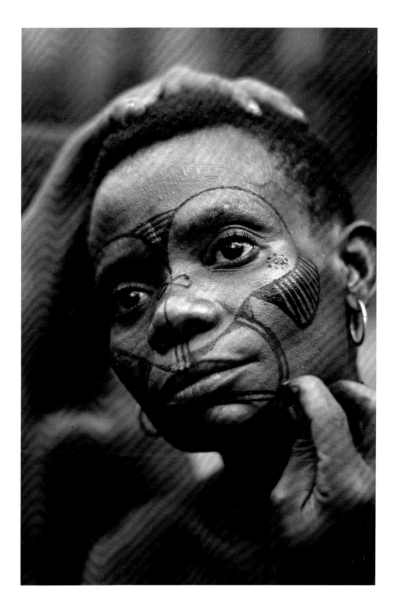

215. An Efe woman has her face painted in the Ituri Forest, in northeast Democratic Republic of the Congo. 1990s. Photograph by Dr. William Wheeler. Courtesy of Linda Penn and Dr. William Wheeler.

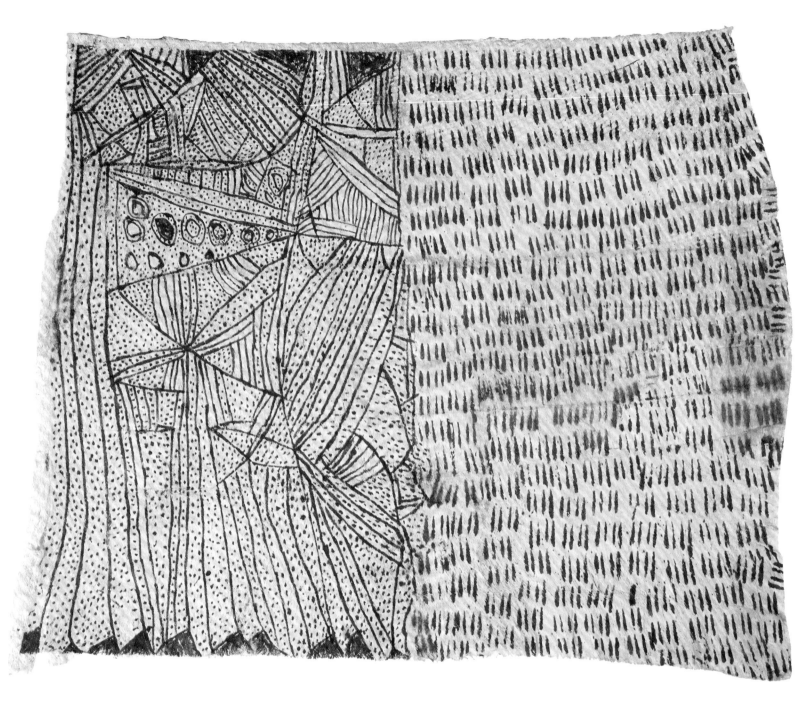

216. Drawing on barkcloth. Mbuti peoples, Democratic Republic of
the Congo, 20th century. Bark, pigment, 24½ × 29 in. (62.2 × 73.7 cm).
Capital Group, Los Angeles, CA.

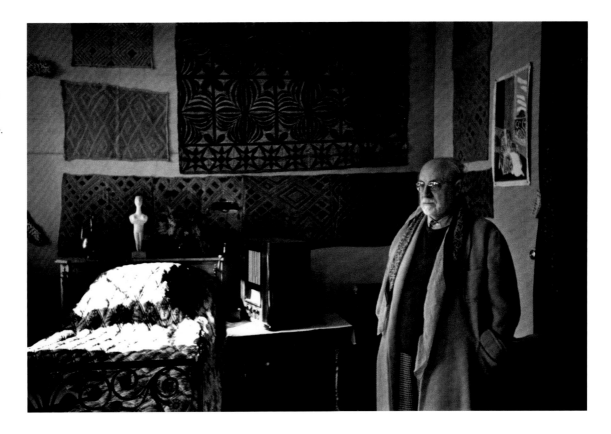

217. Henri Matisse stands in his bedroom, with Kuba textiles on the wall in the background, at his home in the south of France. February 1944. Henri Cartier Bresson/Magnum.

halves, each occupied by an entirely different design, and are filled with motifs, designs and improvised geometries that appear to swarm, disperse and meander in new directions in response to the edges of their irregularly shaped barkcloth "canvases." Repetition and variation, improvisation and spontaneity, and an aesthetic that embraces the interweaving of melody and counter-melody are other aspects of Ituri music that find striking visual equivalents in Ituri drawing. In the Ituri Forest, both musical and graphic arts appear to be informed by the same root sensibilities of improvisation, asymmetrical "phrasing" and multi-vocality, each producing a rich tradition that may be understood as the acoustical and the visual counterpart of the other—one in which undulating lines are melodies, motifs are notes and empty spaces are breaths or silences (figs. 214 and 216).

Finding ways to evoke the rhythms of music and dance via the arrangement of colors and forms on a picture plane was an early and ongoing concern for the French avant-garde artist Henri Matisse. In the 1920s, jazz music swept across Paris like a storm, and for many Europeans its "free," improvisatory style came to represent aesthetically much that was new and disruptive of old regimes and social and political structures. The arrival of jazz also signaled the end of classical music's symmetrical structures and regimented performances as the dominant musical paradigm. How was an artist to respond to these intertwining shifts in the realms of both music and society? While in the process of thinking through and resolving such formal challenges, Matisse took down all the paintings in his studio and replaced them with Kuba embroideries from the present-day Democratic Republic of the Congo. He referred affectionately to these textiles from his personal collection as "my African velvets" (fig. 217).[39] In the summer of 1943, Matisse wrote:

> I'm astonished to realize that, although I've seen them often enough, they've never interested me before as they do today. I never tire of looking at them for long periods of time, even the simplest of them, and waiting for something to come to me from the mystery of their instinctive geometry.[40]

It appears that Kuba textile design played a pivotal role in Matisse's journey toward increasing abstraction and his experiments with visual rhythm. That same year, Matisse produced the first of his designs for what would eventually become his iconic album *Jazz* (fig. 218). Soon after, he began to pin organically shaped colored paper cut-outs to the walls of his studio, constantly moving them about and rearranging their placement to create new compositions. These experiments with colored paper in 1943 eventually led to Matisse's gouache-on-paper cut-outs of the mid- to late forties—works many consider to embody the greatest of Matisse's formal innovations.

Scholars have argued that Matisse was indebted to the principles of textile design and ornament for many of his key innovations in Western painting, including his increasingly flattened pictorial

Henri Matisse

Jazz

Tériade éditeur

Ces pages ne
servent donc
que d'accompa-
gnement à
mes couleurs,
Comme des
asters aident
dans la compo-
sition d'un
bouquet de

18

218. Henri Matisse (1869–1954). *Jazz*, 1947. Illustrated book with twenty *pochoir* plates and text in gravure page, each: 16½ × 25½ in. (41.9 × 64.8 cm). Publisher: Tériade, Paris. Collection UCLA Grunwald Center for Graphic Arts, Hammer Museum; Gift of Mr. Norton Simon.

un moment
d'libres.
Ne devrait-on
pas faire ac-
complir un
grand voyage
en avion aux
jeunes gens
ayant terminé
leurs études.

54

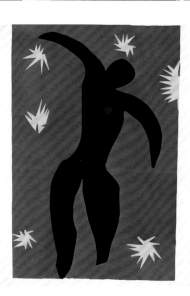

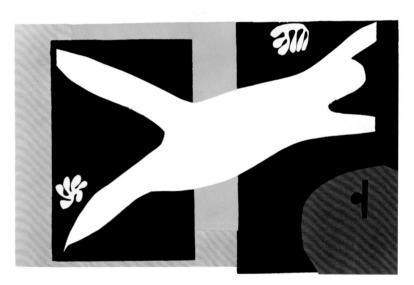

l'esprit humain.
l'artiste doit
apporter toute
son énergie,
sa sincérité
et la modestie
la plus grande
pour écarter-
pendant-son
travail les
vieux clichés
90

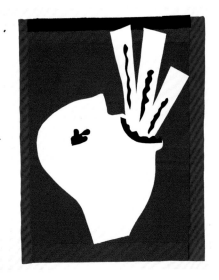
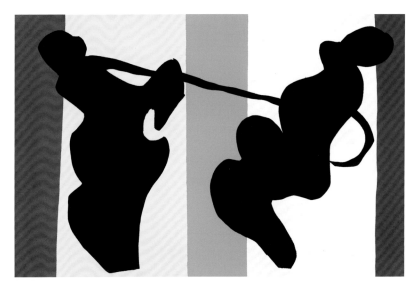
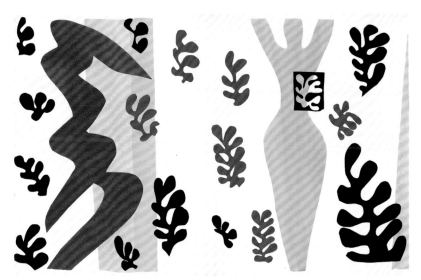

de contes
populaires
ou de voyage.
J'ai fait ces
pages d'écri-
tures pour
apaiser les
réactions,
simultanées

142

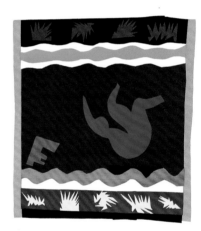

space and his emphasis on the decorative qualities of rhythm, line and color.[41] As Matisse's biographer Hilary Spurling puts it, textiles were for Matisse a "disruptive force" he used "to destabilize the laws of three dimensional illusion."[42] Born and raised in French Flanders, a region known for its production of high-end artisanal silks, and the descendant of generations of weavers, Matisse had known textiles all his life. He began to collect textiles as a poor art student in Paris, where he arrived in 1891.[43] By the time Matisse died in the south of France in 1954, his studio was a treasure trove of textiles from all over the world, including Europe, Africa, Asia and the Pacific Islands. Matisse called his textile collection his "bibliothèque de travail," a "working library" to which he turned again and again for inspiration.[44]

The "African velvets" Matisse so prized were made by Shoowa artists, members of a sub-group within the former Kuba kingdom, now located in the southern portion of the Democratic Republic of the Congo. The Shoowa continue to produce finely woven raffia textiles that are luxuriously embroidered with mathematically complex, open-ended geometric designs (figs. 219–21). Men and women co-create textiles but with a strictly gendered division of labor. Men weave the palm-leaf fiber textiles while women embroider them "freehand," using a linear stem-stitch as well as small stitches which they cut to produce soft pile surfaces resembling velvet.[45] The fibers are dyed in colors that range from deep blacks and browns and a range of tan colors, to red, orange, yellow and also sometimes blue or purple, all deriving from local plant

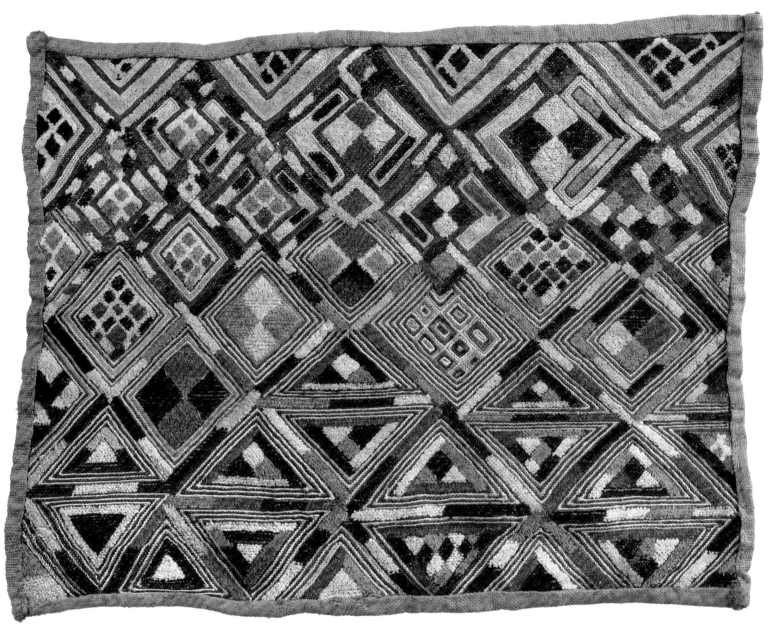

219. Prestige panel. Kuba peoples, Shoowa group, Democratic Republic of the Congo, 20th century. Flat-weave raffia cloth and cut-pile embroidery, natural dyes, 20⅞ × 16⅛ in. (53.1 × 40.9 cm). Fowler Museum at UCLA; Gift of the Christensen Fund.

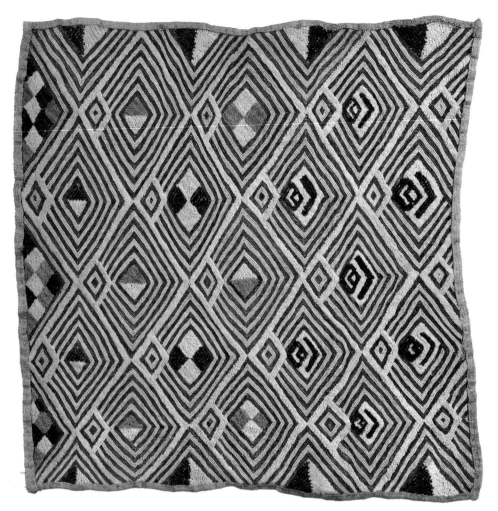

220. Prestige panel. Kuba peoples, Shoowa group, Democratic Republic of the Congo, 20th century. Flat-weave raffia cloth and cut-pile embroidery, natural dyes, 22¾ × 22½ in. (58 × 57 cm). Fowler Museum at UCLA; Gift of the Christensen Fund.

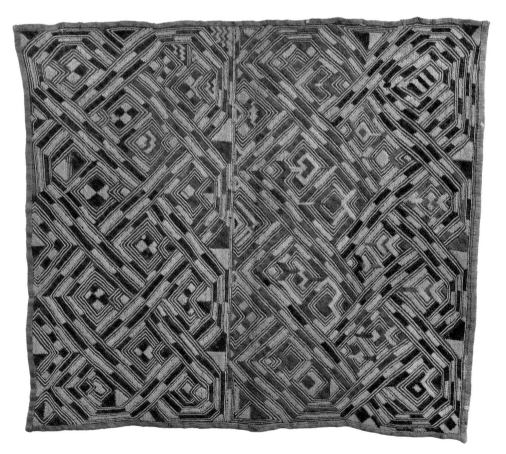

221. Prestige panel. Kuba peoples, Shoowa group, Democratic Republic of the Congo, 20th century. Flat-weave raffia cloth and cut-pile embroidery, natural dyes, 26 × 21⅝ in. (66 × 55 cm). Fowler Museum at UCLA; Gift of the Christensen Fund.

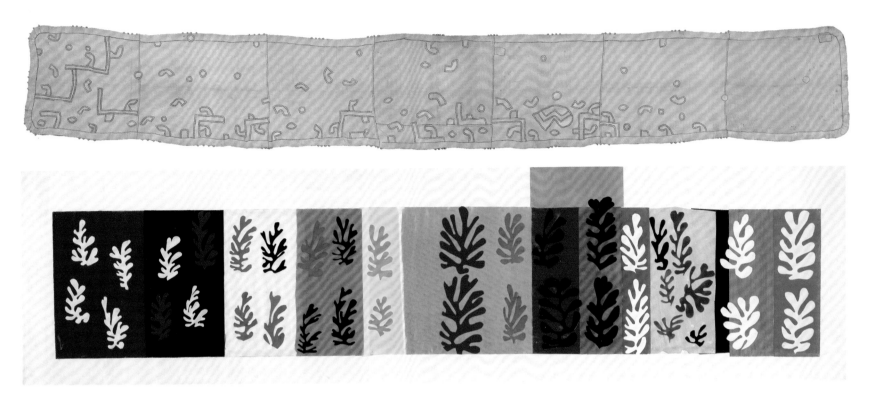

222. Ceremonial skirt (*ncak*). Kuba peoples, Democratic Republic of the Congo, 19th century. Raffia palm fiber, 22⅞ × 178 in. (58 × 452 cm). Fowler Museum at UCLA; Mr. and Mrs. Lachlan Cumming Vass III.

223. Henri Matisse (1869–1954). *Velvets* (*Les Velours*), 1947. Gouache on paper, cut and pasted, 20¼ × 85⅝ in. (51.5 × 217.5 cm). Kunstmuseum, Basel.

sources. Echoing the design preferences of the artists of the Ituri Forest, Kuba artists show a consistent taste for patterning governed by repetition with variation, elements of surprise or "offbeat" accents, and the juxtaposition of constrasting compositional units.[46]

As the art historian Monni Adams has said, these approaches combine to produce compositions that are "restless, provocative, and continually interesting."[47] Kuba design is always rectilinear and geometric, with diamonds, triangles, squares, rectangles, chevrons and interlaces as common motifs. Some patterns, passed down through generations, have specific names, around two hundred of which have been recorded. The Kuba design repertoire, however, is continually expanding, and the creation of new patterns was in the past a particular source of social status.[48] Although the textiles do not directly reference the formal structures of local music, their designs came to be read in twentieth-century Europe and the US as visual analogues for the complex polyrhythms from Africa that in part provided the inspiration for jazz music.

Cut from paper with a pair of scissors just as a tailor cuts cloth, Matisse's cut-outs most closely resemble another sub-category of Kuba textile arts: the Kuba appliqué (fig. 222). Appliquéd Kuba textiles were designed to be worn as very long wrap-around skirts (*ncak*) by both men and women at formal occasions. Typically two to three meters in length, Kuba appliqués are composed from many small plain-weave raffia panels sewn together in series, each bearing its own irregularly arranged embroidered designs and appliquéd forms. The composition of each self-contained panel bears little relation to the composition of its neighbor, other than offering up an instance of variation upon a theme. On occasion, appliqué patches are applied to conceal the accidental holes made in a raffia textile by beating to soften it, but generally the appliquéd forms are deployed for decorative effect and scattered across the length of the textile in an irregular fashion.

Though there is no evidence that Matisse collected Kuba appliqué textiles or displayed them on his walls, such textiles were circulating in Europe at the time, and it seems likely that Matisse would have been familiar with this closely related sub-genre of Kuba textiles as well. The resonances between the appliqués and Matisse's cut-outs are so striking that it is tempting to suggest it was rather Kuba appliqués that provided Matisse with inspiration for the technical and formal processes that allowed him to break new ground with the cut-outs. The title of one of Matisse's

224. Ceremonial skirt (detail). Kuba peoples, Democratic Republic of the Congo, 19th century.

gouache on paper cut-outs from 1947, *Les Velours* (*Velvets*), suggests an explicit acknowledgement on Matisse's part of the role played by Kuba design in firing his imagination (fig. 223). The work's experimentation with seriality, its reliance on cut-out forms laid over a solid background, and its length and proportions reveal specific and striking parallels with Kuba appliqué skirts. While we cannot offer a historically documented explanation for these particular parallels with Kuba appliqué, it seems clear that Matisse's deepening engagement with the principles of Kuba textile design catalyzed the formal innovations that underpinned *Jazz* and eventually led to the cut-outs.

What we do see at play in Matisse's work are cross-culturally appropriated lessons in constructing generative grammars of design; exploring figure-ground ambiguities and reversals; playing with the tensions between the iterative and the improvisatory; and a taste for formal play and experiment within specific parameters. A concern with off-beat rhythms, variation and repetition of pattern, and ambiguities of figure and ground are all design characteristics that are shared by both the Kuba appliqués and Kuba embroideries. We do not know whether the Kuba thought of their designs as being "musical" in any strong sense of the word, but for Matisse visual rhythms shared close affinities with acoustic ones. Matisse's interpretation and uses of Kuba design were necessarily mediated through a Western imagination and the interests

and concerns of a particular historical moment. It is possible that without the emergence of jazz music and Matisse's abiding interest in it, he would not have been open to the "lessons" that Kuba designers had to offer. Ultimately, even if the connections that Matisse forged between Kuba design and ideas around jazz music were born from a historically and situationally specific cross-cultural encounter, we may be happy with the result and consider it a decontextualizing yet productive appropriation, much like a jazz interpretation that (mis)quotes a precedent, honoring it while building upon it as well.

NOTES

1 E. M. McClelland, *The Cult of Ifá among the Yoruba*, Ethnographic Arts and Culture Series; 2 (London: Ethnographica, 1982), 60–84.

2 Ibid., 9–13.

3 Evelyn Roache, "The Art of the Ifa Oracle," *African Arts* 8, no. 1 (October 1, 1974): 26.

4 Ibid.

5 Rowland Abiodun, "Woman in Yoruba Religious Images," *African Languages and Cultures* 2, no. 1 (January 1, 1989): 13.

6 Alisa LaGamma, *Art and Oracle: African Art and Rituals of Divination*, exh. cat. (New York: Metropolitan Museum of Art, 2000), 59.

7 Ibid., 23.

8 Susan Mullin Vogel, *Baule: African Art, Western Eyes*, exh. cat. (New Haven: Yale University Press, 1997), 234–8. The majority of what we know about the connections between Baule art and society comes from field research conducted by the art historian Susan Vogel, during multiple visits from 1968 to the mid-1980s. This short description is based on a trance divination session that Vogel documented in 1972. Though I have no information on the extent to which trance divination is still important for people living in rural Baule communities, it is likely that such practices continue.

9 Ibid., 229.

10 LaGamma, *Art and Oracle*, 23.

11 Jacqueline Cogdell DjeDje et al., *Turn up the Volume: A Celebration of African Music*, exh. cat. (Los Angeles: UCLA Fowler Museum of Cultural History, 1999), 277.

12 Ibid., 282.

13 Christa Clarke, "A Personal Journey: Central African Art from the Lawrence Gussman Collection," *African Arts* 34, no. 1 (April 1, 2001): 27 and 31.

14 Karen Milbourne, *Earth Matters: Land as Material and Metaphor in the Arts of Africa*, exh. cat. (Washington, DC: National Museum of African Art, Smithsonian Institution; New York: Monacelli Press, 2014), 111.

15 DjeDje et al., *Turn up the Volume*, 266.

16 Marie-Thérèse Brincard et al., *Sounding Forms: African Musical Instruments*, exh. cat. (New York: American Federation of Arts, 1989), 41.

17 Wyatt MacGaffey, "Ethnographic Notes on Kongo Musical Instruments," *African Arts* 35, no. 2 (July 1, 2002): 16.

18 Brincard et al., *Sounding Forms*, 41.

19 MacGaffey, "Ethnographic Notes on Kongo Musical Instruments," 12.

20 Wyatt MacGaffey et al., *Astonishment and Power*, exh. cat. (Washington: Published for the National Museum of African Art by the Smithsonian Institution Press, 1993), 56.

21 DjeDje et al., *Turn up the Volume*, 306.

22 MacGaffey et al., *Astonishment and Power*, 58.

23 Arthur P. Bourgeois, *Yaka, Visions of Africa* (Milan: 5 Continents, 2014), 119.

24 DjeDje et al., *Turn up the Volume*, 306.

25 Ibid.

26 Arthur P. Bourgeois, "Yaka Masks and Sexual Imagery," *African Arts* 15, no. 2 (February 1, 1982): 50.

27 Manuel Jordán et al., *Chokwe!: Art and Initiation among Chokwe and Related Peoples* (Munich; New York: Prestel, 1998), 43.

28 Ibid., 45.

29 Ibid., 128.

30 Ibid., 27.

31 Ibid., 131 and 132.

32 Ibid., 44.

33 Georges Meurant and Robert Farris Thompson, *Mbuti Design: Paintings by Pygmy Women of the Ituri Forest* (New York: Thames and Hudson, 1996), 190.

34 Ibid., 140.

35 Ibid.

36 Unpublished manuscript cited by Robert Farris Thomspon. Ibid., 195.

37 Ibid.

38 *Oxford English Dictionary Online*, s.v. "hocket," accessed January 24, 2015, http://www.oed.com/view/Entry/87504.

39 Hilary Spurling, *Matisse, His Art and His Textiles: The Fabric of Dreams*, exh. cat. (London: Royal Academy of Arts, 2004), 31.

40 Letter from Henri Matisse to Marguerite Duthuit, 28 September 1943, Matisse Archives, Paris, quoted in Spurling, *Matisse, His Art and His Textiles*, 32.

41 Christopher Lyon, "Prelude to Morocco: Matisse in Moscow, 1911," *MoMA* 2, no. 5 (July 1, 1990): 9.

42 Spurling, *Matisse, His Art and His Textiles*, 23.

43 Ibid., 14–5.

44 Ibid., 18.

45 Monni Adams, "Kuba Embroidered Cloth," *African Arts* 12, no. 1 (1978): 24; John Mack, "Bakuba Embroidery Patterns: A Commentary on Their Social and Political Implications," in *Textiles of Africa* (Bath: The Pasold Research Fund, 1980), 167.

46 Adams, "Kuba Embroidered Cloth," 24–6.

47 Ibid., 26.

48 Gyararī Nogizaka, *Matisse's Secret: Kuba Textiles of Zaire = Nogizak Ātohōru Kaikan Isshūnen Kimen: Machisu No Himitsu—Zairu, Kubazuku No Senshoku Ten*, exh. cat. (Tōkyō-to: Nogizaka Art Hall, 1992); Mack, "Bakuba Embroidery Patterns: A Commentary on Their Social and Political Implications," 168.

Ariel Plotek

From *Parsifal* to *Parade*:
The Attributes of Music in the Modern Era

Among the paintings exhibited at the Paris Salon of 1885 was a group portrait, *Around the Piano*, by Henri Fantin-Latour (fig. 225). Depicting a group of composers and musicians gathered around the painting's protagonist, Camille Saint-Saëns, the work was popularly labeled *Les Wagnéristes*, the Wagnerians. It was acquired at the Salon by Adolphe Jullien, whose biography *Richard Wagner: His Life and Works* (*Richard Wagner, sa vie et ses oeuvres*), would be published the following year, with illustrations by Fantin-Latour. These lithographs—loosely traced with greasy crayon and worked by rubbing and scratching the stone—testify to the artist's mastery of this modern technique. They would also mark a return to Wagnerian motifs that had fascinated Fantin-Latour for decades.[1]

Already in 1854, the eighteen-year-old painter had given free reign to his roiling, Romantic imagination in an operatic scene titled *The Dream* (Musée de Grenoble). Here was a student at the august École des Beaux-Arts declaring his allegiance to the generation of 1830, those predecessors of the Impressionist circle around Édouard Manet whom Fantin-Latour would commemorate in his most famous group portrait, *An Atelier in the Batignolles* (1870, Musée d'Orsay). Like the lithographic illustrations to Jullien's book on Wagner, *The Dream* had been a form of Romantic escapism, reminiscent of the idylls of Eugène Delacroix—whom Fantin-Latour would immortalize in his *Homage* of 1864 (Musée d'Orsay). The most Wagnerian of Fantin-Latour's group portraits would remain, however, his last: *Around the Piano*, painted in the year following the composer's death. From *The Dream* in 1854 to

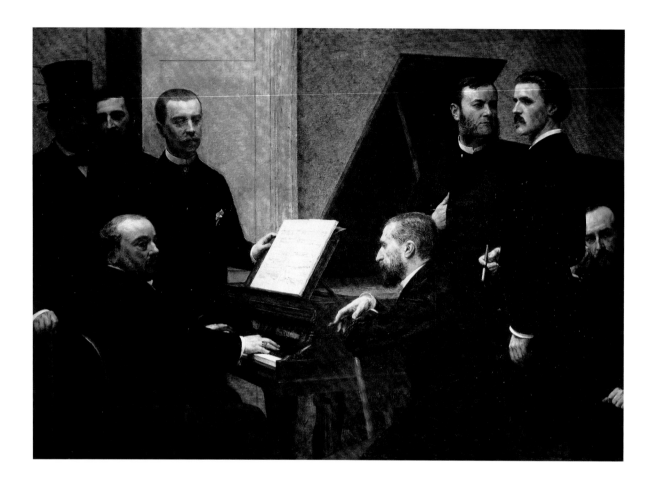

225. Henri Fantin-Latour (1836–1904). *Around the Piano*, 1885.
Oil on canvas, 63 × 87⅜ in. (160 × 222 cm). Musée d'Orsay.

his visit to Bayreuth in 1876, music—and opera in particular—had been a constant source of inspiration to the artist.

Throughout the 1870s, following the Siege of Paris and the brutal suppression of the Paris Commune, Fantin-Latour would immerse himself in far distant fantasies and allegorical tableaux descended from the *fêtes champêtres* and mythological scenes he had copied during his student days at the Louvre. Like the Swiss Symbolist Arnold Böcklin, whose *Nymph and Satyr* of 1871 (fig. 105) recalls Fantin-Latour's interpretations of Wagner's *Tannhäuser*, the Frenchman remained a faithful follower of Titian and his great descendent Delacroix. To appreciate the differences that would emerge after 1864 between Fantin-Latour and his Batignolles comrades, it will suffice to compare two portraits of Richard Wagner. In 1865, Fantin-Latour published an allegorical portrait commonly called *Wagner and the Muse* (fig. 226). In 1882, Auguste Renoir, one of the acolytes who stands by Manet in *An Atelier in the Batignolles*, traveled to Palermo to paint his impression of the celebrated composer who had just completed his *Parsifal*.

By this date the French infatuation with Wagner was at its peak— Charles Lamoureux (1834–1899) had just completed his first series of Wagner concerts with the Société des Nouveaux-Concerts—and,

in the words of Romain Rolland (1866–1944), "the whole universe seemed to be seen through the eyes of Bayreuth."[2] Nevertheless, the Wagnermania of the 1880s had not infected all artists equally. Though Renoir's friend Antoine Lascoux, third from the right in *Around the Piano*, had supplied the necessary introduction to secure a sitting with the composer, the painter's impression was far from reverential (fig. 227). The tenor of Renoir's encounter can be read in a letter to his biographer, Ambroise Vollard. Wagner's own quips on the subject of this likeness are well known.[3] Most remarkable, however, are the attributes that the painter has omitted from his portrait: namely, those of music. With a candor that recalls the art of ancient Rome, Renoir has painted a "verist" portrait of the composer, an image of the maestro as frank and familiar as Suzanne Valadon's *Portrait of Erik Satie* (fig. 228).

In marked contrast to the modernist immediacy of these two portraits stands Fantin-Latour's vision of *Wagner and the Muse*. Looking up from his labors, the composer seeks inspiration from the palm-wielding muse that protects him. Far from the Realism of Renoir, we remain in the quasi-Symbolist realm of Pierre Puvis de Chavannes, or the frozen world of Jean-Auguste-Dominique Ingres, in which a lyre-bearing muse bestows the gift of genius upon the composer Luigi Cherubini. More laden still with classical reserve is Ingres's portrait of the violinist and composer Niccolò Paganini, whose European fame during his lifetime can be compared to the cult of Wagner in the latter part of the nineteenth century.[4] Absent Cherubini's air of melancholy and the trappings of divine intervention (Paganini, on the contrary, was widely rumored to have made a pact with the devil), the violinist, in this pencil portrait by Ingres, possesses the more literal attribute of the musician: his instrument (fig. 229). Likewise the portrait of Paganini painted in 1832 by Ingres's great rival, Eugène Delacroix (fig. 230). With this violin, however, the similarities between the two portraits begin and end. In contrast to Ingres's steely-eyed soloist, it is the supernatural impression of the virtuoso violinist trapped in a demonic trance that Delacroix captures in his oil sketch. As in his celebrated portrait of Frédéric Chopin (1838, Musée du Louvre),[5] what Delacroix has achieved by Romantic means is an immediacy of feeling, especially in contrast to the staid airlessness of Ingres's classical vision. Famed for his attachment to the violin, Ingres's musical attribute is more properly the *kithara*, the Greek lyre at the center of his *Apotheosis of Homer*, painted in 1827 for the Louvre. Like the legend of the blind bard, however, the myth of the "*violon d'Ingres*" persists.

Even more radical than the contrast between the Wagnerist Fantin-Latour's *Around the Piano* and Suzanne Valadon's portrait of Erik Satie, or Wagner's *Tannhäuser* and the "Impressionist" Claude Debussy's *Pelléas and Mélisande*, would be the rupture represented

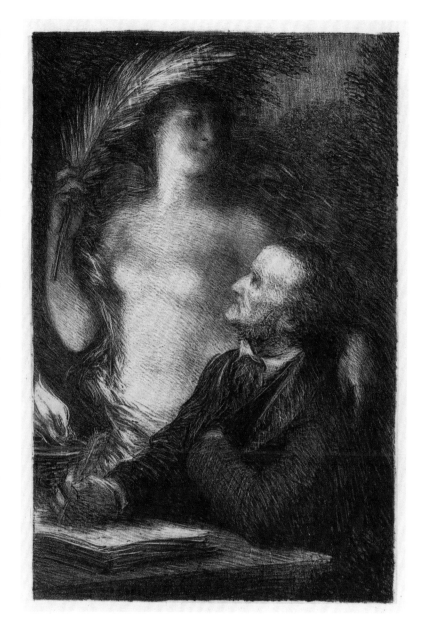

226. Henri Fantin-Latour (1836–1904). *Wagner and the Muse*, from Adolphe Jullien's *Richard Wagner: His Life and Works* (*Richard Wagner: Sa vie et ses œuvres*), 1886. Printed material and 14 lithographs on wove paper, Overall: 12¾ × 9¾ × 2 in. (32.4 × 24.8 × 5.1 cm); Sheet: 12⅜ × 8⅞ in. (31.4 × 22.6 cm) each. Los Angeles County Museum of Art; Gift of Myron Laskin.

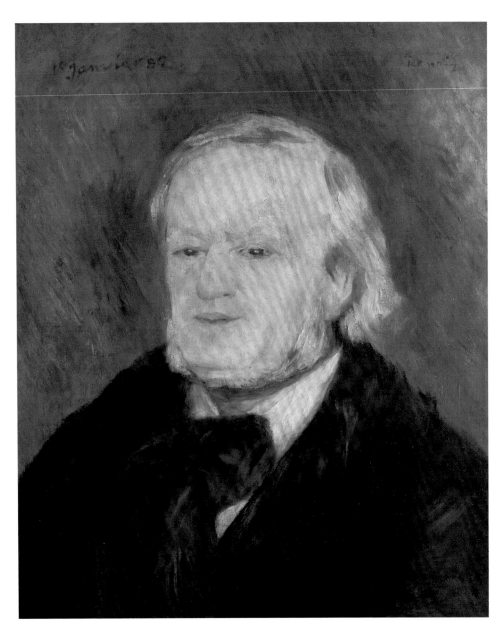

227. Auguste Renoir (1841–1919). *Richard Wagner,* 1882. Oil on canvas, 20⅞ × 18⅛ in. (53 × 46 cm). Musée d'Orsay.

228. Suzanne Valadon (1865–1938). *Portrait of Erik Satie,* ca. 1892. Oil on canvas, 16⅛ × 8⅝ in. (41 × 22 cm). Musée National d'Art Moderne, Centre Georges Pompidou.

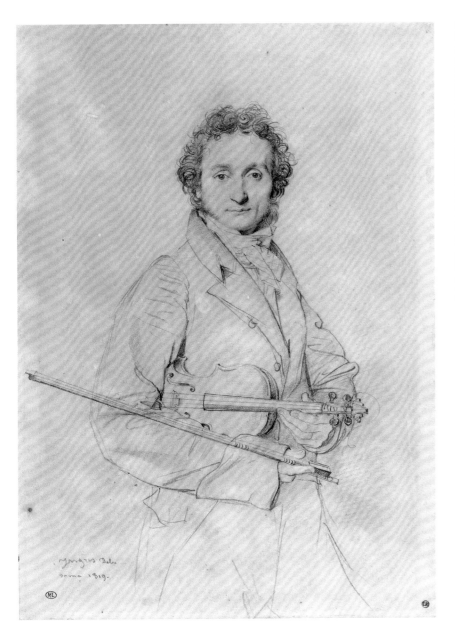

229. Jean-Auguste-Dominique Ingres (1780–1867). *Pencil Portrait of Paganini*, 1819. Counterproof strengthened with graphite and white chalk on paper, 11¾ × 8⅝ in. (29.8 × 21.8 cm). Louvre Museum.

230. Eugène Delacroix (1798–1863). *Paganini*, 1831. Oil on cardboard on wood panel, 17⅝ × 11⅞ in. (44.8 × 30.2 cm). The Phillips Collection.

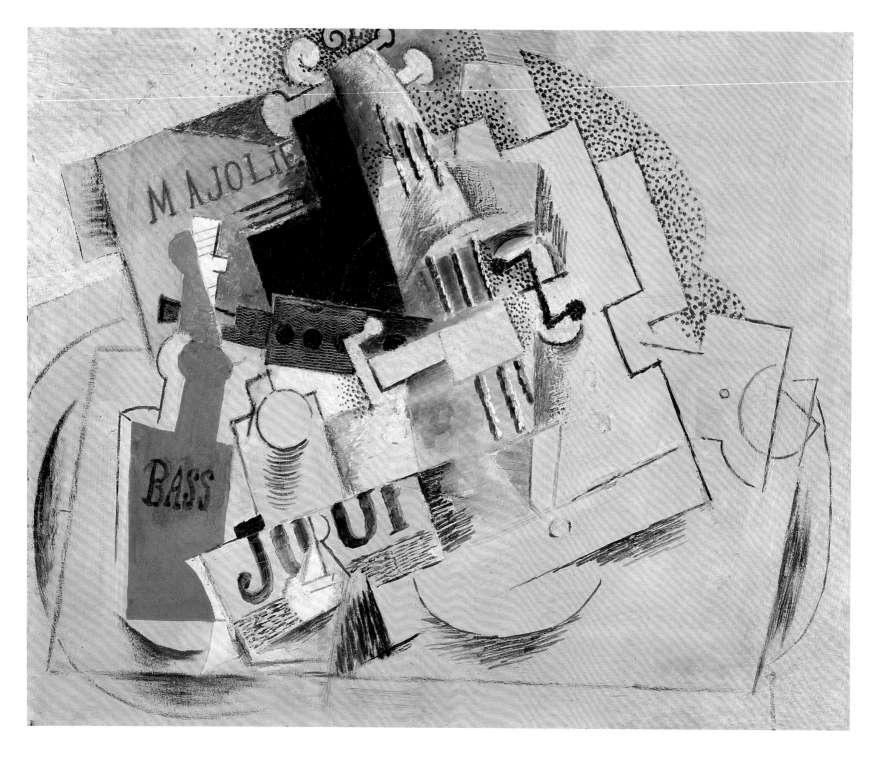

231. Pablo Picasso (1881–1973). *Ma Jolie,* 1913–14. Oil on canvas, 21¼ × 25⅝ in. (54 × 65 cm). Indianapolis Museum of Art; Bequest of Mrs. James W. Fesler.

by the Ballets Russes' production of *Parade*, which premiered at the Théatre du Châtelet in 1917. Paris in the late teens was a very different place from the city where Debussy had first seen *Pelléas and Mélisande* produced in 1902. Alongside the political upheavals wrought in the intervening years were cultural transformations, not least the invention of Cubism by Georges Braque and Pablo Picasso (fig. 231). Most of all, what had paved the way for *Parade*—conceived by Jean Cocteau with music by Erik Satie—was the *succès de scandale* represented by *The Rite of Spring* (*Le Sacre du printemps*), performed by the same Ballets Russes, with a score by Igor Stravinsky. The now-legendary first performance of *The Rite of Spring*, on May 29, 1913, had famously caused a riot to erupt among spectators at the Théâtre des Champs-Elysées, where Vaslav Nijinsky danced under a dome decorated by Maurice Denis (1870–1943). It was in the hope of provoking an even greater scandal that Cocteau had begun work on his own one-act ballet, *Parade*, to which end Sergei Diaghilev had engaged Léonide Massine to provide choreography and Pablo Picasso to design costumes and sets. Billed as a "Realist" ballet,[6] Cocteau's *Parade* would find little favor with French audiences. Nevertheless, this ode to the Dadaist spirit of Tristan Tzara had brought together the most advanced figures in the fields of design, composition and choreography, collaborating on a modernist Total Work of Art.

Among the artifacts that survive from this original production, a Commedia dell'arte–inspired patchwork, are Picasso's painted theater curtain and the costume of the Chinese Conjuror (fig. 233). Through his collaboration with Picasso, Erik Satie became acquainted with a host of other artists, including Georges Braque. The composer also frequented Surrealist circles in Paris, and was close friends with the American artist Man Ray. A pioneering painter and photographer, Man Ray created his most famous visual pun with a touched-up portrait of the model and muse Kiki de Montparnasse entitled *Le Violon d'Ingres*—a playful allusion to the nineteenth-century painter's musical obsession (fig. 235).[7]

No less preoccupied with the relationship between art and music were two American expatriates who had preceded Man Ray in Paris: the painters Morgan Russell and Stanton Macdonald-Wright. Inspired by the art and ideas of the Italian Futurists, Russell and Macdonald-Wright penned their own manifesto, outlining the principles of the style they termed Synchromism. This encounter with Futurism in Paris had occurred at the Galerie Bernheim-Jeune in 1912, the same year in which Vasily Kandinsky published his treatise *On the Spiritual in Art* (*Über das Geistige in der Kunst*), a theory that particularly stressed the relationship between color and sound. What the critic and poet Guillaume Apollinaire called Orphism—an abstract impulse rooted in Cubism—was also predicated on the analogy, much in vogue around 1912, between color and music.

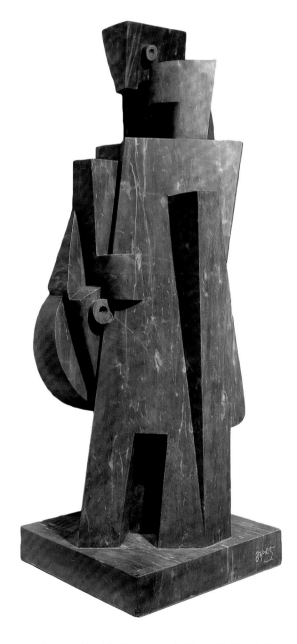

232. Jacques Lipchitz (1891–1973). *Man with Mandolin*, 1917. Marble, 48⅜ × 17⅜ × 17⅜ in. (123 × 44.2 × 44.2 cm). University of Arizona Art Museum; Gift of Yulla Lipchitz.

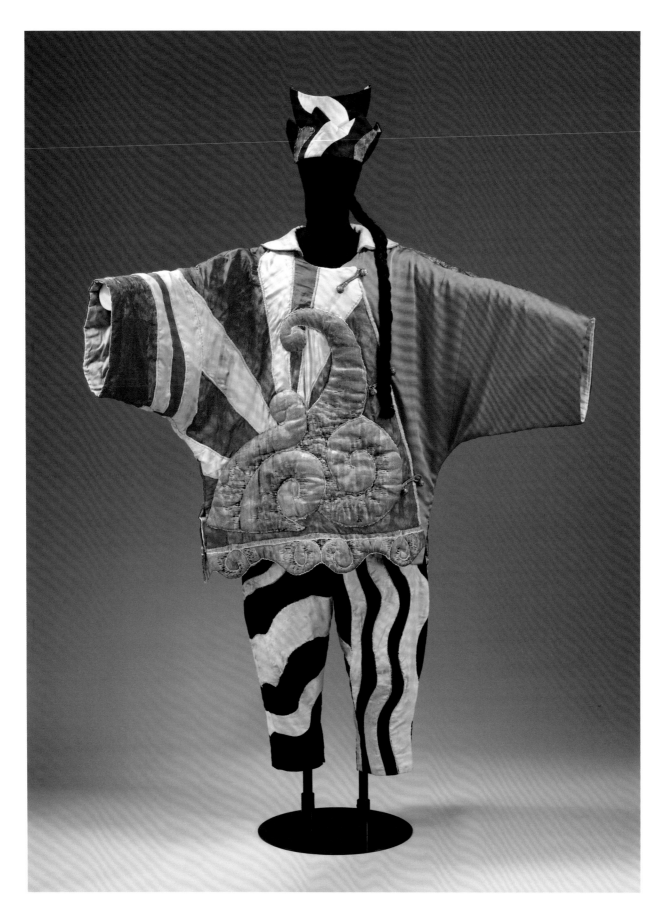

233. Pablo Picasso (1881–1973). Costume for the Chinese Conjurer in the Ballets Russes production of *Parade*, 1917.

Victoria and Albert Museum, London.

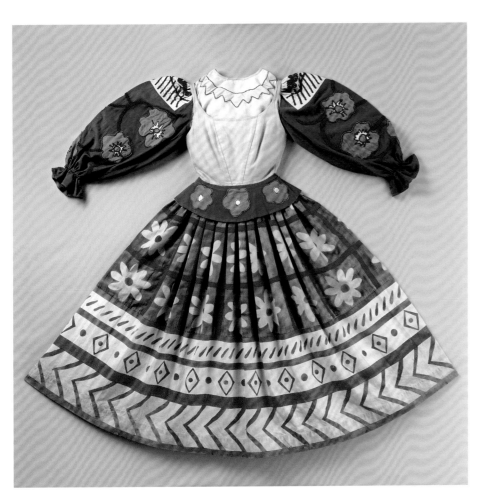

234. Natalia Goncharova (1881–1962). Costume for a Female Subject of King Dodon in *The Golden Cockerel* (*Le Coq d'Or*), 1937, based on the original 1914 design. Cotton, linen, stenciled cotton, cotton braid and embroidered appliqués. Los Angeles County Museum of Art; Costume Council Fund.

235. Man Ray (1890–1976). *Ingres's Violin* (*Le Violon d'Ingres*), 1924. Gelatin silver print, 11⅝ × 8⅞ in. (29.5 × 22.7 cm). The J. Paul Getty Museum.

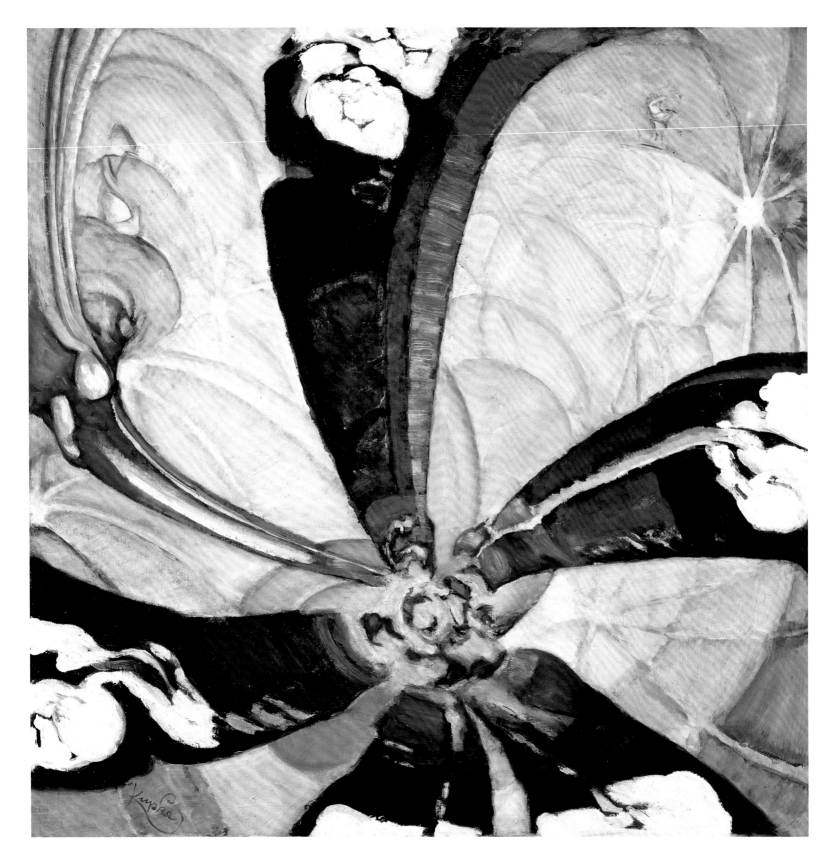

236. **František Kupka (1871–1957).** *Blue Space,* ca. 1912. Oil on canvas,
26⅛ × 26⅛ in. (66.4 × 66.4 cm). The San Diego Museum of Art;
Museum purchase through the Earle W. Grant Endowment Fund.

237. Morgan Russell (1886–1953). *Synchromy with Nude in Yellow*, 1913. Oil on canvas, 39¼ × 31½ in. (99.7 × 80 cm). The San Diego Museum of Art; Museum purchase through the Earle W. Grant Endowment Fund.

While so-called Orphic artists, such as František Kupka, suggested musical correlations through the titles of their pictures, paintings such as Russell's *Synchromy with Nude in Yellow* represented the intersection of Cubism and neo-Fauvism (fig. 237). Henri Matisse too had been investigating the relationship between color and musical motifs, as revealed in two interior scenes painted at Nice between the wars.

In 1919, Matisse painted *Interior with Violin Case*, a view from the artist's hotel room (fig. 238). The plush lining of the violin case of the title (the instrument itself is absent) is painted the same bright blue—a mainstay of Matisse's palette in the period—as the sky glimpsed through the open window. Once more, the musical

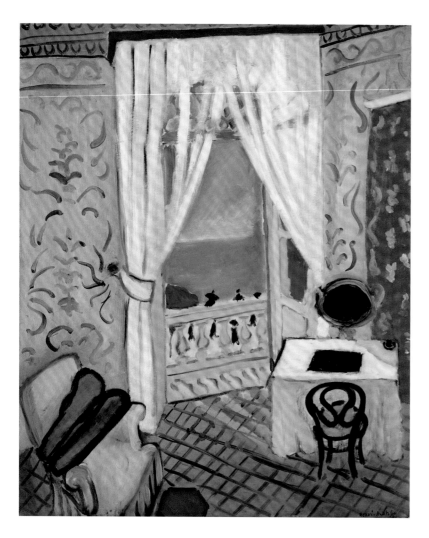

238. Henri Matisse (1869–1954). *Interior with Violin Case*, 1918–19.
Oil on canvas, 28¾ × 23⅝ in. (73 × 60 cm). Museum of Modern Art;
Lillie P. Bliss Collection.

239. Henri Matisse (1869–1954). *Interior with a Phonograph*, 1924.
Oil on canvas, 39¾ × 31⅞ in. (100.5 × 81 cm). Private collection.

motif is used to enliven a familiar genre, albeit the detail of an open case is empty of allegorical meaning. We can consider this interior alongside one painted by Matisse around 1924, *Interior with Phonograph* (fig. 239). The musical note provided by the violin case in 1919 has been replaced by a modern phonograph, an invention whose influence on painters in the first decades of the twentieth century has yet to be fully explored.[8] We can imagine, nonetheless, what the phonograph meant to Matisse: the ability to paint to the sound of music when and where the artist wished. Moreover, the variety of recorded music afforded a new freedom of choice, from chamber and symphonic music to modern compositions, and even the improvised arrangements of American-style jazz—what, in the Paris of Morgan Russell and Stanton Macdonald-Wright, was called *le jazz hot*. In 1943, at the age of seventy-four, Henri Matisse

published a portfolio of twenty prints entitled *Jazz* with the Maison Tériade. Unable to paint, Matisse had begun experimenting with paper cut-outs, a technique that would occupy his final years. Here, at last, was the true emancipation of color: large forms cut from painted construction paper. Like Cocteau's *Parade*, many of the motifs in Matisse's *Jazz* (fig. 218) took their subjects from the theater or circus. In the manner of a musician, the artist-turned-illustrator improvised variations on his favorite themes. Under the sign not of cosmic Orpheus but all-too-human Icarus, Matisse conceived his most radical designs: compositions as abstract and experimental as modern recorded music itself.

NOTES

1 Fantin-Latour produced his earliest works inspired by Wagner, a series of lithographs illustrating scenes from *Tannhäuser*, in 1862.

2 Romain Rolland, *Musicians of To-day*, trans. Mary Blaiklock (New York: Henry Holt and Company, 1914), 253.

3 Wagner purportedly described his portrait as like "an embryo of an angel which an Epicurean had swallowed, thinking it was an oyster." Cited in Edward Lockspeiser, "The Renoir Portraits of Wagner," *Music & Letters* 18, no. 1 (January 1937): 14.

4 In 1827, Paganini was made a Knight of the Golden Spur by Pope Leo XII. From 1828 he toured Europe, triumphing in Vienna, Frankfurt, Leipzig, Paris and London.

5 The portrait of Chopin preserved at the Louvre is a fragment, cut down from an unfinished double portrait. Its companion, a portrait of George Sand, is preserved at the Ordrupgaard Museum, Copenhagen.

6 "Parade. Ballet réaliste." (Paris: Rouart, Lerolle & Cie., 1917). This original program was subsequently amended "Ballet surréaliste," by Guillaume Apollinaire.

7 On this subject see M. Montagu-Nathan, "Le Violon d'Ingres: A Myth," *The Music Times* 95, no. 1337 (July 1954): 384–5.

8 See Patrick Coleman, "Going Electric: Technology and the Musical Body," in the present volume.

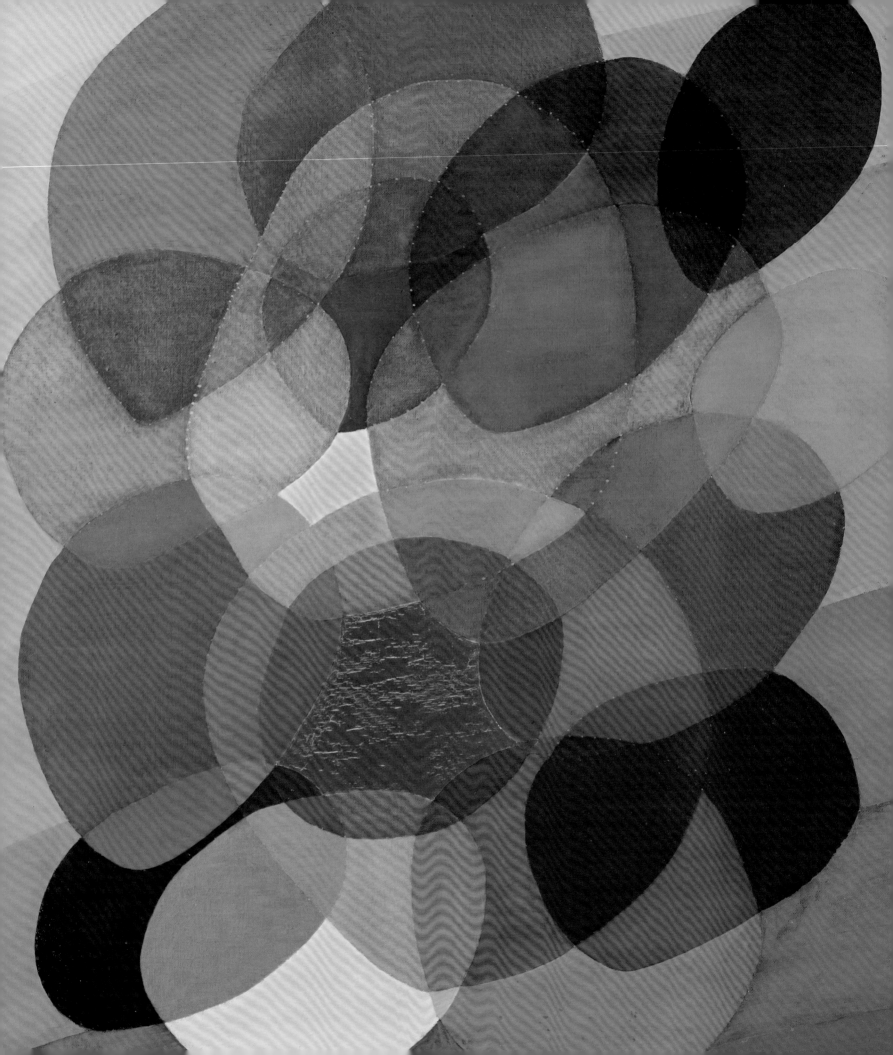

Patrick Coleman

Going Electric:
Technology and the Musical Body

When I was introduced to him [Oskar Fischinger],
he began to talk with me about the spirit which is inside each
of the objects of this world. So, he told me, all we need to do
to liberate that spirit is brush past the object, and to draw
forth its sound. . . . In all the many years which followed up to
the war, I never stopped touching things, making them sound
and resound, to discover what sounds they could produce.
Wherever I went, I always listened to objects.

—JOHN CAGE[1]

Arthur Dove moved the needle. He lifted it, as he'd done count-less times, from where dead wax met the label and returned it to the outermost edge of a shellac record's lead-in groove. It was April 11, 1927.[2] The record was Paul Whiteman and His Orches-tra, a 10-inch single with the bouncy George Gershwin tune "I'll Build a Stairway to Paradise" on the side Dove was cueing up.[3] Like the dog on the Victor record's label (fig. 240), Dove had been staring into this sound for a long time. But instead of cocking his head down into a gramophone horn, he had a canvas before him and an array of materials close at hand. From the Victrola came a momentary crackle, the anticipatory near-silence. Like music, the resulting painting, *George Gershwin—I'll Build a Stairway to Par-adise* (fig. 241), is abstract, made up of the patterning of silvers, blues, reds and blacks in metallic paints and oils instead of sound. It is also a painting that would be very literally unthinkable without the invention of the phonograph in 1877.

The twentieth century is rife with examples of technology pro-viding new tools and techniques for artists to re-think the bound-aries between the visual and the musical: the invention of recorded sound and early experiments in film would give way to more recent innovations of video, installation and particularly sound art, in which the aural takes precedent over what presents to the eye. These are bound up in philosophical and aesthetic shifts during the modern era and in its wake, when the boundaries between the arts were intensely contested, often because of the possibil-ities presented by new technologies, new modes of expression and the peculiar questions that arise from being a sensing and

240. Label for the Victor record of Paul Whiteman and His Orchestra performing George Gershwin's "I'll Build a Stairway to Paradise."

remembering body that took a leading role in intellectual inquiry. In some ways, what it means to be a musical body is one of the central questions of twentieth- and early twenty-first-century art.

The Record and Musical Painting
Dove's interest in the boundary between music and visual art had begun with Kandinsky-esque paintings in the 1910s.[4] Their music-inspired titles—like Whistler's or even some of his friend Georgia O'Keeffe's abstractions, such as *Music, Pink and Blue No. 2* (1918, Whitney Museum of American Art)—were useful in changing the way people looked at his abstract work. It was an attempt to restore to sight a simplicity that is quickly lost in intellection and the hunger for reason, representation, meaning, words, *logos*. These artists wanted viewers to *listen* to their paintings, to attend to them as one does an étude or jazz improvization. For Dove, this emphasis on listening included other acoustic phenomenon, like a babbling creek in *Running River* (1927, private collection) or harbor sounds in *Fog Horns* (fig. 81), as well as a fascination with the radio. But these early paintings were clearly not an imitation of musical forms; the marks on canvas were not meant to transcribe

or represent musical structures directly. They were evocative parallels, a shared pathway—color and music as feeling.

The same could be said of Alfred Stieglitz's *Equivalents*, the body of photographic works that he originally called *Songs of the Sky* (figs. 28 and 29). Between 1922 and 1931, he printed over four hundred photographs, primarily of clouds, chosen for their potential for abstraction. He wrote:

> I knew exactly what I was after. I had told Miss O'Keeffe I wanted a series of photographs which when seen by Ernest Bloch (the great composer) he would exclaim: Music! Music! Man, why that is music! How did you ever do that? And he would point to violins, and flutes, and oboes, and brass, full of enthusiasm, and would say he'd have to write a symphony called "Clouds." Not like Debussy's but much, much more.
>
> And when finally I had my series of ten photographs printed, and Bloch saw them—what I said I wanted to happen happened verbatim.[5]

Here, however, we can see how new technologies are less than readily accepted as viable for artistic use. Ernest Bloch, one of Debussy's protégés, held a disregard for arts of the masses, whose "facile taste is sinking with the love of platitude and the weight of mechanical inventions—phonograph, Pianola, cinematograph."[6] Photography, as a "machine art," was among these by extension. To challenge Bloch's view, Stieglitz staged an Apollo-and-Marsyas-like test, one in which he and Bloch took photographs from the same vantage. Afterward, as he would later tell the story, Bloch was astonished at how poor his image looked in comparison.[7] The less violent conclusion is that Bloch would later produce his own series of semi-abstract nature photographs, each named for specific composers.

And yet technology—which comes from *technē*, the Greek word for "art" (broadly understood) and also the root of "technique"—has always been ingredient in the interpenetration of visual arts and music. Musical notation, which allows aural structures to be transferred beyond the performer and the boundaries of the oral tradition, relies on a system of mark making which translates sound into visual symbols that a stranger can then re-translate into sound (fig. 242). The invention of mechanical reproduction and the resulting impact on musical culture through printed sheet music—amateur players suddenly flush with choice, the changing economics of being a composer, and the eventual turn from a primarily contemporary repertoire to one increasingly dominated by the greats of the past—is well documented.

The record, like musical notation and the printing press, would make an enormous impression upon both the musical and visual arts. Song lengths became determined by the limits of recording

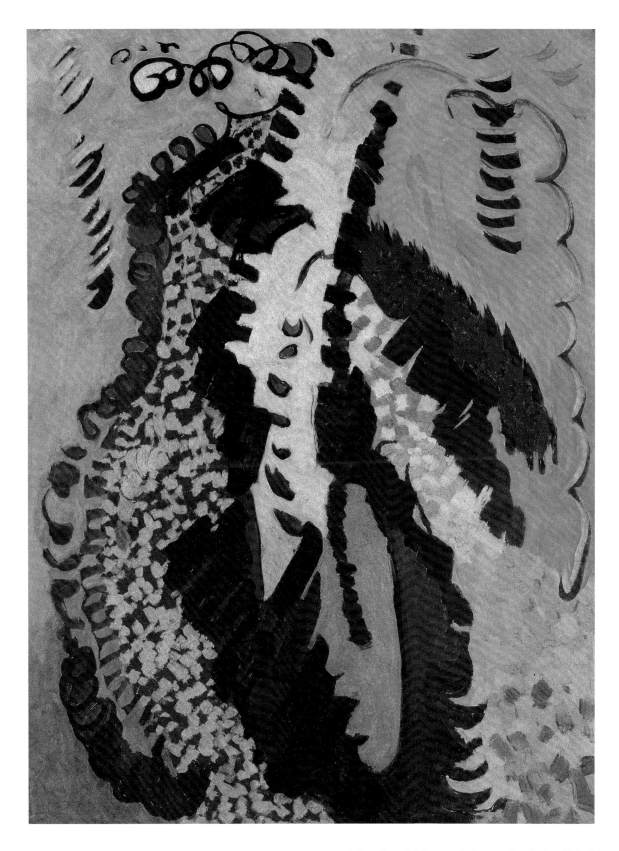

241. Arthur Dove (1880–1946). *George Gershwin—I'll Build a Stairway to Paradise,* 1927. Ink, metallic paint and oil on paperboard, 20 × 15 in. (50.8 × 38.1 cm). Museum of Fine Arts, Boston; Gift of the William H. Lane Foundation.

and playback technology. Later, the length of the compact disc was determined by a desire to fit Beethoven's Ninth Symphony on a single disc. Turntablism and DJ culture, with the emphasis on sampling and remixing, would become the most vibrant and, in many ways, the dominant mode of contemporary culture, musical or otherwise.

And it's almost impossible to imagine the global profusion of jazz without the record. In the beginning of the twentieth century, jazz was a relatively new and exciting form, a fresh and unusual sound that a sheet music transcription couldn't capture. (Later, thanks to John and Alan Lomax among many others, field recordings of blues artists could be made using newly portable recording technologies which preserved the work of musicians that otherwise would be known now only by legend.) Artists in the United States seized upon jazz because of its American character, the way in

242. Initial A: A Man Singing. Italy, ca. 1460–80. Tempera colors and gold leaf on parchment, 23¾ × 17⅜ in. (60.3 × 44 cm). The J. Paul Getty Museum.

which it could help define the modern American artist. It provided a staging ground for African American artists like Archibald Motley and Aaron Douglas to assert their artistic presence to a wider audience. In its emphasis on improvisation and rhythm, jazz became the emblematic music of the twentieth-century city. Europeans like Francis Picabia and Piet Mondrian, among many others, would inflect their work with its alternative rhythms.

Dove seems to have been attracted to jazz for these reasons, and one other: On the same day he attended a concert by Paul Whiteman and His Orchestra (which led him to purchase the Paul Whiteman recording of "I'll Build a Stairway to Paradise"), he bought his first books by French philosopher Henri Bergson, enamored enough with what he found that he would return only four days later to buy more.[8] Like jazz, Bergson posed a new relationship to time, often resorting to analogies rooted in music and emerging media, including motion pictures.

Technology, like music, shapes our sense of time. The invention of the clock ushered in one such temporal revolution, but the radio, the record and the moving picture each have impacted how we perceive the passage of time, how we conceptualize it. Beginning in the late nineteenth century, time itself had become a subject in a new way, ripe for manipulation—a manipulation that was frequently associated with music. The revolutionary stream-of-consciousness novel *Les Lauriers sont coupés* (1887), by *Révue wagnérienne*-founder Édouard Dujardin, consisted of one evening in the life of a young Parisian dandy. Its technique would influence the writing of James Joyce's novel of shifting relationships to traditional novelistic time, *Ulysses* (1922), in which the Sirens chapter was composed using the principles of a musical fugue. In early twentieth-century music, Arnold Schoenberg's *Expectation* (*Erwartung*, Op. 17, 1909) sought, in his words, "to represent in slow motion everything that occurs during a single second of maximum spiritual excitement, stretching it out to half an hour."[9] It features only one character, a woman named Frau, who sings through an elaborate fantasy while alone in a forest at night. *Erwartung* is also notable for being athematic, having no familiar tonal material repeat over 426 measures. In doing so, Schoenberg stripped away the means by which we mark the passage of musical time to expand upon a singular but endlessly complex inner moment of memory and fantasy.

Even Nipper, the dog on the label of the Victor record, had apocryphally experienced the dislocation of a new sense of time. The image is based on a painting called *His Master's Voice* by Francis Barraud, the brother of the model dog's deceased owner. Nipper tilts his head not to enjoy a song or in puzzlement at the odd device before him: he hears the voice of his dead master, calling from beyond the grave. This notion was taken very literally in a

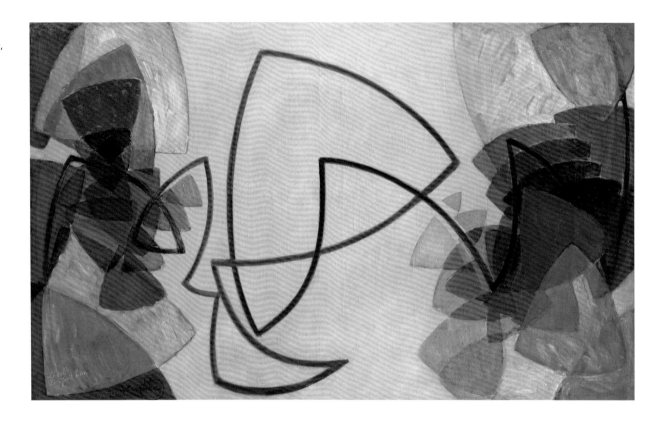

243. František Kupka (1871–1957). *Solo of a Brown Stroke*, 1912–13. Oil on cardboard, 27½ × 45¼ in. (70 × 115 cm). National Gallery, Prague.

story about Guglielmo Marconi, the man responsible for inventing long-distance radio. He allegedly believed that sounds never die and could be heard again, if only he could design a sensitive enough instrument. What he wanted to hear? The music that played on the Titanic as it sank—he was supposed to be a passenger on that voyage—and Jesus delivering the Sermon on the Mount.

Bergson held that moments in time linger and can return, though in a less fantastical way than Marconi. He rejected accounts of time as described by the science and materialism of the day, to say nothing of the dominance of the clock, with its numerical divisions of time, in modern life. (Another of Dove's jazz paintings, *George Gershwin—Rhapsody in Blue, Part I*, has a clock spring attached to its surface.) Bergson argued that a view of time as a series of moments, a set of successive but separate images that we could order spatially like a filmstrip, wasn't true to a person's lived experience of time. Instead, he offered his concept of *duration*. Duration posits an intuitive experience of living in time, without differentiation from moment to moment. In the view suggested by duration, our experience of time is felt in an ever-changing quality of the experience. This experience of duration is grounded in the idea that the mind is not separate from the body, from matter. The clearest image he gives of this is of two spools with a thread running between them. Here, the future unspools through the present

and is wound up on the spool of the past, where experiences are conserved in memory. There the past accumulates and, in an ever-changing way so that no one instant is a duplicate of another, is brought to bear on the present. Instead of separate moments, instants and impressions interpenetrate one another.

František Kupka, who like Dove was a serious reader of Bergson, perhaps reached furthest in expressing this in his Amorpha paintings. He was interested in chronophotography, of the kind pioneered by Étienne-Jules Marey, in which successive images of movement in space are layered in a single photographic image to present a related kind of visual simultaneity.[10] Kupka began with an image of his stepdaughter Andrée, naked and playing with a ball, and submitted it to further abstraction in pursuit of the underlying movement of her play layered in a single image, which he saw as having a musical structure, as a fugue, in *Amorpha, Fugue in Two Colors* (fig. 30). Additionally, *Solo of a Brown Stroke* is a musicovisual equivalent to Bergson's image of the spool: the line, as the trace of a moving point as much as a figure for a musical soloist, originates in one set of triangular forms and etches out a rhythm of harmonious triangular forms before terminating in another set of overlapping triangles of varying transparency, much as the image of duration emphasized the present as a thread unwound from one spool and gathered up in another (fig. 243). Kupka later said, "Yes, fugues, where the sounds evolve like veritable physical

entities, intertwine, come and go."[11] *Solo* is an image of movement in space and in time, of the essence of coming and going, and its registration within the self as duration.

Something similar is at stake for Dove. The intersection of music and Bergson's ideas in Dove's *I'll Build a Stairway to Paradise* comes to the fore in how the painting depends upon Whiteman's jazz orchestra, disembodied by technology yet ready to be called up at a moment's notice—and not just any performance but an approximation of one Dove saw live. Bergson had used music as a figure for the experience of duration when he stated in his lecture "The Perception of Change" that, "There is simply the continuous melody of our inner life—a melody which is going on and will go on, indivisible, from the beginning to the end of our conscious existence."[12] Past and present, he says in *Time and Free Will*, form "an organic whole, as happens when we recall the notes of a tune, melting, so to speak, into one another."[13] Sixteen months—a winter, a spring, a summer, an autumn, another winter, the beginning of another spring—would pass between Dove's attendance at the Whiteman concert and purchase of Bergson books and his composition of *I'll Build a Stairway to Paradise*, accompanied by the band thanks to his record player.

The record, which allows a past performance to return to the present, is an ideal figure for Bergson's theory of duration and memory, and of the new kind of self-consciousness that appears. It allows for the same kind of return of the past self via recording technology that Samuel Beckett dramatized so well in his play *Krapp's Last Tape* (1958). Dove's *George Gershwin—I'll Build a Stairway to Paradise* is then a record in both senses of the word: personal archive and phonographic disc. If we think of Dove's jazz series in this way, we can see why he rejected the label of "abstractions" for his paintings. In a letter to Stieglitz in reference to the jazz paintings of 1926–27, he wrote:

> They [some friends] have waxed enthusiastic over a "thing" of mine being done from Gershwin's "Rhapsody in Blue" not as yet completed, but I feel it will make people see that the so called "abstractions" are not abstract at all. R. [Henry Raleigh] said that in describing it to some people who had heard the music, he found that they understood this even though they had objected to my other "things." It is illustration.[14]

This could lead one to suppose that Dove intended to create a graphic illustration of the musical form of Gershwin's composition, a direct formal translation, but that isn't the case. A couple of years later, Dove had moved away from the term "illustration" but was more emphatic: "There is no such thing as abstraction. It is extraction, gravitation toward a certain direction, and minding your own business."[15]

We can see the painting, then, as an extraction of a Bergsonian experience of time while listening to "I'll Build a Stairway to Paradise." This and Dove's other paintings occasioned by records show an artist for whom "[t]heories have been outgrown, the means is disappearing, the reality of the sensation alone remains"[16]—an artist enthralled with the body, "his own business," with the way the world impressed itself upon consciousness and how an artist might "set down" the experience of that, evoked recursively by the re-playability of records. They present the accumulation of sense impressions across repeated listenings of a song into the synthetic "present" of the picture plane. Some impressions are sonic, some rhythmic, but others visual or associative: the form in the center of *I'll Build a Stairway to Paradise* has enough resemblance to a stairway, hinting at visually associative linguistic perception, but also to a string instrument (a stand-up bass? a guitar? maybe even the

banjo one can hear on the record?), suggestive of the visual memory of a jazz group—perhaps Paul Whiteman's orchestra itself, from the concert he attended on December 15, 1925—triggered by the purely aural reconstruction of one playing on the phonograph. Just as a record will play back not only the sounds etched in its grooves but the pops of dust and warbles of warped vinyl, Dove's painting captures it all, the music and everything the music touched upon.

Karl Benjamin's hard-edged abstraction in this untitled work (fig. 244) seems as if it could be drawn from one corner of Arthur Dove's painting, with the shifting figure-ground relationships of red and pale blue planes. One of the "Four Abstract Classicists," as named in the 1959 LACMA exhibition of the same name, Benjamin replaced the shaggy expressiveness of Dove with a tight restraint

244. Karl Benjamin (1925–2012). *Untitled*, 1957. Oil on canvas, 20 × 50⅛ in. (50.8 × 127.2 cm). The San Diego Museum of Art; Anonymous gift.

245. **John Sennhauser (1907–1978).** *Improvisation,* **1939.** Oil on canvas board, 19⅞ × 16 in. (50.5 × 40.6 cm). The San Diego Museum of Art; Gift from the Estate of John Sennhauser.

246. **John Sennhauser (1907–1978).** *Synchroformic #18—Horizontal Duo,* **1951.** Oil on board, 24 × 72 in. (61 × 182.9 cm). The San Diego Museum of Art; Gift from the Estate of John Sennhauser.

and a non-expressiveness of forms that still relies on intuitive, improvised compositional decisions—something one critic compared to the drumming of Gene Krupa.[17] In fact, Benjamin too listened to jazz records while working. He remembered:

> I think I wore out two copies of [Miles Davis's] *Birth of the Cool*. Miles' music spoke to me, spoke to my attitude, my outlook. In visual arts, negative area—the space between things—is very important, and with Miles, the space between the notes took on new meaning. This restrained lyricism moved me deeply. Of course you're not thinking about it at the time, but the music and the painting coincided.[18]

This new, more restrained mode of musical abstraction wasn't restricted to the West Coast. John Sennhauser, first coming to abstraction through working for Hilda Rebay and her Museum of Non-Objective Painting (later the Guggenheim Museum), worked early in Kandinsky's improvisatory mode and transitioned, after joining the American Abstract Artists, to a more geometric style that nonetheless suggested the relationship of music and visual form (figs. 245 and 246). He later moved from New York to north San Diego County.

Washington, D.C.-based artist Alma Thomas often listened to the radio on drives in the country to scout visuals. She titled her late paintings after the popular and classical music she heard as a way to link the natural world that inspired them to their emphasis on rhythm, as in *Wind and Crepe Myrtle Concerto* (1973) and *Babbling Brook and Whistling Poplar Trees Symphony* (1976). Of the creation of the latter, she said: "I would wade in the brook and when it rained you could hear music. I would fall on the grass and look at the poplar trees and the lovely yellow leaves would whistle."[19] *Red Azaleas Singing and Dancing Rock and Roll Music* has a similarly wind-blown, gestural quality that befits its title (fig. 247). These paintings recall African American textiles, especially those of southern US quilt traditions, but also African textiles like those produced by the Shoowa peoples that hung in Matisse's studio.[20] In fact, it was while convalescing from a severe bout of arthritis that Thomas connected the light moving through leaves outside her window with the cut-outs of Matisse. But Thomas's expressive use of color and tight manipulation of form to give abstract, expressionistic form to nature hark back as much to Kandinsky and Stieglitz as to Goethe and Runge.[21]

247. Alma Thomas (1891–1978). *Red Azaleas Singing and Dancing Rock and Roll Music,* 1976. Acrylic on canvas, 72¼ × 135½ in. (183.5 × 344.2 cm). Smithsonian American Art Museum; Bequest of the artist.

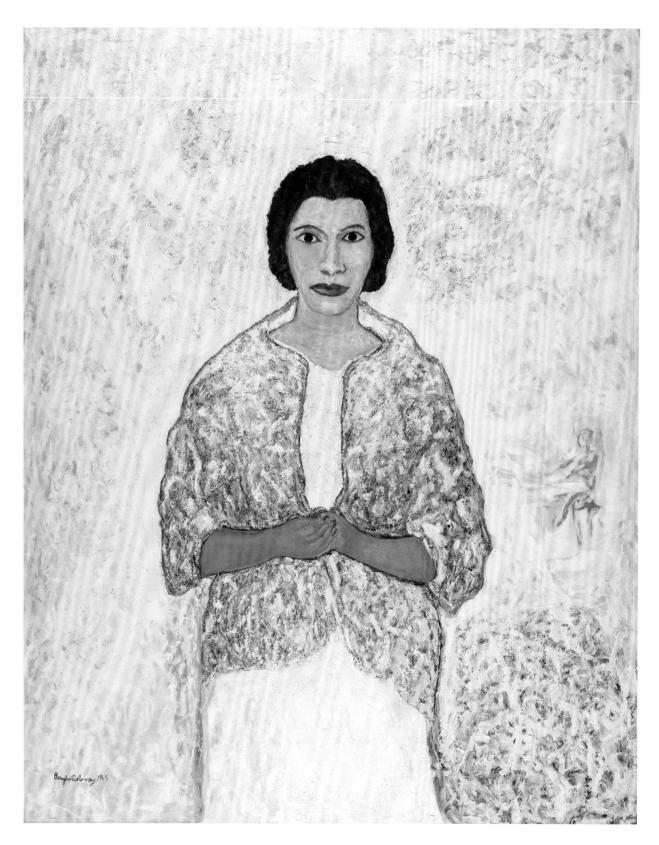

248. Beauford Delaney (1901–1979). *Marian Anderson*, 1965.

Oil on canvas, 63 × 51½ in. (160 × 130.8 cm). Virginia Museum of
Fine Arts; J. Harwood and Louise B. Cochrane Fund for American Art.

Beauford Delaney's portrait of singer Marian Anderson, however, tells a variation on the theme (fig. 248). The world-famous contralto, after being barred from performing at Constitution Hall in Washington, D.C., because of the color of her skin, sang instead to a crowd of over 75,000 people on the steps of the Lincoln Memorial on Easter Sunday, April 9, 1939. For countless more who heard the live radio broadcast, Anderson's presence was registered only through her powerful voice. For others unable to attend in person, the sight and sound of this historic moment of the Civil Rights Movement were unified thanks to newsreels of the event. Others still would be moved simply by newspaper accounts of her edifying renditions of "America" and "My Country 'Tis of Thee" and the photographs of her, jacketed against the cold, eyes closed and singing before the stone edifice of Abraham Lincoln. This one performance, thanks to its transformation and transmission through these different media, changed Anderson from a singer into an icon, one in which image and sound were intertwined even if, in a given form, one or the other was absent.

Before moving to Paris in 1953, Beauford Delaney lived in Greenwich Village, where he was a regular attendee at jazz and blues concerts and associated with, among other artists, Countee Cullen and those in the Stieglitz circle. It was there that he became a "spiritual father" to James Baldwin, who said of his influential first meeting at Delaney's apartment:

> I walked into music. I had grown up with music, but, now, on Beauford's small black record player, I began to hear what I had never dared or been able to hear. Beauford never gave any lectures. But, in his studio and because of his presence, I really began to *hear* Ella Fitzgerald, Ma Rainey, Louis Armstrong, Bessie Smith, Ethel Waters, Paul Robeson, Lena Horne, Fats Waller.[22]

Delaney took Baldwin to see Marian Anderson perform spirituals at Carnegie Hall, of which he recalled her "smoky yellow gown, her skin copper and tan, roses in the air about her, roses at her feet." According to Baldwin, "Beauford painted it, an enormous painting, he fixed it in time, for me, forever, and he painted it, he said, for me."[23] In Paris in 1965, physically distanced from the stateside struggle for civil rights but engaged with it psychologically and artistically, Delaney created this second painting of Anderson after seeing another concert of hers there (the first painting, *Marian Anderson, Greenwich Village, 1951*, is in a private collection). Like Dove's jazz paintings, Delaney's portrait mingles music and memory. Around the figure the transcendent, heavily impastoed yellows seem, in their rhythmic patterns and textures, not only to conjure a piano-playing accompanist or those "roses in the air about her" but to give visual form to how her powerful and versatile voice set the atmosphere vibrating whenever she sang—a voice that could change the world even when, as in this image, it was silent.

Abstract Film and the Soundtrack

While Bergson felt that film and its sequential static images presented an untrue version of time, he was speaking of traditional narrative film. Avant-garde artists of the early twentieth century saw potential in the new technologies of motion picture production for more—for something closer to music. Makers of absolute film saw in motion pictures a potential to evolve ideas developed by painters of color music like Kandinsky. In fact, these early filmmakers, such as Hans Richter and Walter Ruttmann, were painters themselves who, as if leaping off from where Kupka stopped, saw film as a means for combining abstract imagery and the dimension of time. Often based in Romantic, idealist thought, absolute film was to be nonrepresentational and non-narrative, the ultimate expression of what film itself was capable of—an aim that often found its practitioners, like painters of the day, claiming a relationship to music, with or without a musical soundtrack. Richter, in his landmark *Film is Rhythm* (*Film ist Rhythmus*, later *Rhythm 21*, ca. 1921), emphasized the rhythmic potential of film through a strict manipulation of geometric forms wedded to the atonal music of Stefan Wolpe. Lines and forms, for Richter, were the "basso continuo of painting."[24] This mirrored Kandinsky's own invocation of Goethe's claim about a lack of *Generalbass* of painting (understood as a unifying theory for composition or, elsewhere, a grammar of painting), which Kandinsky had hoped to provide.

A 1921 screening of Walter Ruttmann's first film, *Light Play Opus I* (*Lichtspiel Opus I*), had the young German Oskar Fischinger in attendance. Fischinger had studied violin and organ building, then was forced by circumstance to pursue drafting and engineering. His early experiments in abstract film, like *Spirals*, are dizzying in their application of patterns and optical illusions to wreak havoc with viewers' visual and vestibular systems by way of dimensional motion (fig. 249). In the late 1920s, he created special effects for Fritz Lang's *Woman in the Moon* and began working on a series of filmed studies. These were often illusionistically three-dimensional but more painterly, and typically (though not always) closely set to a synchronized soundtrack. Not mere illustrations of the music, these animations depended on the soundtrack—much as other modern artists depended upon titles, artist statements or critics—to make the analogy between abstract visual form and the more familiar abstraction of music.

But music was even more than this for Fischinger. Music was the means by which the interior structure of the film was apprehended. In an extended architectural metaphor, Fischinger wrote in 1932:

249. Oskar Fischinger (1900–1967). *Spirals* (still), ca. 1926. 35mm film, black-and-white, silent, 2 minutes. Center for Visual Music.

Eye and ear supplement each other in orthogonal function. The eye seizes the exterior, surface, form, and color. The ear seizes through sound, which is particular to each body, the internal structure which the eye spies outwardly. This mutual and supplementary orthogonal composite function [*Gesamtfunktion*] of eye and ear is comparable to the front view of a house (the picture for the eye) and a technical cross-section through the house (which reveals the internal structure, and which the key of the sound determines for the physical bodies).[25]

His realization of this reached its pinnacle in *Allegretto*, begun for Paramount Pictures in 1936 after he fled Nazi Germany because of unwanted attention for his "degenerate" abstractions and finished in 1943 with the support of a private grant (fig. 250). With music by Ralph Rainger, the counterpoint of dancing lozenges and cycling, spiral backgrounds all worked tightly with the pop-orchestral jazz. "Dancing shapes" is more than just a fanciful description: In Frankfurt and then Berlin, Fischinger would have likely had some familiarity with the modern dance of Rudolph Laban, Isadora Duncan and Anna Pavlova, as well as the Ballets Russes touring company whose radical choreography of avant-garde musical and visual

250. Oskar Fischinger (1900–1967). *Allegretto* (still), 1936–43. 35mm film, color, sound, 2 minutes 30 seconds. Center for Visual Music.

251. Oskar Fischinger (1900–1967). *Kandinsky/Mickey Collage*, **ca. 1940.** Collage on paper, 8½ × 11 in. (21.6 × 27.9 cm). Courtesy of The Fischinger Trust.

252. Oskar Fischinger (1900–1967). *Light Area, Motion in Space*, 1944. Oil on board, 31⅝ × 38⅞ in. (80.3 × 98.7 cm). The San Diego Museum of Art; Museum purchase with funds provided anonymously.

spectacle is a clear antecedent. Though strict in his use of geometric forms, the ways in which these shapes dance—sometimes relative to the music, other times moving according to some independent principle—recall Kandinsky's Monumental Artwork of the Future, in which dance was an integral component. Each shape has a physical presence and an inner vitality, and the organization of their movements has much in common with early twentieth-century choreography. This is true even in *Radio Dynamics* (1942), which is a silent film but not any less musical for being so.

These films intrigued Walt Disney, who brought Fischinger to work for him on *Fantasia*. Hired as a relatively low-level animator, despite his stature in art circles, he was to help develop the section set to Bach's Toccata and Fugue in D minor (BMV 565), conducted by the magisterial Leopold Stokowski. Then Disney muted the carefully chosen palette and insisted the forms be more representational. Abstract wave forms were replaced by their more literal, sea-bound relatives, and moving lines became violin bows sawing away in a pastel-clouded sky. In response, Fischinger quit. His forms could act as dancers or be abstractions from dance movements, but to be representational things themselves was an affront to Fischinger's high modern sensibility. He would later mock his time at Disney in a series of collages that put a shocked Mickey

and Minnie Mouse upon copies of abstract paintings by Kandinsky and Rudolf Bauer taken from a Guggenheim Museum catalogue (fig. 251).

As financial constraints and studio-system frustrations hedged in the principled Fischinger, he withdrew further into painting. He had never stopped painting after taking it up in earnest in 1936, at times using it as a vehicle to test formal and chromatic ideas before composing a film. Now he seemed to delve more fully into the static canvas's potential for pure, nonobjective art (figs. 252 and 253).

One of his last films (he stopped making them for lack of funds that year), *Motion Painting No. 1* gives an indirect view into Fischinger the painter (fig. 254). Made not with the cel animation of some of his earlier visual symphonies, it was created using stop-motion photography of his painting process in oil on Plexiglas. The result is nothing less than the vivid filmic corollary to Kandinsky's static-dynamic forms and Kupka's mystical fugues, with shades of Klee and even Seurat. Daubs of color shimmer and crescendo. Silent points leap into motion and sound, as if of their own accord. Set loosely to the music of Bach's Brandenburg Concerto No. 3, it is a pure yet already elegiac expression of modern abstraction's aim in the early part of the twentieth century: to pierce the world of

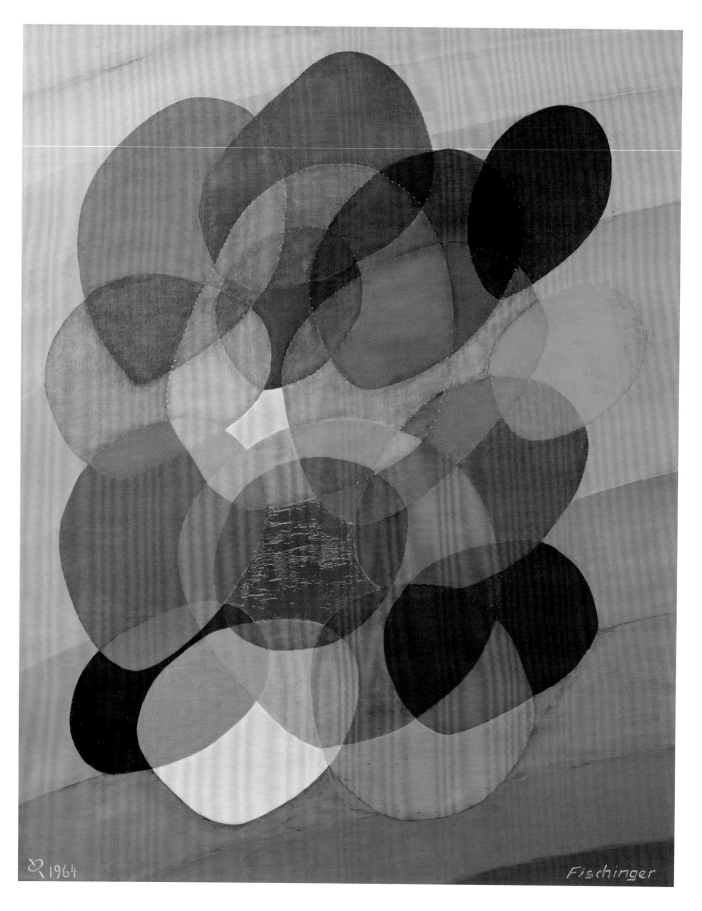

253. Oskar Fischinger (1900–1967). *Balls #16*, 1964. Oil on board, 30 × 24 in. (76.2 × 61 cm). The San Diego Museum of Art; Museum purchase with funds provided anonymously.

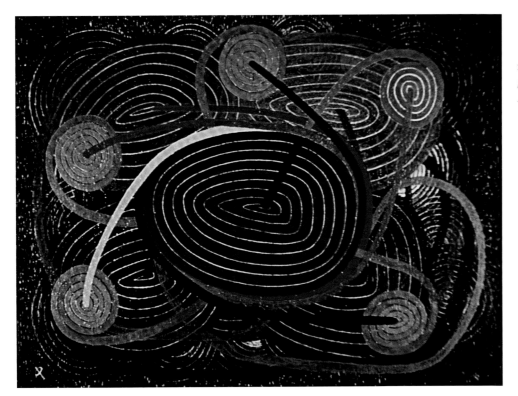

254. Oskar Fischinger (1900–1967). *Motion Painting No. 1* (still), 1947. 35mm film, color, sound, 11 minutes. Center for Visual Music.

surfaces and reach a realm of cosmic spirituality, a new inward and mystical "harmony of the spheres" apprehended through point, line, color and plane, all animated with a vital, musical spirit. In *Motion Painting No. 1*, it is the spirit of an artist whose process is animated before us, whose vision is brought to life by the mutual effect of film and music but whose physical being has been absented save these traces in paint and celluloid.

Theatricality and the Body

The films of Bruce Conner, one of the most dexterously talented artists of the bohemian scene in 1960s San Francisco, straddled the tendencies towards absolute film, with its nonrepresentational uses of the cinematic image, and the incessant presence of popular culture. In BREAKAWAY, Conner uses a series of quick, disjointed cuts between takes of singer Toni Basil dancing—sometimes clothed, suddenly not, then back again, shot with blur-inducing zooms and swerves, stroboscopically edited—to a soundtrack of her song (fig. 255). The result is a dynamo of movement and music in which the camera (and thus Conner's own body) as well as the protagonist it records are dancing, as if in a duet, with the viewer taking one of the parts. It recalls the creative "collaboration" between Walkowitz and Duncan and presages the genre of the music video, of which BREAKAWAY is often called the first. In its visual assault and cinematic scale, the film implicates the body: images flicker and streak away into your peripheral vision and then steady to linger with clarity on Basil's pouting face, accompanied by the propulsive kick drum of the soul song the film was made

255. Bruce Conner (1933–2008). BREAKAWAY (still), 1966. 16mm film, black-and-white, sound, 5 minutes. SFMOMA; Accessions Committee Fund purchase. Courtesy the Conner Family Trust.

256. **John Cage with David Tudor, 1956.** Photograph by
Matsuzaki Kunitoshi, 8⅝ × 5⅞ in. (21.8 × 14.7 cm).
The Getty Research Institute.

for. Visual artists around the turn of the century routinely appealed to music for its ability to shortcut past the rational mind and make direct appeal to the inward, sensing self. The art of the mid- to late twentieth century would make that appeal more direct and more theatrically active, more situational, relational and open-ended in its address to the body.

Much of this turn toward a kind of art that implicates the viewer and her own body in relation to the work is due to John Cage. In influence and polymathic interest that cuts across the categories of art and music, Cage is the mid-twentieth century's answer to Kandinsky: equal parts visual artist and composer; a student of Schoenberg (who immigrated to Los Angeles before the outbreak of World War II) and Fischinger (whom a young Cage assisted briefly); long-time collaborator with dancer Merce Cunningham; a devotee of Zen Buddhism and Marcel Duchamp; a serious, if

unconventional, follower of the *I Ching* and an avid borrower of ideas from Ananda K. Coomaraswamy, the British-Ceylonese philosopher and historian of Indian art that Cage would return to often. One example of this last influence is Cage's Solo for Voice 58, from *Song Books* (1970). He uses the Indian *raga* as a loose framework for eighteen songs in which the score was created using chance-based operations and the lyrics are to be decided by the performer, who should "[t]hink either of the morning, the afternoon or the evening, giving a description or account of recent pleasures or beauties observed."[26]

Cage is most readily identified with *4'33"* (1952), which makes this turn to a viewer-oriented theatricality: As specified by Cage, a performance of *4'33"* consists of a musician who takes up her instrument (no particular one is specified) and proceeds to play nothing for the length indicated in the title, divided into three movements. Instead of a traditional staff, one early manuscript delineates a visual equivalent for the length of each movement with three vertical lines. By frustrating the expectation for instrumental sound, Cage created a space for concertgoers instead to attend to the chance sounds that filled the auditorium or hall—coughs, squeaking chairs, sounds from outside the building drifting into the performance space. These he considered music itself. Of the premiere performance by David Tudor (fig. 256), Cage said, "You could hear the wind stirring outside during the first movement. During the second, raindrops began pattering the roof, and during the third people themselves made all kinds of interesting sounds as they talked or walked out."[27] The inclusion of accidental sound under the rubric of music, as Christoph Cox has noted, first arose in the early twentieth century alongside the popularization of the phonograph, which recorded sound indiscriminately. These sounds began to be incorporated into compositions in the early twentieth century by Luigi Russolo and Edgar Varèse, who rejected the term "music" in favor of "organized sound."

Much like Kandinsky, Cage was given the courage to take this leap into the music of silence by an artist across the aisle: Robert Rauschenberg and his White Paintings, which Cage called "airports for lights, shadows, and particles."[28] This kind of minimalist art and the self-consciousness it created was criticized by Michael Fried in his landmark essay "Art and Objecthood" as "theatrical," dependent on "the circumstances in which the beholder encounters literalist [or minimalist] work" and at war with modern painting.[29] Optical effects, like the changing relations when viewing a sculpture from different angles or the Gestalt effects of shifting figure and ground, are one way of making the viewer's bodily position integral to the artistic effect. Cage's print *Global Village 1–36* (fig. 257) does precisely this: Depending on how you view it, the vertical bars recall either the perforations in player piano rolls or skyscrapers, and they

257. John Cage (1912–1992). *Global Village 1–36*, 1989.
Aquatint on two sheets of brown smoked paper, 38¼ ×
26½ in. (97.2 × 67.3 cm). The San Diego Museum of Art;
Gift of the Daniel R. Stephen Trust.

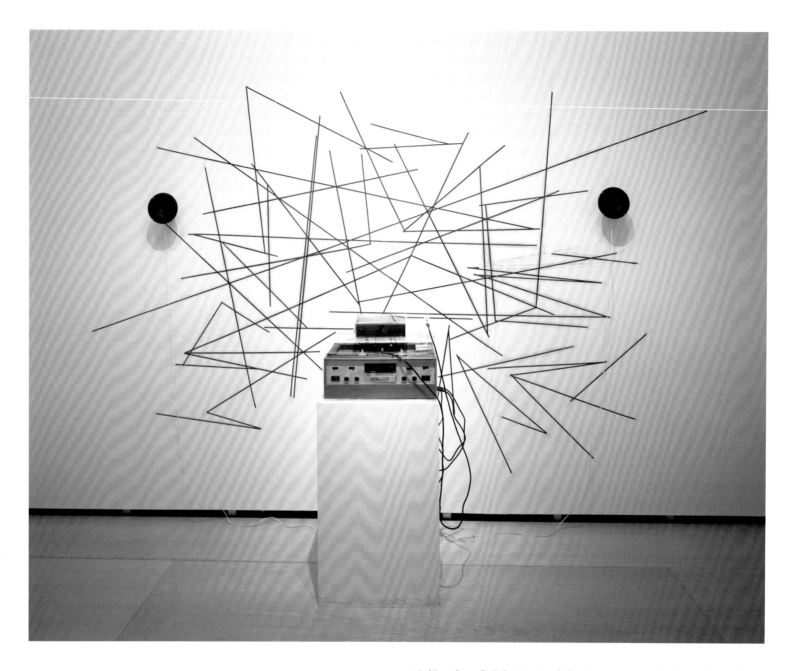

258. Nam June Paik (1932–2006). *Random Access,* 1963/2000. Strips of audiotape, open-reel audio deck, extended playback head and speakers, installation dimensions variable. Solomon R. Guggenheim Museum, New York. Purchased with funds contributed by the International Director's Council and Executive Committee Members, 2001.

are alternately in front of or behind the smoke-like forms that were created by burning paper on the copper plate used to print it. The title recalls media theorist Marshall McLuhan ("The new electronic interdependence recreates the world in the image of the global village"[30]) while the musical allusion puts one in mind of *4′33″* and the music of ambient gallery sound. When asked about this print, Cage said:

> If while you're looking at *Global Village*, you listen, then you could say it was musical theater, no? The idea of musical theater, or opera, is when you both see and hear. But if you're so concentrated that you look without hearing, which I think some people do, then it's seeing. Or, conversely, if you close your eyes, as so many people do at concerts, then it's music![31]

As it did for Kandinsky, the theatrical model (specifically musical theater or opera) opened up new vistas for eye and ear alike, now found in the music of a supposedly silent concert hall or still gallery space. Deliberately manipulating aural effects in such a setting, rising out of the availability and relative affordability of recording and playback equipment beginning in the mid-twentieth century, would take this theatricality in electrifying new directions.

Nam June Paik, the pioneering video and multimedia artist and one of Cage's protégés, actualized this potential with an engineer's facility with emerging technologies. *Random Access*, made for his first solo exhibition, consisted of strips of magnetic tape tacked to a wall in a spidery web (fig. 258). The strips contained excerpts of recorded material. Visitors were encouraged to pick up a handheld device made out of the playback head deconstructed from a tape player, and to play the strips of music in any order and at any speed they wished. The music very literally depended on the viewer's physicality, his gestures and movements, marking *Random Access* as brilliantly ahead of its time in its open-ended interactivity and involvement of the viewer's body in the creation of sonic space.

The preceding examples of art and music in the age of recorded technology are against the general thrust of an argument that technology disembodies us—that musical disembodiment via recording is better than the real live thing and will outlast its mortal performers. Glenn Gould gave up performing live in preference for the studio's offer of perfectibility. "To me," he said in a 1952 interview with the *CBC Times*, "the concentration on purely musical detail is of utmost importance for any performance, a concentration which is much easier to achieve when there is no need to feel responsibility for the visual pleasure of the listener." In looking at the relationship between art and music in the mid-twentieth century and after, it's striking to discover the contrary: how often

technology is used to return us to our bodies, how powerfully sound can recenter us on somatic experience.

Sound Art

Paik is widely acknowledged as the father of video art. But his musico-technological creations and those of Max Neuhaus (1939–2009) were foundational in the creation of the genre of sound art. These breathtakingly fresh "visions"—often free of or minimizing the visual—have appeared with increasingly regularity ever since. Neuhaus, who as a percussionist worked with the likes of Cage, Earle Brown, Morton Feldman and Harry Partch, transitioned to creating "sound installation" in order to turn from traditional music's emphasis on time. Instead, he intended to use sound to create space, one in which the listener could "place [the elements of a composition] in his own time."[32]

Tristan Perich (b. 1982), like Cage, is both a highly regarded composer as well as visual artist. This overlap is clear in his music, in which he methodically yet intuitively investigates pattern and seriality in a way that recalls the work of Philip Glass and Terry Riley as much as the art of Sol LeWitt. Many of his compositions combine live performers playing instruments of the Western repertoire in relatively traditional ways alongside arrays of speakers emitting 1-bit tones, each "played" by individual microchips programmed with a binary score. He privileges the physicality of instruments and composing for what each does best. This is clear in the parts he writes for violin as much as in those for electromagnetic speaker cone, in which basic tones (expressed in the simple on/off of binary code, the smallest unit of information) best express the unique physical and musical properties of speaker technology and processor speeds without seeking, in the way of synthesizers, to mimic other instruments or generate complexly layered invented sounds. In one of his best-known works, *Surface Image* (2013), forty speakers each play different tones to generate fluctuating patterns in a style of repetition and permutation from the simple to the complex, while pianist Vicky Chow both inhabits this impersonal, mathematical rigidity and finds, within it, a startling range of opportunities to inflect it with feeling and mood, including a dazzling solo a third of the way into the composition. This begins with Chow imitating the rush of digital musical data—a move that somehow unlocks the human expressiveness hidden behind the forty speakers' precise, rationalistic restraint. The piece becomes a drama of human and machine testing each other's physical limits and expressive potentials.

Clearly coming from the same creative place but firmly rooted in his art practice, Perich's *Microtonal Wall* exerts a powerful visual pull, even without its sound (fig. 259). The aluminum finish and

259. Tristan Perich (b. 1982). *Microtonal Wall,* 2011. 1,500 divisions of four octaves from C3 to C7. Electronic circuit, 1,500 speakers, aluminum, 54 × 306 in. (137 × 777 cm). Commissioned in part by Rhizome, with additional support from the Addison Gallery. Courtesy: bitforms gallery, New York.

grid arrangement of black speaker diaphragms are minimalistically futuristic as well being a kind of literalist rendition of Phil Spector's "wall of sound." The visitor changes her perception of its sonic effect through movement: a walk through the space or a tilt of the head all change the sound one perceives from the 1,500 speakers, each producing a different 1-bit microtone. Across *Microtonal Wall*'s twenty-five foot length, the tones emitted by the speakers rise in pitch from left to right. Facing it from afar, one is enveloped in the wash created by 1,500 pitches across four octaves reaching the ear simultaneously, which can sound like the ocean or a swarm of bees—"white noise," as the visual-aural metaphor we use every day names it. (In fact, Perich has said this piece is part of a larger project across his visual and musical art practice to investigate the continuum between white noise and tonality.[33]) Drawing close to specific speakers or clusters of tones illuminates the chromatic complexity within the white haze. Moving in one direction or the other, you feel in your dance with it the rightness of metaphors for

"rising" and "falling" pitch, "higher" and "lower" notes—common-place synesthetic associations between vision and sound. Even the electronics were hand-soldered by Perich (with the help of assistants), for whom the technological and the somatic are indissoluble. Like the first electronic instrument, the Theremin—performed by physically manipulating an electromagnetic field and heard on popular songs like the Beach Boys' "I Just Wasn't Made for These Times"—*Microtonal Wall* is both a work of art and, in some sense, an instrument played by the body without touch.

One of the most consistently engaging sound artists in recent years to mine the use of sound to shape space is Scottish-born, Berlin-based Susan Philipsz, winner of the 2010 Turner Prize. Philipsz's work with sound, film, space and often her own untrained voice create a sense of sculpted form in thin air, a form that shifts as you move through it. In *The Lost Reflection*, she sang both parts of the famous barcarolle for soprano and mezzo-soprano from Jacques Offenbach's *The Tales of Hoffmann* (*Les*

260. Susan Philipsz (b. 1965). *The Lost Reflection*, 2007. Two-channel sound installation, 2 minutes 5 seconds. Song: barcarolle in "The Tales of Hoffmann" by Jacques Offenbach. Two recordings, of mezzo-soprano and soprano element of duet. Projected under the Tormin Bridge, Skulptur Projekte, Münster, 2007. Courtesy of Susan Philipsz and Tanya Bonakdar Gallery.

Contes d'Hoffmann, 1881). Philipsz then sited each recording on opposite sides of the Aasee, a man-made lake in Münster, where the voices echoed underneath the Tormin Bridge, traveling across the water to complete the duet (fig. 260). Philipsz's rendition of the song—in a flat, plain style and in English instead of the original French—evokes tenderness and longing not through beauty, exactly, but through the kind of empathy that comes with exposure—with distance, yes, but also the exposure of a loved one's imperfect singing in a public place. She used a similar approach to eerier effect in *Lowlands* (2008/2012), singing three versions of an old Scottish sea shanty. As with *Filter* (1998), in which she sang pop songs in the same fashion over the PA system at a Tesco supermarket, these sweeping sonic presentations are hard to hear without a blush of warm, empathic embarrassment blooming on your cheeks.

But this is part of Philipsz's project. "It's all about how the emotive and psychological effects of sound can heighten your awareness of the space you are in," she said in an interview.[34] The appeal to the ear (over the eye) makes us vulnerable; we're vulnerable to its appeals unless we physically stop up our ears. Equally important, our ears are on alert for the audible clues of impending danger. It's no coincidence that the present audio age (as heralded by McLuhan, over the visual one) has, in the early twenty-first century, coincided with a premium being placed on the *sound* of vulnerability, on how sound can play upon our vulnerabilities in a bodily way. You only need to listen to popular public radio programs like *This American Life* or *Radiolab* to hear this at work. The strategies of a sound artist like Philipsz are on "view" even in pop music: On Drake's "Marvin's Room," the muted bass and lack of treble (produced by Noah "40" Shebib) recreate the lingering sonic after-effect of spending too long in a loud nightclub as the lyrics take the form of a late-night drunken phone call to an ex-girlfriend, immersing the listener in the speaker's aural point of view. The production is a kind of audio theater integral to the emotional impact of the song. On Kendrick Lamar's "Sing About Me, I'm Dying of Thirst," from the album *good kid, m.A.A.d city* (2013), gunshots grotesquely silence the vocals mid-syllable to generate a visceral, aural embodiment of the murder of a friend's brother while another verse fades into a disease-induced mortal silence. In making use of these sonic effects, Lamar relies upon the ear's

direct route to the emotions, the same one that was alluring to countless artists since the mid-nineteenth century. Philipsz does much the same.

While her voice has been her primary instrument, riffing elsewhere on Lucia Joyce (James's daughter) and Will Oldham (the singer-songwriter better known as Bonnie "Prince" Billy), in recent years Philipsz has turned to more complex, less personally vocal designs: In *You Are Not Alone* (2011) she played radio intervals—those few-note motifs which act as a radio station's audible signature when throwing to a commercial break—from around the world in a meditation on Marconi, technology and the collapse of distance. In *Study for Strings* (2012), she staged speakers at the Kassel rail station to play a recording of Jewish composer Pavel Haas's *Study for String Orchestra* (*Studie für Streichorchester*, 1943) in a fragmented form, for only two instruments; each note was recorded separately and moved in playback across eight speakers scattered around the station. Haas, a student of Leoš Janáček, composed the piece while in the concentration camp at Theresienstadt. Afterward he, along with most of the orchestra who performed it for a Nazi propaganda film, was sent to Auschwitz and killed. The weight of these absences, felt in the silences and missing consonances and dissonances around the viola and cello lines, forms one part of the requiem, occasionally joined by the rhythmic percussion and hiss of a train upon the tracks, arriving or departing.

Ragnar Kjartansson, the Icelandic artist and musician, pushes theatricality to its limits in live performances that feature musicians repeating a single song over and over again for extended periods of time: the final aria from *The Marriage of Figaro* for twelve hours in *Bliss* (fig. 261) and six hours of The National playing their song "Sorrow" in *A Lot of Sorrow* (2013). Each tested the patience and stamina of performer and audience alike, and in both cases the eruption of joy at completing the challenge—a long journey, like Orpheus, into and then out of the underworld of repetition, boredom and physical exhaustion—represented the forging of a dense, communal bond in the performance space.

Musical bonds are the subject in Kjartansson's video installation *The Visitors* (fig. 262). Each of the nine channels isolates on a separate screen one member of his assembled band, each in a separate room in a massive abandoned house on Rokeby Farm in New York. The group is united by music through their mutual listening and response, accomplished by way of microphones, cables and headphones strung throughout the home. An audience of friends listens to the 64-minute performance out on a balcony, seemingly at one level of remove but, as *Bliss* and *Sorrow* showed, a thin and penetrable one at best. The effect is reminiscent of Ben Shahn's *Four Piece Orchestra*, with its three musicians of seemingly disparate

261. Ragnar Kjartansson (b. 1976). *Bliss*, 2011. 12-hour performance, Abrons ArtCenter. Courtesy of Luhring Augustine during Performa 11. Performers: Ragnar Kjartansson, 9 singers and a 14-piece orchestra; Conductor: Davíð Þór Jónsson. Courtesy of the artist, Luhring Augustine, New York, and i8 Gallery, Reykjavik.

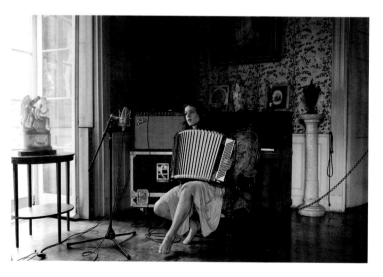

262. **Ragnar Kjartansson** (b. 1976). *The Visitors* (stills), 2012.
Nine-channel video projection, from an edition of 6 and 2 artist's proofs;
dimensions variable, 64 minutes. Photos: Elísabet Davids; Sound:
Chris McDonald; Video: Tómas Örn Tómasson. Courtesy of the artist,
Luhring Augustine, New York, and i8 Gallery, Reykjavik.

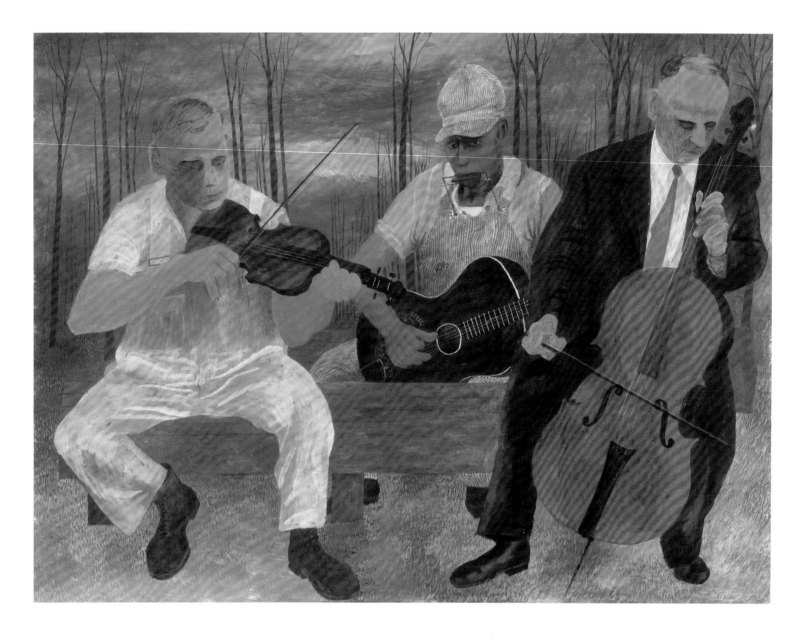

263. Ben Shahn (1898–1969). *Four Piece Orchestra*, 1944. Tempera on Masonite, 18 × 23⅝ in. (45.7 × 60.1 cm). Museo Thyssen-Bornemisza, Madrid.

class and musical style playing together and you, the viewer, the final member of the quartet (fig. 263).

Over the course of an hour near sunset, the group plays and records a single lengthy song in one take. The song they play has lyrics taken from a poem by artist Ásdís Sif Gunnarsdóttir, Kjartansson's ex-wife, while the piece's title is taken from the name of the last album by Swedish pop stars ABBA, which itself features divorce as a theme and has a cover in which the band members look lonely, despite being gathered together in a palatial mansion. As if in response to the allegory presented by Jan Miense Molenaer (fig. 67), in which music signifies marital harmony, Kjartansson's installation is a paen to the fidelity of friendship and music in the face of inconstant romantic love. He has said that he was "trying to visualize the feeling of music, the feeling of making music together with my friends,"[35] one that nonetheless recalls, in its visual form, the atomistic nature of selfhood within community.

This, too, is at the heart of Janet Cardiff's *Forty Part Motet* (fig. 264). Through manipulation of gallery space and musical sound, *Forty Part Motet* and *The Visitors* both dramatize the viewer's place in the singular plural (in philosopher Jean-Luc Nancy's phrasing) of being in society. Cardiff's sound installation is more historically aware, not only because it depends on a choral composition by Thomas Tallis (ca. 1508–1585) for much of its aural body. The circular arrangement of the forty speakers, each an individual voice of a chorister contributing to the soaring lines of counterpoint, evokes the circular form of the canon as heralded by Zarlino and other music theorists of the Renaissance, its perfection and endlessness an image of the divine. In contrast, the lyrics of the motet *Spem in Alium* (ca. 1556–73) plead with an angry but gracious God, "Domine Deus, Creator caeli et terrae / respice humilitatem nostram," or "Lord God, creator of heaven and earth / be mindful of our humiliation."[36] *Humilitas* is an importance concept

264. Janet Cardiff (b. 1957). *Forty Part Motet,* 2001. 40 loud-speakers mounted on stands, placed in an oval, amplifiers, playback computer; 14 minute loop with 11 minutes of music and 3 minutes of intermission. Sung by Salisbury Cathedral Choir; Recording and Postproduction by SoundMoves; Edited by George Bures Miller. Produced by Field Art Projects. Courtesy of the artist and Luhring Augustine, New York.

in Christian doctrine in which a person must not forget her defects and deficiencies, must humiliate herself before God or is humiliated in the sight of God. It represents the need to recognize one's profound dependence and to place oneself in the humble service of others. The root of the word *humilitas* is *humus*, or earth, the antithesis of the immaterial divine.

These words are distributed among eight choirs of five voices each who call and respond, trade off and, in breathtaking moments, unite. Add to the overwhelming degree of melodic and harmonic variation throughout the performance the variations of the visitor's body: Stand in the center of the circle and hear the unified, harmonic effect of the chorus. Tread closer to any one speaker and find yourself within the choir, able to hear the slight imperfections and differences of tone and timbre that mark each human voice as unique. In doing so, you may catch minor mistakes, a cough here, some chatter either before or after the singing begins (it loops continuously). Mistake is the link in the chain of being between music and noise, order and chaos. Musical mistakes are something most of us largely live without hearing; even before auto-tune, the use of over-dubbing and tape-splicing multiple takes resulted in recordings of music inhumanly free of error.

While the visual enjoyment offered by a group of singers arranged in a U-shape has been abstracted in *Forty Part Motet* to the cold form of speakers on stands, the pleasure that arises from the possibility of mistake and accident is thrillingly alive and human. Much like Philipsz's everywoman's voice, these "humiliations" against the possible perfection of recording are coextensive with music itself, as Cage would have us understand, and part of the divinely human that Cardiff has us feel deep within our bodies. The resulting celebration of human aloneness-in-togetherness is a visceral allegory, a profound meditation on the human condition, one only possible through music's collaboration with contemporary art practice and modern technology, yet gloriously earthbound. The radical interdependence of music and the visual arts, considered in a like framework of openness and *humilitas*, yields a similarly overawing impression to both the ear and the eye.

NOTES

1 Quoted in Douglas Kahn, *Noise, Water, Meat: A History of Sound in the Arts* (Cambridge, MA: MIT Press, 1999), 196–7.

2 As referred to in Helen Torr Dove's diary. Entry 11 April 1927. Arthur and Helen Torr Dove Papers, Archives of American Art, Smithsonian Institution, Series 3: Writings. Diaries. Diaries, 1927–1945. (Box 2, Folder 1).

3 See Harry Cooper, "Arthur Dove Paints a Record," *Source Notes in the History of Art* 24, no. 2 (Winter 2005): 75–6n1. Others have recently written about Dove and audio technology, though to different ends. See Rachael Z. DeLue, "Images, Technology, and History: Arthur Dove, painting, and phonography," in *History and Technology* 27, no. 1 (March 2011): 113–21; and Jennifer Parson, "Absence and Presence: Arthur Dove's Paintings 'From the Radio,'" 2012 Archives of American Art Graduate Research Essay Prize winner, http://www.aaa.si.edu/essay/jennifer-parsons.

4 For Kandinsky's relationship to music, see Patrick Coleman, "Echoes of a Dark and Deep Unity: Exchange, Collaboration and Innovation," in the present volume.

5 Alfred Stieglitz, "How I Came to Photograph Clouds," *Amateur Photographer and Photography* 56 (19 September 1923): 255.

6 Ernest Bloch, "Man and Music," *The Seven Arts* 1, no. 5 (March, 1917): 501.

7 As the story was recollected by Jonathan Elkus, quoted in Eric B. Johnson, "Ernest Bloch and Alfred Stieglitz: A Sunday Morning Conversation," http://www.ericjohnsonphoto.com/Eric_Johnson-Photography/Bloch_Stieglitz.html.

8 Helen Torr Dove refers to Bergson on 15 December and then notes that Dove "bought more Bergson books" on 19 December 1925. Arthur and Helen Torr Dove Papers, Archives of American Art, Smithsonian Institution, Series 3: Writings. Diaries. Diaries, 1927–1945. (Box 1, Folder 53).

9 Arnold Schoenberg, *Style and Idea: Selected Writings of Arnold Schoenberg* (Berkeley: University of California Press, 1984), 105.

10 Ann Swartz, "A Redating of Kupka's Amorpha, Fugue in Two Colors II," *The Cleveland Museum of Art Bulletin* 80, no. 8 (1994), 326–51.

11 Quoted in Margit Rowell, *František Kupka, 1871–1957: A Retrospective*, exh. cat. (New York: Solomon R. Guggenheim Foundation, 1975), 184.

12 Henri Bergson. "The Perception of Change," in *The Creative Mind: An Introduction to Metaphysics*, trans. Mabelle L. Andison (New York: Philosophical Library, 1946; Mineola, NY: Dover, 2007), 124.

13 Henri Bergson, "The Multiplicity of Conscious States: The Idea of Duration," in *Time and Free Will: An Essay on the Immediate Data of Consciousness*, trans. F. L. Pogson, M.A. (London: George Allen and Unwin, 1910), 100. Reprinted online at https://www.brocku.ca/MeadProject/Bergson/Bergson_1910/Bergson_1910_02.html.

14 Undated letter, assigned to 30 October 1926 in Ann Lee Morgan, ed., *Dear Stieglitz, Dear Dove* (Newark: University of Delaware Press, 1988), 128–9.

15 Arthur Dove, "Notes by Arthur G. Dove," in *Dove Exhibition*, exh. cat. (New York: The Intimate Gallery, 1929).

16 Arthur Dove, artist's statement in *The Forum Exhibition of Modern Painters*, exh. cat. (New York: Anderson Galleries, 1916).

17 Frances Colpitt, "Hard-Edge Cool," in *Birth of the Cool* (Newport Beach, Munich and New York: Orange County Museum of Art and Prestel, 2007): 98.

18 Hugh Hart, "Mid-century mod and all that jazz," *Los Angeles Times*, 7 October 2007. http://articles.latimes.com/2007/oct/07/entertainment/ca-cool7.

19 Quoted in Sachi Yanari, introduction to *Alma Thomas: A Retrospective of the Paintings* (San Francisco: Pomegranate, 1998), 10.

20 See Gemma Rodrigues, "The Art of Music in Africa," in the present volume.

21 Ann Gibson, "Putting Alma Thomas in Place: Modernist Painting, Color Theory, and Civil Rights," in *Alma Thomas: A Retrospective of the Paintings* (San Francisco: Pomegranate, 1998), 40.

22 James Baldwin, introduction to *The Price of the Ticket: Collected Nonfiction, 1948–1985* (New York: St. Martin's Press, 1985), x.

23 Ibid., xi.

24 Quoted in Standish D. Lawder, *The Cubist Cinema* (New York: New York University Press, 1975), 42.

25 Oskar Fischinger, trans. by James Tobias in "The Composer of the Future and Absolute Sound Film," in *Oskar Fischinger (1900–1967): Experiments in Cinematic Abstraction*, eds. Cindy Keefer and Jaap Guldemund, exh. cat. (Amsterdam: EYE Filmmuseum; Los Angeles: Center for Visual Music, 2012): 96.

26 John Cage, *Song Books (Solos for Voice 3–92)* (New York: Henmar Press, 1970), 1:208. For more on raga and the Ragamala paintings that link music, mood, time of day and image, see Marika Sardar, "Painting the Sounds of Music: A Study of Indian *Ragamala* Images," in the present volume.

27 Richard Kostelanetz, *Conversing with Cage* (New York: Limelight Editions, 1988), 70.

28 Quoted in Daniel Wheeler, *Art Since Mid-Century: 1945 to the Present* (New York: Vendome Press; London: Thames and Hudson, 1991), 129.

29 Michael Fried, "Art and Objecthood," in *Art and Objecthood: Essays and Reviews* (Chicago: University of Chicago Press, 1988), 153.

30 Marshall McLuhan, *The Gutenberg Galaxy: The Making of Typographic Man* (Toronto: University of Toronto Press, 1962), 31.

31 John Cage, and Joan Retallack, *Musicage: Cage Muses on Words, Art, Music* (Hanover, NH: Wesleyan University Press, 1996), 112.

32 Quoted in Christoph Cox, "Installing Duration: Time in the Sound Works of Max Neuhaus," in *Max Neuhaus*, ed. Lynn Cooke (New Haven: Yale University Press, 2009). As Cox discusses, Neuhaus, like Dove and Kupka, was indebted to Bergson.

33 Interview with Daniel Vezza, *Composer Conversations*, No. 42, podcast audio, http://composerconversations.com/2013/07/podcast-42-tristan-perich/.

34 Lena Corner, "The Art of Noise: 'Sculptor in Sound' Susan Philipsz," *Observer*, 14 November 2010, http://www.theguardian.com/artanddesign/2010/nov/14/susan-philipsz-turner-prize-2010-sculptor-in-sound.

35 From an interview conducted upon the opening of *The Visitors* at HangerBiocca, https://www.youtube.com/watch?v=lcwGnWuXJuU.

36 Sometimes translated as "look upon our lowliness."

Checklist

Eleanor Antin (b. 1935)
The Triumph of Pan (after Poussin) from
Roman Allegories, 2004
Chromogenic print, edition 3/4
60½ × 72½ in. (153.7 × 184.2 cm)
The San Diego Museum of Art; Museum purchase
with funds provided by the Artists Guild

Statuette of Apollo
Greek, South Italy, ca. 300 BC
Terracotta and pigment
H: 8⅝ in. (21.8 cm)
The J. Paul Getty Museum, Villa Collection;
Gift of Barbara and Lawrence Fleischman

Anonymous
Apollo and the Muses, n.d.
Oil on canvas and grisaille
49¼ × 50¾ in. (125 × 129 cm)
Pérez Simón Collection, Mexico

**Neck-Amphora with Apollo Playing the Cithara,
and Hermes, Athena, and Dionysos**
Greece, Attica, ca. 510 BC
Black-figure terracotta with added red and traces
of white
H: 17½ in. (44.5 cm); D: 11⅜ in. (29.1 cm)
Los Angeles County Museum of Art;
William Randolph Hearst Collection

Arman (1928–2005)
Hommage à Yves Klein, 1993
Wood violins, pigment, gold-leaf and acrylic in
Plexiglas case, edition 88/99
26⅛ × 12¾ × 9¾ in. (66.2 × 32.4 × 24.8 cm)
The San Diego Museum of Art; Bequest of
Tania Kleid Sumberg

John Baldessari (b. 1931)
Beethoven's Trumpet (with Ear) Opus #127, 2007
Foam, resin, aluminum, cold bronze, electronics
84 × 120 × 84 in. (213.4 × 304.8 × 213.4 cm)
Courtesy of John Baldessari and Beyer Projects

John Baldessari (b. 1931)
Person with Guitar (Red), 2005
Five-color screen print construction
30 × 36¼ in. (76.2 × 92.1 cm)
Hammer Museum, Los Angeles; Purchased with
funds provided by Brenda R. Potter and Michael
Sandler; Courtesy of John Baldessari

Bass Viola da Gamba
Absam, Austria, ca. 1669
Wood
Body L: 27¼ in. (68.7 cm)
The Metropolitan Museum of Art; Gift of
Janos Scholz, in memory of his son,
Walter Rosen Scholz, 1988

Ludwig van Beethoven (1770–1827)
Fidelio, "Er stebe!" Act 2, No. 14, 1814
Copyist manuscript with autograph corrections
by the composer
The Juilliard Manuscript Collection

Ludwig van Beethoven (1770–1827)
Symphony No. 9 in A, Op. 125, solo vocal part,
1824–26
Copyist manuscript
The Juilliard Manuscript Collection

Albert Belleroche (1864–1944)
Lili with a Guitar, ca. 1905
Oil on canvas
31⅞ × 25⅝ in. (81 × 65.1 cm)
The San Diego Museum of Art; Gift of
George C. Kenney II and Olga Kitsakos-Kenney

Karl Benjamin (1925–2012)
Untitled, 1957
Oil on canvas
20 × 50⅛ in. (50.8 × 127.2 cm)
The San Diego Museum of Art; Anonymous gift

**Bhairavi Ragini, a song to be played in
late summer at dawn**
India, Delhi, ca. 1780
Opaque watercolor on paper
9⅛ × 5⅝ in. (23 × 14.2 cm)
The San Diego Museum of Art;
Edwin Binney 3rd Collection

Arnold Böcklin (1827–1901)
Nymph and Satyr, 1871
Oil on canvas
42½ × 61 in. (108 × 154.9 cm)
Philadelphia Museum of Art; John G. Johnson
Collection, 1917

François Bonvin (1817–1887)
Still Life with Violin, Sheet Music, and a Rose, 1870
Oil on canvas
20 × 28 in. (50.8 × 71.1 cm)
Fine Arts Museums of San Francisco;
Museum purchase, Grover A. Magnin Bequest Fund

Attic red-figure kylix by the Boot Painter
Youth Holding a Tortoise-Shell Lyre (interior)
Greece, Attica, ca. 470–460 BC
Terracotta
3⅞ × 12⅜ × 9½ in. (9.8 × 31.5 × 24 cm)
The J. Paul Getty Museum

265. Arman (1928–2005). *Hommage à Yves Klein,* 1993.
Wood violins, pigment, gold-leaf and acrylic in Plexiglass case,
edition 88/99; 26⅛ × 12¾ × 9¾ in. (66.2 × 32.4 × 24.8 cm).
The San Diego Museum of Art; Bequest of Tania Kleid Sumberg.

Fernando Botero (b. 1932)
Dancing in Colombia (Baile en Colombia), 1980
Oil on canvas
74 × 91 in. (188 × 231.1 cm)
The Metropolitan Museum of Art; Anonymous Gift,
1983

Ippitsusai Buncho (active 1760–1794)
The actors Yamashita Yaozo II and Ichikawa Raizo II
in unidentified roles, 1771–1772
12¾ × 5⅞ in. (32.2 × 14.8 cm)
The San Diego Museum of Art; Bequest of
Mrs. Cora Timken Burnett

Hans Burkhardt (1904–1994)
Sex Pistols, 1981
Oil on canvas
42 × 32 in. (106.7 × 81.3 cm)
Courtesy Jack Rutberg Fine Arts, Los Angeles, and
the Hans G. and Thordis W. Burkhardt Foundation

John Cage (1912–1992)
Global Village 1–36, 1989
Aquatint on two sheets of brown smoked paper
38¼ × 26½ in. (97.2 × 67.3 cm)
The San Diego Museum of Art; Gift of the
Daniel R. Stephen Trust

John Cage (1912–1992)
The first meeting of the Satie Society, 1994
Stainless steel valise embossed with the words
of Erik Satie, with shattered glass containing an
introduction and seven artist books
Valise, closed: 26⅜ × 21⅜ × 3¼ in.
(67 × 54.3 × 8.3 cm)
Collection of Jasper Johns

Alexander Calder (1898–1976)
Evelyn, 1970
Gouache on paper
30⅝ × 22⅞ in. (77.8 × 58.1 cm)
Pérez Simón Collection, Mexico

Simone Cantarini (1612–1648)
Mercury and Argus, 1642–45
Etching on wove paper
10¼ × 12 in. (26 × 30.5 cm)
The San Diego Museum of Art; Museum purchase

Giovanni Benedetto Castiglione (1609–1664)
Allegory of Vanity, 1647–49
Oil on canvas
38¾ × 56¾ in. (98.4 × 144.1 cm)
The Nelson-Atkins Museum of Art;
Gift of the Samuel H. Kress Foundation

Giorgio de Chirico (1888–1978)
The Show, 1966
Gouache, watercolor and crayon on paper
11⅝ × 15½ in. (29.4 × 39.3 cm)
Pérez Simón Collection, Mexico

Chuck Close (b. 1940)
Phil, State I, 2005
Jacquard tapestry, edition of 6
160 × 118 in. (406.4 × 299.7 cm)
Collection Phoenix Art Museum; Gift of
Mr. and Mrs. Barry Berkus and Family in honor
of the Museum's 50th Anniversary

Lee Conklin
Chambers Brothers, Quicksilver Messenger
Service, Beautiful Day, Crazy World,
Sly and the Family Stone, 1968
Fillmore Auditorium, June 18–23, 1968
Color lithograph
25½ × 19 in. (64.8 × 48.3 cm)
Lent by Paul Prince

Lee Conklin
Steppenwolf, Grateful Dead, Santana, Preservation
Hall Jazz Band, Sons of Champlin, 1968
Fillmore West, August 27–September 1, 1968
Lithograph
25½ × 19 in. (64.8 × 48.3 cm)
Lent by Paul Prince

Jean-Baptiste-Camille Corot (1796–1875)
Orpheus Leading Eurydice from the Underworld,
1861
Oil on canvas, 44 × 54 in. (111.8 × 137.2 cm)
Museum of Fine Arts, Houston; Museum purchase
with funds provided by the Agnes Cullen Arnold
Endowment Fund

Mario Carreño (1913–1999)
Afro-Cuban Dance (Danza Afrocubana), 1944
Gouache on paper
23½ × 19 in. (59.7 × 48.3 cm)
Collection OAS Art Museum of the Americas

Konrad Cramer (1888–1963)
Improvisation, 1912
Oil on canvas
30 × 26 in. (76.2 × 66 cm)
The San Diego Museum of Art; Museum purchase
through the Earle W. Grant Acquisition Fund

Rafael Coronel (b. 1931)
The Flute Player, 1979
Oil on canvas
78¾ × 59⅛ in. (199.9 × 150.1 cm)
Pérez Simón Collection, Mexico

Merce Cunningham (1919–2009)
Suite for Five, choreographed 1956,
video recorded 2007
Video, 25 min.
Courtesy Merce Cunningham Trust

Salvador Dalí (1904–1989)
Project for *Romeo and Juliet*, 1942
Oil on canvas
27¼ × 31¼ in. (69.4 × 79.4 cm)
Pérez Simón Collection, Mexico

Nathaniel Dance-Holland (1735–1811)
*Cristiano Giuseppe Lidarti and Giovanni
Battista Tempesti*, 1759–60
Oil on canvas
28½ × 24½ in. (72.4 × 62.2 cm)
Courtesy Yale Center for British Art;
Paul Mellon Collection

Edgar Degas (1834–1917)
The Ballerina, ca. 1876
Oil on canvas
12⅝ × 9⅜ in. (32.1 × 23.8 cm)
The San Diego Museum of Art; Museum purchase
through the Earle W. Grant Acquisition Fund

Edgar Degas (1834–1917)
Dancer Fastening the Strings of Her Tights,
ca. 1885–90 (cast 1919)
Bronze
16⅞ × 8½ × 6⅜ in. (43 × 21.6 × 16.2 cm)
The San Diego Museum of Art; Gift of
Mr. and Mrs. Norton S. Walbridge

Beauford Delaney (1901–1979)
Marian Anderson, 1965
Oil on canvas
63 × 51½ in. (160 × 130.8 cm)
Virginia Museum of Fine Arts; J. Harwood and
Louise B. Cochrane Fund for American Art

Robert Delaunay (1885–1941)
Female Nude Reading, 1915
Oil on canvas
54 × 42⅜ in. (137.2 × 107.6 cm)
The San Diego Museum of Art; Museum purchase
through the Earle W. Grant Acquisition Fund

André Derain (1880–1954)
Guitar Player, 1928
Oil on canvas, 32½ × 38⅜ in. (82.6 × 97.6 cm)
The Nelson-Atkins Museum of Art; Gift of
Katherine Harvey

Thomas Wilmer Dewing (1851–1938)
Lady with Lute, 1886
Oil on wood
20 × 15¾ in. (50.8 × 40 cm)
National Gallery of Art; Gift of Dr. and
Mrs. Walter Timme

Gaspare Diziani (1689–1767)
The Musical Contest of Apollo and Marsyas,
ca. 1750
Oil on canvas
38 × 29¾ in. (96.6 × 75.5 cm)
Collection of Frank and Demi Rogozienski,
San Diego

Drum in the Form of a Warrior
Peru, Proto-Nazca period, ca. 300–100 BC
Incised and slip-decorated ceramic
13¼ × 8 × 8 in. (33.7 × 20.3 × 20.3 cm)
Kleinbub Collection

Doré
Ornette Coleman, 1968
Fillmore Auditorium, August 5, 1968
Color lithograph
Lent by Paul Prince

Arthur Dove (1880–1946)
Fog Horns, 1929
Oil on canvas
18 × 26 in. (45.7 × 66 cm)
Collection of the Colorado Springs Fine Arts Center;
Anonymous gift

Alfred Eisenstaedt (1898–1995)
*Stage Rehearsal, The Metropolitan Opera House,
New York*, 1942
Gelatin silver print
9⅝ × 7⅞ in. (24.6 × 20 cm)
The San Diego Museum of Art; Gift of Wanda and
Cam Garner

Henri Fantin-Latour (1836–1904)
The Evening Star (*L'Etoile du Soir*), 1877
Lithograph
11¾ × 8⅝ in. (29.7 × 22 cm)
Jack Rutberg Fine Arts

Henri Fantin-Latour (1836–1904)
Evocation of Kundry (*Évocation de Kundry*), 1898
Lithograph
16¼ × 19 in. (41.2 × 48.3 cm)
Jack Rutberg Fine Arts

Henri Fantin-Latour (1836–1904)
Prelude to Lohengrin, 1898
Lithograph
19⅜ × 13⅝ in. (49 × 34.6 cm)
Jack Rutberg Fine Arts

Henri Fantin-Latour (1836–1904)
Richard Wagner: His Life and Works (*Richard
Wagner: Sa vie et ses œuvres*), 1886
Printed material and 14 lithographs on wove paper
Overall: 12¾ × 9¾ × 2 in. (32.4 × 24.8 × 5.1 cm);
Sheet: 12⅜ × 8⅞ in. (31.4 × 22.6 cm) each
Los Angeles County Museum of Art;
Gift of Myron Laskin

Henri Fantin-Latour (1836–1904)
Tannhäuser: Act III, The Evening Star
(*Tannhäuser: Acte III, L'Etoile du Soir*), 1887
Lithograph
14⅞ × 9 in. (22.8 × 14.9 cm)
Jack Rutberg Fine Arts

Henri Fantin-Latour (1836–1904)
To Johannes Brahms (*À Johannes Brahms*), 1900
Lithograph
23½ × 17⅞ in. (59.7 × 45.4 cm)
Jack Rutberg Fine Arts

Johannes Hendricus Fekkes (1885–1933)
Head of Beethoven, 1918
Lithograph
13⅞ × 10½ in. (35.1 × 26.7 cm)
The San Diego Museum of Art; Bequest of
Mrs. Henry A. Everett

Pedro Figari (1861–1938)
Gato, n.d.
Oil on board
19¾ × 32 in. (50.2 × 81.3 cm)
Collection Pérez Art Museum, Miami; Gift of
Darlene and Jorge M. Pérez

Oskar Fischinger (1900–1967)
Allegretto, 1936–43
35mm film, color, sound, 2 min., 30 sec.
Center for Visual Music

Oskar Fischinger (1900–1967)
Kreise (Circles), 1933
35mm film, color (Gasparcolor), sound,
1 min., 48 sec.
Center for Visual Music

Oskar Fischinger (1900–1967)
Motion Painting No. 1, 1947
35mm film, color, sound, 11 min.
Center for Visual Music

Oskar Fischinger (1900–1967)
Ralls #16, 1964
Oil on board
30 × 24 in. (76.2 × 61 cm)
The San Diego Museum of Art; Museum purchase
with funds provided anonymously

**Gajadhara Raga, Putra of Megh Raga, a song to
be played in the monsoon season**
India, Bilaspur, ca. 1735
Opaque watercolor and gold on paper
7¼ × 11⅝ in. (18.4 × 29.5 cm)
The San Diego Museum of Art;
Edwin Binney 3rd Collection

Giuseppe de Gobbis (1730–after 1787)
The Convent Parlor, ca. 1755–60
Oil on canvas
33 × 45 in. (83.8 × 114.5 cm)
The San Diego Museum of Art;
Gift of Anne R. and Amy Putnam

John William Godward (1861–1922)
The Muse Erato and Her Lyre, 1895
Oil on canvas
28¾ × 32¾ in. (72.9 × 83.2 cm)
Pérez Simón Collection, Mexico

Jean Goermans (1703–1777)
Harpsichord converted to a piano
France, 1754
Wood, various materials
L: 95⅝ in. (241.7 cm)
The Metropolitan Museum of Art;
Gift of Susan Dwight Bliss, 1944

Natalia Goncharova (1881–1962)
Costume for a Female Subject of King Dodon
in *The Golden Cockerel* (*Le Coq d'Or*), 1937,
based on the original 1914 design
Cotton, linen, stenciled cotton, cotton braid and
embroidered appliqués
Los Angeles County Museum of Art;
Costume Council Fund

Natalia Goncharova (1881–1962)
Costume for a Female Subject of King Dodon
in *The Golden Cockerel* (*Le Coq d'Or*), 1937,
based on the original 1914 design
Cotton, embroidered appliqués, cotton lace
Los Angeles County Museum of Art;
Costume Council Fund

Gong
Côte d'Ivoire, Baule peoples, late 19th/early
20th century
Wood, iron
H: 16 in. (40.6 cm)
Fowler Museum at UCLA; Gift of Helen and
Dr. Robert Kuhn

Rick Griffin
Jimi Hendrix Experience, John Mayall and the
Blues Breakers, Albert King
Fillmore Auditorium, February 1, 4, 1968
Winterland, February 2–3, 1968
Color lithograph
27½ × 19 in. (69.9 × 48.3 cm)
Lent by Paul Prince

Rick Griffin
Big Brother and the Holding Company, Santana,
Chicago Transit Authority
Fillmore West, September 12–14, 1968
Color lithograph
27½ × 19 in. (69.9 × 48.3 cm)
Lent by Paul Prince

Rick Griffin
Aoxomoxoa: Grateful Dead, Sons of Champlin,
Initial Shock
Avalon Ballroom, January 24–26, 1969
Color lithograph
33 × 27½ in. (83.8 × 69.9 cm)
Lent by Paul Prince

Rick Griffin and Alton Kelley
Who, Grateful Dead, Quicksilver Messenger
Service, Creedence Clearwater Revival, et al.
Fillmore West, August 13–25, 1968
Color lithograph
27½ × 33 in. (69.9 × 83.8 cm)
Lent by Paul Prince

Gary Grimshaw
Cream, MC5, Rationals, Apostles
Grande Ballroom, Detroit, October 13–15, 1967
Color lithograph
27½ × 33 in. (69.9 × 83.8 cm)
Lent by Paul Prince

Childe Hassam (1859–1935)
The Sonata, 1893
Oil on canvas, mounted on board
32⅛ × 32⅛ in. (81.4 × 81.4 cm)
The Nelson-Atkins Museum of Art;
Gift of Mr. and Mrs. Joseph S. Atha

Utagawa Hiroshige (1797–1858)
Scene II of the play "Treasury of Loyal Retainers"
(Chushingura), ca. 1838
Woodblock print
The San Diego Museum of Art; Gift of
Captain George B. Powell, Jr., JAGC, USN

William Hogarth (1697–1764)
The Beggar's Opera, 1729
Oil on canvas
23¼ × 30 in. (59.1 × 76.2 cm)
Yale Center for British Art; Paul Mellon Collection

Donal Hord (1902–1966)
Thunder, 1946–47
Nephrite
20 × 16 × 9⅜ in. (50.8 × 40.6 × 23.8 cm)
The San Diego Museum of Art; Museum purchase
with funds from the Helen M. Towle Bequest

**Pair of ceramic vessels depicting musicians
playing pipes**
Inca, ca. 1200-1500
9½ × 4 × 4 in. (24.1 × 10.2 × 10.2 cm);
9¾ × 4 × 4 in. (24.8 × 10.2 × 10.2 cm)
Kleinbub Collection

Initial A: A Man Singing
Italy, ca. 1460–80
Tempera colors and gold leaf on parchment
23¾ × 17⅜ in. (60.3 × 44 cm)
The J. Paul Getty Museum

Adriaen Isenbrandt (ca. 1500–1551)
Madonna and Child with Angels, ca. 1510–20
Tempera and oil on panel
9½ × 7½ in. (24.1 × 19.1 cm)
The San Diego Museum of Art;
Gift of Anne R. and Amy Putnam

Jules-Ferdinand Jacquemart (1837–1880)
The Musician, n.d.
Etching
8½ × 6½ in. (21.6 × 16.5 cm)
The San Diego Museum of Art;
Gift of John F. Hollowell

Carl Jennewein (1890–1978)
Greek Dance, 1925
Bronze on polychromed wood base
20½ × 16⅜ × 6½ in. (52.1 × 41.8 × 16.5 cm)
The San Diego Museum of Art;
Gift of Mrs. Henry A. Everett

Jasper Johns (b. 1930)
Dancers on a Plane, 1979
Oil on canvas with objects
77⅞ × 64 in. (197.8 × 162.6 cm)
Collection of the artist

Circle of Juan Rodríguez Juárez (1675–1728)
*From Mulatto and Mestiza Comes Mulatto,
a Step Back*, ca. 1720
Oil on canvas
40½ × 56¾ in. (102.9 × 144.1 cm)
Pérez Simón Collection, Mexico

Vasily Kandinsky (1866–1944)
Motif from "Improvisation 25," folio 16 from *Sounds*
(*Klänge*), reprinted in *XXᵉ Siècle*, no. 3, 1938
Woodcut on paper
12½ × 9¾ in. (31.8 × 24.8 cm)
The San Diego Museum of Art; Museum purchase

Vasily Kandinsky (1866–1944)
On the Spiritual in Art (*Über das Geistige in der
Kunst*), 3rd edition, 1912
Softbound book with deckled edges
8¼ × 7¼ × ⅜ in. (21 × 18.2 × 1 cm)
Los Angeles County Museum of Art

**Kanhada Ragini of Dipak, a song to be played
in early summer after midnight**
India, Jaipur, ca. 1755
Ink, opaque watercolor and gold on paper
11⅞ × 8⅞ in. (30.2 × 22.5 cm)
The San Diego Museum of Art;
Edwin Binney 3rd Collection

Alton Kelley and Stanley Mouse
Skeleton and Roses: Grateful Dead, Oxford Circle
Avalon Ballroom, September 16–17, 1966
Color lithograph
25½ × 19 in. (64.8 × 48.3 cm)
Lent by Paul Prince

Alton Kelley and Stanley Mouse
13th Floor Elevators, Quicksilver Messenger Service
Avalon Ballroom, September 30–October 1, 1966
Color lithograph
25½ × 19 in. (64.8 × 48.3 cm)
Lent by Paul Prince

Max Klinger (1857–1920)
"Evocation," plate 19 from *Brahms Fantasy*
(*Brahms-Phantasie*), 1894
Etching, engraving, aquatint and mezzotint
14⅝ × 17⅜ in. (37 × 44 cm)
Fine Arts Museums of San Francisco;
Gift of R. E. Lewis, Inc.

Cloth (red)
Democratic Republic of the Congo, Kasai region,
Kuba, Shoowa
21⅝ × 26 in. (55 × 66 cm)
Fowler Museum at UCLA; Gift of the
Christensen Fund

Cloth (blue)
Democratic Republic of the Congo, Kasai region,
Kuba, Shoowa
26⅜ × 20½ in. (67 × 52 cm)
Fowler Museum at UCLA; Gift of the
Christensen Fund

Cloth (flat)
Democratic Republic of the Congo, Kasai region,
Kuba, Shoowa
22⅞ × 22½ in. (58 × 57 cm)
Fowler Museum at UCLA; Gift of the
Christensen Fund

Skirt
Democratic Republic of the Congo, Kasai region,
Northeastern Kuba, Shoowa
212¼ × 34⅝ in. (539 × 88 cm)
Fowler Museum at UCLA; Gift of the
Christensen Fund

Skirt
Democratic Republic of the Congo, Kasai region,
Kuba Bushoong, Shoowa
57⅛ × 26 in. (145 × 66 cm)
Fowler Museum at UCLA; Gift of the
Christensen Fund

František Kupka (1871–1957)
Blue Space, ca. 1912
Oil on canvas
26⅛ × 26⅛ in. (66.4 × 66.4 cm)
The San Diego Museum of Art; Museum purchase
through the Earle W. Grant Endowment Fund

Utagawa Kunisada (1786-1865)
Black Crow Dance: The Actor Nakamura Utaemon,
ca. 1838
Woodblock on paper
14⅝ × 9¾ in. (37.2 × 24.9 cm)
The San Diego Museum of Art; Gift of Captain
George B. Powell, Jr., JAGC, USN

Tamara de Lempicka (1898–1980)
Woman with a Mandolin, 1930
Etching and aquatint on paper
22⅜ × 13⅞ in. (56.7 × 35.2 cm)
Pérez Simón Collection, Mexico

Jacques Lipchitz (1891–1973)
Man with Mandolin, 1917
Marble
48⅜ × 17⅜ × 17⅜ in. (123 × 44.2 × 44.2 cm)
University of Arizona Art Museum;
Gift of Yulla Lipchitz

Artist unknown
Listening to the Qin by Candlelight
China, 17th century
Album leaf, ink and color on silk
8¾ × 10¾ in. (22.2 × 27.3 cm)
The Nelson-Atkins Museum of Art; Purchase:
William Rockhill Nelson Trust

Louis Lot (1807–1896)
Transverse Flute in C, 1856
Wood, metal
L: 27⅞ in. (70.9 cm)
The Metropolitan Museum of Art;
Gift of Catherine C. Perkins in memory of
Dr. Osborn P. Perkins, 1983

Lyre
Uganda or Kenya, 19th century
Wood, horn, gourd and skin
L: 28⅝ in. (72.7 cm)
The Metropolitan Museum of Art;
Gift of Miss Alice Getty, 1946

Lyre Guitar
France, early 19th century
Various materials
L: 33½ in. (85.1 cm)
The Metropolitan Museum of Art; the Crosby Brown
Collection of Musical Instruments, 1889

**Madhumadhavi Ragini of Bhairav, a song to be
played in late summer in the late morning**
India, Jodhpur, ca. 1610
Ink and opaque watercolor on paper
8⅞ × 6⅜ in. (22.4 × 16.2 cm)
The San Diego Museum of Art;
Edwin Binney 3rd Collection

**Maharana Sangram Singh with His Children
and Courtiers**
India, Mewar, ca. 1715
Opaque watercolor and gold on paper
16 × 26¾ in. (40.8 × 68 cm)
The San Diego Museum of Art;
Edwin Binney 3rd Collection

Christian Marclay (b. 1955)
Continental, 1991
Two record covers and cotton thread
21½ × 13 in. (54.6 × 33 cm)
Courtesy Paula Cooper Gallery, New York

Christian Marclay (b. 1955)
Looking for Love, 2008
Video, 32 min.
Courtesy Paula Cooper Gallery, New York

Christian Marclay (b. 1955)
Men of the Mall, 1991
Two record covers and cotton thread
23⅛ × 13 in. (58.4 × 33 cm)
Courtesy Paula Cooper Gallery, New York

**Workshop of the Master of Frankfurt
(ca. 1460–1533)**
*Mystical Marriage of Saint Catherine
with Saints and Angels*, ca. 1500–10
Oil on panel
27½ × 18¾ in. (69.9 × 47.6 cm)
The San Diego Museum of Art;
Gift of Mrs. Cora Timken Burnett

Henri Matisse (1869–1954)
Jazz, 1947
Illustrated book with twenty *pochoir* plates and text
in gravure page
each: 16½ × 25½ in. (41.9 × 64.8 cm)
Publisher: Tériade, Paris.
UCLA Grunwald Center for the Graphic Arts

Polychrome Vase
Maya, Late Classic, 650/750–900 AD
Ceramic
8 × 7¼ in. (20.3 × 18.4 cm)
Dumbarton Oaks Research Library and Collection

Drawing on barkcloth
Democratic Republic of Congo, Mbuti peoples,
20th century
Barkcloth
21 × 32 in. (53.3 × 81.3 cm)
Capital Group, Los Angeles, CA

Drawing on barkcloth
Democratic Republic of the Congo, Mbuti peoples,
20th century
Barkcloth
24½ × 29 in. (62.2 × 73.7 cm)
Capital Group, Los Angeles, CA

Drawing on barkcloth
Democratic Republic of the Congo, Mbuti peoples,
20th century
Bark, pigment
15¾ × 40½ in. (40 × 103 cm)
Peabody Museum of Archaeology and Ethnology
at Harvard University; Gift of Renée Bertrand in
memory of Diane Dixon-Daniel

Drawing on barkcloth
Democratic Republic of the Congo, Mbuti peoples,
20th century
Barkcloth
27³⁄₁₆ × 20⅞ in. (69 × 53 cm)
Peabody Museum of Archaeology and Ethnology
at Harvard University; Gift of Renée Bertrand in
memory of Diane Dixon-Daniel

Carlos Mérida (1891–1985)
In a Major Key (*En tono mayor*), 1981
Serigraph
31½ × 94½ in. (80 × 240 cm)
Collection of Susana Pliego

**Attic black-figure stamnos attributed to the
Michigan Painter**
Reclining Banqueters and Revelers
Greece, Attica, ca. 500 BC
Terracotta
H: 13½ in. (34.1 cm)
Los Angeles County Museum of Art;
William Randolph Hearst Collection

**Mirror with Images of Purity and Immortality:
Mount Penglai, Boya Playing the Qin (Zither),
Lotus Pond, and Dancing Phoenix**
China, Tang dynasty (618–907), 8th century
Bronze
6¾ in. (17.4 cm)
The Art Institute of Chicago; Samuel M. Nickerson
Endowment

Jan Miense Molenaer (1610–1668)
Allegory of Fidelity, 1633
Oil on canvas
39 × 55½ in. (99.1 × 140.6 cm)
Virginia Museum of Fine Arts; Adolph D. and
Wilkins C. Williams Collection

Albert Moore (1841–1893)
The Quartet, or a Painter's Tribute to Music, 1868
Oil on canvas
24 × 34⅞ in. (61 × 88.7 cm).
Pérez Simón Collection, Mexico

Victor Moscoso
Blues Project
The Matrix, February 13 & 16, 1967
Screenprint
24 × 17⅜ in. (61 × 44.1 cm)
The San Diego Museum of Art; Gift of Paul Prince

Victor Moscoso
Break on Through to the Other Side: Doors,
Country Joe and the Fish, Sparrow Lights
Avalon Ballroom, March 3–4, 1967
Color lithograph
25½ × 19 in. (64.8 × 48.3 cm)
Lent by Paul Prince

Victor Moscoso
Doors
The Matrix, March 7–11, 1967
Color lithograph (first printing)
25½ × 19 in. (64.8 × 48.3 cm)
Lent by Paul Prince

Victor Moscoso
Big Brother and the Holding Company, Quicksilver
Messenger Service, Mount Rushmore, Blue Cheer
Avalon Ballroom, June 29–30, 1967
Color lithograph
25½ × 19 in. (64.8 × 48.3 cm)
Lent by Paul Prince

Victor Moscoso
Youngbloods, Other Half, Mad River
Avalon Ballroom, September 15–17, 1967
Color lithograph
20 × 14 in. (50.8 × 35.6 cm)
The San Diego Museum of Art; Gift of Paul Prince

A Musical Gathering
India, Rajasthan, Harshagiri, ca. 970
Sandstone
5¾ × 24¾ × 4⅝ in. (14.6 × 62.9 × 11.8 cm)
Los Angeles County Museum of Art;
Los Angeles County Fund

Nasir ud-Din
Khambhavati Ragini of Malkos, a song to be played
in autumn at night
India, Mewar, 1605
Ink and opaque watercolor on paper
7⅞ × 7¼ in. (19.8 × 18.3 cm)
The San Diego Museum of Art;
Edwin Binney 3rd Collection

Naubat Khan, the Vina Player
India, 18th Century
Opaque watercolor on paper
5½ × 3¼ in. (14 × 8.4 cm)
The San Diego Museum of Art;
Edwin Binney 3rd Collection

Ladies of the Imperial Harem celebrating Shab-i Barat
India, Delhi, ca. 1725–50
Opaque watercolor and gold on paper,
mounted as an album page
6⅛ × 8⅞ in. (15.5 × 22.4 cm)
The San Diego Museum of Art;
Edwin Binney 3rd Collection

Tristan Perich (b. 1982)
Microtonal Wall, 2011
1,500 divisions of four octaves from C3 to C7,
electronic circuit, 1,500 speakers, aluminum
54 × 306 in. (137 × 777 cm)
Commissioned in part by Rhizome, with additional
support from the Addison Gallery
Courtesy bitforms gallery, New York

Pablo Picasso (1881–1973)
Ma Jolie, 1913–14
Oil on canvas
21¼ × 25⅝ in. (54 × 65 cm)
Indianapolis Museum of Art;
Bequest of Mrs. James W. Fesler

The presentation of a new bride
India, Uttar Pradesh, ca. 1760
Opaque watercolor and gold on paper
13½ × 17⅛ in. (34.4 × 43.6 cm)
The San Diego Museum of Art,
Edwin Binney 3rd Collection

Qin
China, 19th century
Wood, horn, silk and mother-of-pearl
L: 48⅜ in. (122.8 cm)
The Metropolitan Museum of Art; the Crosby Brown
Collection of Musical Instruments, 1889

Raja Sansar Chand in the company of nobles and dignitaries
India, Kangra, ca. 1810
Opaque watercolor and gold on paper
14 × 19⅛ in. (35.7 × 48.5 cm)
The San Diego Museum of Art,
Edwin Binney 3rd Collection

Robert Rauschenberg (1925–2008)
Music Box (Elemental Sculpture), ca. 1953
Wood crate with traces of metallic paint, nails,
three unattached stones and feathers
11 × 7½ × 9¼ in. (27.9 × 19.1 × 23.5 cm)
Collection of Jasper Johns

Johann Baptist Reiter (1813–1890), after Orazio Gentileschi (1563–1639)
The Lute Player, ca. 1850
Oil on material
55½ × 49¼ in. (141 × 125 cm)
Collection of Frank and Demi Rogozienski,
San Diego

Jusepe de Ribera (1591–1652)
St. Jerome in the Wilderness, 1621
Etching
12⅜ × 9¼ in. (31.4 × 23.5 cm)
The San Diego Museum of Art;
Museum purchase with funds provided by
the University Women's Club

Matthew Ritchie (b. 1964)
Monstrance, 2011
Video, 22 min., 19 sec.
Courtesy Andrea Rosen Gallery

Morgan Russell (1886–1953)
Synchromy with Nude in Yellow, 1913
Oil on canvas
39¼ × 31½ in. (99.7 × 80 cm)
The San Diego Museum of Art; Museum purchase
through the Earle W. Grant Endowment Fund

Kazuya Sakai (1927–2001)
Filles de Kilimanjaro III (Miles Davis), 1976
Acrylic on canvas
79 × 78¾ in. (200.6 × 200 cm)
Blanton Museum of Art, The University of Texas
at Austin; Archer M. Huntington Museum Fund, 1977

Saraswati
India, Calcutta, ca. 1880
Watercolor on paper
17⅞ × 10⅝ in. (45.4 × 27.1 cm)
The San Diego Museum of Art;
Edwin Binney 3rd Collection

Statuette of a Satyr Playing the Pipes (aulos)
Roman, 150–200 AD
Silver and gold
H: 1⅝ in. (4.2 cm)
The J. Paul Getty Museum, Villa Collection;
Gift of Barbara and Lawrence Fleischman

Moritz von Schwind (1804–1871)
Queen of the Night, ca. 1864–67
Watercolor over graphite
16⅛ × 12¼ in. (41 × 31.1 cm)
The J. Paul Getty Museum

Seated musicians, set of four
China, Shaanxi province or Henan province,
Tang dynasty (618–906), ca. 700–750
Low-fired ceramic
each 7¼ × 5 × 4⅜ in. (18.4 × 12.7 × 11.1 cm)
Asian Art Museum, San Francisco; The Avery
Brundage Collection

John Sennhauser (1907–1978)
Improvisation, 1939
Oil on canvas board
19⅞ × 16 in. (50.5 × 40.6 cm)
The San Diego Museum of Art;
Gift from the Estate of John Sennhauser

John Sennhauser (1907–1978)
Synchroformic #18—Horizontal Duo, 1951
Oil on board
24 × 72 in. (61 × 182.9 cm)
The San Diego Museum of Art;
Gift from the Estate of John Sennhauser

Everett Shinn (1876–1953)
Stage Costume, 1910
Pastel and gouache
7⅝ × 9⅝ in. (19.4 × 24.5 cm)
The San Diego Museum of Art;
Bequest of Mrs. Inez Grant Parker

Shiva as Lord of Music (Vinadhara Dakshinamurti)
India, 6th century
Sandstone
16¾ × 13¾ × 4¾ in. (42.6 × 34.9 × 12.2 cm)
The San Diego Museum of Art;
Edwin Binney 3rd Collection

Katsukawa Shunchō (active ca. 1783–1795)
Ichikawa Danjuro V, from the Play *Shida yuzuri wa horai Soga*, 1775
Woodblock print
11⅞ × 5⅜ in. (30.3 × 13.7 cm)
The San Diego Museum of Art; Museum purchase

Luca Signorelli (1450–1523)
The Coronation of the Virgin, 1508
Oil and tempera on panel
50 × 87¾ × 5¾ in. (127 × 222.9 × 14.6 cm)
The San Diego Museum of Art; Museum
purchase through the Gerald and Inez Grant Parker
Foundation, Dr. and Mrs. Edwin Binney 3rd and
Museum Art Purchases Funds

David Singer
Grateful Dead, Miles Davis Quintet, Brotherhood
Fillmore West, April 9–12, 1969
Color lithograph
25½ × 19 in. (64.8 × 48.3 cm)
Lent by Paul Prince

David Singer
Grateful Dead, Taj Mahal
Fillmore West, February 5–8, 1970
Color lithograph
27½ × 19 in. (69.9 × 48.3 cm)
Lent by Paul Prince

John Sloan (1871–1951)
Italian Procession, New York, 1913–25
Oil on canvas
24 × 28 in. (61 × 71.1 cm)
The San Diego Museum of Art;
Museum purchase with funds provided by
Mr. and Mrs. Appleton S. Bridges

Jan Steen (1626–1679)
A Village Wedding, n.d.
Oil on canvas
27¼ × 33¾ in. (69 × 86 cm)
Pérez Simón Collection, Mexico

Alfred Stieglitz (1864–1946)
Songs of the Sky, No. 2, 1923
Gelatin silver print
3⅞ × 4⅞ in. (10 × 12.6 cm)
The J. Paul Getty Museum

Alfred Stieglitz (1864–1946)
Music: A Sequence of Ten Cloud Photographs, no. 1, 1922
Gelatin silver print
7⅜ × 9½ in. (18.7 × 24 cm)
The J. Paul Getty Museum

Rufino Tamayo (1899–1991)
Sleeping Musicians (*Músicas dormidas*), 1950
Oil on canvas
51⅛ × 76¾ in. (130 × 195 cm)
Museo de Arte Moderno, Mexico City

Tapper (*iroke Ifá*)
Yoruba peoples, Nigeria,
late 19th/early 20th century
Ivory, H: 11½ in. (29.2 cm)
Fowler Museum at UCLA; Anonymous Gift

Tapper (*iroke Ifá*)
Yoruba peoples, Nigeria,
late 19th/early 20th century
Ivory
H: 19½ in. (49.5 cm).
Fowler Museum at UCLA; Gift of
Mrs. Maurice Machris

Painter of Tarquinia
Column Krater—Orpheus among the Thracians,
450/420 BC
Painted terracotta
H: 14⅞ in. (37.8 cm); D: 14⅜ in. (36.5 cm)
Portland Art Museum; Gift of the heirs of
Helen Ladd Corbett

David Teniers the Younger (1610–1690)
A Village Kermesse, ca. 1650
Oil on canvas transferred from wood
23⅜ × 31⅛ in. (59.3 × 78.9 cm)
Pérez Simón Collection, Mexico

Teponaztli
Mexico, Mexica culture, Central Altiplano region,
ca. 1500
Wood
10⅛ × 8⅞ × 27¼ in. (25.6 × 22.6 × 69 cm)
National Museum of Anthropology,
CONACULTA-INAH, Mexico City, Inv. 10-78329

Teponaztli macuilxochitl
Mexico, Mexica culture, Mexico City, ca. 1500
Stone (andesite)
13⅛ × 9⅝ × 28⅛ in. (33.5 × 24.5 × 71.5 cm)
National Museum of Anthropology,
CONACULTA-INAH, Mexico City, Inv. 10-222373

Alma Thomas (1891–1978)
*Red Azaleas Singing and Dancing
Rock and Roll Music*, 1976
Acrylic on canvas
72¼ × 135½ in. (183.5 × 344.2 cm)
Smithsonian American Art Museum;
Bequest of the artist

Henri de Toulouse-Lautrec (1864–1901)
Moulin Rouge—La Goulue, 1891
Lithograph
75½ × 46 in. (191.8 × 116.8 cm)
The San Diego Museum of Art; Gift of the
Baldwin M. Baldwin Foundation

Henri de Toulouse-Lautrec (1864–1901)
Yvette Guilbert, 1895
Ceramic
20½ × 11⅛ ×⅞ in. (52 × 28.3 × 2.1 cm)
The San Diego Museum of Art; Gift of
Mrs. Robert Smart

Utagawa Toyoharu (1735–1814)
Perspective Picture of a Kabuki Theater
(*Uki-e Kabuki shibai no zu*), ca. 1776
Woodblock print
10⅛ × 15¼ in. (25.6 × 38.6 cm)
The Art Institute of Chicago; Gift of
Mr. and Mrs. Harold G. Henderson

Utagawa Toyokuni II (1777–1835)
The Actor Ichikawa Danjuro VII in the play
Shibaraku, ca. 1823–25
Woodblock print
8⅜ × 7⅛ in. (21.3 × 18.1 cm)
The San Diego Museum of Art;
Anonymous donation

Two women on a terrace, smoking and kite flying
India, Nurpur, ca. 1785
Opaque watercolor and gold on paper
10⅝ × 7 in. (27.1 × 17.9 cm)
The San Diego Museum of Art;
Edwin Binney 3rd Collection

Bartolomeo Veneto and workshop
(died 1531, active 1502–1555)
Lady Playing a Lute, ca. 1530
Oil on panel
22 × 16¼ in. (55.9 × 41.3 cm)
The J. Paul Getty Museum

Lorenzo Veneziano (active ca. 1353–1379)
*Madonna and Child with Angels, the Crucifixion,
and Twelve Apostles or Saints*, ca. 1360
Tempera on panel
20¾ × 8⅞ in. (52.7 × 22.5 cm)
The San Diego Museum of Art;
Gift of Anne R. and Amy Putnam

Édouard Vuillard (1868–1940)
Misia at the Piano, ca. 1895
Oil on cardboard
10¼ × 9⅞ in. (26 × 25 cm)
The Metropolitan Museum of Art;
Robert Lehman Collection, 1975

Whistle
Kongo peoples, Democratic Republic of the Congo,
late 19th/early 20th century
Wood, horn
H: 6½ in. (16.5 cm)
Fowler Museum at UCLA; Gift of the
Goldenberg Family Trust

Whistle
Yaka peoples, Democratic Republic of the Congo,
late 19th/early 20th century
Wood
H: 5¼ in. (13.3 cm)
Fowler Museum at UCLA; Gift of Helen and
Dr. Robert Kuhn

Whistle
Chokwe peoples, Democratic Republic of the
Congo, Angola, late 19th/early 20th century
Wood
H: 4¾ in. (12.1 cm)
Fowler Museum at UCLA; Gift of Helen and
Dr. Robert Kuhn

Tom Wilkes
Monterey International Pop Festival, 1967
Monterey Fairgrounds June 16–18, 1967
Color lithograph
27½ × 19 in. (69.9 × 48.3 cm)
Lent by Paul Prince

Wes Wilson
Pop-Op Rock: Andy Warhol & his Plastic Inevitable,
with Velvet Underground, Nico, 1966
Fillmore Auditorium, May 27–29, 1966
Color lithograph
25½ × 19 in. (64.8 × 48.3 cm)
Lent by Paul Prince

Wes Wilson

Association, Quicksilver Messenger Service,
Grassroots, Sopwith Camel, 1966
Fillmore Auditorium, July 22–23, 1966
Color lithograph
25½ × 19 in. (64.8 × 48.3 cm)
Lent by Paul Prince

Wes Wilson

Jefferson Airplane, Grateful Dead, 1966
Fillmore Auditorium, August 12–13, 1966
Color lithograph
25½ × 19 in. (64.8 × 48.3 cm)
Lent by Paul Prince

Wes Wilson

The Sound: Jefferson Airplane, Muddy Waters,
Butterfield Blues Band
Winterland, September 23–24, 1966
Color lithograph
35½ × 25 in. (90.2 × 63.5 cm)
Lent by Paul Prince

Wes Wilson

Grateful Dead, Junior Wells, Chicago Blues Band
Fillmore Auditorium, January 13–15, 1967
Color lithograph
27½ × 19 in. (69.9 × 48.3 cm)
Lent by Paul Prince

Wes Wilson

Quicksilver Messenger Service, Dino Valenti
Fillmore Auditorium, February 3–5, 1967
Color lithograph
27½ × 19 in. (69.9 × 48.3 cm)
Lent by Paul Prince

Wes Wilson

Byrds, Moby Grape, Andrew Staples
Winterland, March 31–April 1, 1967
Fillmore Auditorium April 2, 1967
Color lithograph
27½ × 19 in. (69.9 × 48.3 cm)
Lent by Paul Prince

A woman playing the tambura

India, Himachal Pradesh, ca. 1790
Opaque watercolor and gold on paper
7½ × 4⅝ in. (19.2 × 11.9 cm)
The San Diego Museum of Art;
Edwin Binney 3rd Collection

Francisco de Zurbarán (1598–1664)

Saint Jerome, ca. 1640–45
Oil on canvas
73 × 41 in. (185.4 cm × 104.1 cm)
The San Diego Museum of Art; Museum purchase
with funds provided by Anne R. and Amy Putnam

266. Jasper Johns (b. 1930). *Dancers on a Plane,* 1979. Oil on canvas
with objects, 77⅞ × 64 in. (197.8 × 162.6 cm). Collection of the artist.

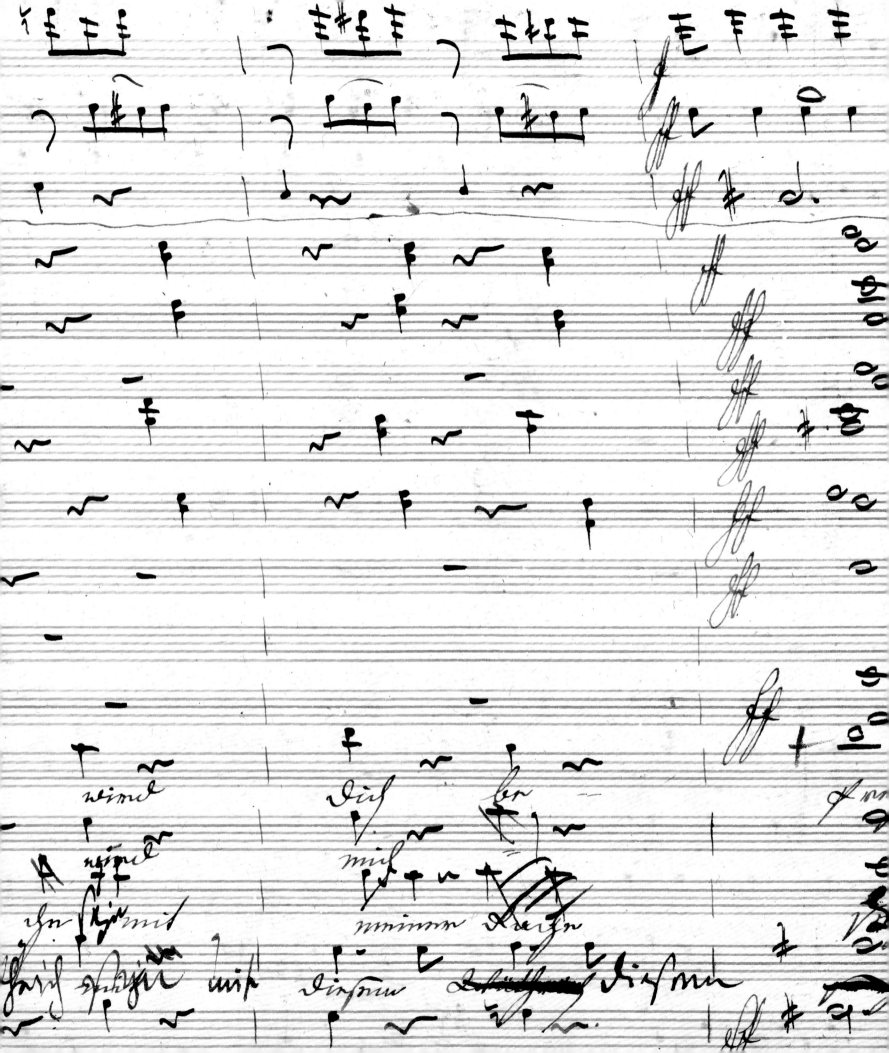

Contributors

Sandra Benito is Deputy Director of Education and Public Engagement at The San Diego Museum of Art.

Michael A. Brown is Associate Curator of European Art at The San Diego Museum of Art.

Patrick Coleman is an independent scholar and writer.

James Grebl is Associate Curator of Research, Archives and Provenance at The San Diego Museum of Art.

Anita Feldman is Deputy Director of Curatorial Affairs at The San Diego Museum of Art.

Richard Leppert is Regents Professor of Cultural Studies and Comparative Literature at the University of Minnesota.

Ariel Plotek is Associate Curator of Modern Art at The San Diego Museum of Art.

Gemma Rodrigues is a Research Fellow at the University of Madeira, Portugal.

Marika Sardar is Associate Curator, Southern Indian and Islamic Art, at The San Diego Museum of Art.

Simon Shaw-Miller is Chair of History of Art at the University of Bristol.

Christina Yu Yu is Director of the USC Pacific Asia Museum.

Exhibition Credits

Organized by The San Diego Museum of Art

Chief Curators:
Sandra Benito
Anita Feldman

Curators:
Michael A. Brown
James Grebl
Ariel Plotek
Marika Sardar

Guest Curators:
Vincent Poussou
Gemma Rodrigues
Julien Ségol
Eric de Visscher
Christina Yu Yu

Exhibition Designers:
Scot Jaffe
Paul Brewin

Registrars:
John Digesare
Joyce Penn

Loan and Checklist Coordinator: Cory Woodall

Head Preparator: James Gielow

Editor: Sarah Hilliard

Graphic Designer: Noell Cain

Spanish Translator: Gwen Gómez

Installation:
Tom Ladwig
Evan Weatherford
Aja Wood
Andrew Marino

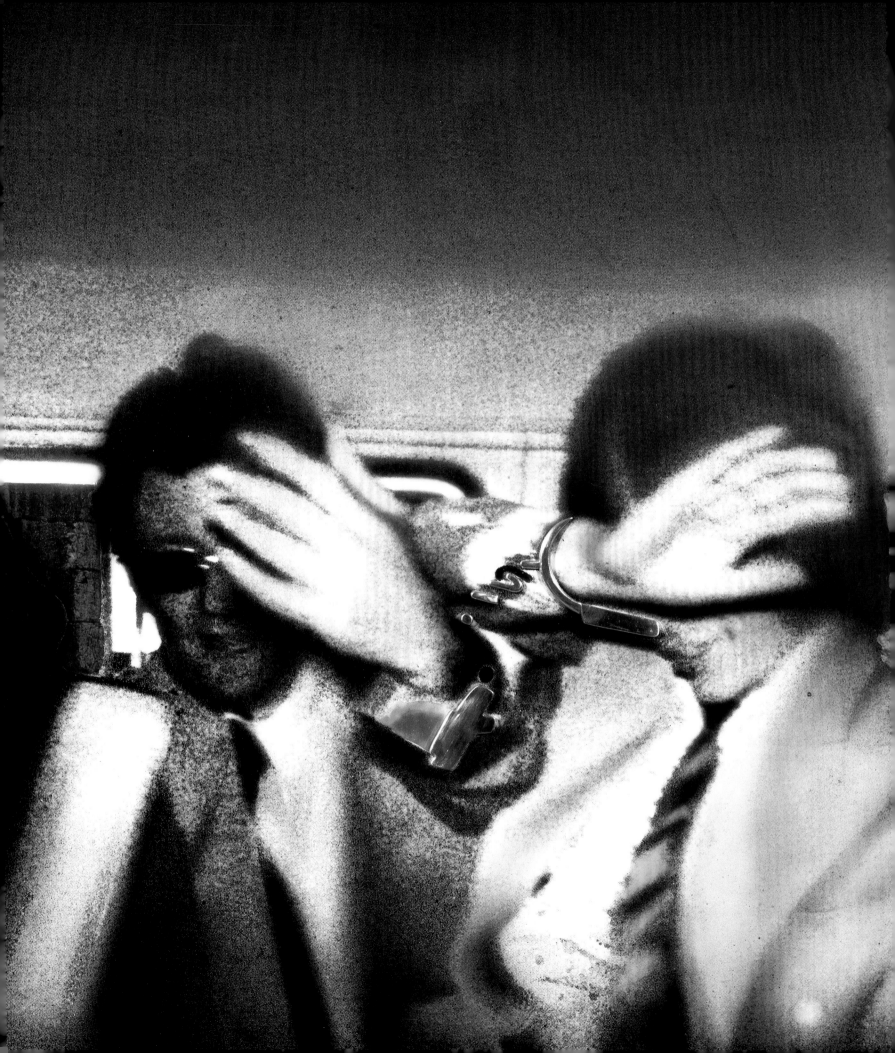

Index

Note: Page numbers in italic type indicate illustrations.

Photography Credits

Copyright information and photography credits of works included in this catalogue are below. Images without specific credit are courtesy the source institution. Every effort has been made to credit the photographers and sources of all illustrations in this volume; if there are any errors or omissions, please contact The San Diego Museum of Art so that corrections can be made in a subsequent edition.

Alfredo Dagli Orti / The Art Archive at Art Resource, NY, p. 254; © The Art Institute of Chicago, p. 150, 153, 159, 162; Art Resource, NY, p. 76, 256; © 2015 Artists Rights Society (ARS), New York, p. 45, 46, 47, 200, 220, 223, 224; © 2015 Artists Rights Society (ARS), New York / ADAGP, Paris, p. 42, 76, 261, 262, 271, 298; © 2015 Artists Rights Society (ARS), New York / CREAIMAGEN, Santiago de Chile, p. 198; © 2015 Artists Rights Society (ARS), New York / SIAE, Rome, p. 23; © 2015 Artists Rights Society (ARS), New York / SOMAAP, Mexico City, p. 190, 191; © Asian Art Museum, San Francisco, p. 151; © 2015 Belmont Music Publisher, Los Angeles / ARS, New York / Bildrecht, Vienna, p. 11, 221, 222, 223, 225; © Ben Shahn/Licensed by VAGA, New York, NY, p. 294; © Benjamin Artworks, reproduced by permission, p. 272, 273; bpk, Berlin / Alte Nationalgalerie, Berlin / Art Resource, NY, p. 116; © 2015 Bruce BecVar, p. 76; © By kind permission of the Trustees of The Wallace Collection, London, p. 112, 117; © 2015 Calder Foundation, New York / Artists Rights Society (ARS), New York, p. 215; © Center for Visual Music, p. 280, 283; © Christian Marclay, p. 55, 56; © Christie's Images/Bridgeman Images, p. 62, 146; © Chuck Close in association with Magnolia Editions, Oakland, courtesy Pace Gallery, p. 31; © CNAC/MNAM/Dist. RMN-Grand Palais / Art Resource, NY, p. 223, 256; Collection Musée de la musique / Cliché Anglès, p. 120; © Conner Family Trust, p. 283; Conservation funds provided by Dr. John Kelly, through the through the Adopt-a-Print program of the Museum's Asian Arts Council. (May 14, 2010), p. 162; Conservation funds provided by Gordon J. Brodfuehrer through the Adopt-a-Print program of the Museum's Asian Arts Council. (August 20, 2009), p. 163; © 2015 Delaware Art Museum / Artists Rights Society (ARS), New York, p. 213; Digital Archive Collections of the National Museum of Anthropology. CONACULTA-INAH-CANON, p. 188; © Dumbarton Oaks, Pre-Columbian Collection, Washington, DC, p. 186; © The Estate of Arthur G. Dove, courtesy of Terry Dintenfass, Inc., p. 101, 269; © 2015 Estate of Beauford Delaney, by permission of Derek L. Spratley, Esquire,

Court Appointed Administrator, p. 278; © 2015 Estate of Pablo Picasso / Artists Rights Society (ARS), New York, p. cover, 252, 258, 260; © Fernando Botero, p. 184, 195; Courtesy of The Fischinger Trust, p. 266, 281, 282; Courtesy of the Denver Art Museum, p. 173; © 2015 The Franz Kline Estate / Artists Rights Society (ARS), New York, p. 50; Gianni Dagli Orti /The Art Archive at Art Resource, NY, p. 188; © 1991 Hans Namuth Estate, p. 51, 52; © Henri Cartier-Bresson/Magnum Photos, p. 241; Image source: Bridgeman Images, cover, p. 2, 3, 14, 35, 60, 65, 78, 79, 104, 106, 107, 122, 169, 216, 252, 258; © J. Paul Getty Trust, p. 41; © Janet Cardiff, p. 295; © Jasper Johns/Licensed by VAGA, New York, NY, p. 1, 305; Courtesy of the John Cage Trust, p. 285; © Man Ray Trust / Artists Rights Society (ARS), NY / ADAGP, Paris 2015, p. 261; © Matsuzaki Kunitoshi, p. 284; © The Metropolitan Museum of Art, p. 24, 39, 52, 53, 74, 75, 76, 77, 115, 139, 152, 156, 157, 158, 161, 184, 195; © The Metropolitan Museum of Art. Image source: Art Resource, NY, 24, 25, 39, 74, 75, 77, 152, 156, 157; © 2015 Museum of Fine Arts, Boston, p. 269; © The Museum of Modern Art/Licensed by SCALA / Art Resource, NY, 264; © Nam June Paik Estate, p. 286; © The National Gallery, London, p. 202; Courtesy National Gallery of Art, Washington, p. 174; © National Trust Images, p. 12, 168, 176; © Nombre del autor, VEGAP, lugar y año de la reproducción. Procedencia: Museo Thyssen-Bornemisza, p. 294; © 2015 The Pollock-Krasner Foundation / Artists Rights Society (ARS), New York, p. 52; © President and Fellows of Harvard College, Peabody Museum of Archaeology and Ethnology, Harvard University. PM #2006.38.34 (digital file# 55120098), p. 238; © Ragnar Kjartansson, p. 291, 292, 293; © Rheinisches Bildarchiv Köln, p. 45; © Robert Rauschenberg Foundation/Licensed by VAGA, New York, NY, p. 26; © RMN-Grand Palais / Art Resource, NY, p. 81, 257; © Salvador Dalí, Fundació Gala-Salvador Dalí, Artists Rights Society (ARS), New York 2015, p. 22; Scala / Art Resource, NY, p. 72; Scala / Ministero per i Beni e le Attività culturali / Art Resource, NY, p. 73; © 2015 Succession H. Matisse / Artists Rights Society (ARS), New York, p. 211, 242–6, 249, 264; © 2015 Tamara Art Heritage / ADAGP, Paris / ARS, NY, p. 175; © Tamayo Heirs/Mexico/Licensed by VAGA, New York, NY, p. 192, 193, 308; © Tate, London 2014; © R. Hamilton. All Rights Reserved, DACS and ARS 2015, p. 30, 310; © Virginia Museum of Fine Arts, p. 82; © Whitney Museum of American Art, NY, p. 50.

Photography

Ardon Bar Hama, p. 21; Michèle Bellot, p. 257; Rebecca Clews, p. 155; Don Cole, p. 230, 232–7, 240, 247, 248, 249; Sheldan C. Collins Courtesy of Peyton Wright Gallery, Santa Fe, New Mexico, p. 44; Travis Fullerton © Virginia Museum of Fine Arts, p. 278; Rick Hall, p. 197; David Heald © SRGF, p. 286; Sid Hoeltzell Photography, p. 194; Franko Khoury, p. 235; John Lamberton, p. 67, 68, 76, 111; Erich Lessing / Art Resource, NY, p. 36, 42, 256; Sean Andrew Maynard, p. 148; Georges Meguerditchian, p. 223; Jamison Miller, p. 172; © Arturo Piera, p. 18, 22, 28, 109, 110, 175, 180, 196, 215; Katherine Wetzel, p. 82.

267. Donal Hord (1902–1966). *Thunder*, 1946–47. Nephrite, 20 × 16 × 9⅜ in. (50.8 × 40.6 × 23.8 cm). The San Diego Museum of Art; Museum purchase with funds from the Helen M. Towle Bequest.

This book is published in conjunction with the exhibition *The Art of Music,* presented at The San Diego Museum of Art from September 26, 2015, to January 5, 2016.

The San Diego Museum of Art Celebrates 100 Years of Art in Balboa Park has been made possible by the generous support of Presenting Sponsor Conrad Prebys and Debbie Turner.

Support for the exhibition *The Art of Music* is provided by Canterbury Consulting, Gallagher Levine, RBC Wealth Management, Wells Fargo, David C. Copley Foundation, Dextra Baldwin McGonagle Foundation, Inc., Farrell Family Foundation, Susanna and Michael Flaster, Marjorie Ann Mopper, Roy and Joanie Polatchek, Taffin and Gene Ray, the members of The San Diego Museum of Art and the County of San Diego Community Enhancement Program. Institutional support for the Museum is provided by the City of San Diego Commission for Arts and Culture.

Published by The San Diego Museum of Art
sdmart.org

in association with
Yale University Press
302 Temple Street
P.O. Box 209040
New Haven, CT 06520-9040
yalebooks.com/art

Produced by Marquand Books, Inc., Seattle
marquand.com

Edited by Patrick Coleman
Designed and typeset by Susan E. Kelly
Typeset in Museo Sans and Proxima Nova
Proofread by Diana George and Sarah Hilliard
Index by David Luljak
Color management by iocolor, Seattle
Printed and bound in China by C&C Offset Printing Co., Ltd.

Library of Congress Cataloging-in-Publication Data
The art of music / edited by Patrick Coleman.
 pages cm
 Summary: "The Art of Music takes the relationship between two of the more prominent and oft-intersecting branches of artistic creation as its subject. The liaison between music and the visual arts has inspired countless generations of artists. The two have had manifold complex interactions across all periods of history, in Western and non-Western contexts alike, yet their intersection has only become a rich vein for research by art historians and musicologists in the last thirty years. By tracing these relationships, new insights into the affinities of the arts become clear"—Provided by publisher.
 Includes bibliographical references and index.
 ISBN 978-0-300-21547-2 (hardback)
 1. Art and music. I. Coleman, Patrick, editor.
 ML3849.A774 2015
 780'.07—dc23 2015017781

Front cover: Pablo Picasso. *Ma Jolie* (detail), 1913–14. Fig. 231.
Back cover: Albert Moore. *The Quartet, or a Painter's Tribute to Music,* 1868. Fig. 86.
Page 1: Jasper Johns. *Dancers on a Plane* (detail), 1979. Fig. 266.
Page 2–3: Jean-Baptiste-Camille Corot. *Orpheus Leading Eurydice from the Underworld* (detail), 1861. Fig. 102.
Page 4: Madhumadhavi Ragini of Bhairav (detail). India, Jodhpur, ca. 1610. Fig. 71.
Page 12: Attributed to Justus Sustermans. *Saint Cecilia Playing the Organ* (detail), 17th century. Fig. 152.
Page 14: Pieter Brueghel the Elder. *The Wedding Dance* (detail), ca. 1566. Fig. 63.
Page 32: Marsden Hartley. *Musical Theme No. 2 (Bach Preludes and Fugues)* (detail), 1912. Fig. 31.
Page 60: Jan van Kessel and Hendrik van Balen, after Jan Brueghel the Elder. *Allegory of Hearing* (detail), 17th century. Fig. 49.
Page 86: Nasir ud-Din. Khambhavati Ragini of Malkos (detail). India, Mewar, 1605. Fig. 76.
Page 104: James McNeill Whistler. *Nocturne in Black and Gold: The Falling Rocket* (detail), 1875. Fig. 83.
Page 128: Apulian red-figure volute krater by the Underworld Painter. Orpheus Playing before Persephone and Hades (detail). Fig. 114.
Page 166: Juan Rodríguez Juárez. *From Mulatto and Mestiza Comes Mulatto, a Step Back* (detail), ca. 1720. Fig. 156.
Page 184: Fernando Botero. *Dancing in Colombia (Baile en Colombia)* (detail), 1980. Fig. 166.
Page 200: Vasily Kandinsky. Motif from "Improvisation 25," folio 16 from *Sounds (Klänge)* (detail), reprinted in *XX^e Siècle,* no. 3, 1938. Fig. 195.
Page 230: Prestige panel (detail). Kuba peoples, Shoowa group, Democratic Republic of the Congo, 20th century. Fig. 220.
Page 252: Pablo Picasso. *Ma Jolie* (detail), 1913–14. Fig. 231.
Page 266: Oskar Fischinger. *Balls #16* (detail), 1964. Fig. 253.
Page 306: Ludwig van Beethoven. *Fidelio,* "Er stebe!" Act 2, No. 14 (detail), 1814. Fig. 7.
Page 308: Richard Hamilton. *Swingeing London 67 (f)* (detail), 1968–69. Fig. 19.